General Editor: Ben Robinson
Project Manager: Jo Bourne
Writers: Ben Robinson and Mark Wright,
with additional material by William Potter and Matt McAllister
Sub-editor: Alice Peebles
Designer: Stephen Scanlan

With thanks to the team at CBS: John Van Citters, Marian Cordry
and Risa Kessler

Published by **Hero Collector Books**, a division of Eaglemoss Ltd. 2020
1st Floor, Beaumont House, Kensington Village, Avonmore Road,
W14 8TS, London, UK.

ISBN 978-1-85875-614-1

Printed in China
10 9 8 7 6 5 4 3 2 1

www.herocollector.com

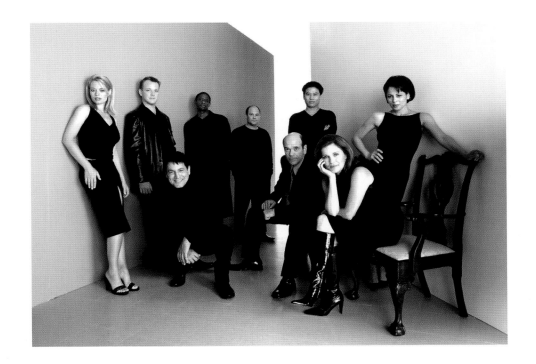

STAR TREK VOYAGER™

A CELEBRATION

CONTENTS

CONTENTS

SPECIAL THANKS

So many people helped with this book, who we have to thank. All the principal members of the cast were generous with their time and gave us new interviews: Kate Mulgrew, Robert Beltran, Tim Russ, Robbie McNeill, Garrett Wang, Roxann Dawson, Bob Picardo, Ethan Phillips, and Jeri Ryan could not have been more helpful. We owe a massive apology to Manu Intiraymi who made time to talk to us, but barely made it into the book. Lolita Fatjo, Dave Zappone, and Bill Burke helped to put us in touch with the people we didn't already know, and Amy Imhoff helped us schedule time with Kate.

On the other side of the camera, directors John Bruno and David Livingston were incredibly insightful and informative. Mike DeMeritt gave us a real sense of what it was like on set. Once again, Michael Westmore proved himself to be an incredible repository of information. In the art department, Rick Sternbach, Mike and Denise Okuda, Jim Martin, and Tim Earls all pulled out their memories and artwork. As always, Dan Curry's VFX team went above and beyond. Dan, Ron B. Moore, and David Stipes shared artwork, stories and explanations, while Rob Bonchune and David Lombardi gave us an insight into life at the VFX houses. Jay Chattaway explained what went into the music and Doug Drexler contributed the story about detailing *Voyager*.

VOYAGER's writers explained how and why things happened. Brannon Braga made time for a marathon interview session that covered the entire series. Ken Biller, Bryan Fuller, Mike Taylor, Mike Sussman, Phyllis Strong, Rob Doherty, Lisa Klink, Nick Sagan, and the wonderful Jeri Taylor all made time for us. Jimmy Diggs and Jim Swallow revealed what it was like to pitch to *VOYAGER*, and André Bormanis explained the secrets behind the science.

We supplemented a handful of pages with interviews from the past so we also owe thanks to Joe Menosky, Richard James, Steve Burg, and Raf Green for their contributions there, and of course to the late Michael Piller, whose spirit you will find throughout this book. And there would be no *STAR TREK: VOYAGER* without Gene Roddenberry and Rick Berman.

FOREWORD

When we set out to write this book, our mission statement was to give you "the best convention ever, in a book." We wanted to share the funny stories and to explain how things were done. But more importantly, we wanted to give you a sense of what the cast and crew are like and what it meant to them to spend seven years of their lives filming *VOYAGER*.

As we worked on the book, we realized what an incredible bunch of people *VOYAGER*'s cast and crew are. Without exception, we found them to be intelligent, insightful, generous, funny people. We can't tell you how much we laughed when we were doing the interviews, and how much we looked forward to the next one. Our hope is that we've managed to communicate at least some of that, and give you a sense of who these people are.

We also hope that by talking to so many people, all of whom had the advantage of being able to look back on the show, we've been able to give you some real insight into how the characters evolved. We firmly believe that if you want to understand Captain Janeway, or Seven of Nine, you don't just want to hear from the actors, but from the writers and designers who shaped their characters. Television is a collaborative medium. Everybody contributed, and you can only just begin to understand what they did by talking to all of them.

On the pages that follow, you'll find profiles of all the main characters, with contributions from actors, writers, and directors. Each of these is based on a new interview with the actor (the only exception being Jennifer Lien, who we wish the very best). Then there is a series of chapters that deal with each of the main departments, which we hope will give some idea of what went into making *VOYAGER*. We have pulled out some of the series' most important episodes to discuss how they contributed to *VOYAGER*'s success. They're not meant to be our selection of the very best episodes, although many of them are. They are there because, in some ways, they changed things, or they exemplify a particular kind of *STAR TREK*. Finally, we have a few stories and tackle a few tricky questions about the show. We hope that when you've read all of the above, you'll want to go back and watch all of *VOYAGER*. You should. As Bryan Fuller said when we talked, "It's a really good show!"

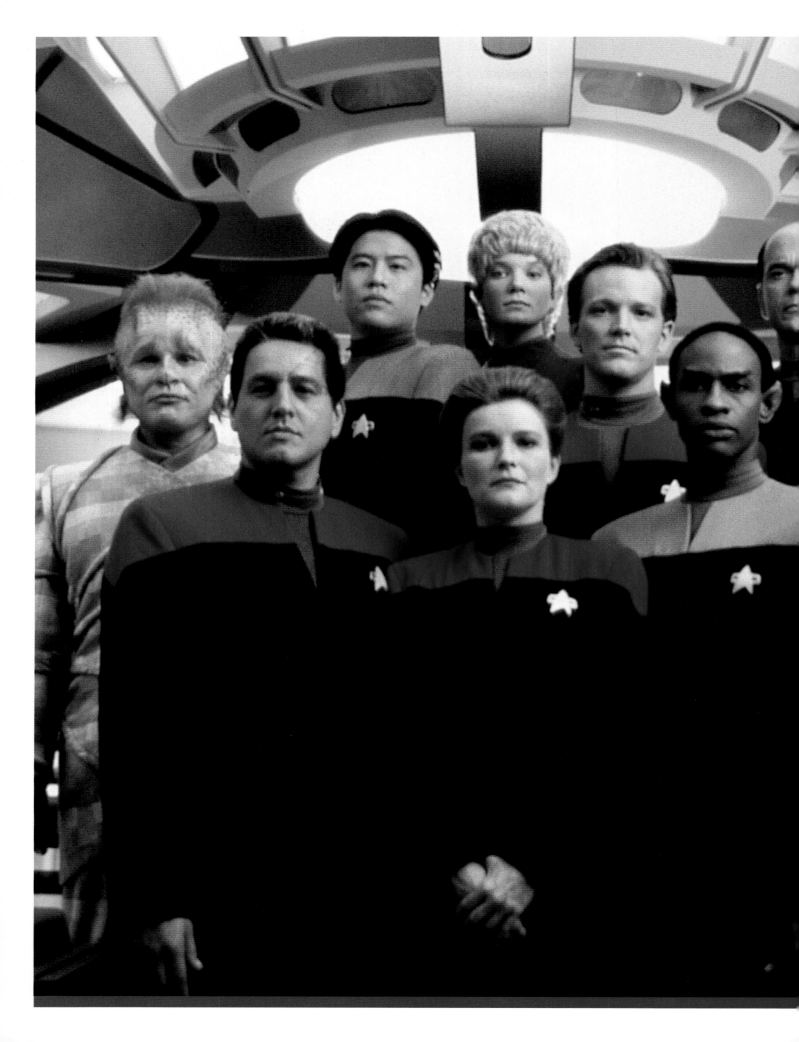

FAR FROM HOME

THE SEVEN-YEAR JOURNEY

STAR TREK: VOYAGER went further than ever before and gave the franchise many of its most memorable moments and characters.

I f *STAR TREK* was to survive, it would have to grow and change. The question was: how to change it without losing sight of what made it special. The franchise had never been more popular and *STAR TREK: THE NEXT GENERATION* was a ratings powerhouse that only got stronger in its final season. It was inevitable that when it ended its run, Paramount would want to replace it. As *VOYAGER*'s cocreator, Rick Berman remembers, there was broad agreement that any new show should follow closely in the *Enterprise*'s footsteps. "With *DEEP SPACE NINE* being a station-based show, we wanted to get back out into space," he says, "so we knew we wanted to put the show on a starship. We knew it couldn't be the *Enterprise* because the *Enterprise* was continuing on into the movies. We created *VOYAGER* in order to make the series different and fresh."

Berman brought in writers Michael Piller and Jeri Taylor to cocreate the new show, and together they set about thinking exactly how they could make it different. From the beginning, the idea was that their new ship should have a female captain. "The decision to make the captain a woman was the premise that got

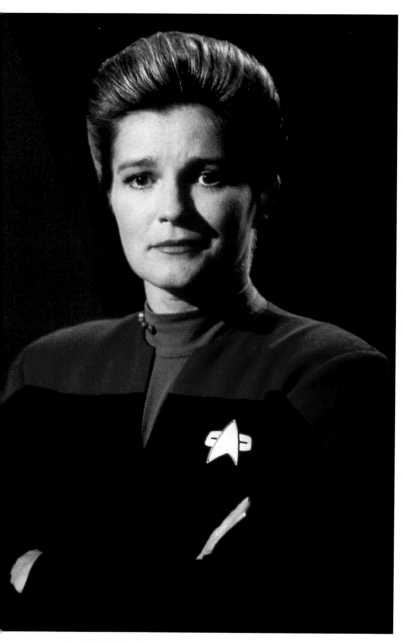

ABOVE: *From the beginning, VOYAGER's producers were determined that their show would have a female captain. They would have to overcome the studio's anxiety and cope with losing their lead actor during filming, before they cast Kate Mulgrew and brought Kathryn Janeway to life.*

it going," Taylor says. "All three of us felt it was time, but there was a great anxiety about whether the vast array of *STAR TREK* fans would accept a woman as a captain, there never having been one. The prized audience was men between 18 and 49, and if they didn't accept her, it would have been a disaster, so the studio asked us to keep our minds open about the casting of Janeway. For a long, long, long time we were reading and reading, and it didn't look like we were going to get the right woman, so we began to read some men."

The implications of this change would have been significant. It wasn't just that the writers would have been bitterly disappointed, they would have had to reconsider the casting of the new ensemble cast. In particular, Taylor says, they would have reinvented the first officer as a woman. However, they eventually agreed to a deal with an Oscar-nominated actress, Geneviève Bujold, and took a big – if misplaced – sigh of relief. Ultimately, Bujold realized that she wasn't cut out for the rigors

> "We were trying to come up with a combination, an element, a wrinkle, something that hadn't been done before."
>
> Jeri Taylor

of episodic television and handed in her notice after two days of filming. This left the producers scrambling for a replacement, who they were delighted to find in the form of Kate Mulgrew.

For the rest of the cast, Taylor explains that they concentrated on inventing characters we had never seen before. "We were trying to come up with a combination, an element, a wrinkle, something that hadn't been done before, anything that would keep it fresh. In the beginning that was our goal. We didn't want to be repetitive, so we were looking for any little nuance that might provide the propulsion for a character."

The team started by thinking about elements of TNG that had been interesting and they felt could have been explored further. 'The Child' contributed the idea of a character with an accelerated lifespan. 'The First Duty' gave them a disgraced Starfleet officer who had broken the rules, while 'Elementary, Dear Data' provided the idea of a sentient hologram. Since TNG and DS9 had avoided Vulcans, they decided it was time to bring one into the mix, though this time they wanted him to be a full Vulcan and black. At this point, he was also older and would have been the ship's wise elder statesman. In a desire to push the show's inclusiveness, they decided to include a Native American. Finally, they rounded the cast out with an alien guide, a newly graduated Starfleet officer, and a half-Klingon engineer.

TNG also provided another important piece of inspiration. Michael Piller was concerned that however much they came up

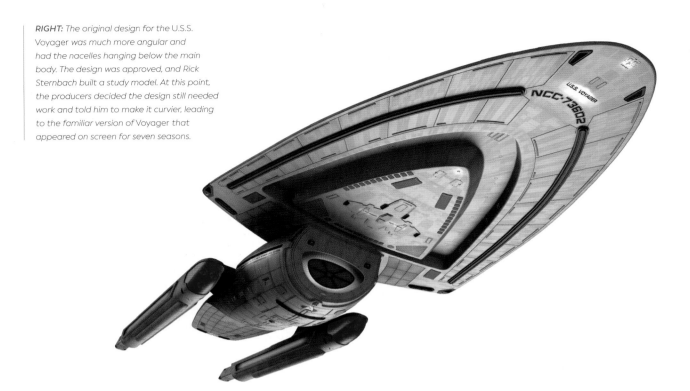

RIGHT: The original design for the U.S.S. Voyager was much more angular and had the nacelles hanging below the main body. The design was approved, and Rick Sternbach built a study model. At this point, the producers decided the design still needed work and told him to make it curvier, leading to the familiar version of Voyager that appeared on screen for seven seasons.

with new characters, their new show would just be an extension of TNG, and he was determined to come up with something that set it apart. "I think in one conversation," he recalled, "I mentioned the original Borg show in which Q had sent the *Enterprise* off to what must have been the Delta Quadrant. I thought, 'What if Q didn't release us from that spell at the end of the episode, what would happen if suddenly we found ourselves out in the middle of nowhere?'"

Taylor remembers that Piller was so convincing, that the idea rapidly became part of the show's premise. "Michael made the very passionate argument that stranding them light years from home is what would set it apart from all the other incarnations of *STAR TREK*. If they had that kind of quest and there was uncertainty about whether they would get home. That made it unique."

Stranding the crew on the other side of the Galaxy also opened up some new possibilities. One element that everybody who wrote for TNG had to confront was the lack of conflict. In Gene Roddenberry's vision of the future, people had evolved to the point where they were above petty squabbles. "We wanted to be able to spike up the conflict between our characters a little bit," Berman recalls.

The solution was to create a group of freedom fighters who were also trapped in the Delta Quadrant and joined Janeway's crew. The Maquis had left the Federation to defend their homeworlds, which had been handed to the Cardassians as part of a peace treaty. The idea was developed specifically for *VOYAGER* and the seeds of the storyline were sown in both TNG and DS9.

"The Maquis were another element that hadn't been there before," Taylor says. "They weren't necessarily there to create conflict. If there was a situation when that could be dipped into, then fine, but it was not a case of 'Oh boy, we can really use this to create some stories.' That would have violated Gene's rules. These people were all alone out there, and somehow the obstacles they had to overcome seemed greater. They needed to

ABOVE: Director Winrich Kolbe instructs the cast on the surface of the Ocampa planet during the filming of VOYAGER's pilot, 'Caretaker.'

ABOVE: Part of Janeway's crew was made up of Maquis rebels, who included former Starfleet officers, a Cardassian spy, and a psychopath. This could only have happened on VOYAGER, since if the ship was in the Alpha Quadrant, they would have been handed over to the authorities. Jeri Taylor was at pains to point out that the producers never intended to make the Maquis a regular source of conflict.

pull together against the larger obstacles instead of squabbling among themselves."

Piller, however, felt that more could have been made of the potential for conflict. "Personally I would have liked to use it for longer, but it seemed pretty clear from the get-go that Rick and the studio felt that the fans were unhappy with the amount of conflict on *DEEP SPACE NINE* and they would be more welcoming into their homes of crewmembers who got along."

Setting the series in a distant region of space we had never visited before had other significant implications. TNG had put a lot of effort into developing alien cultures that reappeared, particularly the Klingons, Romulans and Ferengi. Since *Voyager*

was so far from home, they would have to be left behind. "That," Taylor believes, "was much more liberating than constraining. There was a great sense of relief not to have to use the old standbys. We could do anything we wanted to."

The writers felt that *Voyager* would need its own villains, and Piller proposed a new race called the Gazon (later changed to Kazon), who were based on the gangs of LA. His idea was that their society had made them violent and that they would pursue *Voyager* throughout the series as the crew headed for home.

Brannon Braga was still writing for TNG but he knew that he would be working on *VOYAGER*. He contributed another idea that he'd expected to use on *THE NEXT GENERATION* –

"They needed to pull together against the larger obstacles, instead of squabbling among themselves."

■ Jeri Taylor

ABOVE: *The Delta Quadrant was an unexplored region of space, so it had to be filled with new aliens. Michael Piller hoped that the Kazon, who were introduced in the pilot, would prove interesting. However, their relative lack of technology and sophistication meant that they never really took off and at the beginning of the third season the producers decided to leave them behind.*

the Vidiians, a race who had been driven to take desperate and often horrific measures by an incurable plague. As he recalls, borrowing an idea from TNG wasn't a problem, since it was clear that for all the differences, *VOYAGER* would still be a very familiar kind of *STAR TREK* show. "Why would you change it?" he asks. "*NEXT GENERATION* was hugely popular. The unspoken directive was, we're going to do more of this cool stuff that's been so successful. The main difference was the characters and the core, narrative dilemma for Janeway getting her crew home."

While the writers were developing the characters, the art department, led by TNG's production designer Richard James, set to work designing a ship that the series bible described as being much smaller than the *Enterprise*-D. They thought they had found a design and built a study model before the producers had second thoughts, and literally sent concept artist Rick Sternbach back to the drawing board to make the ship curvier.

As usual the VFX team, led by Dan Curry, pushed the effects into new territory. For the first time, the titles featured a computer-generated version of the ship, which made certain kinds of shots – such as parting clouds – affordable. Makeup supremo Michael Westmore and costume designer Robert Blackman switched their duties on TNG for the new show, and the production swung into action. After seven years of making TNG, the crew knew exactly what they were doing and although the workload was intense, there was relatively little drama.

VOYAGER's pilot, 'Caretaker', aired on January 16, 1995, launching a new network – UPN. The ratings for the pilot were huge, and although they were never as large again, *VOYAGER* soon settled into being a solid ratings performer.

As more and more episodes went into production, the new characters crewing *Voyager* started to take on a much more definite shape as the series progressed. As Jeri Taylor puts it, when they created the show, their goal was to set up potential. "You create characters on paper but they don't come to life until the actors inhabit them. It becomes such a collaboration between the writers, the actors, and the whole production crew that you can't predict how it's going to go. Some characters take on a life of their own."

In particular, the Doctor emerged as a standout character who allowed the series to explore many of *STAR TREK*'s key themes – only this time with a comic twist. As Taylor had predicted, the conflict with the Maquis proved of limited interest, although it did provide the opportunity to introduce two characters who would never have made it through Starfleet's rigorous tests: the Cardassian spy Seska, who was posing as a Bajoran, and the psychopathic Lon Suder.

By the end of the second season, *VOYAGER* reached a major turning point when Michael Piller decided to step away from the series. Piller is widely admired, and many of *STAR TREK*'s best writers owe their careers to him, but it's hard to argue that the series didn't find a new sense of purpose after his departure. Taylor took sole charge of the writers' room. She says her goal was to encourage the staff to pursue their ideas. "I am not a controller," Taylor explains. "I try to provide the safe room where anybody can say anything and you never know what's going to come. It allowed Brannon especially to come into his own. I gave him a much freer hand, and he responded by becoming enormously creative."

With this creative endorsement from Taylor, Braga would start to assume more and more responsibility before he eventually took control of the writing staff as executive producer himself during the fifth season. "Season 3," Braga says, "is when we started to cut loose a little bit. The episodes start getting better. Something was happening. We knew what we were doing. We were confident. We were having fun and I think it shows in the writing."

> *"Something was happening. We knew what we were doing. We were confident. We were having fun and I think it shows in the writing."*
>
> ■ Brannon Braga

ABOVE: By the third season, visual effects technology had advanced to the point where VOYAGER could experiment with CG aliens. Species 8472 were introduced in the third season, and made repeat appearances during the fourth and fifth seasons. They were designed to look truly alien with three legs and unexpected holes in their anatomy.

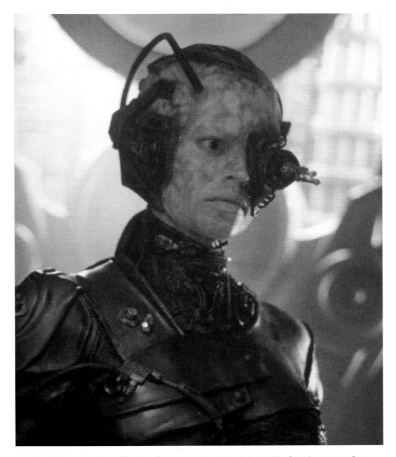

ABOVE: *Seven of Nine (Jeri Ryan) was only introduced during the fourth season after Brannon Braga realized how much potential there was in adding a former Borg drone to the Voyager crew. She brought a unique perspective to the show and allowed the writers to explore how the Borg viewed the world.*

Braga identifies *VOYAGER*'s second two-part story, 'Future's End,' as a significant turning point. TNG had explored multi-part stories with varying degrees of success, but they would become a signature element of *VOYAGER*, with most of the remaining seasons involving at least one two-parter in the middle of the run. Almost without exception they stand out as some of *VOYAGER*'s best installments.

The third season also saw the VFX team embrace CG graphics, which were still in their infancy. The change started gradually, but the long-term effects were profound. Until this point, new ships had been extremely expensive. Now they could be built and adapted with relative ease and would eventually become so commonplace that they almost appeared in every other episode. CG also lent itself to creating profoundly alien creatures that didn't rely on actors in costumes or puppetry.

The first episode of the season, 'Basics, Part II' featured a land eel that appears in the semi-darkness of a cave. By the end of the season, the team were confident enough to introduce the three-legged Species 8472.

By that point it was clear that Jeri Taylor was going to retire and that Braga would take her place as showrunner. There was some concern that the ratings were drifting, so Braga suggested adding a new character: a former Borg drone who would become Seven of Nine. Berman embraced the decision. Jeri Ryan was cast in the role between seasons 3 and 4, and introduced in the season opener, 'Scorpion, Part II.' The change was immediate and impressive. Seven gave the show a new sense of identity and provided Janeway with a foil, who could disagree with her and be mentored by her. As Taylor explains, "You could see the stories coming from Seven and she injected

an energy into the show that I'm not sure you could have found in any other way."

In an unrelated development, Jennifer Lien was struggling with personal issues that were beginning to effect her reliability. The producers reluctantly took the decision to terminate her contract and write Kes out of the series.

With the arrival of Seven, *Voyager* entered Borg space and this would become another defining element for the show. "'Scorpion,'" Braga says, "was when the show found itself." The danger of traveling through Borg space helped to redefine the show, giving it an increased sense of jeopardy. As Braga remembers, this was just a part of what he hoped for. "I just wanted the show to be bigger," he explains. "I wanted it to be the biggest physically, production wise, emotionally. I want the ship to be frozen. I want the ship to blow up. I want the ship to

be duplicated. I want to push the production team. I wanted to open up the script and say how are we going to do that? More action, more heightened emotions, more experimenting."

In particular, Braga wanted the show to be cinematic. "I remember talking to Joe Menosky, who I wrote with, and saying, 'What's *VOYAGER* going to be known for? Let's make it big. Let's do these two-parters. Let's do as many as we can think of every season.'"

For Braga, the fourth and fifth seasons are the show's best. It was a period when they were firing on all cylinders and pushing the boundaries of what was possible. As well as the Borg, the series introduced several recurring species: the Hirogen, who built their culture around hunting; the Malon, who polluted the Galaxy with toxic waste, and the Hierarchy, a species that relied obsessively on surveillance.

> *"What's VOYAGER going to be known for? Let's make it big. Let's do these two-parters. Let's do as many as we can think of every season."*
>
> ■ **Brannon Braga**

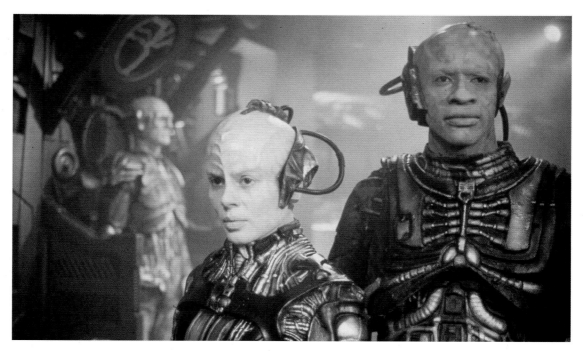

ABOVE: *Two-part stories like 'Unimatrix Zero' became a major feature of VOYAGER. They weren't simply restricted to the cliffhangers at the end of the season, and often featured during the middle of the season. Most of them were written by Brannon Braga and Joe Menosky, who set out to make the show as cinematic as possible and some were broadcast as two-hour events.*

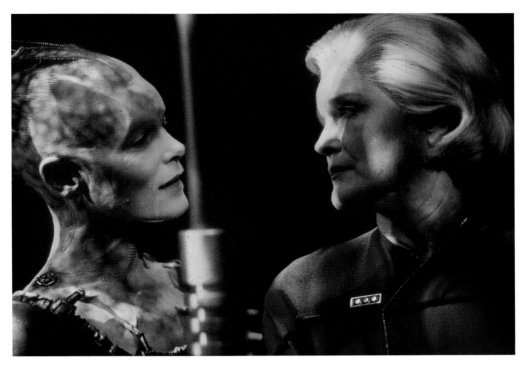

ABOVE: *Janeway and the Borg Queen represented opposing views of the world and offered Seven of Nine competing mother figures. It was inevitable that they would confront one another in the series finale. What was unexpected was that the Borg would be defeated by an older Janeway from the future who broke countless rules to get her crew home safely.*

"We were always in search of new aliens," says Braga. "If we're lucky we jump thousands of light years, so you have to be careful about the Delta Quadrant seeming like a small place that's filled with recurring species. When you found a cool new species that worked, you might bring them back, but you had to be careful about how many times you'd bring them back."

By the sixth season, it was time for Braga to step away from day-to-day involvement with the show so that he and Rick Berman could cocreate the next *STAR TREK* show, which would become *ENTERPRISE*. Ken Biller, who had joined the show in the first season and been with it since the beginning, took control of the writers' room to steer the ship home. He remembers that his goal was just to tell the best stories possible. Because the show was in its last season, the studio was more relaxed about trying stories that allowed a degree of serialization, so the writing staff were able to explore the romance between Tom and B'Elanna which had become serious in the fourth season. This eventually culminated in them having a baby in the season finale.

The big question hanging over the final year was when and if *Voyager* would get home. There was never any serious doubt that this would happen in the last episode, but Biller was keen to introduce some surprises along the way. Two episodes before the finale, he had Neelix leave the ship to join a lost Talaxian colony.

Biller, Berman, and Braga met regularly to work out the details of what would happen to the rest of the crew, eventually settling on a time travel story: Janeway from the future returns to ensure that *Voyager* makes it back to Earth without loss, and deals a devastating blow to the Borg.

Seven years after the *U.S.S. Voyager* had set out into the Badlands to search for the Maquis, the ship had returned home. It's legacy is considerable – it had the first female captain, and the most diverse cast ever. It earned 33 Emmy nominations and won seven. It helped to pioneer changes in visual effects that would transform television. It introduced an entire new region of space to *STAR TREK* and explored the Borg, who had always been one of the series' greatest villains. And in Seven of Nine and the Doctor, *VOYAGER* created two of *STAR TREK*'s most enduring and popular characters. Above all, it took the franchise to new worlds and injected it with a new and unexpected energy.

THE
TITLE SEQUENCE

Visual effects producer Dan Curry masterminded *VOYAGER*'s title sequence, the ship's epic space flight through the Delta Quadrant, played out to a magisterial orchestral theme from Jerry Goldsmith.

Dan Curry was still working on the visual effects for *STAR TREK: THE NEXT GENERATION* and *DEEP SPACE NINE,* and had already started developing the *VOYAGER* pilot when executive producer Rick Berman and supervising producer Peter Lauritson asked him to design *VOYAGER*'s title sequence. The pair accorded Curry creative freedom in the brief, and he set to work devising an ambitious sequence, combining traditional and nascent CG techniques.

"I envisioned a flow of images showing *Voyager* encountering spectacular phenomena in unexplored regions of the Delta Quadrant," says Curry. "I wanted to show the places I'd like to go and things I'd like to see if I had a starship."

The inspiration for the visually impressive title sequence came from work that digital effects house Santa Barbara Studios had undertaken for a science documentary, demonstrating a hypothetical tour around the Solar System.

With work ongoing on other projects, Curry enlisted the help of visual effects supervisors David Stipes and Ron B. Moore, Image G's crew, the CIS compositors, The Post Group (Amblin Imaging's team), and Santa Barbara Studios' artists, to realize his vision. One of the studio's artists, Erik Tiemens, developed Curry's ideas with storyboards (detail above).

"We were always trying to push the boundaries, and those titles did a lot of things that wouldn't have been practical before we had CG," says Curry. Amblin Imaging built a CG model of *Voyager,* wrapping photographic images of Tony Meininger's physical model around their CG hull. It was *STAR TREK*'s first-ever virtual model of a hero ship. "For close shots where we

would see a lot of detail we used the physical model," remembers Curry. "For wider shots we could use the CG ship."

The combination technique was very effective. David Stipes and the Image G crew filmed the motion-control *Voyager*, together with other physical elements, "Including a 2D planet I painted in oils on a cardboard disk that the ship passes as it leaps to warp," Curry recalls.

Meanwhile, Santa Barbara Studios were developing the computer animation. "The title sequence wouldn't have been possible before CG," says Curry. "We couldn't have shown *Voyager* reflected in the ice rings around the planet, or creating turbidity passing through the vapor clouds, practically any other way. When the ship flies over the ice rings, what you see on screen is a combination of CG and the physical

model, using motion-control technology. The chunks of ice and the reflection in them are CG, but we used the model ship."

This combination of techniques is present from the start of the sequence, with the sun created in CG while Curry electronically airbrushed the title card. The gas cloud is CG, (and almost didn't make it in to the titles, as Rick Berman initially didn't think it worked, but was persuaded otherwise by the rest of the crew). Finally, when *Voyager* goes to warp speed, the planet at the end of the sequence is painted on card.

The visuals were set to composer Jerry Goldsmith's orchestral theme, evoking the show's spirit of exploration. The Academy of Television Arts & Sciences honored the team with an Emmy nomination for Outstanding Individual Achievement in Graphic Design and Title Sequences.

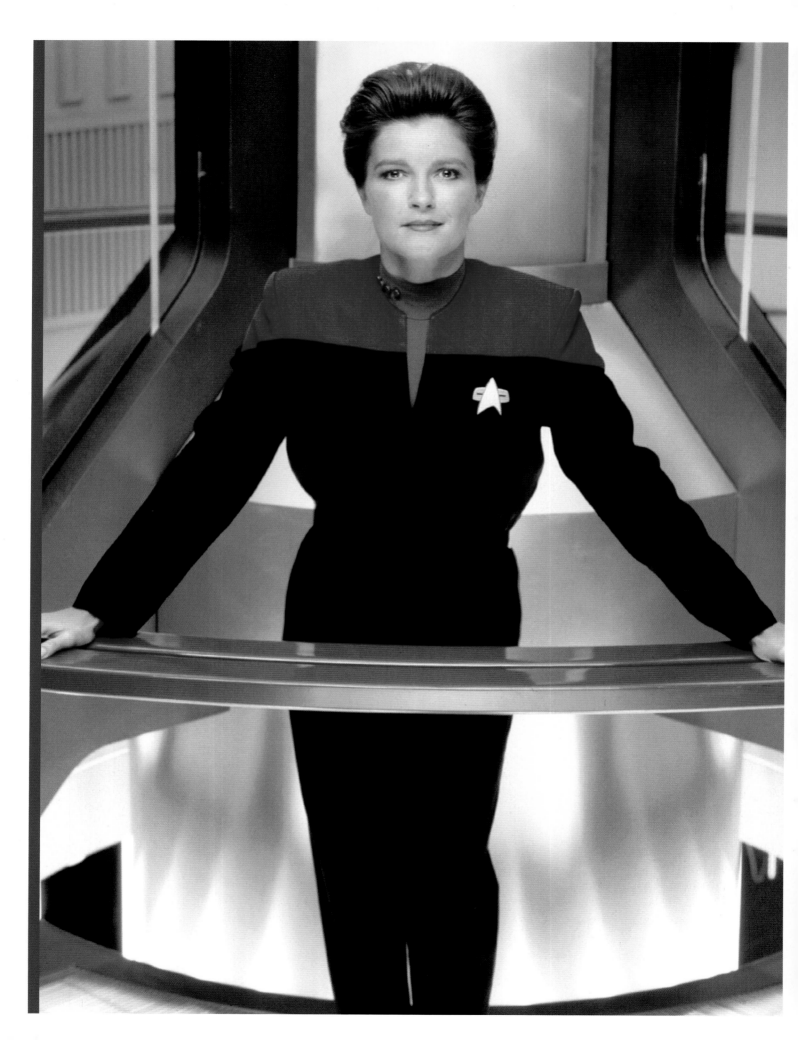

JANEWAY
TAKING COMMAND

Captain Kathryn Janeway found herself trapped on the other side of the Galaxy. She was determined to do whatever it took to get her crew home, without losing sight of the values that made her an exceptional Starfleet captain.

Kate Mulgrew fills up a room. There's nothing half-hearted about her. She's focused, energetic, friendly. She uses your name and looks you straight in the eye. She seems to have a little more life force than other people and there's not much doubt that she's in command. In short, she has all the qualities you'd look for in a Starfleet captain. In September 1994, that was exactly what *STAR TREK: VOYAGER*'s producers needed.

They had already cast Captain Janeway. The Oscar-nominated Geneviève Bujold had taken the role, but after two days of filming, the actress had realized she was the wrong person for the job and decided to leave. This left the producers desperately trying to find a replacement. They called back all the most promising actresses they'd auditioned, including Mulgrew, even though she was half a world away.

"I'd gone to Ireland," she remembers. "I took my young sons with me on holiday. My agent called me, and said, 'You might come back now because there's been a little bit of a furor. This actress left and now this part has opened. I said, 'No, I have a week left of my holiday and I'm not coming home for that.'"

A little over a week later, Mulgrew was sitting on the Paramount lot waiting to audition. She remembers that she had memorized two scenes but that she wasn't feeling at all well. "I was running a fever, but I didn't care. One of the scenes was with Tuvok and there was humor in it; the other was Janeway's speech to her new crew as they find themselves lost in the Delta Quadrant."

Despite her insistence on completing her holiday, Mulgrew knew that this could be a big deal. Very few people get the leading role in a TV series, only two of them had been cast as Starfleet captains, and neither of them had been women. "I knew it had to be a knockout," she says. "But I love competing. There's always an added dimension of heightened stakes and energy when an audition is that important. I understood, however primitively, that probably billions of dollars were riding on this and it was very unusual that they were going to switch to a woman. All of that just went into the dish for me.

"I went into the room and there must have been 35 people in there. Jeri Taylor was one of the few women. Maybe the only woman in that room. The rest were Paramount and UPN brass.

I targeted, right away, Rick Berman, I had seen his face before, and I just really let it go. I said, 'I don't know anything about this. So as far as I'm concerned, Janeway is just delicious. Can I just have her be delicious?' I think that's when Berman smiled and said, 'All right, you're going to crack wise.'"

Mulgrew clearly brought all her qualities to bear in that room. Series cocreator Jeri Taylor remembers the sense of relief that they had found their captain. "When Kate came back she just occupied the character in such a complete way that she felt like the inevitable choice. She filled up all the spaces. We took a deep breath of gratitude that she was aboard."

Looking back, Mulgrew smiles. She knew she had given her all, but she adds that this is the life of a working actress and that she would not have been devastated if she had missed out on the role. "I probably had a kind of presence that made them think that I could pull it off with panache. I think Rick said, 'This girl can do this. She has laughter, and she has heart and she moved me. That's what we need, those are the most important components in the captain. The rest she will learn.' And I did."

Mulgrew auditioned on the Monday and Rick Berman called her that Friday. "He said, 'Welcome aboard, Captain,'" she recalls, "'congratulations. We'll see you Monday morning,' at," she adds, "some ungodly hour. That's how fast it was. I went right to work."

From the moment she arrived, the workload was enormous: it wasn't just that Janeway was front and center in every episode, her look had to be worked out, she had reams of seemingly incomprehensible dialogue to learn, they were behind schedule, and the world was watching. "The press demands immediately were absolutely overwhelming," Mulgrew remembers. "There was never a moment of silence. Then I'm going home to two young boys who need me, far more than STAR TREK did. On top of that, there was all this technobabble, which I was expected to not only ingest and assimilate, but then regurgitate beautifully. It was an impossible task. I don't know how I did it, but I guess that's what Berman

ABOVE: *Kate Mulgrew was rushed into hair and makeup and onto the soundstage. She'd seen the script but barely had time to think about the character, and she says she only started to really get under Janeway's skin after a dozen or so episodes.*

recognized in me: that I would somehow do it. Because I did it. And I did it, if I may say so, without missing a beat."

That part about never missing a beat is one of the keys to understanding Kate Mulgrew. Everyone you talk to describes her as the most prepared, the most professional actor they can imagine. In seven years, she was late to makeup once – by five minutes. That air of professionalism and preparedness helped to set the tone on the set and, as fellow actor Robert Picardo says, made working with the series star a real pleasure. "There's nothing more fun than shooting a scene with Kate Mulgrew. She's so immaculately prepared and yet will respond to anything that you throw at her. She's just the best."

The way Mulgrew describes that first season, it was a complete whirlwind so that, as a result, she didn't have the chance to step back and assess how to approach things. "I've never been a deer in the headlights, but I felt a bit like a fox and the hounds were after me. It was a very dense forest."

Early on, Mulgrew made some firm decisions about how to approach playing Janeway. One of the first, she reveals, was that at some level, she embraced being stranded on the other side of the Galaxy. "After having given that long monologue, saying we are alone in an uncharted part of the Galaxy. I turned to the camera and, in my mind, I winked. 'Yes!' she's saying to herself, 'a whole quadrant, uncharted, unknown, to explore. If I'm stuck here for the rest of my life, so be it.' I loved that. The scientist in her was thrilled by it. She's a true explorer."

But the speed of production was so great and the stakes so high, that at the beginning Mulgrew put herself completely in the producers' hands. In 1994, the entire studio felt anxious about the idea of putting a woman in charge of a starship, and as a result there was enormous scrutiny of Mulgrew's appearance. They even reshot scenes in the pilot, 'Caretaker', because they wanted to give her a new haircut. That anxiety continued throughout the first season. "Within weeks," she says, "I knew that being the first female captain was an

ABOVE: *This rare behind-the-scenes shot from 'Caretaker' shows Kate Mulgrew's original hairstyle as Janeway. The studio was so concerned about the captain's look that this was one of several scenes that was reshot, after they decided that she should wear a wig.*

extraordinary thing and that I needed to be very damn good, very quickly. So I acquiesced to everything, to all of those silly hairdos, and all of those costume changes and the four-inch boots made in Italy, and all that."

On a day-to-day basis, Mulgrew was putting huge effort into dealing with the technobabble while still finding ways to imbue Janeway with a sense of personality. "The material was very demanding, very challenging, and I needed to rise to that. I thought, 'How can I endow her with all the traits of warmth and levity, and even things like loneliness and anxiety, all the human traits that I find so attractive, whilst spewing this technobabble? How can I get under it? What does this mean to Janeway? I came to the conclusion that I was just going to have to master it. I went to a thing they called the 'Okuda bible,' and there was an explanation for almost every word. I read the explanations and from that moment forward I determined to make real sense out of what I was saying. I could apply an emotional underbelly to certain technical phrases. Then I would remember the phrase because it was supported by the emotions. It was very, very, very good, for me. It was both an acting exercise and it was a way to get under the technobabble."

As Jeri Taylor explains, those human traits were at the heart of what would make Janeway different. "I wanted her to be allowed to demonstrate a greater range of emotions than might be expected of a man, at least in 1995. I wanted to show that she had vulnerabilities, that she had uncertainties, that she had needs. She bore her responsibilities admirably, but it was a huge responsibility and she should be allowed to show some of what that cost her. Maybe she could at least – if not openly, then privately – show some of those uncertainties."

At the end of the season, Mulgrew had a chance to breathe. She went to the producers and told them that if they wanted

> *"'Yes!' she's saying to herself, 'a whole quadrant, uncharted, unknown, to explore. If I'm stuck here for the rest of my life, so be it.'"*

Kate Mulgrew on Janeway's predicament

her best work, they needed to stop being so anxious and give her a chance to take command. "I realized," she remembers, "that what was in jeopardy here was the captaincy itself. If everybody was going to continue to argue my gender versus my command, Captain Janeway would never work, so I said you have to leave me alone. You have to trust me or we'll never win the demographic that you seek so ardently, which are young men 20-35. Let me win them myself. Take this corset out and these dumb shoes. I'm going to let my hair down both figuratively and metaphorically, and I'm going to get down to the business of implementing my sense of command."

What that meant was that Janeway became a more defined character, who drew on more of Mulgrew's personality. As Jeri Taylor puts it, "Kate didn't change her so much as fulfill her. She has a very clear intent. Janeway knows what she wants. Knows how to get it. Doesn't hesitate to do what she needs, or wants, to do." Writer and executive producer Brannon Braga adds that Mulgrew's performance helped the writers to understand who this character was. "Kate has this distinctive voice. You're suddenly doing Kate Mulgrew impersonations when you're writing the scripts," he laughs. "Kate's funny – Janeway was funny and a little more personable than the other captains. Picard was aloof. Janeway was more in the soup."

At least at first, the humor wasn't necessarily written into the scenes, but came from Mulgrew. "It's a part of my personality, I hope," she smiles. "I'm very Irish. There's a lot of laughter in my life and I just felt it was absolutely key that we get this levity established."

Mulgrew goes on to explain that she didn't play the humor the same way with every character. "Humor defines relationships better than any other emotion. She's got a dry relationship with Ensign Kim, and a deeper relationship with Tuvok. With Chakotay, always respectful – our humor was very much equal. With Mr. Paris it was a field day because he was funning right back. Even Seven of Nine became funny because I taught her to be funny. That was even funnier! I think it's delightful to have that kind of a stew going on, don't you?"

Janeway's humor achieved exactly what Taylor had hoped for – making her a much more open character, but there were always going to be limits to how much the captain could be part of the crew. She couldn't confide her fears in many people or be particularly close to individuals without compromising her sense of command. It was also obvious that society applied different standards to men and women and this raised issues. In particular, the writers rarely put Janeway into romantic situations with guest stars. "They had to bridge many chasms

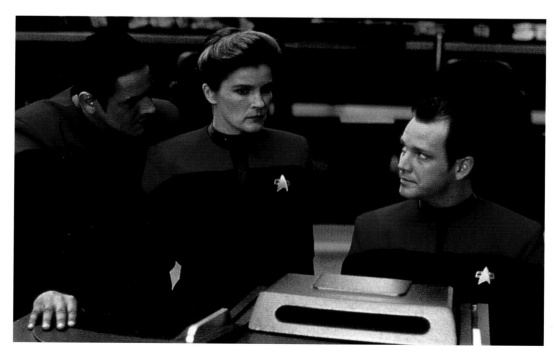

ABOVE: *Mulgrew says that humor is one of the best ways of defining characters' relationships with one another, so it was natural that she had a different kind of humor with each member of the cast. Janeway and Chakotay were very much equals and shared a sense of wry amusement, whereas Janeway teased Paris, knowing that he would give as good as he got.*

ABOVE: Janeway was engaged to Mark (Stan Ivar) when Voyager was stranded. Perhaps inevitably, he moved on, but she couldn't. Her responsibilities made it impossible for her to find lasting romance.

that they wouldn't have to with a man," Mulgrew says. "Foremost amongst them, the sexual. What was good for Kirk and Picard, at least in my opinion, was unsuitable and inappropriate for Janeway."

In the absence of any 'romance of the week' stories, many viewers latched on to what seemed to be an underlying attraction between Janeway and Chakotay. For the writers, this came out of the desire to give Janeway a meaningful friendship. "It was lonely out there," Taylor says. "People want to find bonding relationships."

The writers started to subtly play up the flirtation between the two characters but, Mulgrew adds, although she could absolutely see the attraction, she felt it would have been a mistake to take it any further. "They were pushing the Chakotay/ Janeway thing," she remembers. "I really liked Robert Beltran and would find him inarguably very attractive, but this was not what I had in mind for Janeway. So I went to them and said, 'I don't think Janeway should have sex with anyone. I don't think she has time for romance: she's got a 165 complement here, we're lost in the Delta Quadrant, we're 75,000 light years from home. Give me a break. It will be difficult enough to win them as a woman leader, let alone if I'm asking Chakotay to join me in my ready room. I just can't do that. I don't think that science fiction is ready for that. So I'd rather you didn't.'"

MOTHER OF JANEWAY

It's impossible to talk about Captain Janeway without talking about Jeri Taylor. *VOYAGER*'s cocreator was instrumental in bringing her to life, and as the head of the writing staff for the show's first four years, played a massive role in shaping her. Taylor is happy to admit that she based a lot of Janeway on herself. "There are many elements that I like to think are in me, in her. When I was writing Janeway I would say, 'What would I do?' and I would dip into myself to make those decisions."

Taylor confesses that she had to separate herself from the character a little once Kate Mulgrew was cast. "That was a little hard for me in the beginning with Janeway, because I felt so close to her and then came Kate, and then Kate was Janeway too. But the exciting thing is to see actors fill out their characters and bring nuances and texture and layers to the roles. They grow and evolve, and became very exciting."

Taylor also took the time to write a novel, *Pathways* that explored Janeway's life before she took command of *Voyager*, which is as close to a missing episode of the series as it is possible to be. Asked about the similarity, she responds, "I always say when I grow up I want to be Captain Janeway."

Taylor agrees, saying that although the writing staff discussed what would happen if Janeway and Chakotay became a couple, it was never a serious option. "We knew it could never reach fruition. We could show that they were drawn to each other but never allowed to fulfill anything meaningful. There's probably nothing more powerful in a relationship than the idea that you can't have it." However, Taylor goes on to say, that kind of teasing relationship can only be played for so long before it has to be addressed or it just becomes annoying. At the end of the second season, she wrote the episode 'Resolutions' specifically to show that the relationship was not going to happen.

The fact that Janeway had no opportunity to have a life away from *Voyager* subtly informed Mulgrew's approach. It's not immediately obvious on the surface, but she gave her an undercurrent of sadness than ran through her performance. "I think her loneliness was acute," Mulgrew acknowledges. "This is a woman of great feeling, and depth. She has a longing for love. Among the first things to happen was the boyfriend breaks off the engagement, takes my dog! Marries somebody else. I know then I will be alone, conceivably for the rest of my life. What this loneliness does is, it fastens to Janeway with a kind of inherent sadness. I think she cloaks that with humor,

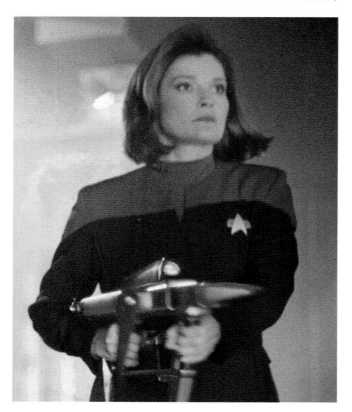

ABOVE: *Mulgrew was always happy when the story gave her the chance to break out a phaser rifle and get physical. There was no reason why she shouldn't, and she enjoyed the break from the technobabble.*

but increasingly I think she was a solitary figure. A lot of alone time in my quarters, you know?"

As the series progressed, the writers became more relaxed about showing Janeway taking on more traditional male roles. The third season episode 'Macrocosm' is very much her *Die Hard* moment, with her running around the ship stripped to a vest and carrying a phaser rifle. Episodes like this delighted Mulgrew, and not just because of what they said about her character. "Whenever there was that kind of physical action, I was freed by it," she says. "It was a relief from the mental challenge of constantly having to be on top of it with the language. I could get my phaser and I could haunt those corridors and get on my shuttlecraft."

As the fourth season opened, Janeway underwent a major change with the introduction of Seven of Nine. As Braga explains, one of the main motives for creating Seven was to throw the captain into sharper relief. "I was always interested in defining and refining Janeway's predicament. Seven of Nine was a galvanizing character for her. Everything she represented was somebody Janeway's trying to save – someone from the Delta Quadrant who is human, a girl raised by wolves, and Janeway's going to save her."

From the moment Seven was introduced, she was in conflict with Janeway and this made the captain set out her vision of what it meant to be human. Mulgrew admits that, at first, she was unnerved by the introduction of a new character and worried that Seven was simply there to boost the ratings in a simplistic way. Over time, she came to realize what a strong character Seven was. "They brought in Seven of Nine, who was astoundingly attractive, sexually and in every other way. At the time it was difficult, because I was so hoping to be able to do it all by myself, but I commend Brannon Braga. She was a terrific invention. I see that now, of course. She should have been what she was and Jeri Ryan did a wonderful job playing Seven."

For the rest of *Voyager*'s run, Janeway would share more scenes with Seven than any other character. It became one of the elements that defined the show. "It was always working on many levels in those scenes," Mulgrew explains. "That's something I really enjoyed. It was a teacher/student, mother/daughter relationship. I was always looking for the human in Annika/Seven. I was always probing her and trying to unravel that mystery. At the same time, I was absolutely intrigued by the Borg in her, because Janeway was nothing if not a scientist."

Janeway's relationship with the Borg would become a defining thread for the series. As Braga puts it, being stranded in Borg space thousands of light years from home, pushed her to places where no other *STAR TREK* captain had been before. "As I continued to help develop Janeway," he says, "I started to

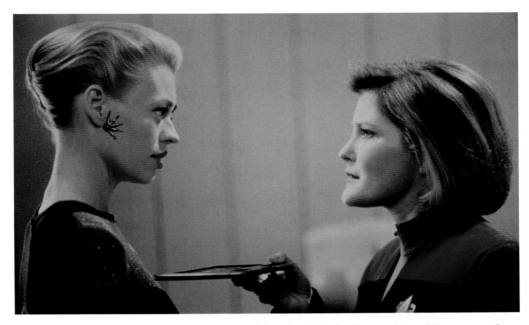

ABOVE: *Janeway's relationship with Seven of Nine was only introduced in the fourth season, but would become one of the defining elements of VOYAGER. Brannon Braga says that when he created Seven, one of his goals was to give Janeway her own Spock – a character who she could talk to and disagree with.*

see her as somebody who was defined by her predicament, and maybe being a risk-taker. Sometimes she's a little out there. The defining moment for me was when she made a deal with the Borg. Chakotay was saying you're making a huge mistake. That's who Janeway was. I don't know that Picard would ever go there, but she had to."

Mulgrew agrees that only Janeway would make the deal with the Borg. "I think that she's undaunted. Hers is that Spartan pioneer courage of old, she's a bit old-fashioned that way. As a scientist, the Borg of all species, absolutely mesmerize her. How did they happen? Why did they happen? What will they come to?"

Writer Bryan Fuller remembers that the writers saw Janeway as more of a rule breaker than any captain since Kirk. "How we described Janeway in the writers' room was that she had a little bit of Mel Gibson in *Lethal Weapon* about her. She was a person of the law, but she had her own unique sense of morality. She was certainly someone who subscribed to situational ethics. I remember a lot of people criticized her decisions in 'Equinox,' when she has the crewmember in the cargo bay and she drops the shields so the aliens can come and kill him if he doesn't talk in time. Lots of people said, 'A Starfleet captain would never do that!' But I just thought, 'Janeway is so cool for doing that!' I loved the way she said, 'Okay, if this is how you are going to play, then I'm going to use your rules

against you. You've made that morally possible for me.' I found that exciting and dangerous."

That willingness to go further than other *STAR TREK* characters was at the heart of what made Janeway different. Mulgrew is keen to point out, however dire her situation, she never lost sight of her values, even when it came to her greatest enemy. "Janeway is nothing if not absolutely on it. She understands the Borg to be pernicious. My angles were how do I bargain? What can I give them? I'll give them this, and I'll get that. But none of that in the end worked. The Queen had to bite the dust. She had to be taken out, it was that simple, but not until every possibility was exhausted."

Braga picks up the theme, saying that the writers always wanted to push Janeway as far as they could without losing her integrity. This showed her under pressure and revealed the true strength of her character. "She's a risk-taker," he says. "She's cool. She's a badass." When this is put to her, Mulgrew laughs. "Can't she be goodass? She was brave, she was tough, but at the same time a great heart. I really wanted her heart to come through."

Ultimately, that willingness to do whatever was needed, with compassion and certainly and heart is what defined Janeway and her commitment. Like Kate Mulgrew, there was nothing half-hearted about her. "She was total," Mulgrew says. "If she was in, she was all in."

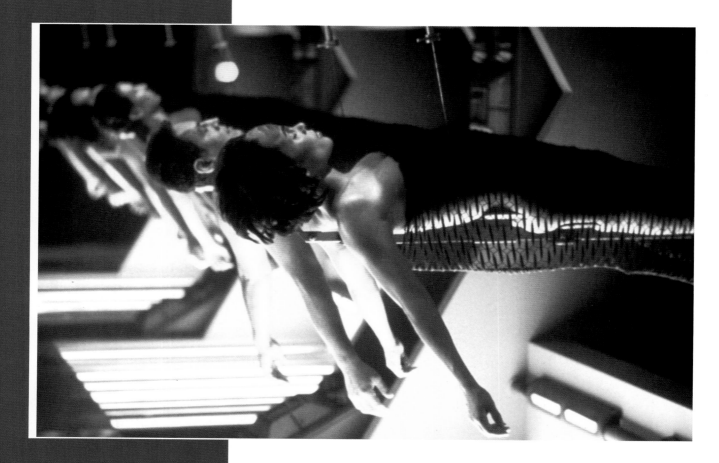

SEASON 1

EPISODES 1/2

AIR DATE: JANUARY 16, 1995

Teleplay by Michael Piller & Jeri Taylor

Story by Rick Berman & Michael Piller & Jeri Taylor

Directed by Winrich Kolbe

Synopsis Pursuing a Maquis ship, the U.S.S. Voyager is blasted 70,000 light years away from the Alpha Quadrant. Captain Kathryn Janeway must forge uneasy alliances to ger her crew home.

CARETAKER

'Caretaker' had just 90 minutes to travel 70,000 light years, introducing a new ship and crew along the way. *VOYAGER*'s pilot episode – and format – hinged on one fatal decision made by Captain Janeway.

Pilots are tricky beasts; they establish a house style, introduce a distinctive cast of characters, and entice viewers to return the following week. The pilot of a new *STAR TREK* series has to work even harder, and for 'Caretaker' the pressure was immense. As the third pilot episode of the modern *STAR TREK* era, it had to sell a format that was utterly distinctive yet resolutely *STAR TREK*, would feature the first female lead in the franchise's history, and effectively launch the new UPN television network – all in 90 minutes.

The process of laying the foundations of

VOYAGER and the plot of 'Caretaker' started in the summer of 1993, with cocreators and executive producers Rick Berman, the late Michael Piller, and Jeri Taylor hammering out

RIGHT: 'Caretaker' introduced the Kazon, who were originally meant to be the main villains of the series.

the format. "We remembered the episodes where Q would show up and throw one of our ships off to some strange part of the universe," Piller remarked in the DVD special feature, 'Braving the Unknown.' "We'd have to figure out why we were there, how we were going to get back, and ultimately – by the end of an episode – we'd get back home. We talked about what would happen if we didn't get home."

"That led to the thought about the ship, in the pilot episode, being tossed into the netherworld, into another quadrant," adds Berman.

Jeri Taylor was keen to embrace the challenges presented by placing *Voyager* thousands of light years away from the Alpha Quadrant. She recalls, "We were going to say to the fans, 'You're not going to see any more of that.' That was certainly a decided risk, because people love the home turf of

> **"If these sensors are working, we're over 70,000 light years from where we were."**
>
> *Harry Kim*

STAR TREK. We would be responsible for creating something in the Delta Quadrant that was as beguiling and enticing as what had emerged in the Alpha Quadrant. But we took a big gulp, and we said, 'OK, this is what we want to do.'"

Where *DEEP SPACE NINE* had introduced a more cerebral approach to *STAR TREK*, 'Caretaker' brought back a faster-paced treatment. "I felt the audience was ready for 'run-and-jump' adventure again," said Piller. "I felt we had done a very internal, psychological series with *DEEP SPACE NINE* – but I think the excitement of being out there alone was part of the original *STAR TREK*. Space had become very crowded, and we'd learned a great deal about the Alpha Quadrant. How do you recreate that feeling of being alone in space?"

At the heart of the plot – and the series format – was Captain Janeway's decision

to prioritize stopping the Caretaker's array falling into Kazon hands over returning home. It's a decision that defined Kate Mulgrew's Captain Janeway and continued to have consequences. "Very late in the game, we felt that Janeway should have a lot of brooding moments where she is a good captain but that other side of her was lost – that nurturing side," explained Piller. "We felt it was important for it to be in the pilot, because not only did it give greater insight into her character but also served to make her different from Picard."

"I know the studio was wary of the fact that it may have seemed depressing, and a

ABOVE: *Although he looks like an old man with a banjo, the Caretaker himself is an extra-dimensional being who has been looking for species to take over his role caring for the Ocampa.*

downer," adds Taylor, "and urged us to keep a sense of optimism. So the hope is always there – this is not a depressed, glum, dejected crew that is just sailing along."

However, some conflict among *STAR TREK*'s latest crew was seen as necessary, placing further weight on 'Caretaker.' "I remember the three of us talking about marrying an outlaw crew," recalled Piller. "The idea that these were noble people with a cause, but who had chosen a cause that branded them as outlaws." From this idea, the Maquis was born.

"The idea of them being forced together with a Starfleet crew was a very appealing one."

> **"Somewhere along this journey, we'll find a way back. Mr. Paris, set a course for home."**
>
> *Captain Janeway*

Given the concept of a Starfleet crew forced together with Commander Chakotay's Maquis freedom fighters meant that 'Caretaker' would not have to do all the heavy lifting alone. "We went back into *THE NEXT GENERATION* and *DEEP SPACE NINE* and created stories that helped us define the

Maquis," said Piller, "so we didn't have to do it all in 'Caretaker.' The Maquis had already been established."

Twenty-five years after a premiere watched by 21 million viewers, 'Caretaker' remains a masterclass in creating a fast-paced new format for the *STAR TREK* franchise. At the time of broadcast, Jeri Taylor said, "['Caretaker'] managed to be about something and delivered the franchise. The actors walked into that pilot as though they had been living the lives of their characters for years."

CHAKOTAY

THE STRONG RIGHT HAND

Chakotay was designed as a "contrary" – a man who had followed his principles to leave Starfleet and who had spiritual beliefs in a very secular world. But he was also a man Janeway could trust implicitly.

Robert Beltran doesn't take himself – or the more fantastical elements of science fiction – too seriously. Looking back at his seven years on *VOYAGER*, his most frequent response is a wry laugh. His voice is very even, cool, and laid back. As you talk to him you realize that this kind of calm stoicism – this refusal to be impressed – was at the heart of his portrayal of Chakotay.

"The world that we lived in," he explains, "abounded in amazing things. Chakotay was constantly being confronted by incredible characters and aliens. Weird things happening was the norm. You just deal with them, so there's no real reason for Chakotay to not respond – if not calmly – at least not hysterically.

"I remember one time I was doing a scene where some enemy ship blew up and the director kept wanting me to show more of a reaction. After about the fifth time that he asked me to do more, react more, I said, 'Look, we have seen so many outrageous things here, you want me to react to a ship blowing up? Come on! This happens every week. That's nothing compared to some of the stuff we've

gone through!' You temper everything with that. What is the norm? Outrageous things happening every day. That's the norm."

That calmness in the face of the extraordinary became one of Chakotay's defining characteristics, and helped shape the way the character grew. When Michael Piller reminisced about seven years of *VOYAGER*, he said, "I think Robert provided a warm, strong, male presence who was unflappable and made that role believable." For Jeri Taylor, Chakotay was Janeway's "strong right arm," someone she could rely on when everything seemed out of control.

Those aspects of Chakotay's character became far more important than some of the ideas that the writers originally had in mind for him, but this was something they were very relaxed about. As Taylor explains, when they were creating the series, they didn't set out to craft fully-formed characters, but rather to set up elements that could grow into something interesting and, above all, to give the audience something new. How that would play out would depend on the actors and the writers, and on what worked.

Chakotay was something we had never seen before on *STAR TREK*. It wasn't simply that he was a Native American – he was always intended to be spiritual. Gene Roddenberry had insisted that human religion had no place in the 24th century, so that part of human nature had been off the table throughout TNG's seven-year run. The writers, in particular Michael Piller, wanted to create a character who could be used to explore spiritual themes and would be slightly at odds with the world around him. The writers' guide, colloquially known as the "bible," describes Chakotay as "a contrary" and as someone who was at home neither with his own people nor with Starfleet.

When Beltran came in to audition, he could see that the character offered a lot of opportunities. "I knew he could be interesting in many ways," he says, "and that he had a lot of potential to grow." As a classically trained actor, Beltran could also see parallels with some of the founding myths of Western society. "I didn't know very much about *STAR TREK*. I didn't watch it. When I read the script I thought the idea of these guys having gotten lost, so they are on their own trying to get back to their homes, was a very good one. It's like the *Odyssey*."

Beltran was also impressed by some of the other casting. The producers had held off casting Chakotay until they had found a suitable female captain, so when he was auditioning he knew that Janeway was going to be played by Oscar-nominated actress Geneviève Bujold. "I was anxious to work with her," he remembered, "so I said, 'Yes, I'd love to audition.' Then," he laughs, "before I had the chance to work with Geneviève, she left the show!"

When Beltran started work on the series, he knew relatively little about Chakotay, and the decisions he made about how to play scenes would become an important part of where the writers took the character. As Brannon Braga explains, it's difficult for writers to work with a character until they have seen an actor inhabit the role. At that point, he says, the writer starts to hear their voice much more clearly.

Beltran remembers that as well as the first few scripts, he had the writers' bible to help him build his character. "They

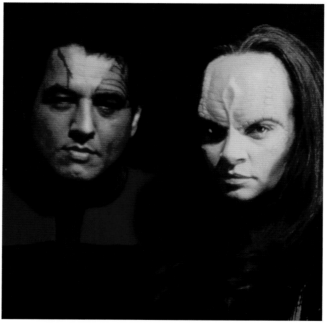

ABOVE: *Chakotay and Seska. The major storyline that ran through the first two seasons involved Seska's betrayal of the crew. She and Chakotay were former lovers and he was at the center of the storyline in which Seska claimed to have impregnated herself with his DNA.*

give you that so you have a sense of where they might go with it. There are things that you establish about the character in your own mind, and then hopefully your vision and the writers' vision are the same."

One thing that Beltran thought shouldn't be over-emphasized was Chakotay's Native American background. "You can't walk around as a Native American Indian," he explains. "You have to walk around as a human being. How would you constantly walk around as a Native American anyway? Do they walk differently than another human being? Do they eat differently? What differentiates them to the point where you have to make this clear every episode? This is a Native American guy, you know? He's different! What makes him different? Nothing. He's a human being."

What he did respond to was the idea that Chakotay was inherently spiritual. "I think it's a great choice," he nods. "He has this belief, which brings a spiritual element into *STAR TREK* that you didn't get before."

As Jeri Taylor explains, the writing staff were at pains to make sure that their portrayal of Native American culture was respectful. So this intention, together with a wish to portray a 24th-century version of Native American spirituality, led the writers to make Chakotay belong to a fictional tribe and to have beliefs that weren't directly related to any specific Native American group. "I think it's purposely a kind of generic Native American spiritualism," Beltran says. "It has some truth in it and some stuff made up, because I don't think they want to offend anybody or trivialize anything. It was Indian religion filtered through Hollywood and sometimes it got maybe a little heavy-handed, but not to the point where it became annoying. I don't think it ever got to that point where it became the single thing that made Chakotay what he was."

Beltran does remember one occasion when he felt that the writers lost their way, but as soon as he told them, the scene was cut. "It was after Seska claimed that we had a baby," he remembers. "I had a line that said, 'Excuse me, Captain, I have

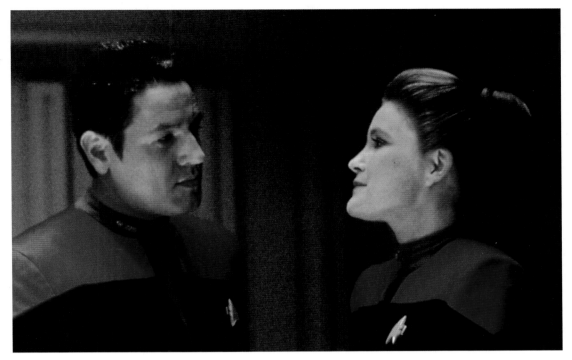

ABOVE: *The early episodes often threw Chakotay and Janeway together. As the most senior member of the crew, he was often the person she confided in. This led the actors to bring a degree of intimacy to their performances, which the writers picked up on. Members of the audience started to hope they would become involved.*

to go talk to my dead father.' I just thought it was silly, even if you know that he can go talk to his dead father!"

So while Chakotay's Native American background was inevitably a part of who he was, Beltran never felt that it was the key to his character. Another thing that the script for 'Caretaker' established was that Chakotay was a member of the Maquis, who had left Starfleet in order to fight the Cardassians for control of his home planet. "My own secret about Chakotay," Beltran reveals, "was that I couldn't wait to get back and get the Maquis started again. I thought it was a mistake that ended so soon. I always liked the idea that Chakotay was leader of the rebel faction. I thought it was one of the things that made him interesting. There was an episode where I tell B'Elanna the Maquis are now quashed forever. Roxann had a great idea: once we found out that the Maquis rebellion had been quashed, maybe Janeway would get a

command to imprison us. I thought that might be interesting."

However, the producers never saw the conflict between Starfleet and the Maquis crews as a major element of the series. "That would have violated something Gene felt very strongly about," Taylor explains, "that in the 24th century people wouldn't simply fall back into conflict based on what had happened in the past. They needed to pull together against the larger obstacles. We never wanted Chakotay to oppose Janeway for the sake of it. He was a superb first officer: competent, capable, intelligent, brave, a rock that she could count on."

Given that Chakotay wasn't going to regularly oppose Janeway, Beltran was left to look for other ways of bringing him to life. "You have to find a dimension to your character," he says. "They have to have some depth besides just being a nice guy. I find that more interesting in a lot of ways than playing

"He was a superb first officer: competent, capable, intelligent, brave, a rock that she could count on."

■ Jeri Taylor on Chakotay

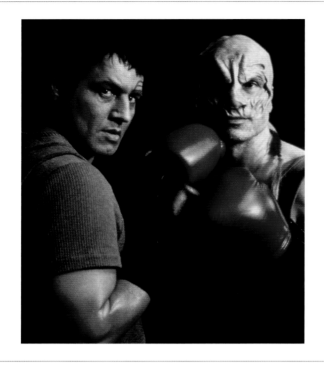

BOXING

Chakotay's interest in boxing, which played a major role in the episode 'The Fight,' came out of a conversation that Beltran had with the writers Brannon Braga and Joe Menosky. He remembers they asked him what he would like to see for his character. "I told them honestly, as far as science fiction, my mind doesn't work that well. Because everything seems possible, it's hard to narrow down what you would like to see done.

"I did say that if I personally had a holodeck, I would be playing every great football team against every other great football team in history, and I would be playing the greatest baseball teams against each other, because that's what I like. They kind of picked up on it and said, 'Well, we've done baseball. We can't really do football. What about boxing?' I wouldn't want to be a boxer myself, but I can appreciate it. I can enjoy two good boxers going at it, where there's great artistry and great athleticism. So that's how it came about."

the obvious bad guy, even though those can be fun and have a lot of dimension too."

Beltran was careful to give him a sense of discipline. In his mind, Chakotay was very much someone who respected the chain of command and saw it as his role to support the captain. Most of Chakotay's scenes were on the bridge, where he played an important part in advancing the plot. But, he says, there were also scenes that gave you a glimpse of his character, and this was where the decisions he made as an actor came to the fore. "Then there was the personal, the intimate stuff where you could cast off your Starfleet uniform and just be the person behind the commander. In every scene there are so many close-ups and it all depends on how they cover you, but if you get enough close-ups, you can convey a lot without words. I can only come up with things that make sense to me. That can be out of tune with what the writers have in mind, but that doesn't matter. What's important is that there's something seething. What that might be is part of the intrigue. If you got very specific about it and knew all the time that, for example, a character was thinking about his dead wife or whatever, that would be limiting. If you can sense something beneath the surface, that's all that's necessary."

Most often, Beltran explains, these decisions would involve the way Chakotay reacted to the other characters. "You have a relationship with each character and within that relationship there's familiarity that grows. That allows for a lot of nuances that are available to you to play, and that makes every scene with the character different."

Looking for examples, he hits upon the way Chakotay responded to Neelix and the Doctor. "I thought it would be a natural human response to be amused by Neelix and the Doctor. Also at times," he laughs, "he'd be annoyed by the Doctor. A lot of the time I wanted to say, 'Look you pixelated, pontificating putz of a doctor, shut up!'"

One of the most significant relationships that Chakotay had was with the captain. From early on, both actors chose to play the scenes so there was an underlying attraction between them. This was something that both the viewers and the writers picked up on. As the series progressed, the writers came up with more and more scenes that suggested they might become a couple.

"I guess at the start," Beltran says, "there were letters from the viewers saying, 'This flirtation between the captain and the first officer is really interesting. Let's see more of it.' I think that intrigued the producers. But they kept us in the dark. Were they going to get together? We didn't know. What mattered to me was that if we did get together, that it made for good scenes. If we weren't going to be together then I would hope that the quality of the scenes would remain very high."

Eventually, though, the writers felt that the flirtation was becoming too serious for them to ignore, so in the second season episode, 'Resolutions,' they stranded Janeway and

GUEST STARS

For Beltran, one of the best things about working on *VOYAGER* was the opportunity to work with the guest stars. "I have to say that working with Virginia Madsen in 'Unforgettable', Kate Vernon, who was in 'In the Flesh,' and Kurtwood Smith in 'Year of Hell' was terrific. I really enjoyed my relationship with Ray Walston. Really good guy. I enjoyed talking with him and we became friends. He had the kind of longevity in his career, playing so many different roles going from the stage to movies to TV. He had a wonderful career and I admired that about him. That's probably the one thing that stands out in that way. Being able to work with him on a couple of episodes was not enough."

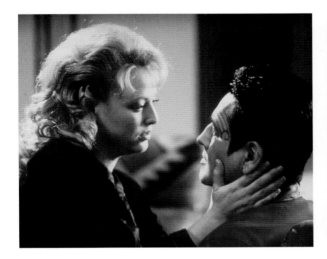

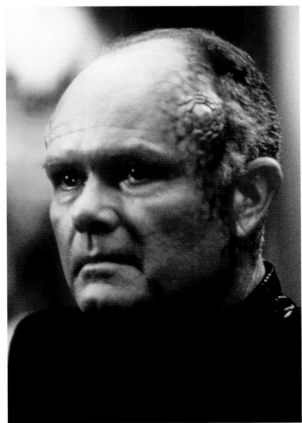

ABOVE: *Chakotay romances Seven of Nine. Beltran was intrigued by the idea of a relationship betwee the two characters, but it emerged so late in the final season that there was barely any chance to explore it.*

Chakotay on a planet where they were stripped of their Starfleet roles and their true feelings could come to the fore.

"That episode," Beltran recalls, "written by Jeri Taylor, was directly a response to all of the fans saying we want something happening with Chakotay and Janeway. There was a clamor for us to get together. Jeri wrote this episode to put the brakes on that and say, 'No, it's not going to happen. This is a very strong, intimate relationship, and this is the way it's going to be. It's not going to be a romantic one. It will have its own beauty because of that, its own strength that is just as fun to watch as it would be if they were married or something like that.'"

By the time Janeway and Chakotay returned to the ship, it was clear that although they could be very close, they were not going to be in a romantic relationship. However, Beltran says, in his mind Chakotay was still open to starting something more. "He did tip his hand that he would have gone for it. There wasn't a clear shut door, she didn't shut it. She was just not ready to deal with it, so the door was still open, but it

was going to have to be a continuing effort by Chakotay to make it happen.

"There were a few episodes after that where he would try something, say something, do something that made it clear that he was still interested in that happening. She kept shutting the door. I think Chakotay was in love with Janeway right up to the episode where he gave her a watch in 'Year of Hell' and she rejected it."

At this point, Beltran decided that Chakotay should be mature and wise enough to move on. "It was beginning to make Chakotay look like a chump," he smiles. "That's when I called the producers and said, 'Look, this has got to stop – either something happens, or we stop having him constantly getting his heart broken by this woman.' He's an intelligent man, and I think most intelligent men know when the game's over. Even though he may still be pining for her, I think he made up his mind that it was dead. It was over with." Fortunately, he remembers, the writers had come to exactly the same conclusion and from that moment on, the idea

that there was any romantic tension between Janeway and Chakotay fades away.

What started to happen at around the same time was that Chakotay started to become Janeway's conscience. As Ken Biller remembers, at some point the writers decided to make Janeway more extreme and had her taking bigger risks in her determination to get the crew home. Whereas Chakotay had initally started out as the rebel who broke the rules, he now became the voice of reason.

"When the romance part is taken out, then it's all business, right?" Beltran says. "I enjoyed the moments when I disagreed with the captain, you know? I liked that aspect of him." He goes on to explain that he rarely thought that Chakotay fundamentally disagreed with Janeway – given their situation, he could see the logic of doing whatever it took. It was more that Chakotay was naturally more restrained than his captain.

"When you're out there, sometimes you might just have to kill somebody, you know? You might have to go against your conscience for the sake of saving everybody on the ship. That was not a problem for me. To me it became, 'Is it really necessary right now? Don't we have other options right now?' My input to the captain is, 'Okay, maybe there will be a time when we have to decapitate 300 enemy soldiers, but let's wait and see until that's absolutely the only thing that we can do, and then,'" he laughs, "'let's chop their heads off!'"

That calmness and restraint were very much part of who Chakotay was, and the amused, cool attitude is very clearly part of who Robert Beltran is. The two men are not identical, though. "I wish I had his discipline," Beltran smiles.

ABOVE: *Chakotay questions Janeway's treatment of the* Equinox *crew. From the moment that Janeway made her deal with the Borg in 'Scorpion,' Chakotay frequently took the role of a wise adviser who suggested moderation.*

TECHNOBABBLE

One of the biggest challenges that Robert Beltran faced was how to deliver expositional dialogue that helped advance the plot without saying much about his character. A lot of Chakotay's scenes were on the bridge, where he had to pass on information to the captain. He admits that it wasn't always easy to remember whether, in a particular episode the shields were at 32 percent or 47 percent, for example. Things were made worse, because especially in the fifth and sixth seasons, the actors would often be handed new pages late at night and told that their lines had changed. "People don't understand that we would get a scene late at night on Sunday, when we had to be in makeup by 5.30 in the morning." This issue became even more problematic when the new scenes involved reams of technobabble. "Those scenes with all that stuff could have been shortened," he groans.

At times, Beltran's solution was to write his lines on notes which he stuck to the monitor in front of Chakotay. On one occasion, he tapped on the monitor to enter a command and the Post-its flew up in the air leaving him to lament," My lines! My lines!" It's a story that other members of the cast have told more than once. "Don't let them kid you," Beltran laughs, "I wasn't the only one pasting stuff. No, no."

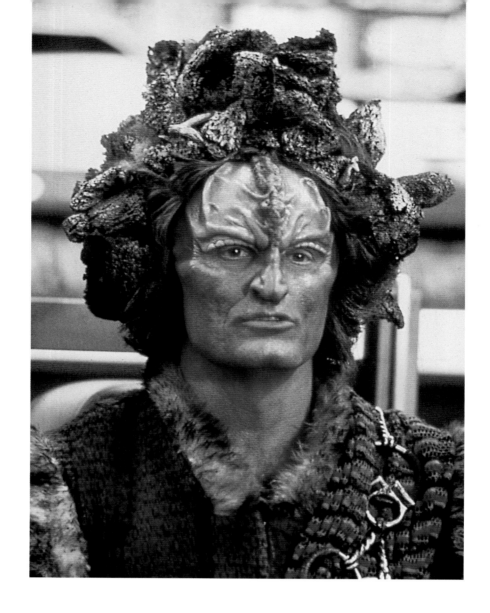

THE KAZON

DELTA QUADRANT GANG CULTURE

The concept behind the Delta Quadrant's Kazon was plucked from the headlines of 1990s Los Angeles. As Michael Piller explained, they were a very pure science-fiction idea: an alien society based on contemporary LA gangs like the Bloods and the Crips. "The Kazon," he recalled, "were originally created – and this was my idea – to be a futuristic version of an urban blight ruled by youthful street gangs. The idea was that all of these aliens were young – they were all essentially teenage to very young adults, because they were living in anarchy and killed each other before they had a chance to get old."

As Brannon Braga remembers, Piller wanted the writing staff to populate the Delta Quadrant with a variety of new species, and they expected the Kazon (originally called the Gazon) to threaten *Voyager*'s crew for several years. "One thing Michael wanted to do, and he was probably right, was to establish the geopolitical landscape to start generating stories, so that the Kazon were a continuing villain. My concern, and I think that I was alone in this, was that we should just have new aliens every week, so that they never encountered the same people twice, unless the villains were really good."

From the beginning, there were problems with executing Piller's concept. His idea that the Kazon should have a youthful profile – since very few would survive to old age – meant that they would often be rash and short-tempered. However, the producers found that strong young actors were in short supply.

ABOVE: *Michael Piller's concept was that the Kazon were basically interstellar street gangs, that were made up of young men, who died before they could reach old age. This idea was only really clear in the second season episode 'Inititations,' in which Aron Eisenberg starred as a young Kazon warrior earning his place in the sect.*

"The Kazon were being cast by Jeri and Rick," Piller remembered, "and they were not satisfied with the quality of young actors, so they decided to cast them with traditional older actors. I think that took away from who the Kazon might have been."

Nevertheless, Piller was so convinced by the merits of the idea, that he pushed the staff to continue using the Kazon and to make them an ongoing feature of the second season. When Ken Biller turned in his first draft for the story 'Initiations,' Piller called him up and told him that they had to make the Kazon more complex and give them a distinct identity. "Michael assigned me to write a backstory for the Kazon," Biller remembers. "He told me Ron Moore had done something similar for the Klingons, and he wanted me to do it for the Kazon: to establish what their history was, how they developed, and how their society functioned.

"He was very interested in the idea that the Kazon had these competing sects. He wanted them to be based on Los Angeles gang culture. There would be rival gangs competing for limited resources, with initiations for gang members. I read a book called *Monster* about LA gangs. I was able to take some of the stuff in that book and extrapolate it into the realm of science fiction, to work out how Kazon culture would work.

Then I wrote something like a 20-page manifesto about who the Kazon were. I thought that was a cool and unexpected assignment."

That resume established a lot of the detail that formed the basis of the episodes 'Initiations' and 'Alliances,' but there were still problems casting young actors, and many people felt that the metaphor Piller was so intrigued by wasn't playing out in a way that made Kazon society interesting. "When it came to it," Biller recalls, "the Kazon just seemed like thugs. I think Michael had this idea that there would be something deeper – that living a life of deprivation had made them violent and we might find their humanity, but I think they weren't interesting or distinct."

The rest of the writing staff, led by Jeri Taylor, were all in agreement with Biller's view, and as *VOYAGER* approached the end of its second season, the decision was taken to leave the Kazon behind. "I was very vocal in saying let's get rid of these guys," Taylor says. "Ideally, the Kazon could have pursued the ship throughout the series and that would be our running alien conflict. They would be the people that we wouldn't have to create every week. But it just didn't seem to gel. I do not know why. It's one of those mysterious chemistries that either happens or it doesn't. It didn't – so they had to go!"

SEASON 2

EPISODE 16

AIR DATE: FEBRUARY 5, 1996

MELD

In the second season, Tuvok melded with Lon Suder, a sociopathic killer who couldn't explain his violent tendencies. The meld unleashed his own suppressed violence and resulted in a classic episode.

Teleplay by Michael Piller

Story by Michael Sussman

Directed by Cliff Bole

Synopsis: When one of the *Voyager's* crewmembers is murdered, Tuvok rapidly uncovers the killer. To Tuvok's confusion, Suder had no motive, so the Vulcan decides to mind-meld with him, hoping it will help him to understand. The consequences are serious.

Every time Michael Piller switched on the news, he was confronted with meaningless violence. He couldn't understand what drove people to kill innocent people like nuns and children, and he started to wonder how a Vulcan like Tuvok would make sense of it. Piller was convinced that there was a story there, but he didn't know what it was, so he told the writing staff and any freelancers who pitched to *VOYAGER* that it was something he was interested in. He remembers that the idea had been kicking around for at least a year before anyone came up with a solution.

During the second season, Mike Sussman, who would later join *VOYAGER's* writing staff, was working as an intern in the writing department. As he remembers, he got a

RIGHT: Brad Dourif was cast as Suder and returned in two more episodes. The meld helped him to overcome his own lack of control.

chance to pitch a story idea to Piller. "Michael had made it very clear that he was looking for a Tuvok story. He became obsessed with the idea of how would a Vulcan react to the kind of senseless violence that we so often experience in the United States. I pitched him

> ## "He is a man with an incredibly violent nature living in an environment without any outlet to express it."
>
> *Tuvok*

a bare-bones version of a story about Tuvok mind-melding with an alien serial killer and absorbing the compulsion to kill from him, then having to fight those instincts himself. Michael stared up at the ceiling, put his hands behind his head. I thought, 'Oh no. He doesn't like it.' Then he said, 'I've never heard a story quite like this before,' and he bought it. I came in the following Monday as a paid writer, which had been my dream for so long."

In Sussman's original pitch, Tuvok actually melded with an alien from the Delta Quadrant rather than a member of the crew. "In my initial idea, it was a reptilian creature," he recalls, "and Tuvok's interaction with the primitive and alien parts of this reptilian brain resulted in a defective mind-meld. There was something very interesting to me about this reptilian part of a human – or Vulcan – brain getting activated. That was more or less lost in the finished episode."

As Sussman remembers, Piller set him up to work on the story, but the schedule was so demanding that it wasn't long before Piller took over the writing himself. "They were really behind and needed to get this story into place. If they gave me the chance and I didn't deliver a usable draft they would have been in terrible shape. Michael took over the script and wrote what I consider to be a minor masterpiece for *VOYAGER*."

Piller reworked the story, removing the alien element and having Tuvok meld with a human member of the crew. This was something that could only happen because the Maquis were onboard the ship. As Piller told Stephen Poe for the book *A Vision of the Future*, "The murderer is a man who joined the Maquis, because he really, really likes to kill. Finally he kills somebody aboard *Voyager*. If we had no Maquis on the ship, you would never find a human Starfleet officer – one who's gone through the complete Starfleet training – who would do that. It just doesn't happen."

When Tim Russ saw an early draft of the story, he suggested that they make Suder some kind of alien rather than a human, because Vulcans had a long history of mind-

ABOVE: Sussman's original idea was that the mind-meld would malfunction because it involved an alien species. This was still behind the idea of Tuvok melding with the Betazoid Suder.

melding with humans without any difficulty. Suder became a Betazoid, a race known for their passion and their ability to sense the feelings of others. The black contact lenses that were used for Betazoids served to make

> ## "In its own way, violence is attractive, too. Maybe because it doesn't require logic. Perhaps that's why it's so liberating."
>
> *Lon Suder*

Suder even creepier. Brad Dourif, who had been Oscar-nominated for his role in *One Flew Over the Cuckoo's Nest*, was cast in the role. His girlfriend knew Ethan Phillips and he had let it be known that he'd be interested in doing an episode of *STAR TREK*.

Tim Russ was delighted with the opportunities the script gave him to explore a different side of Tuvok. He saw it as a way of bringing a whole new insight into the character of the very modulated Vulcan, and to show what happens to him when his usual controls are removed.

Piller made sure he did his research, and consulted an expert at the California Institute for the Mentally Insane. He was very careful to ensure that there were no easy explanations for Suder's violence. This left him with a problem: how would the story resolve itself? The solution, suggested by Jeri Taylor and Rick Berman, was to have Tuvok advocate executing Suder, which raised the issues of whether capital punishment was about justice or about fulfilling one's own violent needs.

The finished story would be one of Michael Piller's favorites. Fittingly, it was the last full television script he ever wrote for *STAR TREK*. As Jeri Taylor puts it, 'Meld' was classic Michael Piller: dark, intellectual, and challenging – and one of *VOYAGER*'s very best.

TUVOK
THE FULL VULCAN

For the first time in 26 years, *STAR TREK* had a Vulcan as a series regular. But Tuvok was very different from Spock. He had no human traits to suppress and had left a wife and family at home in the Alpha Quadrant.

Tim Russ sounds surprisingly Vulcan. There's a measured and careful tone to his voice as if he is considering everything with a critical mind. It's easy to imagine him raising an eyebrow whenever you ask a question. The fact that he seems so Vulcan made him irresistible to the writers and led them to radically rethink who Tuvok was.

When *STAR TREK: VOYAGER*'s creators first imagined the character, they wanted to make him much older. They felt that people who looked as if they were in their sixties were underrepresented on TV, and they saw this as an opportunity to redress the balance. But when they started auditioning, they didn't see anyone ideal so they opened the doors to younger actors. "I know that they changed their minds about how old he was a couple of times," Russ remembers, "because they put out a casting call for it. I was told I was going to go in and read, and then they said, 'No, they've changed the age so it's not going to happen.' I know they did read people for that older role, but after a while they called me in anyway."

Russ was well-known to the producers. Seven years earlier, he had nearly been cast as Geordi La Forge, and he had gone on to make several guest appearances on TNG and DS9. During his audition, he nailed what it meant to be Vulcan. As series cocreator and executive producer Jeri Taylor remembers, this left the producers with a dilemma. "Tim Russ came in and read, and he was much younger than we had anticipated, so we looked at each other and said, 'Wow, he really reads well, but he's very young!' So we kept reading and reading but Tim just stuck in our minds. Finally we said, 'A wonderful actor has come along. Let's not be rigid in our concept.'" With Russ cast in the part, the writers set about reworking the character of Tuvok, ditching the orignal concept that he was a grandfatherly presence who would act as a mentor to the other characters.

Russ is flattered by the idea that his audition made such an impact. "I'm sure they could have found someone in the city to play the role," he laughs, but admits that playing a Vulcan came easily. "To play your emotions completely flat? I can fall out of bed and do that. That's cake and ice cream, man. That's nothing! Trying to play a scene emotionally, where you break down or get angry, you shift gears three times emotionally within one scene. Are you kidding me? All those nuances and change, that's work. The emotional control is easy."

ABOVE: *Russ says that one of the differences between Tuvok and Spock is that Tuvok is a father. The second season episode 'Innocence' introduced child-like aliens whose behavior tested Tuvok's Vulcan resolve. This led him to reveal details about his own children that deepened our understanding of his character.*

The key, Russ says, was to dial back his performance to the point where it was as subtle as possible and appeared to be doing almost nothing. "As Bob Picardo once said, 'Tuvok plays King Lear with an eyebrow.' You're very, very subtle. That's what it's all about. You're never going to see Tuvok throw a dish across the room, but he may have an expression that resonates as slight irritation, or suggests he's thinking, 'Why is this person doing this?'"

That understanding of what it meant to be Vulcan was based on years of watching television. Like many Americans, Russ had grown up watching *STAR TREK*, along with *Gilligan's Island* and *The Twilight Zone* in reruns. Along the way, he'd picked up that Vulcans are far from robotic.

"You want to do just enough," Russ explains, "to let people know that Vulcans are not without emotions, they simply control their emotions. In fact, their species had them in great quantities and that's why they almost destroyed themselves. The only way they could save themselves was by deciding to suppress their feelings, so they used meditation and other techniques to suppress all of their emotions, good or bad. They don't allow them. That's what their philosophy is, that's what they've done for a very long time. In the Vulcan mind, it is inappropriate to show emotion. It is embarrassing. It is just not done. That's really what it comes down to."

So, from the beginning, Russ set about adopting subtle expressions that implied the emotions that Tuvok was holding

> *"You're never going to see Tuvok throw a dish across the room, but he may have an expression that resonates as slight irritation."*

Tim Russ

in – and one of those overriding emotions was annoyance. "Whereas Spock might be curious, I intended from the very beginning to ramp up Tuvok's potential to be annoyed," Russ continues. "He's annoyed the first time that we meet Neelix, for example. This character is 100 percent Vulcan, while Spock's character was half-human, so I think my character could show some very subtle annoyance more frequently than maybe his predecessor would."

At this early stage, the producers planned to put Tuvok and Neelix together a lot, in an attempt to create their own version of the popular Spock-McCoy dynamic. Russ realized this was happening, so he made sure his performance as Tuvok contrasted with Ethan Phillips' Neelix. "The fun is to have two characters that aren't the same," he says, "so you're bouncing each character off the other. If you have two characters playing the same beat, you don't have the difference." Russ adds that if you watch his scenes with Neelix, Tuvok always explains exactly why he is annoyed.

ABOVE: *Tuvok and Neelix were always seen as* VOYAGER's *odd couple, but in the end, they normally shared scenes rather than whole episodes.*

Russ could see the appeal of Tuvok's logical approach to life, but he was also aware of its limitations, and he was keen to have the kind of storylines that challenged him. "I said to the writers early in the first season, put him in circumstances where he has to use his intuition, because he doesn't really have intuition. He won't base a decision on a guess or deal with somebody's emotions if they're threatening the ship. That's his Achilles heel: how does he deal with situations that might require a human instinct, a human guess?

"When you're faced with something that is not logical, you cannot use pure logic to solve it, you have to use human intuition, you have to use some kind of understanding of human nature to be able to manipulate the circumstance to get out of the trouble that you're in."

The question of what happens when a Vulcan is confronted by something that makes no logical sense at all was the basis of the second season episode, 'Meld.' Russ knew enough about STAR TREK to anticipate an episode in which Tuvok would lose control, but he was intrigued by how it happened. After a crewmember is murdered for no obvious reason, Tuvok discovers that Lon Suder, one of the Maquis, is a serial killer who can't explain why he kills. Tuvok's logical mind cannot encompass this, so he mind-melds with Suder.

"It was a very interesting episode," Russ remembers, "because Tuvok interacts with a character who's outright violent. I wanted to examine and understand what it was that this character was going through. That makes total sense. Who would be better able to tap into this person's mind and find out what's going on? At the same time, Suder is absolutely fascinated by how stable I am."

The mind-meld seriously unbalances Tuvok and leaves him struggling with his own violent rages, until he can eventually regain control. "'Meld' really tested him," Russ says. "It was a very good start to opening this character up, to get to know who he was, and to demonstrate what happens when you take away those Vulcan controls."

A few episodes later, the writers explored a different side of Tuvok. One of the big differences that Russ identified between Tuvok and Spock was that his character is a family man. "Tuvok has gone through *Pon farr*. He's taken a wife, and he has children. That's two or three steps beyond what Spock's character had throughout the series. The same way it is with humans, once you have a child it changes all your perspective and your attitude about a lot of things, because your lifestyle has changed. Now you're in a position of raising a child."

In 'Innocence', Tuvok has to care for what appear to be children. "Seeing my character interacting with children was very interesting. It would have been very different with any of the other crewmembers. With Tuvok, it's even more interesting because of the juxtaposition of him being Vulcan and having discipline and order and logic, and these kids who are running

around acting crazy. How does he deal with it? That's a perfect environment for exploring his personality, his character, and his potential backstory as a father."

The episode showed that Vulcans make pretty good parents even if they expect their children to be extremely disciplined, and it implied a lot about Tuvok's own upbringing and how he interacted with his family.

Whereas 'Innocence' explored parts of the Vulcan life that had been a mystery to us, it was inevitable that at some point the writers would have to deal with *Pon farr*, the period in a Vulcan's life in which they lose control of their emotions until they can take a mate. Most people had expected the story to focus on Tuvok, but the writers decided to use Vorik, a different Vulcan, who attempts to mate with B'Elanna when he enters the blood fever.

"In this case they needed as much input from me as I needed from them," Russ explains. "They didn't have anything to base some of this stuff on, so they had to kind of wing it. I worked with the writer Lisa Klink on the *Pon farr* episode. We talked about that extensively before the episode was written, and while it was being written. There were aspects of *Pon farr* that had never been explored before, so we had to make up things right off the bat, to fill out the lore.

"We put a scene in that episode where I had to have a conversation with Vorik and it's very uncomfortable. That's what we wanted to demonstrate. Even though I understand what he's going through, it's uncomfortable for him and it's uncomfortable for me to see that display of uncontrolled emotion. It was clear that I didn't want to be in his presence and he would not want me to see him like that, and yet we had to interact with each other. Later on, there's another episode where I go through *Pon farr* as well, and I wanted the same kind of thing. I remember we had to discuss how many times do they go through *Pon farr*. Is it every seven years, even after you get married?"

In episodes like this, Tuvok is absolutely at the mercy of his biology. That loss of control is chemical and there is nothing he can do about it. But in other episodes, he is pushed by circumstances and by other characters to express different kinds of emotions. In cases like this, Russ wanted to make sure that his performance was as subtle as possible.

ABOVE: *Russ had a lot of input in to how the writers treated* Pon farr, *and was keen to show that it was not something Vulcans talked to one another about.*

"Some of it came out in the episode 'Rise.' Neelix was telling him he was acting like an ass and I had to stand there and debate him. You can see Tuvok is losing it. It's very subtle. But it's there in my reaction to what he's saying. Neelix accuses me of being this, of being that, and eventually I realize that he was right. That has to show, and you do get a sense that the wheels are turning behind the eyes. You have that inference and that's all you need. He's not a stone, he's not a rock, he's just in control, for the most part, of his emotions."

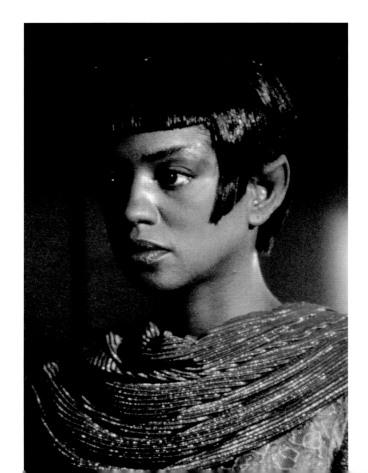

RIGHT: *Tuvok's wife T'Pel appears several times, although she is a hologram or a vision and we never actually see the real person. It was important to Russ that we understood that Tuvok is a family man and this gave him a very different background to most STAR TREK characters.*

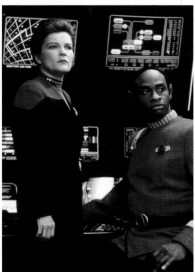

FLASHBACK

Tuvok was at the center of one of *VOYAGER*'s most memorable episodes. 'Flashback' was written in 1996 to celebrate *STAR TREK*'s 30th anniversary and featured guest appearances from George Takei as Captain Hikaru Sulu and Grace Lee Whitney as Janice Rand. The episode revealed that Tuvok was serving aboard the *U.S.S. Excelsior* under Sulu during the events of *STAR TREK VI: THE UNDISCOVERED COUNTRY*.

The story involved Janeway mind-melding with Tuvok to help him deal with a psychic infection. This allowed the writers to show the past from Tuvok's perspective. The script addressed the reasons why Tuvok originally left Starfleet before his return: as a young man he found humans to be egocentric and overly attached to their own values. But when he had children he realized that life was more complicated.

Tim Russ was particularly happy with the episode. "Having George Takei work on it was just great," he says. "It was great to recreate that whole scene from the film – we didn't just use the stock footage [from *STAR TREK VI*], we created it, so that was very cool." And he relished the chance to flesh out an important part of Tuvok's past. "I had to play myself as a younger cadet. Giving myself a backstory with Kate was also great."

ABOVE: 'Gravity' was an exercise in leaving things unsaid. Noss falls in love with Tuvok. He appreciates her but cannot reciprocate, and as a Vulcan will not discuss it.

> *"Vulcans are not born with perfect, emotionless logic.*
>
> *It's their culture to triumph over emotion."*

Nick Sagan on 'Gravity'

Another important episode, 'Gravity', forced Tuvok to deal with more positive feelings, when he is trapped on the surface of a planet and Noss, played by Lori Petty, falls in love with him. The teleplay was written by Nick Sagan and Bryan Fuller. As Sagan explains, the idea of the episode was to explore how Vulcans learn to deal with emotion. "The phrase we kept spinning around was 'emotion creates its own logic.' That leads to these flashbacks of young Tuvok that remind us that Vulcans are not born with perfect, emotionless logic. It's their culture to triumph over emotion."

That dilemma posed Russ with new questions and new aspects of Tuvok's character to explore. "The character," he recalls, "is faced with a woman who's very emotional, who wants to be with him. How does Tuvok deal with her? How does he convey that he understands what she's going through?"

The answer to the latter question came from Russ, who suggested reworking the final scene to dispense with the dialogue. "At the very end of 'Gravity,'" he remembers, "there was a moment I suggested to the writers about how to convey how Tuvok feels when he leaves her. We know that she's falling in love with him, but he has to go. How does he tell her that he's married and has children, and that he can't really… that he appreciates… I said, 'Why doesn't he just mind-meld with her, without saying a word? All you have is the expression on her face. He gives her total understanding of what he's all about, which is the most intimate thing she could have. In just that moment he conveys to her how grateful he is, how he appreciates what she's done, what he thinks of her and what he might hope for her and why he has to go. Who he is.' All that was done in just a minute of melding with her."

Sagan remembers being hugely impressed by the suggestion and the way it improved the scene. "That was beter than anything we would have scripted," he says enthusiastically. "It was all Tim Russ. We had written some speech and Tim had the brilliant idea that he could do it telepathically. I get chills when I see that scene."

If there had ever been any doubt, that scene made it clear that, however unfeeling Tuvok might seem, there are very real emotions going on beneath the surface. That compassion surfaced again in the series' penultimate episode, when Neelix leaves the ship. The episode opens with Neelix trying to persuade Tuvok to dance. Inevitably, the Vulcan tactical officer is not amused, but at the end of the episode, Tuvok shows what he really thinks of the person who has annoyed him so much for the last seven years. "Neelix wanted me to dance," Russ recalls. "All I did was move my foot from one side to the other, and that was it. He didn't do it because he enjoyed it. He did it because he knew that's what would make Neelix happy at the time. He didn't have to do that. It was an act of compassion, an act of gratitude."

For Russ that depth of understanding was the real achievement of his seven years on *VOYAGER*. In that time they had not only explored Tuvok, but they had deepened our understanding of the Vulcans. "There are others who have come before me who have laid the pathways, so all I'm doing is following the path. But I could branch off into a few different directions and we could diverge and broaden the path. So now the people who come after us can base future stories with Vulcans on what we established."

ABOVE: *Tuvok plays the Vulcan 'game' Kalto, one of the many new aspects of Vulcan culture introduced in* VOYAGER's *seven years.*

WEARING THE EARS

Tim Russ didn't have to wear much makeup but, of course, pointed ears are an unavoidable part of what it means to be Vulcan. "They took 20 minutes or so to put on," Russ explains. "Not very long. Not like Ethan or Roxann. The eyebrows are premade, the ears are premade, so they just had to glue 'em on and then put the makeup on top to blend them in and that was it. Once the ears are on, you're not aware that they are there. I couldn't feel the eartips at all. They were soft rubber, you only knew they were there if you touched them."

"What a lot of people forget about prosthetic make-up is that you can't just rip it off and wash your face at the end of the day. They used a special remover to take the ears off," Russ says. "The only thing was that although you use something to take the glue off, it never all came off. Your ears look like they're clean, they might feel like they're clean, but in fact they're not. There's still a layer of glue there. After a day or two of not wearing the ears, you'll notice these little tiny balls of glue that keep coming off on your fingertips. That happened to me for seven years."

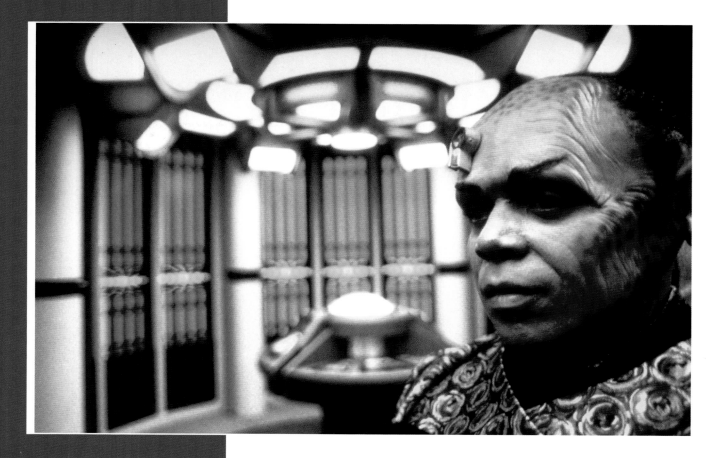

SEASON 2
EPISODE 24
AIR DATE: MAY 6, 1996

Teleplay by Kenneth Biller

Story by Andrew Shepard Price
& Mark Gaberman

Directed by Cliff Bole

Synopsis Transporter trouble merges
Tuvok and Neelix into one,
creating Tuvix.

T U V I X

'Tuvix' could have been a forgettable episode – instead it posed Janeway with a classic moral dilemma and called on Brannon Braga to take on a senior role and fix a story.

Transporter accidents were nothing new in *STAR TREK*. The Original Series' 'The Enemy Within' had seen Kirk split in two: one good, yet indecisive; the other bold but erratic. Splicing together *VOYAGER*'s double act of rational Tuvok and exuberant Neelix seemed a fun, if lightweight, notion for a story, but showrunner Michael Piller saw greater potential. Writer Ken Biller recalls Piller pitching Andrew Price and Mark Gaberman's plot as seemingly "a cheesy sci-fi idea – these two people get merged – but, if it becomes a moral dilemma for Janeway, then it's interesting."

Writer/producer Brannon Braga remembers 'Tuvix' as a great example of an episode that just shouldn't have worked. "It had no right to work," he says. "'Tuvix' is a terrible title, it's a terrible idea – a transporter accident – where two characters are combined and let the hilarity ensue... but what happened with that episode was that it went through many rewrites and, for whatever reason, we decided it's not a comedy, it's a tragedy."

Biller gets the credit for the teleplay, which saw the disconcerted Tuvok/Neelix crossover emerge as a likeable and unique being, who deserved life as much as those he replaced. The story was originally going to be played for laughs, but the writers struggled to make it work. Eventually, they hit on the idea that it

should be a tragedy. The job of rewriting the episode was handed to Braga, who remembers Michael Piller telling him, "Get used to it. This is your future."

> "He possesses Tuvok's knowledge and expertise. He also possesses Tuvok's irritating sense of intellectual superiority and Neelix's annoying ebullience."
>
> **The Doctor**

Key to making the episode work was the casting of Tuvix. According to Brannon Braga, "They cast the perfect guy – he really looks like a combination of the guys, and he was a really good actor."

Tom Wright, who knew both Ethan Phillips and Tim Russ personally, felt his best course of action in auditioning for the part would be to play a combination of the personalities and styles of those two *VOYAGER* cast members. Wright told *STAR TREK: VOYAGER* Magazine, "I felt that it would be unique to create a totally different character that had never been created on *STAR TREK* before." Wright struggled under the heavy makeup and with the requisite technobabble, but succeeded in developing a character who shared the mannerisms and phrasing of his predecessors and had the potential to replace both (though there was scant expectation that Phillips and Russ were going to see their contracts expire at the end of season 2). The best of both characters seemed reborn in Tuvix, a security officer capable of acting on a hunch, and possessing both a logical mind and a sense of humor. Even his culinary skills improved. Kes, unsurprisingly, finds the transformation the most upsetting, despite Tuvix's assertion that Neelix's love for her survives.

When the prospect of bringing back Tuvok and Neelix arises, Tuvix, in a speech that evokes Shylock's pleas in *The Merchant of Venice*, reminds Janeway that he laughs, he cries, and that she is suggesting an execution to be rid of him. The predicament of doing

ABOVE: It was important to the writer that Tuvix was likeable and sympathetic.

away with a living, breathing being – one who passionately argues his right to live – to restore the status quo is just the kind of moral quandary that *STAR TREK* enjoys confronting, and the resolution split opinion in its audience.

Biller considers Janeway's resolution. "I don't know if Picard would have decided that differently but, in that episode, everybody loves Tuvix and he's his own person, and Janeway says, 'Well, I'm going to kill you so I can get my

friends back.' He makes a huge, passionate plea and tries to fight, doesn't want to die, and Janeway does it anyway and she has to wear it because that's what the captain has to do."

The Doctor is unwilling to break his Hippocratic oath and end Tuvix's short life. Ultimately, it was the captain's decision. Was the choice of losing Tuvix one step too far for Janeway? Kate Mulgrew considers the harsh choices her character has to make over seven seasons. "It never went too far. I came close with Tuvix, but I don't think that I actually did anything that I would condemn myself for." Her decision is shared by the crew, none of whom support Tuvix in his refusal to undergo the surgical procedure to split him back into Tuvok and Neelix. When Janeway leads Tuvix to sickbay, it's like the walk of a condemned man.

Having rewatched the episode, writer and coproducer Bryan Fuller sums it up: "This is an

> "At what point did he become an individual and not a transporter accident?"
>
> **Janeway**

excellent episode of television! How did that happen?! A transporter accident, like it's such a one-line joke, but it's executed with such beauty and sensitivity."

ABOVE: The original intention was to play the story for laughs, but the writers realized it should be a tragedy and rewrote it to pose Janeway with a serious moral dilemma.

THE VIDIIANS

THE NEVER-ENDING PLAGUE

The Vidiians nearly ended up on *STAR TREK: THE NEXT GENERATION*. As their creator Brannon Braga remembers, he had the idea for them when he was working on *TNG*'s seventh season. "My concept for the Vidiians was: what would the world be like if the bubonic plague never went away and you were living with that plague in its most aggressive state forever? After many generations here was this alien race, who were so desperate they were abducting people for organs and skin grafts." Braga knew that he would be joining the *VOYAGER* writing staff and he realized that the idea would be more useful there than in the Alpha Quadrant. "I thought these could be some really scary aliens in this mysterious

Delta Quadrant." What appealed to him was that although the Vidiians would be repulsive and at home in a horror movie, anyone could understand what was driving them. "What I like is that they're not villains – they're tragic figures. They are desperate. It's awful and they look awful. You feel sorry for these guys."

The producers identified the Vidiians as a race that was interesting enough to recur, making their debut in 'Phage,' where they steal Neelix's lungs. They appeared again toward the end of the first season in 'Faces,' in which a Vidiian scientist separated out B'Elanna's DNA to create two versions of her. The story was written by Ken Biller, who was fascinated by the

concept. "Somebody had pitched the idea that B'Elanna got split in half," he recalls. "I was the one who said, 'What if it's the Vidiians that have split her in half, because they want to get this Klingon DNA and use it as a cure?'"

Biller was interested in exploring how this would affect B'Elanna, and which brought up attitudes body image that he extended to the Vidiians. "To me," he explains, "it suggested ideas about physical appearance and body image and identity, and plastic surgery. There's a lot in that episode about the dangerous superficiality that we place on appearance."

Once again the concept of the Vidiians provided both horror and pathos. The doctor who splits B'Elanna in two is so attracted by her vigor and health that he falls in love with her. "That doctor was played by Brian Markinson, who is such a good actor. He did this creepy thing, where he put the other guy's face on his face in order to get her to love him. That had a horror and a pathos to it."

Biller returned to the same themes in 'Lifesigns,' where the crew rescue a Vidiian. She uses holo technology to move around while the Doctor treats her ravaged body. Again, Biller was intrigued by ideas of body image. "The holographic tech made this woman beautiful again. The Doctor didn't have any prejudices about appearance. He really fell for her."

Biller explains that, as they explored the Vidiians, they realized the concept of living with a horrible disease and what it would do to a society opened up stories. "The idea of a plague

was a cool idea, and nobody has cooler ideas than Brannon, but it turned out to have legs."

The Vidiians gave Michael Westmore's makeup department the chance to go to town. "We started off with this patchwork-quilt type of makeup," Westmore remembers. "The skin was a variation of colors. As we kept doing more shows with them, we started doing silly things like adding a chunk of flesh with an ear in it! There's one that has a Vulcan ear stuck to the back of its head; there's another one with a very obvious chunk of Talaxian skin.

"We'd make a chunk of skin spotted and the next one striped. We punched different alien hair into it. Then we started flocking areas on it, so there would be a fuzzy chunk next to a smooth chunk.

"I thought it would look strange for them to have nice human-looking teeth. So, I started making a series of teeth that had a fang in them or something unusual. The teeth tend to look like [they belong to] various alien species."

The Vidiians made a final appearance in 'Deadlock,' which Braga remembers as being particularly effective because they were genuinely scary. "If you've been watching the show, you know it's going to be bad, even though we could only afford two of them!"

Then, thanks to the nature of *Voyager*'s journey, they were left behind. "I wish we'd done more with them." Braga says, "I really liked them."

ABOVE: At the heart of Brannon Braga's horrific concept for the Vidiians was a great deal of pathos, as episodes explored how a society would be changed by a virus that ravaged its victims. This unique alien race inspired the makeup team to create a patchwork of skin types for each Vidiian.

TOM PARIS
CHARMING ROGUE

Few of *VOYAGER*'s main characters changed as much as
Tom Paris. He starts out as a bitter convict looking for a
place in the world and ends up a happily married man.

Originally, Tom Paris was envisaged as a troubled, charming rogue, someone who would flout the rules and share Kirk's tendency to womanize. Robbie McNeill was cast in the role because he had already played a character like this on *STAR TREK: THE NEXT GENERATION*: Nick Locarno, a charismatic cadet, who had been expelled in the episode 'The First Duty.' "I had a blast on *NEXT GENERATION*," McNeill remembers. "Most of the time I was in scenes with Wil Wheaton or Patrick Stewart, and the other young actors. I had one of the best weeks of my career."

Locarno stayed in the producers' minds. This was a character who had the kind of edge that *NEXT GENERATION* often lacked. Their early notes for *VOYAGER* actually referred to 'Locarno,' but ultimately they decided that the character had too much baggage and was too compromised, so they renamed him Tom Paris and adjusted his backstory.

At first they assumed this meant they needed a new actor, so when the casting call went out, it referred to 'a Robert Duncan McNeill type.' Unsurprisingly, when McNeill heard about the role he was confused: surely no-one was more of a Robert Duncan McNeill type than he was? "I was doing a play in New York when my agent called and told me about it," he recalls. "They said, 'It's not exactly the same character so you'd have to audition again.'" He went into the casting agent's office in New York and recorded an audition, which was sent off to LA. Before long, the producers asked McNeill to come out to Hollywood for a full audition – but this presented a problem. He would have to leave the play and since he didn't have an understudy, it would have to shut down while he was away. "I really struggled with the decision," McNeill remembers. "I needed the job – I was making $400 a week off-Broadway – but ultimately I told my agent, 'If they want me to come out, they'll have to wait until a day when I'm free.'"

Fortunately for McNeill, the producers agreed. A few weeks later, he flew out on a Monday, risked buying a suit that he couldn't afford, and auditioned for the network. They cast him the same day.

The shadow of Nick Locarno would hang over Tom Paris throughout the first season. "In the beginning," McNeill says, "I was stuck with the idea that he was like Nick Locarno, which was not very appealing. He came off as a jerk a lot of the time. I think Locarno was a bad guy who pretended to be a good guy.

Deep down inside, he was rotten. In contrast, inside Tom was a good guy who pretended to be a bad guy. He sort of wanted everybody to think he didn't give a damn and that he was a lone wolf, but deep down he wasn't like that."

Although the writers had wanted a character with rougher edges, executive producer Michael Piller admitted that they struggled to work out how to write someone like this into the *STAR TREK* universe. "I think the series started the same year as *ER*. The success that George Clooney had as the bad boy character on that show was really what we intended Paris to be on *VOYAGER*. But it seemed that nothing we tried worked very well. Maybe you can do that in a contemporary situation, but it was just not the right chemistry for *STAR TREK*."

Like *ER*'s Doug Ross, Paris was meant to be the series' romantic lead. McNeill even remembers there was a suggestion that he and the captain could become a couple. "I think," he says, "some of the stories they conceived for that first season certainly had Tom in a prominent role. One of the things I know they had discussed was that Tom might potentially be the love interest for the captain. I think ultimately, when they ended up with me and Kate Mulgrew, that we just weren't the right kind of match so that went away."

ABOVE: *The character McNeill played on TNG was charming and charismatic, but eventually revealed himself to be selfish and cowardly.*

> "*Locarno was a bad guy who pretended to be a good guy. Deep down inside, he was rotten. In contrast, inside Tom was a good guy who pretended to be a bad guy.*"

■ Robert Duncan McNeill

ABOVE: *Tom became a consistent presence at the front of the bridge, proving himself to be a good man as well as a great pilot.*

McNeill feels that his performance wasn't helping. Because he had Locarno in mind, he was giving Tom villainous undertones that often made him seem immoral. "I struggled to find the place where he could just relax and have less of a chip on his shoulder. That took some time for me to find as an actor."

As executive producer Jeri Taylor recalls, part of the problem was that the writers were looking for ways to make Tom interesting, but they never found good enough reasons for his questionable behavior. "It was an absence of something," she says, "We never explored him to any great depths."

"It's part of his character to be the rebel," McNeill agrees, "but I think perhaps sometimes they played that quality without a valuable meaning. You know, he goes gambling in the holodeck for no reason. He does things that are rebellious or selfish or not very admirable, but you don't know why."

Another issue was that the series was in full production and moving at pace. The writers had already completed half-a-dozen or so scripts before the pilot was filmed, so they didn't get to see a finished episode in time to make adjustments. As McNeill recalls, it was no different for the actors. "We'd been filming for four months before we finally saw the pilot. I had no way of knowing if something was

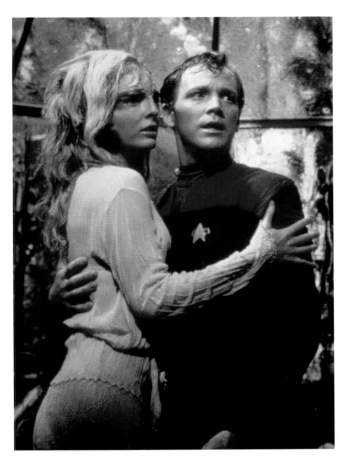

ABOVE: Like Captain Kirk, Paris got involved with alien women, some of whom – like Lidell in 'Ex Post Facto' – had their own agendas.

working or not. In hindsight, I wish that there had been some discussions about some of those bigger tonal notes. All of us could have adjusted to those and dialed down certain qualities, or dialed up other qualities."

Paris's womanizing was particularly tricky. What seemed acceptable for Kirk in the 1960s felt out of place in the 1990s. He flirts with *Voyager*'s Betazoid pilot in 'Caretaker,' sneaks off with a married woman in 'Ex Post Facto,' and fills his holodeck programs with attractive young women. Most troublingly, Paris appeared to make advances toward Kes, even though she was in a relationship with Neelix. As Michael Piller explained,

"We threw him into this odd romantic relationship with Kes, which was a triangle with Neelix, but it came off as sleazy so we pulled away from it." When the writers resolved the love triangle, for McNeill, it helped with playing the character. "The arc with Neelix and how that related to the Kes story softened him quite a bit. It made him a more complicated and well-rounded character."

In the second season, the writers tried to take advantage of Tom's reputation by creating an arc that gave the outward appearance that the character was struggling with Starfleet, allowing him to deceive the Kazon. But the issue was that unless viewers saw the entire development of the arc, they wouldn't realize that he was only playing a part. Far too many people only saw Tom behaving badly.

Ultimately, as executive producer Brannon Braga remembers, Paris's bad boy nature would be left behind. "Tom has a little bit of a troubled past and an attitude, but the crew are in an utterly singular and terrible situation, so how long before you just hate the guy? We're lost in the far reaches of the Galaxy. Get your shit together!"

In general, Braga feels that the kind of flawed characters that make up so much of contemporary drama just don't belong in *STAR TREK*. "I'm a big believer in Gene Roddenberry's vision: these are Starfleet officers. Even under the most extreme duress, they are good people who aren't burdened by the same primate crap that we are. They find a better way through."

As a result, the writing staff took another look at Tom and thought about different aspects of his personality they could emphasise. "From my perspective," Braga remembers, "at some point Tom Paris became a blank slate. You had to say, 'Who is this guy?' The actor Robbie McNeill is a very charming guy. His charm comes across on screen, but what else is there? When I started to think about Tom, I began to have some new

ideas about him being a character who might have a fascination with the 20th century, and that this might give us a portal to do some interesting little stories with him as kind of a self-reflexive, post-modern, science-fiction experiment. Because of that you end up with things like Captain Proton."

COFFEE GAMES

The filming days on *VOYAGER* were notoriously long, so the actors found many ways to keep themselves amused. McNeill remembers that scenes in the briefing room were particularly painful, because the actors had to repeat their dialogue countless times as the scene was filmed from different angles. To relieve the tedium, he and Robert Beltran invented a secret game that they played with one another.

"Beltran and I developed a running gag where we couldn't drink coffee at the same time. We tried to see how often we could take a drink without drinking at the same time. The idea was to catch each other out. It had no purpose, but we would just find it endlessly amusing because we got so bored doing the same scenes over and over and round and round."

That connection with the 20th century started when Paris lent the Doctor a holodeck program that involved a '57 Chevy on Mars. McNeill suspects that part of that fascination with old vehicles and an earlier period in history stemmed from his own love of motorcycling, but as an actor he wasn't always clear what drove Tom's fascination. "The thing I would struggle with was when it felt decorative rather than fundamental. I didn't always know why that 20th-century stuff meant something to him. I thought we needed to go deeper into why he was emotionally connected to it. The times when it did touch on that, it was more effective. Somehow, Captain Proton embodied that swashbuckling adventure silliness that I think was fundamental to who Tom wanted to be. That's who he aspired to be: Captain Proton."

The 20th century would also play a major role in the two-part story 'Future's End,' which brought the crew to 1990s Los Angeles. McNeill sees this episode as a turning point in the series. As he explains, *STAR TREK* has a particular, stylized approach to acting. "It is an artificial style, for sure. I remember [executive producer] Rick Berman saying, and I thought it was very wise, 'You know, we've got people with rubber on their faces, if we do too much acting or go for too much naturalism, it's going to make our world seem false or foolish.' That's why a lot of theater actors and more classically trained actors did well on *STAR TREK*. I think bringing our characters into the

| **ABOVE:** In 'Future's End', Tom visits the 20th century and meets Rain Robinson. McNeill credits the enjoyable episode with loosening up the cast's performances.

ABOVE: McNeill is a huge fan of Captain Proton, who he describes as the person Tom Paris really wants to be.

MONSTER MAKEUP

Tom Paris takes the lead in one of the strangest episodes in *STAR TREK*'s history. He makes an experimental flight in a shuttle that travels to warp 10, meaning that he exists in every point in the universe at the same time. When he returns, he evolves – or devolves – into a salamander-like creature. He kidnaps Janeway, who then experiences a similar evolution/devolution, before they are both rescued and returned to normal, leaving their evolved offspring behind on a planet.

"I know the fans hate it, but I love 'Threshold,'" McNeill laughs. "I always enjoyed being able to put on prosthetics. When I was a student, I was blown away by the play *The Elephant Man*. and when the script came out for 'Threshold,' I imagined my own opportunity to be in something like that. I was very excited to have that chance to play big, larger-than-life scenes. I could do this 'I'm not a monster' sort of thing. As an actor, you're not really responsible for the whole story because you're not writing it, you're not editing it; all you can be responsible for is playing each scene as best you can. For me, 'Threshold' was all about that and I really enjoyed it. I don't know that turning into a lizard and kidnapping Janeway and having lizard babies is the best story to tell, but the things I got to do in that story were really fun for me."

real world made a difference. They'd gone back in time to Earth and were walking around Santa Monica pier. All of a sudden, we were thinking, 'Wait, some of this heightened performance style feels very false when we set it in the real world,' and we relaxed a bit. I think that helped all the characters' performances."

Another thing that had a major effect on McNeill's performance was that he became a director. "Once I started directing, my experience as an actor changed pretty dramatically. Before that, I had just been focused on my one little story thread and my own priorities as a character. When I directed I had to look at the priorities of the whole show so I felt a sense of living in a world that was completely filled out. It

ABOVE: *On the first day of filming, McNeill told Rick Berman he wanted to direct. He would eventually helm four episodes: 'Sacred Ground,' 'Unity,' 'Someone to Watch Over Me' (above), and 'Body and Soul.' He credits directing with making him step back and look at the whole episode rather than just his part in it as an actor.*

took my actor ego down a bit and changed my mindset from servicing my character to 'how can I service the whole thing?'"

The third season also saw the writers abandon Tom's womanizing and start to play around with the idea that he and B'Elanna were attracted to one another. "We had to think long and hard about that one," Braga remembers, "because we'd just done a human-Klingon relationship with Worf and Troi. It was working with Worf and Troi, but it was just that we started it so late in TNG season 7 that it didn't have time to go anywhere. I thought that was a good thing to explore. It gave us some interesting storylines."

McNeill remembers that initially, he and Roxann Dawson had no idea whether the writers were serious about pursuing the idea of a relationship. They just saw their characters flirting

and getting closer. "My worry was that they were never going to let them commit to a relationship. At a certain point, you can't keep playing the will-they, won't-they thing." But in the fourth season, at almost exactly the moment that Seven of Nine arrived, Tom and B'Elanna actually became a couple, and this gave a new definition to the characters for the rest of the series.

McNeill remembers embracing the opportunities this gave him as an actor. "I think Roxann and I were both like, 'All right, let's do this. Let's explore what a real relationship is.' We were ready to play some different kinds of scenes with each other." He particularly enjoyed working with Dawson, who he says brought out the best in him as an actor. "Roxann is such a serious actress and a creative person. It was good for me to be partnered up with someone where I could see the work she

was doing. She demanded that I up my game. She is very well prepared. You couldn't just show up and wing it. We talked about the characters, we talked about the storylines we were involved in. We just took it scene by scene, episode by episode. We'd analyze the script and think, 'All right, how do we make sure this fits in to what we've played before, and build upon it.'

"We thought about the ways these characters could identify with each other's experience. Both of them had issues with where they came from. They both had chips on their shoulder about things in their history and their childhood, so they were able to comfort each other about that and to understand one another in a way that nobody else did."

For McNeill, the relationship redefined Paris, and helped him grow into a more mature character. "The B'Elanna relationship was a big part of the evolution of his character. Giving him a relationship that he was invested in, that he had to be vulnerable in, that he had to learn and grow from, allowed him to grow a lot and give up some of his less mature tendencies. I came to the conclusion that because he's invested in this relationship, he had to learn the qualities that maybe he didn't have when he was growing up and needed to develop."

For all the changes that their characters went through, it was important to everyone that neither Tom nor B'Elanna became completely domesticated, so there were still stories that played on Tom's naturally rebellious nature and his interest in fast vehicles. Both of these elements came to the fore in episodes like 'Alice,' which saw him tinkering around with a psychotic spaceship, and 'Drive', which saw him join an interstellar rally. Although Tom mellowed considerably and evolved into a reliable partner, by the seventh season he had become the kind of charming rebel the writers had always wanted. "I don't know that he's the kind of guy who would be comfortable with a secure life," McNeill smiles. "I think he wants more adventure, more excitement than just having a nice job and punching the clock on the bridge. I think he wants to be out there living a little more on the edge."

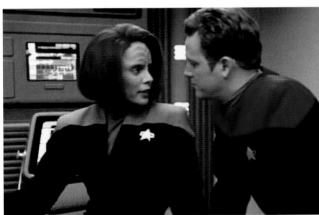

RIGHT, TOP TO BOTTOM: In the third season, Tom and B'Elanna start to flirt with each other, but the actors had no idea if it would come to anything.

In 'Blood Fever,' B'Elanna is infected with Pon farr and has a violent need to mate. Out of respect, Tom tries to resist, but the attraction is mutual.

B'Elanna finally confesses that she is in love with Tom in 'Day of Honor,' when they are stranded in space and think they are going to die.

The couple eventually get together in the episode 'Revulsion,' opening up a storyline that will ultimately lead to marriage and parenthood.

SEASON 3

EPISODES 8/9

AIR DATES: NOVEMBER 6/13,
1996

Written by Brannon Braga & Joe Menosky

Directed by David Livingston (Part I)
 Cliff Bole (Part II)

Synopsis After an attack from a
 Federation timeship from the
 future, *Voyager* is thrown back
 to 20th-century Earth.

F U T U R E ' S E N D

VOYAGER leaves the Paramount lot for a cinematic two-parter set in
1996 Los Angeles. For cast and crew, 'Future's End' was a chance to relax
in some casual clothes and to tell a cinematic story.

At some point, most every *STAR TREK* crew has to head back for a romp in the 20th (or 21st) century, whether through time travel or the holodeck. Usually, this is an excuse for a wry look at our era's dated tech and baffling culture (unhealthy and antisocial habits, environmental destruction, mohawks). *Voyager*'s turn to be taken aback by fashion and haircuts came with the season 3 two-parter, 'Future's End.'

'Future's End' was the first of *VOYAGER*'s midseason two-parters. This was something that Brannon Braga says was part of an

attempt to create more expansive stories and give the series a more cinematic feeling. "*VOYAGER* started its turnaround for us, personally and creatively, when we did the

RIGHT: Henry Starling has no scruples about using future technology for his own profit.

very first two-parter," Braga remarks, "because we said to ourselves, 'Let's start having fun. Let's do something insane.' Now it sounds ridiculously antiquated...*VOYAGER* in 1996! And we conceived of big action sequences and big concepts with an epic villain."

Director David Livingston enjoyed the opportunity that 'Future's End' provided to do more location work. "We got to shoot on Melrose in Los Angeles with Sarah Silverman, who was a hoot, and Ed Begley, Jr., who played the opposite of the person he really is, trying to dominate the world – the evil Bill Gates. The location shows – and when we went outside the timeline, did flashbacks or different realities – were always the most intriguing."

The cast – those that were allowed off the ship – also enjoyed their time in the West Coast sunshine. Tim Russ recalls, "We were off the soundstage and running all over Los Angeles in the beautiful spring weather for almost a week and a half. It was just a kick in the pants to be able to do that."

Robert Duncan McNeill also found a benefit to coming back to Earth. He felt that having their characters drop back into the 20th-century world really helped the cast reflect on their acting style. McNeill remembers how they suddenly found that an intense, accentuated approach did not ring true at all in the context of the real world. The actors were beginning to relax, and the experience influenced how they molded their performances subsequently.

"Secret agents" Paris and Tuvok developed a double act over these episodes. Showrunner Jeri Taylor kept the relationship running through later stories. The pair were even given the final lines of repartee in Part II, harking back to the classic sign-offs between Kirk, Spock, and McCoy.

The two-parter's villain, Ed Begley, Jr., was

ABOVE: The story introduced the idea of temporal police from STAR TREK*'s future. One of them, Captain Braxton, has been trapped in the 20th century, where his technology risks polluting the timeline.*

known for his long-standing TV role on *St. Elsewhere*, the movie *Meet the Applegates*, and as a committed environmental activist. Executive producer Rick Berman was amused by the casting. "Who better to play a man willing to destroy the solar system's environment than the most committed conservationist in Hollywood?"

Stand-up comedy star Sarah Silverman was called upon to play scientist Rain Robinson. Used to ad-libbing, Silverman was taken aback by the strict adherence to the script on set. As she told *STAR TREK Monthly*: "I remember I wanted to change one word in the line, and they got the cell phone out. They called the producers. They called the writers. It was wild."

The idea for the story came about when the writing staff got together to discuss ways of attracting new viewers. Writer Ken Biller remembers suggesting that they could completely reinvent the premise of the show. "I said, 'Here's a radical idea: what if we have the ship end up back on Earth in the 20th century and from now on the whole series is about them having to hide their existence.

It's a whole new kind of *STAR TREK*. That was too radical. Then Brannon and Joe [Menosky] said, 'Could we do an arc – maybe four episodes?' Then it got whittled down to two."

Part II delivered a permanent change for one regular cast member when Henry Starling fitted the Doctor with a mobile autonomous holographic emitter. Robert Picardo was, at

> *"Time travel. Ever since my first day in the job as a Starfleet Captain, I swore I'd never let myself get caught in one of these god-forsaken paradoxes. The future is the past, the past is the future. It all gives me a headache."*
>
> *Janeway*

first, wary of giving his character the freedom to leave *Voyager*'s sickbay. "I thought that part of the audience's interest in the character was because of the limitations the character had. But Braga was right. It opened up whole new storytelling vistas and I was the first to tell him that I was wrong."

Jeri Taylor described 'Future's End' as "the show that reestablished us as a big action-adventure show." Essentially, 'Future's End' was the beginning of the future for *VOYAGER*.

> *"The future you're talking about, that's 900 years from now. I can't be concerned about that right now. I have a company to run and a whole world full of people waiting for me to make their lives a little bit better."*
>
> *Henry Starling*

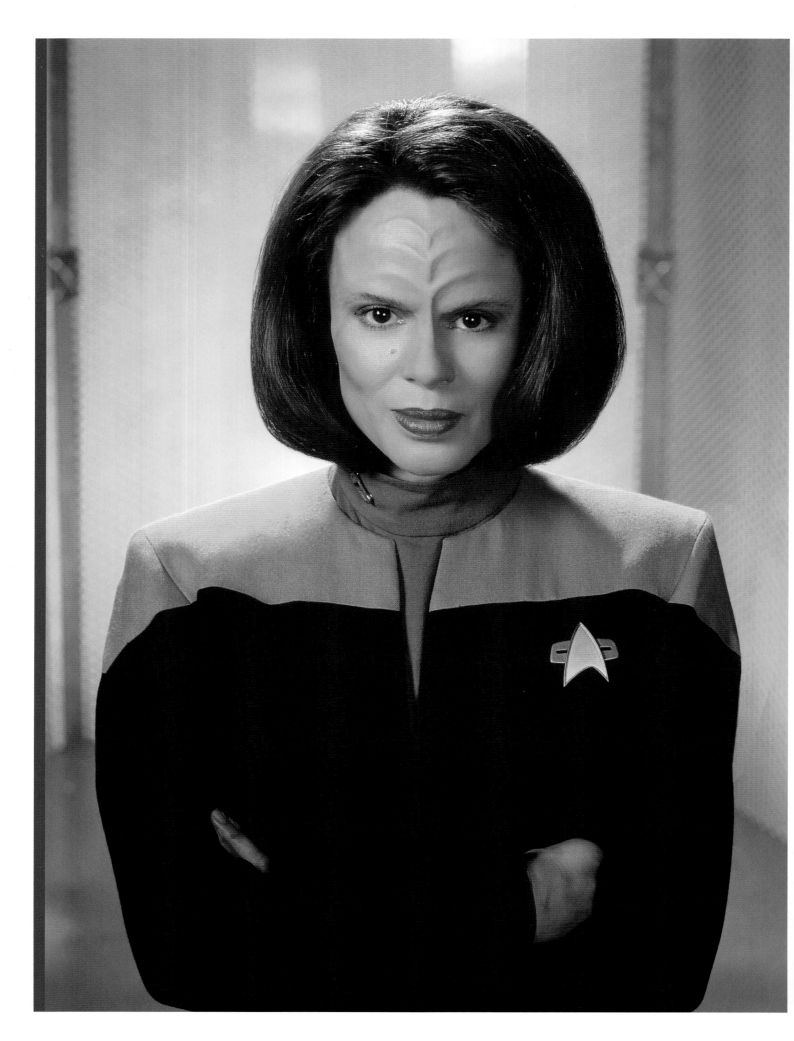

B'ELANNA TORRES

DIVIDED NATURE

Voyager's chief engineer was always at war with herself and her Klingon nature. No one was harder on herself than B'Elanna Torres, but she found a home – and a family – on the opposite side of the Galaxy.

E veryone who knows Roxann Dawson describes her as phenomenally well prepared. "I'm a research person," she nods. "The minute I get anything, I do research." So after she was cast as B'Elanna Torres, she sat down and watched old episodes of *STAR TREK* to get her head round what it meant to be Klingon, but, as she explains, she found more of B'Elanna in herself than in the Klingon Empire. "To be honest, I didn't find the previous versions of the Klingons spoke to me. It was more about personalizing it. What attracted me to the role," she remembers, "was the duality – the struggle between her human and Klingon sides. I found that very accessible. It was a great science-fiction way of dealing with something many people, if not all of us, deal with on some level – the many sides of ourselves, whether it is our heritage, genetics, or an emotional side, a psychological side."

Importantly, B'Elanna wasn't just half-Klingon and half-human, she was also a Latina. Up to that point, Dawson explains, her Hispanic heritage had often put limits on the roles she would be cast in. *STAR TREK*'s commitment to diversity and the science-fiction setting meant that that would not be an issue. "Throughout my career," she explains, "I haven't fit in with how people have normally defined roles. I had no role models when I was growing up. But I also saw no boundaries. When this role came up, I thought, 'Wow, I get this character on a lot of levels. Who am I? How do you define yourself? How do people see you? What are you ashamed of in terms of either your physicality or the way you look or your genetics?' All of this really touched home base for me. I thought, 'Oh, I get that, and I can take that to the next step and beyond. I can own that and move it further.' Bravo to them, I thought, when I first read the pilot. It was really good. It made me want to do this."

When Dawson arrived at Paramount, she was given another key to playing B'Elanna. At the time no one knew exactly what B'Elanna should look like, so she went through a series of makeup tests. "It went from monster makeup to beauty monster makeup," she shudders. "You should have seen the original makeup tests with the teeth! It was scary, because they could just say, 'Yeah, that's the one we like.' I was in my prime age as an actor and I was thinking, 'Oh my God, I'm spending the next seven years of my life as a monster!' We did several tests, and

ABOVE: *Director Winrich Kolbe and Roxann Dawson on the set of VOYAGER's pilot episode, 'Caretaker.' Dawson remembers being impressed by the pilot and the character of B'Elanna, who was dealing with issues related to her heritage and self-acceptance.*

you can tell which ones I was not pleased in! They would have me try to talk with the teeth in and I would deliberately make myself inaudible because I did not want to spend the next seven years wearing teeth. I kept saying, 'I'm half human, let's remember that, guys! We need some human stuff!' They did their best to make B'Elanna beautiful. If she's half-human, half-Klingon, at least in terms of the

visual I thought she should be the best of those two worlds."

Even though B'Elanna did end up looking beautiful, the makeup meant Dawson had no trouble understanding how she would resent her Klingon side. "If you're feeling that resentment," she says, "use it. Lean into that feeling of being uncomfortable in your own skin. Literally."

As Michael Piller explained, *VOYAGER*'s creators always

> "B'Elanna is very judgmental and she judges her herself the harshest. I think she feels that gives her the right to judge everybody else."

■ Roxann Dawson

wanted B'Elanna to be ill at ease with herself. "Torres started out being an extraordinarily anguished and angry character. When we created her we wanted her to be tortured, wanted her to be a half-Klingon who hated the Klingon half of her, so everything that she was doing was operating from that distrust."

That conflict came to the fore in the first season episode 'Faces,' which was written by Ken Biller. In the story, a Vidiian scientist splits B'Elanna in two, creating human and Klingon versions of her. "To me," Biller says, "it was all about her identity. I remember pitching it as, 'She doesn't like the way she looks.' The note I got back was that in the evolved *STAR TREK* future nobody cares about appearances. What they bought into eventually was that she had these feelings of self-hatred about being a Klingon because it brought out a part of her personality that she didn't like and she was always fighting against. She wanted to change herself and not be who she was."

Having B'Elanna's inner conflict externalized in such a literal way deepened Dawson's understanding of what was driving her character. "That was a great episode," she remembers, "I got to play a character that was so vulnerable, devoid of any strength, and then one that was so strong-headed and didn't understand the importance of vulnerability. I'm glad that it came in the first season because it defined my issue as a character. You can then move on, knowing exactly what that is."

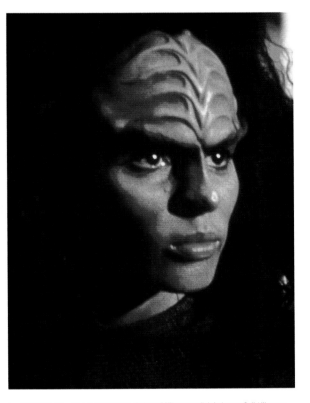

ABOVE: *Dawson was relieved that B'Elanna didn't have full Klingon makeup, though she got to try the look out in the first season episode 'Faces.' She admits that as an actress in her thirties, she did not like the idea of spending seven years looking like "a monster."*

As the series progressed, Dawson did everything she could to make sure that B'Elanna was as three-dimensional as possible. "It's always an emotional experience just reading the script and figuring out what they're doing," she explains, "or you realize that you're not in the episode at all, and you think why am I not in this story?!

"Sometimes there were moments where a script was treating B'Elanna without a lot of depth, especially if the episode was not focused on her. I always wanted to make sure that when I was saying a line, it's not like it could be said by anybody else. When it feels generic, you want to make it more specific. It was often about phrasing. Let's say there was something I might be invested a little more in. I'm a bit of a rebel and if they made me follow every rule without having some sort of attitude. I would ask, 'Why am I suddenly Miss Goody Two-shoes here? I need a little angle. I need a little something that is going to make me rub up against the other characters.' Sometimes it's as simple as that. It's an easy fix and it makes the script richer and more realistic. You can bring up things like that, or point a scene in a direction. I think the writers found that helpful. They were certainly very open about letting us do that."

Like any actor, Dawson would do more than simply comment on the script. In her performance she would constantly make choices that were based on her understanding of who B'Elanna was. Over the years, the writers saw what the actors were doing and this fed back into the way they wrote the characters. In particular, Dawson brought out the humor in B'Elanna and, as she explains, this was very much about how the character viewed the world. "B'Elanna is very judgmental," she explains "and she judges herself the harshest. I think she feels that gives her the right to judge everybody else. There are moments when she can judge, whether it's with a look, an eye roll, or the way she comments on something. Then when she agrees with someone, it means a lot. That is a sign of respect that has been earned."

At times Dawson would go further than suggesting small changes to a line. The story for the episode 'Extreme Risk' came out of her desire to see just how badly B'Elanna's issues of self-loathing were affecting her. "The longer I delved into the character and made her my own, the more I wanted them to explore some emotional and psychological aspects of her that I felt would be important. I talked to them about B'Elanna getting to a point where she felt so disjointed about how she fit into the world that she became numb, and she started to take risks that were meant to make her feel something."

ABOVE: *Dawson suggested the story idea that became the basis of the episode 'Extreme Risk.' She wanted to show that B'Elanna finds it so difficult to feel part of the world that her emotions shut down. In order to feel something, she deliberately puts herself in more and more dangerous situations.*

ABOVE: *Dawson was particularly pleased with the episode 'Remember,' in which B'Elanna experiences the memories of a woman who was involved in "ethnic cleansing," which has been written out of her planet's history. "I think that had a very important message,"* *she says, "Especially in the world that we live in now, where history can be altered and we can actually not be aware of the atrocities that humans have committed."*

"I think that a lot of people could identify with what it's like to be overloaded by not being able to understand yourself and how you fit into the world. Sometimes the safe place is to be numb. With many teenagers that results in cutting and things like that – anything they can do to feel something. Or they will do things that are unreasonable, in order to try to see who they are in the world. The writers really took that idea and did a great job with the script. It was great to show this secret side of B'Elanna, as she was trying to wrestle with the disparities between her two sides."

While these parts of B'Elanna's story came from Dawson herself, most storylines came from the writing staff, and she happily admits that they could be a surprise to her. During the third season, the writers started to play with the idea that Tom and B'Elanna were attracted to one another. As Biller explains, this came about because they saw how well the actors worked together. "It seemed like Roxann and Robbie had good chemistry. They had a spark. When the characters are going to be trapped on the ship for so long, how can you not contemplate the idea that some of them are going to get together? It seemed dishonest not to. As writers, that's what's fun to write about: relationships, love and betrayal, jealousy and all that stuff.

"B'Elanna was feisty and capable of violence and Paris was the guy who was kind of like a ladies' man. What would be more fun than putting the player together with a woman who would kick his ass if he got out of line? And you know she would kick his ass! He was this easy-going, devil-may-care

ABOVE: *B'Elanna and Tom became a couple in the fourth season. They butted heads all the time, but soon became one of the most realistic relationships in* STAR TREK. *Dawson says that their equally troubled backgrounds gave them a unique understanding of one another.*

UNDER THE MAKEUP

For seven years B'Elanna's Klingon makeup was an unavoidable part of Dawson's life. "Ethan [Phillips] and I were the first ones to arrive and the last ones to leave," she remembers. "We were there at 4am for a 7am call. I was a three-and-a-half hour application and a 45-minute removal. When that makeup was off it was freedom. There's wear and tear on your face. You put on this whole mask and you have to act with it. It had a lot of aspects to it: it was exciting and daunting and disturbing and rewarding and it was emotional. I've talked to Ethan about this. He's a guy, he's a character actor. I was not. It was different for me.

"When I first was shadowing on the set when I was learning to direct, my own crew didn't know it was me on the set because they'd only seen me in makeup. It was crazy.

"The worst days were when you put your makeup on at 4am and they never get to you. They're running so behind and you're waiting around all day, waiting to do your stuff and finally at 5 or 6 in the evening, they say, 'You know what, we're not going to get to this scene.' You have to go through 45 minutes of makeup removal and drive home and go, 'That was just a waste of time.' Those would be the worst days for me."

kind of guy and she was superintense. So in some ways they were really opposites of each other, but it seemed like they would be hot for each other. It was a good relationship and added something to the show."

Dawson loved the contradiction and once again sees it as playing into B'Elanna's divided nature. Here was something that forced B'Elanna to confront her feelings and how she fits into the world. "I loved that it could bring out the flaws in her

> "Tom just pushed all of her buttons and because he did, she was attracted to him, because he was going to force her to be a better person."
>
> ■ Roxann Dawson

character, and make her deal with stuff that she didn't want to deal with. In this case it was her emotions. She's starting to fall for somebody and doesn't want to fall for him because that shows a weakness. Those conflicts I embrace."

Dawson and McNeill worked together on the scenes, making sure that they talked about what made the relationship work and where the tensions were. "If I was in an acting class," Dawson smiles, "I'd be saying, 'Please let me work with Robbie.' He's an awesome acting partner. He's completely there, and he gets it. I can't remember when we weren't on the same page in scenes. I think we saw our characters developing. We'd call each other and talk about the scenes. He was always prepared and always had an overview in mind, not just the individual beats. We could bounce off of each other. I loved working with him, He was awesome."

As the relationship developed, Dawson and McNeill put a lot of thought into what made it work for their characters. Dawson could see why B'Elanna would resist Tom, but in many ways this was the key to the relationship for her. "It doesn't make any sense, does it?" she asks. "That's what the problem

LEFT: Today Roxann Dawson is a full-time director. She got her start on VOYAGER, shadowing various members of the production team before she got her first chance behind the camera. She directed two episodes in the second season 'Workforce, Part II' and 'Riddles.'

was: she was all in for some part of him and it just freaked her out because it didn't make any sense on any level. I think that's where her inner conflict was. I think she admired his passion, his sense of humor, the things that made him human. It made her even more ashamed of having a part of her that was Klingon, and yet he was so understanding about that part of her, and she hated that he was understanding and why wouldn't he stand up for himself? Tom just pushed all of her buttons and because he did, she was attracted to him, because he was going to force her to be a better person."

However much the relationship made B'Elanna more confident and stable, she still had some serious demons to fight. The inner conflict that had been at the heart of the character since the first season came to the fore as the series drew to an end. When B'Elanna is pregnant, she asks the Doctor to intervene and alter her baby's DNA to remove the Klingon elements that she's been fighting all her life.

For Michael Piller, this was a classic *STAR TREK* story that dealt with an ethical issue and went to the heart of the character. "To me that was at the absolute core of B'Elanna's conceptual quality as a character, because she's basically struggling with her Klingon heritage and the shape of the baby." Ultimately, of course, Tom persuades B'Elanna not to make the changes, and in the finale B'Elanna gives birth to their daughter.

Looking back, Dawson feels that one of the show's great successes was that B'Elanna was able to grow and to change without ever losing the issues that defined her character. "The danger is that she goes through all of this stuff and there is no growth. What is the point of all of that? I definitely think there was some improvement, but there's always room to grow. She

gained a certain amount of wisdom, and an ability to accept the strengths and weaknesses of both of her sides. I think that Paris helped her with that because of his unbelievable acceptance of all parts of her. She began to accept her emotions while at the same time not denying her strength. She's come a long way but there's still a long way to go."

ABOVE: B'Elanna was always deeply troubled by her Klingon heritage and asked the Doctor to alter her baby's DNA to remove the Klingon traits. Dawson was delighted to discover the episode was being used to teach medical ethics at her daughter's university.

WEEKEND WARRIOR

B'Elanna hardly embraced her Klingon nature, but Dawson still got a chance to learn how to fight with a *bat'leth*, and she loved it, so much so that she'd visit the *bat'leth*'s inventor (and *VOYAGER*'s VFX producer), Dan Curry on weekends to practice. "It was so much fun," she laughs. "I come from a bit of a dance background so I enjoyed learning how to use it, and Dan, of course, is the complete expert. He had his own *bat'leth*, I think he had a few. Some that were sharp, some that were rubber tipped." As she talks, Dawson realizes that she actually still has a *bat'leth* herself. "I think I have two in my attic! Why do I have a *bat'leth*? It must have been in my trailer. When you start to clear everything out it all gets packed up. I mean, it isn't hanging on my wall!"

SEASON 3

EPISODE 23

AIR DATE: APRIL 30, 1997

DISTANT ORIGIN

Written by Brannon Braga & Joe Menosky

Directed by David Livingston

Synopsis: An alien scientist finds evidence linking his species' ancestry to Earth, but officials refuse to accept his evidence, which conflicts with their existing doctrine.

'Distant Origin' boasts a smart script, a star turn for Robert Beltran, and a challenge for the makeup and VFX crew. But how did "lizards with AK-47s" transform into a take on Galileo's trial by the Inquisition?

The first 15 minutes of 'Distant Origin' is the Gegen and Veer show, a scientific and political drama starring saurian scientists investigating their race's ancient origins. The molecular paleontologists from Voth are an engaging pair, evaluating theories about the bones and scraps of clothing they uncovered on an archaeological foray. Only when they find an ensign's pips and ID code among the bones is it confirmed that we are watching an episode of *VOYAGER*. In a link to season 3's opener, Gegen and Veer discover the remains of Ensign Hogan after he was killed by a Hanonian land eel in 'Basics, Part II.' They track *Voyager*'s trading route, then the ship's warp signature.

RIGHT: The Voth left Earth so long ago that they have forgotten their origins and do not want to acknowledge the truth.

Given a script that followed the Voth's perspective for the first quarter of an hour, director David Livingston sought to provide a more extraterrestrial camera view. He recalls, "I chose to shoot them with a really wide-angle lens, in close, to magnify and get as much detail and distort even the makeup. So, we put the camera right up against their face, and they look really weird and somewhat terrifying." When the dino duo cloak themselves and steal aboard the NCC-74656 they bring a refreshingly dispassionate eye to their study of the male-female interaction of Paris and Torres, and of Janeway's matriarchy leading the bridge crew. After the *Voyager* crew discover the infiltrators, we see the crew as hostile, pointing phasers at a supine scientist.

Once the interlopers have been outed, the regular cast are once more the protagonists,

"It appears we've underestimated our endotherms."

Forra Gegen

but there's more to this episode than a quarter hour of *Voyager* as natural-history subject, and much more than its original premise, which cowriter Joe Menosky described as "dinos with automatic weapons." According to Menosky, it was during a story meeting between him, Brannon Braga, and Jeri Taylor that the fuse was lit. As he recalls, Rick Berman walked into the office and heard the pitch for an action-packed episode. "Brannon had this image of dinosaurs with guns, but Rick hated it. He said, 'All I see is a bunch of lizards with AK-47s. This should be Galileo.'" Menosky, who spent months living in Italy studying the Renaissance and writing a drama about it, could instantly see the potential.

In the 17th century, the Italian astronomer Galileo Galilei was put on trial by the Roman Catholic Church's Inquisition for teaching that the Earth moved around the Sun, against the Church's credo that Earth was the center of the universe. Professor Gegen's treatment at the hands of the Voth Ministry of Elders deliberately parallels Galileo's experiences.

"It was our retelling of Galileo's trial, in science-fiction, *STAR TREK* terms," says Menosky.

"It's kind of *Planet of the Apes* with Chakotay," says Braga. "They captured him and he's put on trial and he's great in the episode."

Michael Westmore also excelled himself with the makeup for the Voth. "I have a lot of dinosaur books because that's basically what I based the Klingon foreheads on," says Westmore. "After having read the script for 'Distant Origin,' it was obvious that these [alien] dinosaurs weren't T. rexes. So, I looked through my books and based their design on plant-eating dinosaurs."

"Each head was painted individually. I had different artists paint them, with a basic scheme of how the patterns would work, but the colors for each one were different. This was so each character was an individual. I also had to design contact lenses and teeth. We would hand paint each lens so they were like lizard eyes. The teeth were based on what a horse's teeth might look like, because they weren't meat eaters. They were flat across the edges because they wore them chewing."

Often the actors would come in at 4am to start getting their heads on, and sometimes it would be 10pm before they had them removed. The makeup department operated with a surprisingly small team of five. "That one

"I will not deny 20 million years of history and doctrine!"

Minister Odala

show in particular was really, really deserving to all the people who worked on it, because there was so much work that we did," says Westmore. "We had won so many Emmys before, but we didn't even get nominated that time." Despite this disappointment, the Voth were a highlight for Westmore. "The Voth were probably one of my favorites," he says.

Braga describes 'Distant Origin' as "just about perfect. It was a very ambitious show that really turned out great." Michael Piller was so impressed by the teleplay that he sent a memo to the writing team saying it was "the best Voyager script I've ever read." High praise indeed.

ABOVE: Berman told the writers to base the story on the trial of Galileo, in which the authorities deny the truth. In this case, Gegen presents absolute proof of the Voth's origins in the form of Chakotay, but still loses.

HARRY KIM
THE NEW ENSIGN

Voyager's ops officer was fresh out of Starfleet Academy when he was stranded in the Delta Quadrant, so he had the most opportunities to grow, often in unexpected ways.

Imagine it is 1995 and you've just watched 'Caretaker' for the first time – you might well think that Harry Kim is going to be the star of the show. After all, he and Tom Paris have more screen time in the pilot than anyone else. "If you watch the pilot episode," Garrett Wang says, "it's a lot of Harry. I would even say that he's the main character. Robbie and I both filmed 30 of the 31 days' shoot. Janeway filmed 16. Bob Picardo filmed two."

Harry was a kind of character we hadn't really encountered before: a newly graduated bridge officer, who was seeing everything for the first time. "We saw Harry as an innocent," Jeri Taylor remembers, "someone who comes into a situation wide-eyed and bushy-tailed and eager to please. Then he gets thrown into this untenable situation and simply has to grow up." For Brannon Braga, Harry was the point of view (POV) character, the one most like us.

After Wang was cast, he was sent the script for 'Caretaker,' and as he recalls, he could hardly have been happier. "I thought 'Wow, this is great. I really like this script.' I think it flowed really well. I think it established the characters well."

When it came to Harry, he saw someone with enormous potential. "The script tells you that Harry's a recent graduate of Starfleet Academy. This is his first posting. Obviously, he's done well enough that he's been promoted to officer. An ensign is not a private like in the army; ensign is the most junior officer. He's fresh. He's young. He is the POV character. He's the everyman, so he's probably the most relatable."

In retrospect, Wang might have been concerned that, as was often the way with television of the era, Harry's character was a little sketchy and was defined by his youth and inexperience – both things that would change over the next seven years. However, rather than being concerned by this, he embraced it. "I was lucky," he smiles, "because I got to be the actor who comes with the blank canvas. If you think of Janeway and her character, her canvas was already filled with colors and shapes. There's a lot on there already. Same thing with Tom Paris. Every character except for Harry has colors, hues, and shapes already on their canvas. Kim had a blank canvas. If you think about it, Harry had a lot of potential."

Taylor explains that when she, Michael Piller, and Rick Berman created *VOYAGER*, they didn't want to set everything in stone from the beginning; rather they wanted to throw in

some new elements and see how they played out. One of the things Wang thought might have happened as the series progressed was that Harry and B'Elanna could have become a couple. "After we did the pilot, I thought B'Elanna and Kim were going to be in a relationship," he remembers, "because we had that sort of cute thing, 'Hey Starfleet,' 'Hey Maquis.' We had nicknames already."

In fact, Harry and B'Elanna did spend a considerable amount of time together during *VOYAGER's* first season, often teaming up to solve various scientific problems. It's easy to forget that when *VOYAGER* started out, Harry was *the* science guy. Unlike many of his cast mates, Wang was very comfortable with the technobabble that came with this role. "I'm a huge sci-fi fan," he says, "and someone who paid attention when I was in physics class in high school. These were the things that really contributed to my understanding of the technobabble. Most of my fellow actors were not *STAR TREK* or 'science' fans beforehand. I remember the whole first two seasons just overhearing other actors, and sometimes they would come to me and say, 'Do you even understand this stuff? This is really frustrating.' And I'd go, 'Erm, yeah, I do understand. Let me try and explain what an EPS manifold is...'"

ABOVE: In 'Non Sequitur,' an accident alters the timeline and sends Harry to a reality where he is back on Earth and seems to have everything he wants.

> *"He was the most homesick member of the crew... he was also the most inexperienced on the crew."*
>
> ■ **Garrett Wang**

While Wang was at home with the technical side of the dialogue he was given, he was less comfortable with the approach *VOYAGER's* producers wanted him to take to the character moments. He explains that Rick Berman told the cast to underplay their reactions because the situation they were in was already heightened and he felt that the aliens and explosions provided all the color the show needed. Wang recalls being instantly concerned that this constant underplaying would make him look as if he wasn't acting at all. "We had to do everything in a suppressed kind of way," he remembers. And if there is one thing Garrett Wang is not, it is suppressed. He's very unlike the stoical and measured Harry Kim. "I'm an entertainer," he smiles. "I was born in 1968. In Chinese astrology that's the Year of the Monkey. We are the entertainers of the Zodiac. The charisma, gregariousness, being personable. That is who I am."

You can't talk to him for long before he breaks into an impression, and his energy and enthusiasm are irrepressible. At *STAR TREK* conventions he does a stand-up routine. He likes to have fun and he wanted to bring a little more of that to Harry, but straightaway he had to dial everything right back.

"I just wanted him to be a human being with feelings," Wang explains. "Think about how heavy a weight he had to carry. This was supposed to be a short mission to test out a new starship. It was going to be a 12-day mission. Then you're probably going to be reassigned to some other ship. Now you realize that there's a chance that you will never see your parents again. At the tender age of 22, that's a huge weight to have on your shoulders. I wanted to convey more of that: that he was the most homesick member of the crew, that he was also the most inexperienced on the crew.

"He was probably feeling judged or worried about what his peers were thinking about him. But most importantly, I just wanted some more human undertones to come out. When we

ABOVE: 'The Chute' was an important episode for Harry, since it flipped his relationship with Tom, making him the protector rather than the "little brother."

finally break through some anomaly that is crushing the ship, I wanted him to be more obviously relieved. 'We got through! We almost died, but we made it.' I wasn't allowed to do that in the first few seasons."

However, Wang subtly increased the amount of emotion he put into his performance, gradually bringing the intensity level up. "I took the emotions from 2D to 3D, very slowly. It's like the thing about throwing a frog in a pot of lukewarm water and slowly turning the heat up so it won't know what's happening, whereas if you throw it in hot water it's going to jump out."

As the series developed, Harry got fewer scenes with B'Elanna and more scenes with Tom, and, like many of the human characters, he often starred in stories that could have been given to anyone rather than ones that stemmed from his nature. "I think it was easier for the writers to write for the Doctor or for Seven of Nine," Wang says. "With characters like that they can write a scene about the first time Seven eats pudding, or the first time the Doctor has a cold. Harry's had pudding before, he's had a cold before. We don't have to have an episode showing him singing Italian opera!"

BEST FRIENDS

Like their characters, Garrett Wang and Robert Duncan McNeill really are the best of friends. "The first time I met Robbie," Garrett remembers, "was in the alleyway between hair and makeup. Someone said, 'Oh, this is Robbie McNeill, he's playing Tom Paris.' I looked at him and I gasped because as cheesy as the live-action version of *Masters of the Universe* is, I'm a fan of that movie. So I knew exactly who he was. I was trying to contain my excitement and, as casually as I could, I said, 'Hey man, weren't you in *Masters of the Universe*?'" He was like, 'Yeah, I did that a while back.' I remember he gave me a once-over, like he's thinking, 'Who's this long-haired hippy?' Years later he told me he actually thought, 'This guy is part of the hip young Hollywood set.' I'm so hip," Garrett laughs, "I'm thinking he's cool because he was in *Masters of the Universe*."

"I would lighten the mood by doing all of my lines in somebody else's voice. If the captain asked me, 'Status report, Mr. Kim,' I would pick George Takei..."

■ **Garrett Wang**

Harry plays a notable role in most of the first season episodes, but he only really stars in one: 'Emanations.' In this story he is transported to another realm where it is believed that our dimension is the afterlife. "It deals with a very important topic," Wang says. "That was the first episode I could really sink my teeth into. At the end, Kim is the first *Voyager* crew member to die and come back to life. I always joke at conventions that it should be in Starfleet regulations that if you die and come back to life, it should be an automatic promotion!"

By the end of the first season, Wang was itching for the chance to do some more action. This led to his big second season episode, 'Non Sequitur,' which finds him back on Earth as if nothing has happened. "I remember going to Brannon after season one was over. I said, 'Look, everybody else on the show has had a stunt double and got to do some action or got to do romance. What about Kim? Does Kim get anything?' And that's when 'Non Sequitur' was written. They threw everything into that one episode: the action and the romance."

With the action being spread around the other characters, Wang found himself doing a lot of scenes on the bridge, often reporting on the state of the shields or on the anomalies the ship was encountering. Like the rest of the cast, he found constant filming on the bridge extremely repetitive and demanding. "We had all these names to refer to any time we had to shoot on the bridge," he shakes his head. "We called it 'bridge hell,' 'bridge fury,' 'bridge typhoon.' Tuvok, Janeway, Chakotay, Kim, Paris – we were there all the time. The bridge stuff could last 12 hours or 17 hours. They'd try to do everything in three takes but sometimes the technobabble would trip someone up. I think it was in 'Time and Again' we did 17 takes because Beltran kept saying 'subspace bacon' instead of subspace beacon!"

Famously, the repetitive nature of the filming led the cast to find different ways of having fun, and Wang's nature put him in the thick of it. "Clowning around was the only way to neutralize the frustration and boredom of being on the bridge," he says. "I was in the middle of it. When we shoot a scene, we start by

rehearsing it for the film crew. It's all the technical stuff, so it's not for the actors. During that rehearsal, I would lighten the mood by doing all of my lines in somebody else's voice. If the captain asked me, 'Status report, Mr. Kim,' I would pick George Takei and would say in his voice, 'Well, shields down to 30 percent, Captain.' I would pick various people from *STAR TREK* history or I would do different accents and impersonations to make people laugh.

"We had this thing where we would take electrician's tape, and roll it up into a big ball and we'd throw it at each other. It would be me, Robbie, and Tuvok trying to hit each other. I have the worst aim. I am trying to hit Tuvok, but I end up throwing a curveball and I hit Kate right on the side of the head. I remember I ducked behind my console trying to make it look like I wasn't even there. When I finally came back up from my hiding place, Kate was waiting there holding the ball of tape. She threw it right back at me and hit me. She's a good aim!"

When Harry did get away from the bridge, the episodes that focused on him tended to show different sides to his character. In the first two seasons, he was often portrayed as a very dutiful man. Increasingly, the episodes put him into grittier situations that showed he wasn't just a young man who missed his parents. A few episodes into the third season, we saw Harry and Tom in prison. Until now Harry had often seemed like Tom's sidekick, but at this point he took the lead role.

"'The Chute' was a big episode," Wang agrees, "because up until that point, Tom Paris was his big brother – somebody who kind of looked after him – and Harry was really the wide-eyed ensign. This was the one time that Harry was forced into the role of being the protector, because Tom Paris has been stabbed in the stomach by another prisoner and that wound is infected and he's dying."

Wang was very happy to be taking the lead, but he also remembers that filming the episode was physically demanding. "It was truly blood, sweat, and tears because the majority of that episode was filmed on a prison set. They had to fill that place with dust and there was a lot of fake smoke being pumped in.

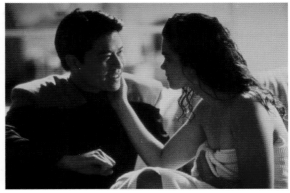

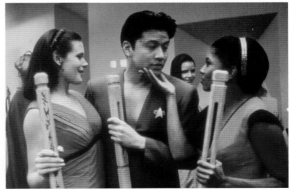

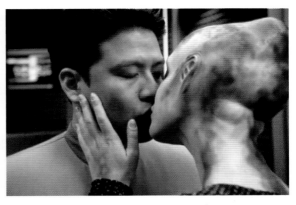

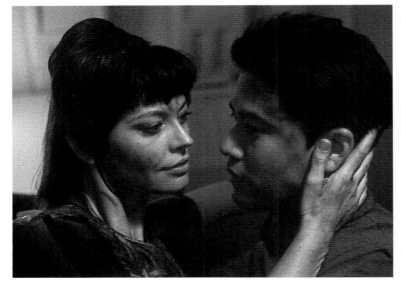

Now when they use smoke on sets, it's much healthier than it was in the '90s. We had to breathe that, we had to breathe all the dust and dirt that they had trucked in to make it look like it was dangerous. There was one part of the set that had these metal stairs. I tripped and fell and I cut my knee open. But in terms of character development, that was a good episode."

Importantly, the episode changed the way that the audience saw Harry, and allowed Wang to progress his portrayal of the character. "That was a big change for Harry," he nods. "He came out from Tom's shadow and got to be the big man on campus. When you have a milestone like that, it imbues your character with more confidence, and changes the way your character responds to things around him."

With the writers backing away from the idea of Tom Paris as a "ladies' man," they started to give Harry more and more of the episodes that involved sex and romance. In 'Favorite Son,' Harry is irresistibly drawn to the planet Taresia, which is largely populated by females who want to mate with him. In 'The Disease,' Harry falls in love with Tal, a Varro engineer, and thanks to her alien physiology, experiences extreme physical reactions. In 'Ashes to Ashes,' he is romantically involved with Lyndsay Ballard, a character who has come back from the dead. Add in the fact that he is shown with his girlfriend Libby in 'Non Sequitur' and double dates the Delaney sisters with Tom, and you suddenly see Harry as the show's principal love interest.

This is something Wang hadn't realized until it is put to him, and he is both pleased and amused by the revelation. "That's a very interesting observation," he muses. "I guess he did have the most relationships with female characters, now that I think about it! It wasn't because he was trying to be a playboy,

definitely not. Harry does take on the Kirk role in a way, but I think he really wanted a relationship. He wanted stability. Just like Paris became linked to B'Elanna, Kim wanted that for himself. He really loved Lyndsay Ballard, but she was dead," he laughs, "so that wasn't going to work out.

"'Favorite Son' was a crazy episode. The premise was that the Taresians sent out the virus into the universe, and whoever gets infected is drawn to that planet. In the original storyline, that was not the case. It started out with the idea that Kim actually had Taresian DNA in him. Then they kind of changed it into these female vampires sucking the life force out of all the men that they can lure to the planet.

"'The Disease' was my stand-up to Captain Janeway episode, where I say to Janeway, 'Do you even know what love is?' I remember I kept getting so worked up while I was doing that speech that I would get all the way down to one or two sentences from the end, and then I would blank out. I was building and building, and I was so emotional that I just forgot my next line."

But the thing that Wang wanted for Harry even more than a relationship was a promotion. "It's ridiculous!" he exclaims. "I asked the question of somebody in the U.S. Navy, 'If you're an ensign, seven years later what are you?' The answer was, 'Almost lieutenant commander.' He definitely should have been lieutenant junior grade, which is the next step up above ensign."

The lack of a promotion for Harry sill rankles with Wang, so much so that when he goes online, he uses the name 'Forever Ensign,' and he's given the same name to his one-man show. "I still don't get why," he says. "I remember going to Brannon and saying, 'Come on, man! Throw me a bone here. Why hasn't he

ABOVE: *Harry took the lead role in VOYAGER's 100th episode, 'Timeless.' In the story, the crew try to use a quantum slipstream drive to get home faster, but it ends in disaster when Harry makes a tiny mistake. After this, Harry becomes obsessed with reversing his error and changing history to save the crew.*

ABOVE: *Harry finally gets a taste of command in the seventh season, when he takes control of a ship called the* Nightingale.

been promoted?' This was season five. He goes, 'Well, somebody's got to be the ensign!'"

In the seventh season, the writers did address this in the episode 'Nightingale,' when Harry takes command of an alien ship. "I figure they thought, 'Let's give him a little taste of what it's like to not be an ensign,'" Wang says. "The actor who played the preacher in *Firefly,* Ron Glass, was in that episode and I had a great time working with him. Of course, I screw it up. My entire crew mutiny and are like, 'We're not going to follow you anymore. You're the worst ever!' But," he smiles, "it was nice to have a little bit of command thrown in there."

For all his frustrations, Wang takes great comfort from the fact that Harry has the leading role in what may be *VOYAGER*'s greatest episode: 'Timeless.' "The way Brannon billed it to me," he remembers, "was, 'This is the 100th episode of *VOYAGER*. This is the quintessential episode and we want this to be the best episode.' It's all about my character. The ship crashes into the ice planet and everyone dies except for Chakotay and Kim. The only way that everyone comes back to life is that 15 years later, a very bitter Kim, with the aid of Chakotay, gets to send a message through time and save the crew.

"Five years into it, I get the chance to knock it out of the park. After I shot that final scene where I figured out the right computations, Bob Picardo walks over to me and says, 'Garrett, you can act!' Of course, I'm thinking, 'Bob, you're supposed to be my friend and to know that I can act!' But the fact that it was all Kim really made me feel like I did in the pilot. They gave me what they deemed to be the best episode. I can't ask for much more than that."

NOT AN ELBOW!

"Jeri and I were rehearsing a walk and talk in the hallway. A lot of times when we do these rehearsals we'll stop after 10 or 20 seconds. The director says, 'Cut! Back to first position,' so I reached out to take Jeri's arm to lead her back, but instead of grabbing her arm, I accidentally grabbed her breast. I remember thinking, 'This is not her elbow!' I pulled my arm back. She looked at me – her nickname for me was 'Goobie' – and she said, 'Goobie!' I said, 'I'm sorry! I thought it was your elbow, I'm sorry!' She goes, 'Oh yeah, my elbow, huh?' Everyone in the crew is laughing and going, 'Yeah, right! Her elbow!' We finish the rehearsal and we go back to our trailers. When everything's ready to shoot, they call us back on the set. I get there first. Jeri comes in about a minute later and I can just hear her cackling – she has this crazy laugh – and people are just cracking up. I'm thinking, 'What is going on?' Finally, when she walks onto the set, I see her and she has a yellow Post-it note stuck to her

shoulder and written in a black Sharpie, it says, 'Elbow' and it's pointing down toward her elbow. She has another Post-it note right above her breast, and it says, 'Not an elbow.' She's modelling it and goes, 'What do you think, Goobie?' And I started laughing so hard. She said, 'I just thought you needed a visual aid to help you out.'

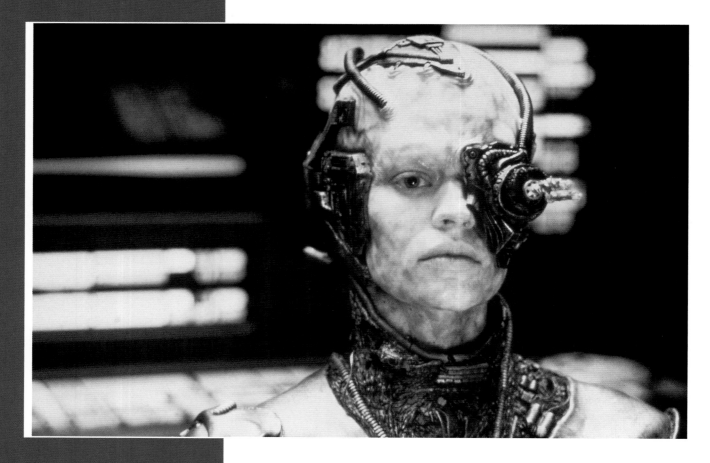

SEASONS 3/4

EPISODES 26/1

AIR DATES: MAY 21, 1997

SEPTEMBER 3, 1997

Written by	Brannon Braga & Joe Menosky
Directed by	David Livingston (Part I) Winrich Kolbe (Part II)
Synopsis:	When *Voyager*'s crew discovers that the Borg are fighting a losing battle with Species 8472. Janeway's response is to offer them a deal, exchanging weapons for safe passage through Borg space.

S C O R P I O N

The third season finale was the beginning of a soft reboot for the series, which reinvented *VOYAGER* by taking the crew into Borg space and introducing a new character.

There's no question that 'Scorpion' is a major turning point in *VOYAGER*'s history. After three years in the Delta Quadrant, the show was perfectly successful, but the ratings had declined since the heights of the pilot, and the series lacked an element that really made it stand out from the other *STAR TREK* shows. There were frequent discussions about how the show could be given more energy that would attract some attention.

Toward the end of the third season, Jeri Taylor announced that she would do one more year before retiring as head of the

writing staff. Brannon Braga was nominated as her successor and stepped up to take more responsibility. He was thinking about ways that the show could be reinvigorated.

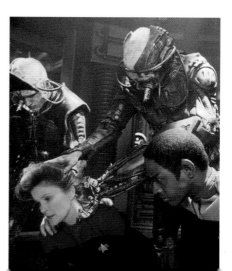

RIGHT: Braga was fascinated by the idea that Janeway might do a deal with the Borg.

"We were always talking about ways we could improve the ratings," he recalls. Many of Braga's ideas would come to fruition in 'Scorpion,' the two-part story that bridged the third and fourth seasons.

After the Borg made their first appearance in 'Unity,' Braga was inspired to suggest that they add a former Borg drone to the crew. "You can't underestimate how the success of FIRST CONTACT influenced my thinking. It was definitely part of my initial idea that we would now start to encounter the Borg, but it was more important that we had a new character to shake things up." He adds that the character who became Seven of Nine could "give Janeway her Spock," and would push all the crewmembers into new and interesting places.

But Braga relates that Seven was only added to 'Scorpion' after work had started on the story. "Strangely enough, when we wrote Part I we weren't even thinking about Seven of Nine." Braga wanted to work out a different way of handling the Borg, so he came up with the idea of a species that was even scarier than they were. Advances in technology meant that it could also be STAR TREK's most ambitious attempt at a fully CG creature.

> "I've reached an agreement with the Collective. We're going to help them design a weapon against Species 8472. In exchange, they've granted us safe passage through their space."
>
> *Captain Janeway*

Species 8472 were designed to have three legs, with unusual cavities in their bodies. They would be envisioned by a combination of VFX producer Dan Curry, who remembered a tripod creature he had once designed for a play, and concept artist Steve Burg. They would be built by John Teska at Foundation Imaging. In 1997, no one had attempted anything this ambitious on a TV budget. Writer Ken Biller remembers that there was

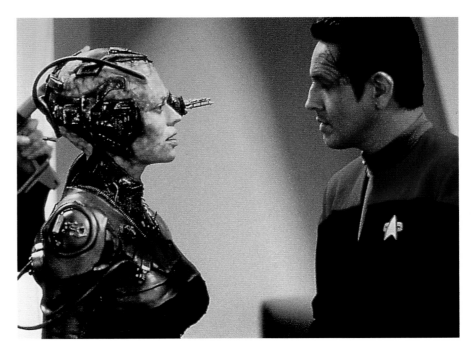

ABOVE: The Borg send Seven of Nine to act as a liaison with Voyager's crew. The rest of the drones who come with her are destroyed, leaving her 'stranded' on Janeway's ship.

some anxiety about whether they could really afford an effect like this...

Braga explains that Species 8472 were only there to pose a threat to the Borg. "When you see them, you think, 'Oh, they've got a problem! This is interesting.'" Species 8472 were so dangerous that they would force Janeway to do a deal with the Collective, thereby alarming Chakotay, who objected to her orders. This marked the beginning of Braga's attempts to push Janeway as far as he could, so that she took an increasingly extreme approach to being stranded in the Delta Quadrant. The idea of doing a deal with the devil provided the story with its title, as Chakotay reminds Janeway of the story of the scorpion and the fox, in which the scorpion cannot help but sting its ally, because that is its nature.

While Janeway is dealing with the Borg, she seeks advice from a holographic version of Leonardo da Vinci, played by John Rhys-Davies. This holo-program would recur throughout the fourth season. Jeri Taylor explains that Janeway needed someone she could confide in, and who better than one of Earth's most inventive scientists? "She could not have an intimate relationship with any of

her crew, but to have this powerful, creative and compassionate personality that she could talk to – I'd do it in a minute."

The first part, directed by David Livingston, ends on a cliffhanger, as the Borg bring Janeway aboard a cube, only to be attacked by Species 8472. During the hiatus between the seasons, the producers cast Jeri Ryan as Seven of Nine. She would prove to be an inspired choice and Seven would become one of the series most beloved characters.

During the second part, she is completely encased in a Borg costume that was made of neoprene with various hard components attached to the outside. Famously, the neck was so tight that it pressed on Ryan's carotid artery, making it extremely uncomfortable. But she didn't want to complain so the production team only realized when she swooned. The director of the second part, Winrich Kolbe, helped Ryan shape her performance, by suggesting that she adopt a stiff posture "like a Prussian general."

'Scorpion, Part II' ends with the crew developing a weapon that keeps Species 8472 at bay, before severing Seven's link to the Borg Collective and setting the scene for a new chapter...

IT'S A BIG SHIP

VOYAGER covered new ground by showing a Starfleet starship landing for the very first time – but exactly how big was *STAR TREK*'s newest ship?

ust how big was the *U.S.S. Voyager*? As a question, that has a very easy answer. "We knew that the *Enterprise*-D was 2,108 feet in length," says Rick Sternbach, who produced the detailed blueprints of *Voyager*. "That was an okay starting point. *Voyager* itself ended up being around 1,130 feet or 345 meters long."

That scale is easy to manage when you're working with a studio model of *Voyager* that's only 5 feet long. The sheer size of the ship only becomes apparent when you have to land a starship on a planet for the first time.

"It was tricky," says VFX producer Dan Curry. "I had asked the art department to make little foam core mock-ups of *Voyager*, and we used to bring them out on location and we could eyeball and think, 'Oh, it would look good about here.'"

"We shot at Bronson Caves for 'The 37's'," adds visual effects supervisor Ron B. Moore. "Dan and I both felt we got the scale wrong. It's hard to tell because there's always the issue of perspective. When we did 'Basics,' we went out to Lone Pine on a scout to get an idea of what we were going to do."

"I had a box of rope brought out," continues Curry. "We knew the correct length of *Voyager*." The team strung lengths of rope together to the exact length of the ship.

"We had a teamster with us," laughs Moore. "He had one end of the rope and we sent him out to see where the other end of *Voyager* was. He was so far away we could barely see him!"

"When we took that rope and spread it out to the length of *Voyager*, it was way bigger than we imagined," Curry sums up. "Everybody was like, 'Oh! It's that big?!'"

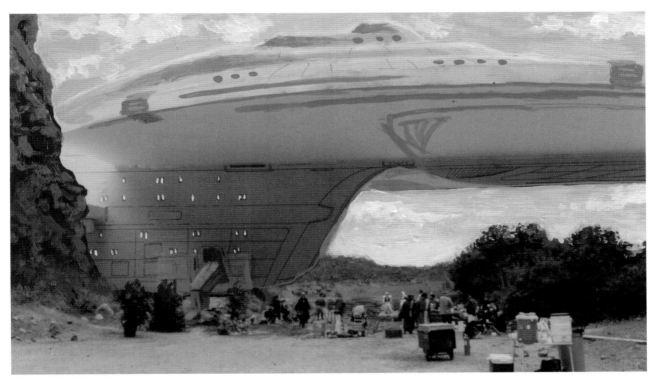

ABOVE: A behind-the-scenes shot, combining location photography from 'The 37's' with a painted-over Voyager foam core model, to plan visual effects sequences of Voyager in its landed position. 'The 37's' was the early finale of season 1 and featured the ship landing for the very first time.

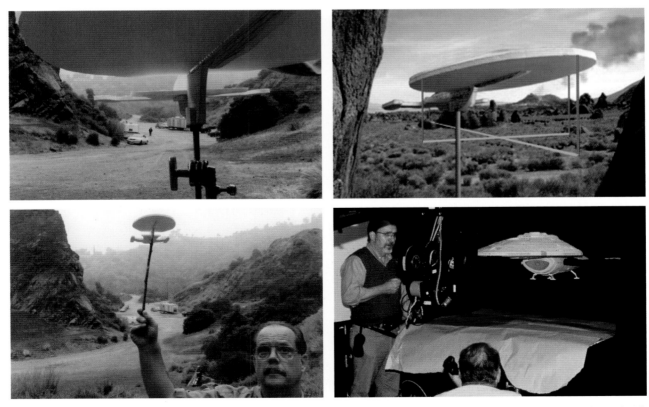

ABOVE: The VOYAGER crew on location at Bronson Canyon, using a foam core model of Voyager to judge perspective and the ship's size.

ABOVE: The Voyager foam core model used to show scale on 'Basics, Part I,' and landing the studio model on brown paper to give realistic lighting.

NEELIX

COOK, AMBASSADOR, GUIDE

Voyager's self-appointed morale officer was cheerful, aggressively friendly, and could be annoying. He was also kind and positive, his cheerfulness masking a tragic background.

Every morning at 4:30am, before the LA dawn, Ethan Phillips would walk across the empty Paramount lot. He might stop in the darkness and joke with the security guards, who would tell him ghost stories about old movie stars. He would respond by telling them one of the thousand jokes he has memorized, carefully timing the punch line, before walking into the makeup trailer. He'd greet his makeup artist, Scott Wheeler, who would have jazz quietly playing in the background. Phillips would sit in the chair, watching and listening as the world unfolded around him.

"The makeup trailer is like the nexus of the set," Phillips says. "That's where you hear everything – all the gossip. I was there for it all. People would come in and leave and get through makeup, but I'd be there the whole time, so I heard everything. I met every guest star. It was a cool place to be, because you're at the center of things."

Totting it up in his head, Phillips reckons that in the course of seven years he spent something like 2,700 hours in that makeup trailer. When he'd first auditioned, he had no idea that would happen. In fact, he remembers being quite confused about what Neelix looked like. "I thought he was a human

being with a boil on his neck for some reason," he laughs. "I didn't know what they were talking about. Right before I went in for my audition, I was sitting next to a woman who I guess was on her fifth or sixth callback for Janeway. She said, 'Have you heard what the character of Neelix is? He looks like a hedgehog.' Just as she said that, I hear 'Okay, Ethan Phillips!' So I went in with that image in my head. I didn't know what to make of it," he shrugs, "so I just read him like a human being."

The studio auditioned a lot of actors for Neelix, who the writers' bible described as 'a strange one – small, squat, and charming. He's part scavenger, trader, con man, procurer, and sage.' Phillips insists that the producers must have been worn down by the time they got to him, but there was clearly something about his performance that brought the character to life. "When I read the sides," Phillips remembers, "I could see he had a friendly demeanor. He looked like a good guy, not malevolent in any way. He seemed to be pretty exuberant, which I took to be a hallmark of either him or maybe his entire race. I decided right there that they want this guy to be a little emotional and a little exuberant. He was the opposite of the military guys. He wore his heart on his sleeve.

He was intrusive. He was annoying. He was emotional. That was my sense of him."

Phillips remembers auditioning in front of something like 40 people, all of whom were resolutely stony-faced, with one exception – the director Winrich Kolbe, who was sat at the back of the room grinning. Phillips felt he'd done a good job, and headed home to New York. It would be another month – maybe even six weeks – before he would hear he had got the role.

Phillips returned to Paramount, where work began on the makeup, which had been designed by STAR TREK's legendary makeup supremo, Michael Westmore. "I was told to think of something nice," Westmore remembers. "He was a vegetarian, he was the cook. He had to be pleasant looking so his coloring had to be kind of bright. At that time The Lion King was out. I remembered the happy little boar running around, and the meerkats. I thought, 'I'll combine those two.' The wig on the top of the head was like the boar's Mohawk. The mutton chops were from the boar too. He had soft and floppy eyebrows like the meerkats. You didn't want it all to be one color so we went with spots. That worked well because they could be done quickly with an airbrush. I made teeth for him. Instead of making them fangs, I cut them straight across like a horse's teeth."

After all the castings and fittings, Phillips remembers seeing the makeup for the first time. "I didn't have my glasses on," he says, "so I put the contacts in and looked in the mirror. I stared at myself and I was delighted. I thought it was one of the most beautiful things I'd ever seen. He was a really super-looking guy, and," he laughs, "relatively handsome for a Talaxian. There was a slot in the nose, that you see on cats and dogs. That was a mistake, but Mike Westmore said let's keep it, it gave him an animal look. I told people it was my credit card slot!"

Once Phillips was in full Neelix makeup, he and Westmore walked out of the makeup department, got on a golf cart and rode across the studio to executive producer Rick Berman's office, where they discussed some final refinements. "Originally," Phillips recalls, "the sides of the head, the temple, were done in a dark pink. Rick Berman looked at me and he felt the pink looked more like a wound. It didn't look right, so they went to yellow, which made it friendlier."

Phillips felt relatively relaxed about the reality of wearing such a substantial prosthetic makeup. "I'm not the kind of person it bothers for some reason. I was in my 40s and I'd done makeup roles before. I did have one problem, though – I wore these contact lenses that were yellow. I'm a big reader. I could not read when the contacts were in, and they were in all day. Other people could go to sleep in their trailer, but I couldn't do that. I'd crush the wig. I couldn't really talk on the phone as it would stick to the makeup, so I was encapsulated for the time I was on set. I guess I listened to people and did a lot of chatting and maybe listened to music."

The rest of the cast and crew remember Phillips as an incredibly positive and cheerful presence, who was constantly laughing and joking around. "I am a clown," he agrees. Over time, he admits the makeup could become frustrating. "You're in it for 15 hours and it really sucks. It was heavy and it was very hot. It was a long process to get it on and a relatively long one to take it off. It added four or five hours to my day. But I loved the look. I never once complained in seven years. Complaining puts cracks in the universe for me. They paid me really well and it wasn't like I was digging ditches."

With the makeup in place, Phillips could get down to work. The principal cast was assembled and Rick Berman threw a lunch for STAR TREK's newest ensemble. Some people already knew one another – Phillips had known Robert Picardo since they had started out in New York theater decades earlier, but this was the first time most of the cast had met. Phillips immediately bonded with Tim Russ, who played Tuvok. "After

LEFT: *Neelix and Tuvok were VOYAGER's odd couple. The two men could hardly be more different, with Neelix wearing his emotions on his sleeve.*

ABOVE: *Neelix was determined to make himself indispensible, so he took over Janeway's private dining room and turned it into a galley for the crew. Phillips improvised much of his cooking, which included clapping at the flames to encourage them.*

the lunch was over, everybody was told to stroll over to Stage 8 and take a look at the sets. We all branched off, and Tim and I ended up walking down this long alley together. We didn't really know each other, and we were just talking about how excited we were to be on the show and got to know a little bit about each other. We became very good friends."

The two actors were together again when they filmed Phillips' first scene as Neelix materializes in *Voyager's* transporter room. He meets Tuvok and enthusiastically hugs the stoic Vulcan. "We did the take," Phillips remembers, "and after it's over, the director goes, 'Moving on,' which means that they like it. I love it when the take is over and I just hear 'Moving on!' That means they got what they wanted. I thought, 'Good, they liked what I did. They're glad they cast me! 'Moving on.' Great, we're off to a good start here.'"

Over the next year, Phillips worked on exactly what it meant to be Talaxian. "I tried a few things in the first year that I thought might be alien-like but they were discouraged," he explains. "After a while I thought, 'You know what? They want a guy who's me.'"

UNEXPECTED PERFORMANCE

"It was about the third season. They finished my makeup around 7. I was going over to Stage 16 where we shot the cave scenes. I walked down the long alley between the stages. As I turned the corner I could see way up the other end of the alley another person walking towards me. It was just sunrise. We got closer and closer. We're about 10 feet from each other, and I realized it's Robin Williams, who was on the lot doing *The Birdcage*. He sees me and goes, 'Oh my God, Mr Neelix!' Then he does this whole routine about what it's like to be a chef in outer space. 'The eggs are floating, the pancakes are getting too big!', a Robin Williams shtick. I had a private performance for like a minute and it was really funny. Then he came up, gave me a big hug and said, 'I love your character, sir.' Such a sweet, sweet man, I'll never forget that."

> *"For whatever reason, Neelix thought Tuvok was the bomb, but I never could get his approval, so that was always a very clear thing to play."*

■ **Ethan Phillips**

There's an old show business adage that there are two types of actor: ones who pretend that they are someone else, and ones who pretend that someone else is them. "On television," Phillips says, "they cast you for you. I just put myself, Ethan, into the situation. [Writer] David Mamet says there's no such thing as a character. My Aunt Bessie is a character. It's like cops and robbers when you were a little boy. You just try to make it as real as possible, and the way you can do that is by using yourself. There are trappings to the character, he might have a limp or an accent, you add that on, but you make it as personal as possible."

That's not to say that there are no differences between Ethan Phillips and Neelix; Phillips drew on parts of his own personality and amplified them as the Talaxian. "He had a better heart than I did," he says. "Neelix was a very generous character. He was even aggressive sometimes in his generosity, and that could be annoying. He was a little too much in your face in terms of wanting to help, but that's how he was written and that's how I played him. In the beginning he just wanted to save Kes, so he found himself on board, but then he thought, 'Hey, this is a good place to be for a while!'" Executive producer Brannon Braga agrees that Neelix could be annoying. "I think Neelix

ABOVE: *When it came to Kes, Neelix was extremely jealous and he particularly disliked her friendship with Tom Paris. This was something Phillips felt uncomfortable with, and he was very pleased when this aspect of Neelix's character was left behind.*

was trying too hard," he says. "That was part of his character. He was so eager to please."

That need for approval formed the bedrock of Neelix's relationship with Tuvok. From the beginning the writers could see them as an odd couple, who were so different that they would play well against one another. "For whatever reason," Phillips explains, "Neelix thought Tuvok was the bomb, but I never could get his approval, so that was always a very clear thing to play. There was a good yin and yang there. Neelix is so emotional and giving toward Tuvok, who's like a two-by-four. It's always wonderful to play obstacles. Here's this guy, I really wanted his approval, but he's annoyed by me."

Neelix was also conceived as part of another odd couple. He and Kes were created together with the intention that they would be an alien couple, who provided a different way of commenting on the mostly human crew. For many reasons the relationship never worked exactly as the writers had hoped. "I think that the relationship between Kes and Neelix disappointed us," executive producer Michael Piller remembered. "Originally, they were conceived as a couple who

were going to learn about humanity from the outside looking in. We'd never seen that done with a male and female, but it just didn't seem to work."

In the first two seasons, the writers set up a triangle between Neelix, Kes and Tom Paris. Paris was clearly interested in Kes, even though she didn't give him any encouragement. This led to Neelix being jealous. Almost everyone involved, in particular the actors, felt that the storyline was never comfortable and made both Paris and Neelix look bad. "I didn't like the fact they made Neelix so jealous," Phillips says. "I thought that was a bad color, but I played it as best I could."

Ultimately, Kes spent more time with the Doctor in sickbay, and there was less and less focus on her relationship with Neelix. By the third season, the writers decided to split her and Neelix up. "She decided that she was going to leave me and we kinda break up. They filmed a wonderful scene with me and Jennifer Lien. She told me that she loved me but wanted to get away from the relationship and could they just be friends. Neelix really came to a comfortable place and so did she. It was really a nice scene, but they never included it. I guess the episode was running long."

For the most part, Neelix seemed irrepressibly positive about his situation, but in the course of seven years there were several episodes which revealed that there were darker

LEFT: *In 'Fair Trade' we learned that Neelix was worried about how useful he would be once Voyager left the area of space he knew well.*

elements to his life. "I knew they were going to go off and explore some depths to the character," Phillips says. Towards the end of the first season we learned that Neelix was one a handful of Talaxians to survive a devastating attack on their colony, which had been wiped out by a weapon called the metreon cascade. A distraught Neelix confronts the weapon's creator, Jetrel. "We were very lucky to have James Sloyan playing Jetrel," Phillips says. "Jimmy's an extraordinary actor. That helped my performance. I could just look in his eyes and it was right there. He's a very generous dude, and you just try to respond. I don't have any idea what it's like to be in a nuclear holocaust, but that stays with you. It resonated throughout the seven years in a lot of ways. It was a nice color. Neelix, like everybody else, has pain and sorrow and regrets and sadness."

Braga feels that the episodes where Neelix was forced to confront the darker aspects of his life were among the most successful. "I like Neelix and I think Ethan Phillips is an amazing actor. I made a concentrated effort to find stories for him. It worked great when you gave Ethan something dramatic to do. 'Mortal Coil', where Neelix was dead for a while, is one of my favorite episodes. It's not what his religious beliefs taught him to expect, and this character who you normally see as a goofy guy, has an existential crisis."

"That was a pretty powerful journey for Neelix," Phillips agrees, "because he is a guy who really did have great faith that there was eternal life. And he finds out there isn't. I was taught by Jesuits and they always said that the sin God hated the worst was consenting to despair. Neelix does that, and that stuck in my mind.

"I remembered a novel Jean-Paul Sartre wrote called *Nausea*. It's wonderful, the seminal piece of fiction on existentialism. The character has a moment when he comes across a huge chestnut tree and he can't figure out why it's there, what the point of it is. It's physically nauseous. When he's confronted with the fact that there's really no meaning for anything because he can't determine essence, he can only determine existence. I'm going way out on a loop here, but I think that's what happens to Neelix. He realizes this is it, and what's the point? What brings him back is when Chakotay tells him, 'You're needed. The goodness and the kindness we all show each other is the whole reason we're here.' That was one of the most appealing things I've ever had to play. It's the message that *STAR TREK* has – that we respect people not for what they look like or how much money they have or power. We respect people because they do the right thing. I felt great that I could contribute to that with that episode."

ABOVE: *Neelix left* VOYAGER *two episodes before the end of the series, joining a colony of Talaxians in 'Homestead.' At first, Phillips was disappointed, but he soon realized that this approach meant that Neelix was given a proper send-off.*

'Mortal Coil' provided a rare insight into Talaxian culture. "I generally thought of Talaxians as a positive people, a kind race," Phillips says. "I think you could say they're basically a gentle people. They're vegetarians, and they don't like to fight. They're short and furry and friendly looking, and a lot of emphasis is put on family and food and holidays, that kind of thing. So they're very domestic, and they have a great sense of fun and play."

Ultimately, the writers decided that rather than get back to Earth with the rest of the crew, Neelix should be reunited with his own people. By the final season, Ken Biller was running the writing staff and, as he explains, they wanted to surprise the audience, "I wanted to have things you didn't expect. Was everybody going to get home? We decided early on that we were going to leave Neelix behind. That was a huge deal. It was something a little sad – bittersweet."

Biller goes on to say that at first, Phillips wasn't overjoyed with the idea. "I was surprised," Phillips admits, "because everybody through the years was saying, 'Well, what are you going to do when Neelix gets to Earth?' When Ken Biller called me up and told me what was going to happen, I was a little sad that he wasn't going back to Earth with the rest of the crew. But the more I thought about it, the more I decided they were right. Why should he go back to Earth? He's not from Earth. He doesn't have anything going on down there. Instead he runs into this beautiful creature who is Talaxian, just like him. She has a child, and he has the option to be a father and a husband and a man of respect in a community of his own people. He saves this band of Talaxians from their aggressors, and he becomes a hero."

That episode also meant that Neelix got his own send-off rather than being lost in the crowd when the crew arrived home. As Phillips remembers, when Neelix walks to the transporter for the last time, the crew line the corridor to wish him well. "It was not only the cast and the extras we had worked with for many years, a lot of the crew and some of the writers put on the uniform, so when I was walking down that hallway, I was saying goodbye to everybody. It was extraordinarily emotional because this had been my family for seven years. That was a pretty powerful day for me."

Neelix did, however, make a brief appearance in the series finale. Phillips came back to Paramount to record one last scene when he talks to Seven on a monitor. When he was done, he bumped into Tim Russ. Seven years after they'd first walked over to the sets together, they found themselves walking down the same alleyway, this time leaving the *Voyager* stages behind them. "We found that kind of beautiful," Phillips says. "We'd come full circle."

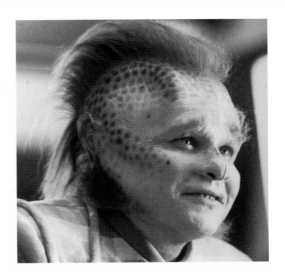

IN AND OUT OF MAKEUP

As Ethan Phillips remembers, every day began early in the morning before he got into makeup and normally ended late at night. "I used to walk through the lot early in the morning. It was completely deserted, you'd walk through the New York City set and you'd feel like you were in downtown New York on a very bleak, lonesome night.

"I was in really good hands. Scott Wheeler was my makeup guy. He applied it and took it off every day for seven years. We became good friends. He was very specific and very gentle. He was also, as all makeup people are who work on people with prosthetics over a long period, a pretty stable dude, because the actor can go in and out of moods depending on what's going on on the set or whatever. He always had a very calm presence. I would get in there at 4 in the morning. We were in tune with politics, he was way more left-wing than I was. I think he was a Maoist! We had a lot of great conversations.

"For somebody who's working all the time, the removal process is a little elaborate. If you're a guest star and you only had two or three turns in makeup, they could just use alcohol and take it off just like that. They wouldn't use that on me as it's very drying. They used isopropyl myristate which is a very dense oil. They have to really get under and detach the glue. It's very messy, but they want to save the head. They want to try to get seven or eight uses out of the head, so they really took their time taking it off."

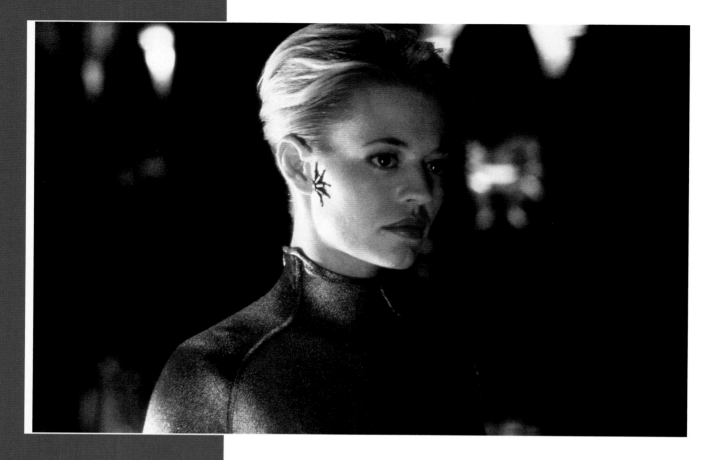

SEASON 4

EPISODE 2

AIR DATE: SEPTEMBER 10, 1997

Written by Joe Menosky

Directed by Anson Williams

Synopsis: Kes's powers grow rapidly while *Voyager*'s new Borg crewmember has to deal with her new individuality.

THE GIFT

Change is afoot on *Voyager*, as Kes powers up and Seven of Nine exchanges the rubber and cables of her Borg self for a silver regeneration suit. The show graduates into its golden period.

'Scorpion,' the two-parter that straddled seasons 3 and 4, provided a whole new beginning for *STAR TREK: VOYAGER*. But the real changes took place in the next episode, as Seven of Nine became part of the crew, while Kes headed for the exit. Brannon Braga recalls, "The decision to lose a character was a complicated one. It was not a callous decision. It was a hard decision." Executive producer Jeri Taylor adds that, when the decision was made, "We knew we would probably want to eliminate her in some interesting way."

Bryan Fuller joined the writers' room at

that time. "When I started coming in, I was pitching a bunch of ways for Kes to leave," Fuller remembers. "I came in and I pitched that her powers were getting away from her

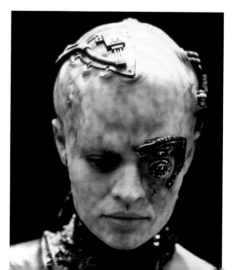

RIGHT: The studio was keen to see Ryan shed her Borg makeup as quickly as possible.

and she's evolving into this next phase of the Ocampan evolutionary process. They were like, 'That's great. We're going to do that.'" Fuller never got to write her farewell, as it turned out. "They decided to make that happen much quicker," he remembers. "So, Joe Menosky took over and executed it beautifully." Originally intended as the fifth episode, 'The Gift' ended up following season opener 'Scorpion, Part II' when Lien's departure was brought forward.

'The Gift' saw Seven of Nine lose many of her Borg trappings as she was cut off from the Collective. Unsurprisingly, Janeway was central to the revolving door of crewmembers. "There was a parallel with Janeway having to keep things together, going from the new

■ "My gift to you..."

Kes to Janeway as she leaves Voyager

person onboard, Seven, to the person who was entering this strange transformation of her own and leaving," Menosky told *Cinefantastique*. "Janeway was dead in the center of those two relationships, the coming and the parting." In the episode, Janeway compares the Borg to wolves, and it is this analogy that shaped the development of Seven. Menosky explained, "We came up with the idea of the wild child, the wolf child, the little girl who was raised by wolves in a forest and is finally reclaimed by humanity. She always was human, but for a formative period of her life she was also a wolf. That didn't make [Seven] a victim. It also gave her an edge of arrogance and haughtiness."

When Seven had been introduced, she was a full Borg, so Jeri Ryan had been dressed in a neoprene bodysuit with an outer layer of Borg armor. As the story progresses, she is literally stripped of that armor as the human underneath begins to emerge. The transformation was approved by Brannon Braga. "You can't ask an actress to come in nine hours a day and wear 30 pounds of makeup," he says. "I also think seeing her as a Borg would have got tiresome."

From the beginning, the themes that will define Seven become clear: she is not

happy to leave the Collective and sees the contradiction in Janeway forcing freedom on her. For her part, Janeway becomes determined to rescue Seven and help her to regain her humanity.

While Seven settled in, Kes began a new journey. After three seasons, the departure of regular Jennifer Lien was emotional for her fellow cast members. Kate Mulgrew considers the captain's feelings: "It's as much a sorrow for me as Kate, as it is for Captain Janeway. I found

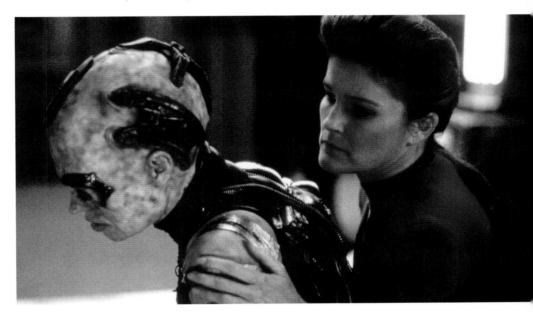

ABOVE: Seven's pain at being separated from the Collective is very real and Janeway has to force her to stay onboard. Braga compares her to a cult member who is being "rescued" by force.

it very difficult to get through that episode."

Ethan Phillips described 'The Gift' as "the best show we've done in the last three years. I have one scene with Kes where we acknowledge for the first time, between ourselves and for the audience, that we're just friends now. So that's an important scene." Lien is serene as Kes, adopting her almost god-like powers.

To create the effects where Kes destabilizes, VFX producer Dan Curry remembers, "We wanted something a little strange and a

little alien to kind of feather into Kes as she's going through her transmutation. I just did a freehand drawing of odd tissue and veiny things, inspired by water buffalo placenta. And then we would occasionally double expose that into Kes as she's kind of fluctuating in and out of our physical reality."

Ryan was pleased with her dialogue with the captain. "They did an excellent job with the debate between Seven and Janeway. They made the argument not so black and white. Janeway's choices are not clear-cut. I applauded the fact that the writers had the guts to make it a gray issue. They didn't make Janeway completely right and the Borg completely evil, because they're not."

The episode ends with Janeway and the Doctor joining Seven in the cargo bay. The former Borg drone has been completely transformed and she is now sheathed in her iconic silver suit. Nothing would ever be the same again.

> "I'm just giving you back what was stolen from you, the existence you were denied, the child who never had a chance – that life is yours to live now."
> "I don't want that life!"
> "It's what you are. Don't resist it!"
>
> **Janeway, Seven of Nine**

K E S
THE MAYFLY

With her short lifespan, Kes was designed to have a unique perspective on life and, as half of a couple with Neelix, to provide an unusual commentary on what it means to be human.

The first time we see Kes, she is battered and bruised. She's been taken captive by the Kazon, before being rescued by *Voyager*'s crew. She joins the ship where she embraces the idea of exploration, but her life is so short that ultimately she evolves into a new life-form and leaves the crew behind.

As Michael Piller said in an interview he recorded for the DVD release of *VOYAGER*, the hope was that the character would have her own special take on existence. "We had the idea of a species that had a very, very short time to live – seven years, eight years, whatever it might be – which would force that character, and force us as an audience, to look at each day that went by in an entirely different fashion, to appreciate time. Maybe [because] we live 80 years as humans, we might not stop to take a look at that. We also thought it created great challenges for an actor, great challenges for the growth of a character over, say, a seven-year run. That ultimately became Kes."

The writers' bible describes Kes as "delicate, beautiful, young… She is an innocent who sees humanity through a fresh perspective, and the crew of *Voyager* never cease to fascinate her." Jeri Taylor remembers that at her audition, Jennifer Lien impressed the producers by combining those qualities with an unexpected strength. "When she read," Taylor remembers, "she had this wonderful elfin quality. She was delicate and yet there was something strong about her, too. She was such an interesting actress and she filled up the spaces in the character."

Taylor goes on to say that the writers always thought about Kes and Neelix together. As the writers' bible makes clear, the two aliens were conceived as "a truly odd couple, [who] become oblique commentators on the human condition." The idea was that they would provide different views on humanity. "It was the pairing of them that was important," Taylor adds. "That was the foundation of the character." In early episodes, Neelix is often amazed at the crew's willingness to take risks, whereas Kes is enthused by their desire to explore. It was also important to *VOYAGER*'s creators that the characters made an unexpected pairing. Kes is very young and beautiful, whereas Neelix is less conventionally attractive.

Lien has retired as an actress and doesn't give interviews, but during press coverage for *VOYAGER*'s launch she did give an interview that was used to promote the series. In it she

reflected on how much she liked the unusual relationship. "Neelix and Kes complement each other," she explained. "Neelix makes up for a lot of what Kes is lacking, and Kes makes up for a lot of what Neelix is lacking. They are a true team, which makes for a lot of humor and sincerity and intimacy. They are a good couple, quirky and offbeat.

"You have these two incredibly independent, very different creatures, who meet in a barren, dry, waterless wasteland filled with fighting, scavengers – not the ideal circumstances to make a match made in heaven. Kes is at a camp filled with Kazons. Neelix finds her, sees that she's in a bad situation. There's no water anywhere in this camp. He brings her water – he steals it from them and brings it to her, knowing that he could lose his life, and he does it anyway. I'm very attracted to that – somebody who would be that daring and go through all the danger and be that kind and giving and true.

"The triumph of it is that these two can actually bond, see the beauty in each other and become lovers and friends and partners, and have some relationship going in these sort of circumstances. That in itself is created by two unique people."

Jeri Taylor says that the relationship between these two alien characters brought something new to the table, something we hadn't really seen before. "I think the appeal of that couple was that they just seemed so happy together and so suited for each other. It was a feel good thing."

Ethan Phillips, remembers being hugely impressed by Lien's abilities as an actress even though she was only 20 years old. "Jennifer was extraordinarily easy to work with," he remembers. "I don't know what her process was but she seemed unedited – you never saw her acting – she just seemed to be Kes. There are some actors with whom you can find your performance in their eyes, and Jenny was one of them. She was very present, she didn't fake anything. That is what you want in a scene mate. She upped my game a lot, I felt."

Lien also shared many of her scenes with Robbie McNeill. As he recalls, she had worked on a daytime soap in New York, as he had. "I had spent three years on a soap opera in New York as well, so immediately she and I had a common experience. It's a culture that's like nothing else because you are making an hour-long episode every day. Everyone knew each other and went to events and restaurants together. So I started asking her about people we knew in common. She did her soap maybe six or eight years after I had, but a lot of people were the same. We talked a lot about that."

Both Phillips and McNeill remember Lien being very well prepared and serious about her acting. As McNeill says, "I got a sense from Jennifer that really deep down she wanted to be a very serious actress and to do independent films. That seemed important to her. I respected that. This was the '90s when there was nothing actors wanted more than to be in an independent film that won a prize at Sundance. She seemed to be very interested in literature and poetry. I remember her as being lost in art and poetry."

Another aspect that Lien commented on in the promotional interview was how unusual her role was. Kes was about as far from the average adolescent girl as it was possible to imagine. "I'm not playing a teenager in this," she said. "I'm playing a young mind, spirit, body. So much that is associated with [being] young… has to do with things that this role really doesn't encompass, which is good in a lot of ways, most of the

ABOVE: This rare picture shows Jennifer Lien on location during the filming of VOYAGER's pilot, 'Caretaker,' shortly before she is rescued.

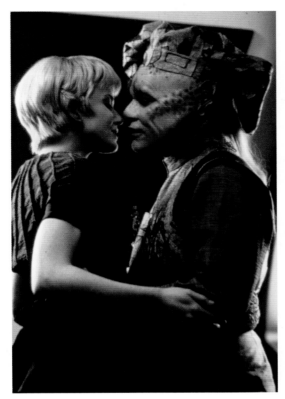

ABOVE: *Kes and Neelix were originally intended to operate as a couple, providing different and equally alien perspectives on Voyager's human crew. Despite appearances, Kes was probably the more alien of the two, with her psychic abilities and alien physiology.*

ways because it's so different. I think it's an excellent role. It's a joy to pretend to be this extraordinary creature. So open, and everything so new. No sort of cynicism or precociousness or pretentiousness or sarcasm, none of the usual young female… it's good. It's very good. It's classic. It's a joy to pretend."

Most of Kes's other scenes were shared with the Doctor, and she was the first member of the crew to see him as a person rather than a tool. She was instrumental in persuading Janeway to give the Doctor control of his own program and, as McNeill observes, she played a major role in his evolution.

"I don't think the Doctor could have become who he was without her. She really was critical to accessing a humanity and a personality and an empathy and a sense of humor for the Doctor. All of those things came out in the scenes with Kes. She was naïve about humans and he was also naïve in many ways, and together they sort of discovered humanity. I don't know what he would have become if she wasn't there. It would have been much more difficult for Bob and for the writers to grow that character so quickly."

"I got a sense from Jennifer that really deep down she wanted to be a very serious actress…"

■ **Robert Duncan McNeill**

In addition to the role Kes played in humanizing the Doctor, her Ocampan nature provided the writers with different ways of telling stories. She had a number of vaguely defined psychic abilities that could be used in different stories, and on occasion she sensed temporal anomalies.

However, the idea that her exceptionally short lifespan would give her a unique perspective never quite worked. "Kes

> "The sets were nothing but splinters when she was done. I think she revealed something about her inner life in that episode that I found quite intriguing."

David Livingston

was intriguing," Brannon Braga says. "I thought Jennifer was a great actress. She brought a lot of depth to that character, but I struggled with that aspect of her a bit. I never knew what to do with that concept."

Taylor agrees that Kes's short lifespan never became an essential part of the character. "You come up with things like that at the beginning," she shrugs philosophically. "You say, 'That's a cool idea' but what does it mean in terms of the character? Sometimes that gets lost in the overall arcs of the storytelling. I don't know that it was something that we paid that much attention to in the end."

Although they enjoyed working with her, none of the actors felt that they knew Lien particularly well. "Jennifer was an enigma," McNeill says. "She was not talkative." Phillips adds that "she had a quiet sense of humor and a mysteriousness about her. Most likely because she was not one to chatter aimlessly or make too much small talk."

The rest of the cast had a sense that her family life had not been easy, but as McNeill explains, she rarely – if ever – talked about herself. "She was very inquisitive, kind of like her character. She would ask you questions about your life, but she was very private. As soon as you asked her much about herself, she would get very demure. She wasn't expressive about herself. As a person I think she probably internalized a lot of things. I think she put a lot of that stuff into her acting. As a character, you could feel this pot boiling a bit, and as an actress, she could let it out in ways that were surprising. Her strengths often expressed themselves in these strong, combative moments."

Looking back at the early episodes, Lien's performance is surprisingly direct and forceful. Kes may look like an innocent but she is far from a pushover. As Lien described her, "Kes is strong, courageous," as well as "intelligent, open, curious."

RIGHT: Kes shared many of her scenes with the Doctor, showing herself to be a friend who didn't assume that he couldn't feel because he was a machine.

Lien got a chance to show just how forceful she could be in the third season episode 'Warlord,' when she is possessed by an alien warrior. "I thought she was amazing in it," says the episode's director David Livingston. "I remember thinking, 'Look at what this woman is doing. This is something I never expected to see from her.' The sets were nothing but splinters when she was done. I think she revealed something about her inner life in that episode that I found quite intriguing."

That capacity for darkness is something that all the actors recognized in Lien. "I always sensed deep waters in her," Phillips says. McNeill thinks very carefully before saying, "There was always a bit of a weight that she seemed to carry that you couldn't quite put your finger on. There was a seriousness that she carried all the time, personally and in her performance."

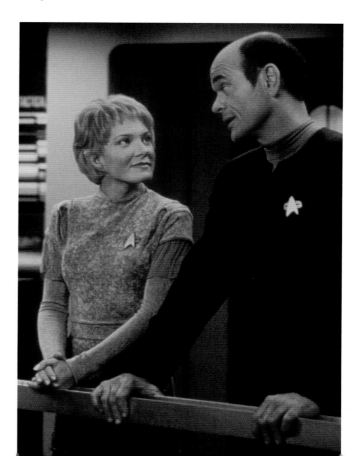

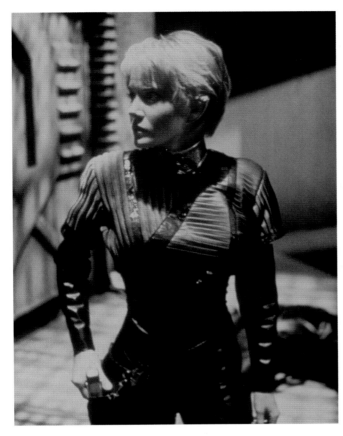

ABOVE: *Lien showed her range as an actress and potential for darkness in 'Warlord,' in which Kes is possessed by a violent warrior.*

As time progressed, that emotional weight became an issue and the cast and crew started to realize that Lien was struggling with personal – and many assumed addiction – issues that had a serious effect on her. Those issues started to affect her reliability and as a result, the producers reduced the amount of screen time devoted to her. "We knew that there was something going on," Taylor says, "but she wouldn't talk or let us offer to help. She just shut down."

The situation became so serious that, reluctantly, the producers decided to drop Lien's character during the fourth season. At the time, everyone felt it was inappropriate to discuss the real reasons in public but her problems later in life have been well documented. Like everyone involved in *VOYAGER*, Ken Biller was saddened that things didn't work out better. "I felt a real connection to Kes and to Jennifer," he says. "I really admired Jennifer's acting ability. She seemed to commit fully to whatever we put in front of her. I was very fond of her personally and wished I could have gotten to know her better. I remember her being almost painfully shy, though there seemed to be a huge well of emotion behind those averted eyes. I can't help thinking that in a way, Jennifer's lifespan on the show, like Kes's, was way too short."

KES RETURNS

Kes returned during *VOYAGER*'s sixth season in an episode called 'Fury.' We learned that after leaving the ship she wasn't ready to cope with her evolving psychic abilities and felt she had changed too much to return to Ocampa. She blamed Janeway's crew for what had happened to her so she returned to the ship, determined to change her fate by traveling through time, killing the *Voyager* crew, and sending a younger version of herself home.

As Bryan Fuller remembers, there was a feeling among the writing staff that there was more of Kes's story to tell. "We originally intended her to stay

around for more of the fourth season," he remembers. So bringing her back seemed natural. The writers were intrigued by the idea that her evolution had not been a success and she would return as a villain. "The point of this episode," Fuller says, "was to do something larger and grander than her original send off. As is always the case, the story started out bigger and more ambitious. I think it was a great idea to have her be the villain, but we never quite worked it out and it always felt a little forced. Originally, there was a much more thorough exploration of why Kes went mad and why she was so angry, which involved these other aliens. It felt like it should have been a two-parter but there just wasn't time. We had talked about keeping her around but it didn't work out."

SEASON 4
EPISODES 8/9
AIR DATES: NOVEMBER 5/12, 1997

YEAR OF HELL

'Year of Hell,' season 4's epic two-parter, showed *Voyager* taking a serious battering, and was the first story to really explore the effect that being stranded in the Delta Quadrant could have on the ship.

Written by Brannon Braga & Joe Menosky

Directed by Allan Kroeker (Part I)
Mike Vejar (Part II)

Synopsis Obsessed with restoring the Krenim Imperium, a temporal scientist creates changes in history that push *Voyager* to the brink

The season 3 episode 'Before and After' provided a glimpse of a possible future, when Kes visited a timeline where *Voyager* is hit by the Krenim's chroniton torpedoes. It was another season before the Krenim turned up, by which time Kes had exited the ship and Seven of Nine had enlisted. Brannon Braga was eager to explore this doomsday scenario for Janeway and crew. "Although I don't like to do episodes that rely on other episodes for exposition, I loved the phrase 'Year of Hell' that Ken Biller came up with for that episode," says Braga. "I loved the look of the show. I loved the

look of a destroyed *Voyager*." In fact, Braga was pushing to make it much more. "My initial pitch," he remembers, "was to make it last the entire season. I knew it was not going to

RIGHT: Janeway becomes increasingly desperate as the ship is destroyed around her.

happen, but it was a good starting point." The idea was that, because of the changes in the timeline, we would see *Voyager* undergoing some serious damage. The phrase 'Year of Hell' also inspired the setup. "The notion of having a story that took place over the course of a year," Braga recalls, "I thought was a very fresh structural approach." But ultimately, the studio wasn't ready for such a heavily serialized approach and the story was cut down to a two-parter.

'Before and After' established that the Krenim used temporal weapons. Cowriters Braga and Menosky now needed to work out what they were. Braga came up with the idea that the Krenim were using a "Death Star-like

> **"This vessel is more than a weapon. It's a museum of lost histories."**
>
> *Annorax*

weapon" that could wipe a planet out of history. "What you have done is erased a thread from the time continuum, everything resets, and the present is different." The ability to change and change back time allowed the writers to show the ship taking massive hits, but with a way back at the conclusion. "That was enough for us to start running with this as an episode," Menosky told *Cinefantastique*.

The character and casting of the Krenim military temporal scientist, Annorax, were crucial to the success of the story. While Annorax clinically wiped civilizations from history, he had a sympathetic motivation. "Brannon came in one morning," Joe Menosky recalls, "and said, 'It's *20,000 Leagues Under the Sea*. This guy is Nemo.' He's evil, but he's also tortured. All we had was a guy who was changing the timeline to benefit his race. But once you had Nemo [...] you had a guy who was trying to not just restore the timeline, but to bring back his wife, lost to him through his own arrogance."

To play Annorax, the producers invited Kurtwood Smith from *Star Trek VI* and *Deep Space Nine*. Despite a crushing schedule,

Smith gave a masterful performance. "All of my scenes in the first part were compressed into one day," Smith recalls. "That was a little intense. We also shot the heaviest scenes at the day's end, so it was hard to have much energy by the time we got to them. Otherwise, it was great. I had a good time with Annorax, and I got the girl at the end. If you know my career, you know that almost never happens."

With *Voyager* becoming more and more crippled through the two episodes, the

VFX team had their own trials ahead. Rick Sternbach produced drawings that showed how *Voyager* would become increasingly damaged as the story progressed. "I made modified photocopy sketches to show the producers what the damage might look like, and give some visual guides." Sternbach's sketches were handed to Foundation Imaging, where VFX supervisor Adam 'Mojo' Lebowitz headed the team that turned them into reality.

"The final battle was one of the most ambitious in the show's history," Lebowitz remembers. "The ships literally collide, scraping alongside one another and doing damage never before seen. This was one of the most complicated and difficult FX shots we ever attempted." It not only made for a

spectacular denouement... "It resulted in something totally unexpected: the first Emmy nomination Foundation Imaging would receive for work on *STAR TREK*."

The conclusion for 'Year of Hell' was much debated. "We had at least half a dozen different endings," Menosky recalls. "Brannon wanted to keep the ship wrecked for the entire season, and he didn't want to end with a reset. The studio didn't want to do that. Rick Berman didn't want to do that. So, we didn't."

ABOVE: *The timeline is reset when Janeway crashes* Voyager *into the Krenim temporal weapon ship. As Braga says, Janeway finally achieves what Annorax could not: restoring his wife to life.*

The ending, while impressive, wasn't totally satisfying for Menosky. "Rick said, 'Just plow *Voyager* into the weapon ship, and reset the timeline, and nobody remembers.'"

On keeping the ship in tatters, Braga remarks, "People weren't doing serialization. The ship could have been dilapidated each week, but it just wasn't the show that we did." Nevertheless, Braga was happy with the result. "'Year of Hell,' a lot of people would say, was a defining moment."

> **"If that ship is destroyed, all of history might be restored. And this is one year I'd like to forget."**
>
> *Janeway*

THE DOCTOR
VANITY AND VULNERABILITY

The Doctor was a new take on a classic *STAR TREK* character: the artificial life-form who is exploring what it means to be human. As Robert Picardo discovered, it would be a fascinating journey.

Robert Picardo didn't get it. No matter how hard he tried, he just couldn't see what was interesting about the Doctor. "When I was first cast," he explains, "I told all of my friends, 'It's a great job. It'll put my children through college, but I have the worst part in the show. I am the dullest character. It says he's a colorless, humorless computer program.'"

Of course, looking back, Picardo can see how wrong he was, but it's easy to appreciate why he was concerned. Of all the characters, the Doctor changed the most and when the show started out, he had very little to go on. Series cocreator/executive producer Michael Piller had no doubts that the Doctor was going to be a breakout character, but he couldn't explain it to Picardo. "I could not figure out a way to communicate it," Piller said. "The Doctor does not have much to do in the pilot, but I knew that he was going to be special."

As cocreator/executive producer Jeri Taylor explains, *Voyager*'s creators saw the Doctor as following in the footsteps of characters like Spock and Data: an outsider who explores what it means to be human. "We created the Doctor with that function in mind. We had been through enough incarnations of

that to know that it works as a mirror for humankind. We were thrilled when we came up with the holographic doctor, because we felt that he could serve that function in a way that was unlike any of the others, but," she adds, "I wasn't as confident as Michael that he would work. You simply do not know what will happen until it is produced. You can only set up potential. The Doctor became immensely popular. A lot of that was to do with Bob."

When he reported for work, all Picardo had to go on was that people liked it when the Doctor was rude and sarcastic. "I used to say to people, 'I think they hired me because my face at rest is so unhappy looking. I'm disdainful. If I don't smile, I have resting bitch face.' I thought that must be why they cast me." Writer/executive producer Brannon Braga agrees that there is an element of truth to this. "I think that's one of the reasons they cast Picardo," he says. "He's a really good actor, but there's something inherently funny about him even when he's being serious."

Apart from Michael Piller's word, Picardo didn't have much to work with. The Doctor barely appears in the pilot, 'Caretaker.' Picardo remembers that he only had nine lines, one of which

was only added after he ad-libbed it himself in the audition. "The pilot was so small," he remembers, "that I kind of faked my way through it. I got a big laugh when I say '*medical tricorder*' with dripping sarcasm. I say that line as if I'm saying, 'What kind of an idiot are you?' but I didn't really understand the character. I was naive enough to think that Tuvok would be the Spock-like character. But," he adds, "it became clear to me in short order that I had gotten the plum role."

The key to the Doctor's character was revealed to Robert Picardo in *VOYAGER*'s first regular episode, 'Parallax.' "Kes, lovely Jennifer Lien, comes into the Doctor's office," Picardo remembers. "She needs soil samples. The Doctor starts out by explaining to her that he possesses the combined medical knowledge of 2,000 medical text books, and the combined experiences of 47 top Starfleet Doctors. He just laundry lists his brilliance. Then he says, 'Yes, let me get your dirt for you.'

"I borrowed that sense of injured merit from *Paradise Lost*. Milton describes the fallen angel Lucifer as having this sense that everybody in heaven didn't realize how swell he was as God's greatest angel. The reason why the Doctor was so cranky was that he wasn't getting the respect that he deeply believed he deserved."

ABOVE: *The Doctor barely has any screen time in* VOYAGER's *pilot and only appears in two scenes. He is impatient and rude but incredibly efficient. When he annoys people, they switch him off. It was only in the seventh episode, 'Eye of the Needle,' that Janeway gives him control of his program and sets him off on his journey of self-discovery.*

As the scene continues, the Doctor learns that he is gradually shrinking because his holo-emitters are malfunctioning, but no one in the crew has time to fix them. We discover that he has no name because no one ever thought he would be left switched on long enough to need one. Then, as she leaves, Kes deactivates him.

"That," Picardo says, "explained to me as an actor the core of his dilemma. On the one hand, he had this enormous body of knowledge. If knowledge is power, he is the most powerful doctor ever. But he also has a vulnerability because anybody could flip him on and off like a light switch. Think about that:

you're the best of the best of the best, but any idiot has control over whether you're alive or dead."

Picardo could see what Piller had been telling him all along: the Doctor was the classic *STAR TREK* character. "It all boiled down to the great entitlement issues," Picardo says. "If an individual is an artificial intelligence, then what is it entitled to and how does it differ for an organic crewmember? *STAR TREK* deals so well with those issues, starting with Spock: I'm not all human, I'm half this other thing. Then Data: I'm an android. I have this incredible artificial brain that's far more powerful than any human, being, but I have no emotional component."

Unlike Data, the Doctor was rude and would never admit to his failings. His disdain for others had been on display from the very beginning. Picardo had played the sarcasm, and got laughs, but now he understood where it came from. "Once I latched on to that," he says, "I understood that his whole arrogance and superiority was obviously just a cover. My image for the character was that he was Humpty Dumpty. He was constantly teetering on his own sense of self-importance. Like Humpty Dumpty, he puffed himself up, but he would still fall off the wall."

Picardo goes on to explain that the Doctor combined very real abilities with entirely understandable insecurities. "He's absolutely sold on how brilliant he is, but why wouldn't he be? It's a matter of data. I know absolutely everything that's been done in medicine for thousands of years, and I have the personal experience programmed into me of 47 incredibly successful doctors. Why wouldn't I be vain? That's a matter of fact, right? So why would I ever doubt that? The answer is, I wouldn't. I would only doubt something I wasn't designed to do, which is kiss a girl in a drive-in movie on Tom Paris' Mars holodeck program. He only becomes vulnerable about things that he doesn't know about, which is every other area of life."

ABOVE: *The Doctor's vulnerability was on display whenever he stepped out of sickbay. In the second season episode, 'Lifesigns', he develops feelings for the Vidiian scientist Danara Pel and they go on a date in one of Tom Paris' holodeck programs. The Doctor has no idea what to do because the experience lies outside of his programming.*

This combination of qualities was at the heart of the Doctor's character and, as Picardo soon realized, it was a gift to an actor. "That was what was fun about him," he nods. "The Doctor could be a complete windbag and know it all, and then he could turn on a dime to being vulnerable, because he didn't know what to do in the situation, or didn't know how to help."

Picardo believes there was something about that combination of characteristics that specifically tied into his strengths as an actor. "There are all sorts of things that turned out to be in my tool kit," he says. "I have a very expressive face, and I can make huge expressions, but I can also make subtle expressions. As the Doctor, I could overact and then underplay.

I was given the license to do that by the nature of the character, but I also had the equipment to do it because it's fun to watch me roll my eyes and mug because my face is very expressive. Then when you drop all that and you have a subtle reaction, it catches the audience off guard. A lot of actors wouldn't necessarily want to cop to that," he laughs. "Not many actors go, 'Oh yeah, I love to mug, I love to over-emote.' But in this case I could really go full boat and act like a petulant three-year-old, and then immediately get extremely realistic and vulnerable later in the same scene. That gave me a freedom and distinguished me from other characters in the franchise. I didn't have to obey the rules, and that's what made it cool."

"I would only doubt something I wasn't designed to do, which is kiss a girl in a drive-in movie on Tom Paris' Mars holodeck program."

■ Robert Picardo

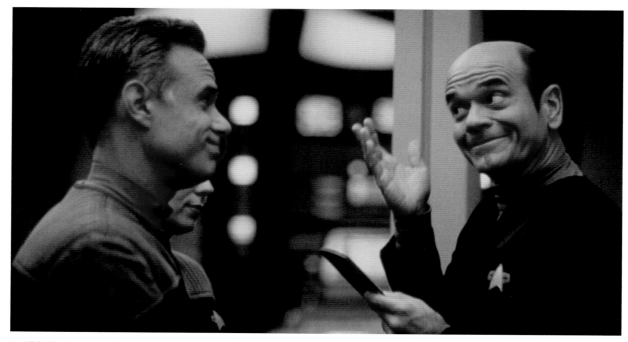

ABOVE: *Picardo describes himself as having an expressive face and a willingness to "mug and wink" and this influenced his portrayal of the Doctor. He could aslo switch his performance to be much more subtle and subdued. He says this ability to change tone made the Doctor more intriguing.*

One of the great gifts was that, unlike every other Starfleet officer in modern *STAR TREK*, he could be vain and foolish. "I could have all these negative qualities," Picardo agrees enthusiastically. "I could be self-involved, self-important, arrogant, a windbag, I could be cowardly in a situation that was outside of my designated expertise. I think that's what really interested the audience. He could behave so arrogantly or childishly and then when the chips were down, he could rise to his better self and learn lessons."

Again, Picardo says, this played to his strengths, and explained why the producers had been so keen to cast him. "I guess as an actor I have had an ability to play characters that you initially don't like, but you grow to like because you see what makes them act the way they do. Whatever their neuroses or vulnerability, whatever drives them to act like an asshole, you come to understand it. Then," he explains, "you root for them. That kind of feeling happens when the audience feels that they have figured out why you act the way you do, and they want you to be better or be happier with your lot."

This approach made the Doctor radically different from Data, who always saw himself as inferior. As writer Bryan Fuller explains, the Doctor had no such doubts. "Picardo played the Doctor as this irascible character who believed in himself. That was the thing that distinguished him from Spock

or Data. He found his humanity by doubling down on what he believed in and not going back. I think Bob's accessibility as an actor was very important. And he is a lovely human being!"

Once Picardo got what it was that made the Doctor tick, he was filled with ideas. Like the rest of the cast, he soon discovered that *STAR TREK* was not a place where you could ad-lib. "The way I described it," he says as dryly as the Doctor, "was, 'You can be spontaneous on *STAR TREK* as long you're spontaneous five days in advance.'"

Knowing this, and having already been on a long-running show – *China Beach* – he understood that the best way to influence the way his character was written was: talk to the writers. "It's hard for them to write 26 episodes a year," he says, "and if you give the writers an idea they like, there's no reason that they wouldn't use it, as long as it's good for the storytelling. If I read an early draft of the script, and I had an idea for a joke, I would call the producer and I would pitch my jokes. If they liked them, they would subsequently appear in rewrite pages."

Picardo happily admits that he wasn't shy about approaching the writers with ideas. "Brannon Braga teased me mercilessly that I would hide in the bushes outside the writers' building. Whenever he snuck out for a smoke I would pop out of the bushes and say, 'You know Brannon, I was wondering…' It's a little bit of an exaggeration, but it's not that far off," he laughs.

"It's true," Braga confirms. "Bob had a lot of good ideas. He was very engaged and very imaginative. I appreciated it, because he was into it." Over the course of seven years, Picardo pitched much more than just jokes. Or at least, the best jokes were rooted in character and revealed something about the Doctor. The first idea he pitched is a perfect example. "The earliest suggestion I remember making," he says, "was that the Doctor was so confident he would be a better patient than his organic patients that he programs himself with an illness. Of course, he turns into the worst patient ever."

The idea appeared in the second season episode 'Tattoo' and contributed to the Doctor's growth, giving him a greater sense of what it meant to be human. Another of Picardo's suggestions, which took a while to bear fruit, opened up a whole swathe of new territory for the character that he never anticipated. "I suggested to Jeri Taylor that the Doctor be an opera fan. I can sing and I have Italian ancestry. I thought it would be funny that a character with no emotional palette at all would be a fan of the most passionate form of human expression. Why would this machine be listening to opera? That was it. Jeri said, 'We're doing some Klingon opera stuff on DS9, so it's not good timing,

ABOVE: Picardo lobbied the producers to let him – and the Doctor – sing opera. He thought the idea of a computer program liking such a passionate art form was funny. The idea of the Doctor having interests outside his job became a key part of the character's ongoing development.

THE DOCTOR AND SEVEN

In 'Body and Soul,' the Doctor hides inside Seven's cybernetics, taking control of her body. As a result, Picardo had the fun of seeing Jeri Ryan play his character. "Jeri loved to laugh and goof off on set, and that's what made it so much fun to see her break that austere and very limited character when she had to impersonate me. She was so hilarious.

"I had done that exact gag in the movie *Innerspace*, with Martin Short," Picardo recalls, "I said to Joe Dante the director, 'Ask Martin if he'll shoot my scenes. I'll watch his performance and pick and choose what I think I can do.' I suggested the same thing to Robbie McNeill, who directed this episode. I think that was very helpful because Jeri hit it out of the park. She nailed the bugging eye rolls that I do. I was delighted by it. At my suggestion we stole a gag from the first *National Lampoon's Vacation* movie, where Chevy Chase goes to his brother-in-law, played by Randy Quaid. Quaid is slugging down a can of beer, and he says 'Hey, would you like a cold one'. Chevy Chase says, 'Sure,' so he hands him the spit left in his beer and pops a new one for himself. We did that exact gag where Jeri Ryan is stuffing down cheesecake, and says 'Hey, would you like a piece?' She hands her two-thirds eaten slice to the guy and then grabs a fresh one for herself. You steal from the greats."

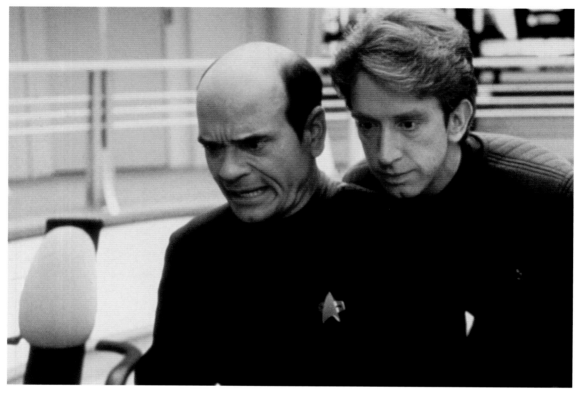

ABOVE: *Because the Doctor was a computer program, he could be transmitted to the Alpha Quadrant. The first time this happens, in 'Prometheus,' he discovers he has been superseded by the EMH, Mk II, played by Andy Dick. The two become a comic double act as they try to save the U.S.S.* Prometheus *from Romulan invaders.*

but we'll keep it in mind.' Sure enough, about nine months later, I got a script called 'The Swarm.' The main story is really an Alzheimer's story. The Doctor's program is decompiling and he's losing his ability to remember things. He's singing opera in a holodeck program and he forgets a lyric. The opera turned into the opening salvo, of the Doctor having interests beyond his designated role. It really symbolized his development as a character: I am not simply my job. I have a life. He was trying to expand his program with recreational activities, which alone is funny since he's designed as a walking first aid kit."

Of course, there were plenty of times when Picardo admits he just pitched funny lines. After several years of playing the Doctor, he had developed a wide variety of hologram jokes. "My favorite joke I suggested," he remembers, "was at the end of 'Message in a Bottle.' The Doctor is piloting the *Prometheus* and they're being fired on by Starfleet because they think the Romulans are in charge. I'm very panicked. I turn to Andy Dick's character, the EMH Mk II, who is hovering over me, and I say, 'Stop breathing down my neck!' Originally that was the only line but I suggested the EMH Mk II kind of chortles and

says, 'My breathing is merely a simulation.' I respond, 'So is my neck. Stop it anyway!' I thought that was a pretty good Frasier and Niles hologram exchange."

One of the other suggestions Picardo made turned out to have a much-more profound impact on the series. During *Voyager*'s first three years, the Doctor had shared many of his scenes with Kes, who played a vital role in humanizing him, so when Picardo heard that Jennifer Lien, who played Kes, was leaving the show, he was concerned. "I went in to Brannon's office," Picardo remembers. "I said, 'My concern is that the Doctor is losing his sounding board, his mentor in humanity. Kes is the one he says things to that he wouldn't say to anyone else. If I lose her, I'll just slide back into being a joke'. Brannon said, 'We're introducing a new character, Seven of Nine, she's a former Borg and she's going to be brought back to humanity.'

"I thought about it and a little later I went back to Brannon and said, 'Okay, suppose we reverse my relationship with Kes. Now the Doctor feels that he is the best person to teach her how to be human. That appeals to all of the Doctor's arrogance, right? I'm convinced I'm a better person to teach Seven how to

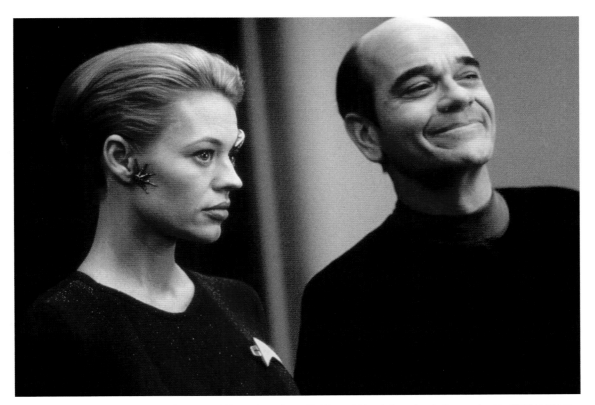

ABOVE: *Picardo suggested that the Doctor would have the vanity to think he could teach Seven how to become human. This became a running gag, with the Doctor and Seven trying out various role-playing exercises. In the process, the Doctor falls in love with his pupil.*

reclaim her humanity than any human would be.' I suggested we could have role-play exercises where I could demonstrate appropriate behavior in different circumstances."

That dynamic culminated in one of the cast's favorite episodes, 'Someone to Watch Over Me', in which the Doctor tutors Seven in dating. "It was very much a futuristic version of Henry Higgins and Eliza Doolittle," Picardo says, "and the Doctor falls in love with his star pupil."

Picardo also has the unique distinction of being the only castmember to have a writing credit on one of the live-action STAR TREK series. During the filming of 'Tinker, Tenor, Doctor, Spy' he became good friends with the director, John Bruno. Together they came up with the idea of a story about the Doctor meeting his creator. Picardo saw it very much in terms of the play *I Never Sang For My Father*, which deals with the conflict between a father and son and each being disappointed in the other. "I thought, here we've got a technological child of a human parent. Why wouldn't it be the same dynamic between Dr Zimmerman, the programmer of the Doctor, and his EMH program MK I? From the engineer's point of view,

I'm just a program. There were hundreds of them deployed on many different ships, so he couldn't accept the Doctor as an individual. The Doctor had all of these non-essential expansions to his program, like opera singing. As far as Zimmerman was concerned, he was designed strictly for emergency medical use, so that seemed not only trivial but downright stupid."

As the series continued, the writers came to appreciate how strong the concept behind the Doctor was, and how versatile Picardo was as an actor. In particular, they responded to the fact that the Doctor gave them the chance to tackle serious themes in a comedic setting. As writer Phyllis Strong explains, "because the Doctor had the chops to be funny we could explore the same themes with a lighter spin."

Looking back, Picardo now says that far from being the worst part, the Doctor was probably the best. "I have heard all of my castmates say, 'your character had the best arc,' which is no credit to me. When you start with a blank slate, you've got the farthest distance to travel. I think conceptually, my character was designed to have the best potential. I couldn't be happier with the way he turned out."

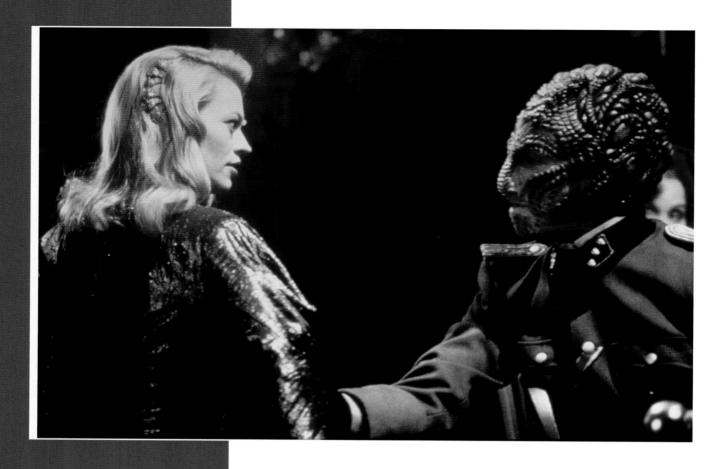

SEASON 4
EPISODES 18/19
AIR DATE: MARCH 4, 1998

Written by Brannon Braga & Joe Menosky

Directed by David Livingston (Part I)
Victor Lobl (Part II)

Synopsis The Hirogen take over *Voyager* and force the crew to fight as holodeck characters in World War II.

THE KILLING GAME

When Brannon Braga introduced the Hirogen, he knew it was all about moving toward a massive two-part story that took *Voyager* to places it had never been before.

Just weeks after their season 4 debut, the Hirogen were back to prey on the *Voyager* crew. While their obsession with hunting and collecting trophies bore a resemblance to Predator, their inspiration came from a more grounded source. 'The Killing Game' cowriter, Brannon Braga, recalls watching *Monday Night Football* with Ken Biller and Bryan Fuller. "I was saying, 'Have you ever been to a sideline near these NFL players – they're huge, seven feet tall and 300 pounds.' And I just started thinking about having those

guys on the show... My inspiration for the Hirogen started as these giants with body armor, with an ethos of hunting. There was definitely a Predator angle in there too."

RIGHT: The Hirogen used the holodeck to create different simulations where they could hunt.

The Hirogen were the perfect vehicle for a subject that writer/producer Joe Menosky had been wanting to cover since his time living and working in Europe. He told *Cinefantastique*,

> **"You wanted a war? It looks like you've got one."**
>
> *Harry Kim*

"I thought it would be real cool to do a World War II episode with our characters, and have a little French town and tanks and our people in GI uniforms. We just never knew how to work it. Once we had the Hirogen, that seemed like a good time to resurrect this World War II thing."

In Menosky's original story, the Hirogen had a planetary holodeck, but Ken Biller came up with the idea of setting the action aboard *Voyager*. "We cut right to the action, didn't deal with the takeover of our ship, and got right into this holodeck story," said Menosky.

The invention of the Alpha Hirogen Karr (played by Danny Goldring) was key to the story's direction. Menosky said, "Brannon and I arrived at the notion that one member of these hunter aliens was starting to question the way his society behaved, in terms of hunting and killing the species around them and what that would lead to. [It was] a metaphor for exhausting your resources. Suddenly, that gives a bad guy some depth." Braga agreed, "With any luck we managed to dimensionalize [the Hirogen] a little bit more and say something about culture."

The World War II setting gave the cast and crew a chance for location work, and provided director David Livingston with his number-one episode. "I did the first part and that was my favorite, because we got to go back and do World War II and Nazis and the heroics that are involved in that. Jeri Ryan became a torch singer. It had so many different elements to do, and we got to shoot on the back lot at Universal in a period village there. All of those elements were a lot of fun to do."

As the chanteuse Mademoiselle de Neuf, Jeri Ryan had a singing role. "I understood that she sang in musicals when she was in high school or college," Livingston recalls. "She did an unbelievable job and that scene is one of my favorite moments in anything I've done. I started off on the piano and ended up on Janeway, and went through the whole room and did this huge, huge Steadicam shot. I loved everything about that episode. It was a total kick."

"Of course, 'The Killing Game' was just a riot," says Ryan. "I got to play Seven as a totally different person. I got to step out of the corset and the catsuit for a while." The VFX crew also had a blast, literally, blowing up the Nazi HQ in Part I. Ronald B. Moore describes the explosion as "probably one of the biggest effects that we've ever done on *STAR TREK*."

The effect required Vision Crew Unlimited and pyrotechnician Thaine Morris to construct a seven-foot replica of the building. The explosion was filmed by three high-speed cameras, two running at 360 and one at 120

> **"They're Nazis, totalitarian fanatics, bent on world conquest. The Borg of their day. No offense."**
>
> *Tom Paris to Seven of Nine*

frames per second. Visual effects producer Dan Curry was impressed with the result. "I thought that episode was particularly cool – one of our more stellar explosions."

The cast were freed from their Starfleet uniforms for most of the shoot. In Roxann Dawson's case, she had even more freedom, not having to hide her real-life pregnancy as the holodeck character Brigitte. "I was able to let it all hang out there," she laughed. "We didn't have to hide it." Ethan Phillips, however,

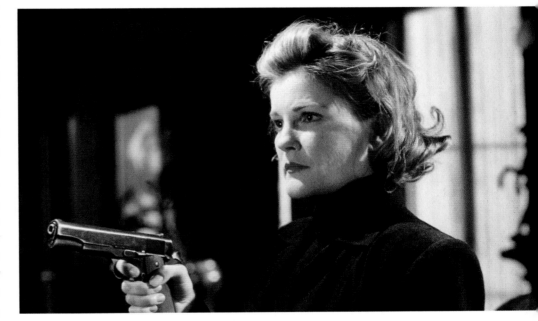

ABOVE: 'The Killing Game' was designed to be ambitious and cinematic. It gave the crew a chance to get out of their Starfleet uniforms and to show their characters in a different light.

had to spend extra hours in makeup. "That was... hell, because not only did I have to have the Talaxian makeup, then I've got to have Klingon makeup on over it," Phillips remembers. "That's a lot of rubber!" But playing a different alien for a change was a lot of fun. "Klingons are outrageous to play," says Phillips. "And they had these big bones, lamb shanks, that we were all sitting around the campfire eating. We sang some drunken songs. It was fun."

Writers Braga and Menosky were delighted with the completed two-parter. Braga says, "It had a lot of scope and adventure, and it also had some interesting themes about how cultures change of necessity. There were parallels between Germany and the Hirogen, and even ourselves."

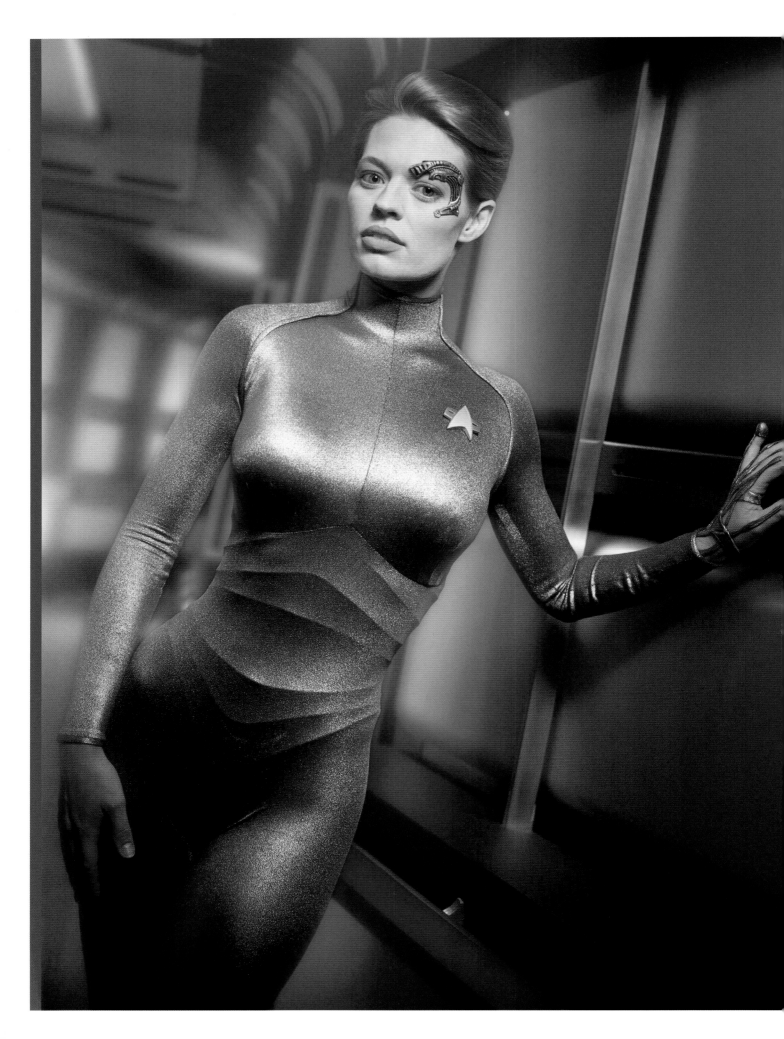

SEVEN OF NINE
THE WOLF CHILD

The former Borg drone was one of *STAR TREK: VOYAGER*'s greatest creations: a reluctant escapee from the Collective who could see the flaws in humanity. She was convinced of her own superiority, but underneath her exacting exterior, Seven of Nine was a vulnerable and tragic figure.

J eri Ryan is nothing like Seven of Nine. She is friendly and funny, and, as she puts it herself, "quick to laugh," but it's impossible to imagine anyone else playing Seven. It stands as one of the great pieces of casting in *STAR TREK*'s history. Seven became one of the franchise's most iconic characters, ranking alongside Spock and Data. "How much of that is Jeri?" Seven's creator, writer Brannon Braga, asks. "How much is the writing? I can't tell you, and that means it's working."

As Jeri Ryan explains, the writing made her job much easier. "This character was so beautifully written," she says, "that it was never a struggle to figure out how I should play a scene. She was a gift as an actor. If you know who your character is and what drives her, then you can just play the words on the page, and play off what you're getting from the other actor."

Seven of Nine was born in February, 1997. Then-supervising producer Braga was at home watching a promo for the *VOYAGER* episode 'Unity.' The story dealt with former Borg drones who were struggling to make a new life. "What if," he thought, "we had a former drone as a member of the crew?"

Braga was so intrigued by the thought that he rang fellow-writer Joe Menosky and the pair rapidly thrashed out the concept. "It wasn't just about it being cool to have a Borg on board," Braga recalls, "it was more important as a galvanizing character for the rest of the crew, and in particular, Janeway."

By the end of their conversation, Braga was so excited that he called executive producer Rick Berman and pitched the character to him. Berman added one final element: make the former drone a beautiful woman. "Originally, I saw it as a more cybernetic-looking creature," Braga remembers. "During the conversation we started to think, do we want a big, rubbery cybernetic thing walking around, or could this be somebody who has a certain amount of sex appeal?"

At the time, *VOYAGER*'s writers were thinking about ways they could give the show more of everything, whether that was sex appeal, action, or romance. As the third season ended, the ratings were solid but they had dipped from the stellar heights of the premiere, and there was a feeling that the show was a bit soft. Braga was taking on an increasingly prominent role and he wanted to create some excitement.

RIGHT: Seven was introduced in 'Scorpion, Part II,' where she acts as a liaison between the Borg and Janeway's crew.

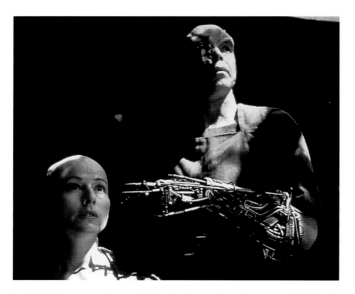

ABOVE: Seven owes her creation to the former Borg who appeared in 'Unity', who wanted to return to the Collective.

"All the characters were working pretty well," he says, "but I just didn't have the thing – that one science-fictiony character. Someone Janeway wanted to understand but couldn't understand; someone who would be a thorn in her side; someone who was invaluable. Janeway didn't have a Spock or a Data. Seven would be a foil for her."

The character would also introduce a new and distinct point of view to the show, and would give the writers the chance to explore the Borg, who were one of *STAR TREK*'s most compelling villains. "Just the mere mention of the Borg got the audience excited," Braga recalls. The foundations of the character were very strong, but casting Seven would be key.

When Ryan first heard about the part, she told her agent she wasn't interested. At the time she was concerned that taking a role in *STAR TREK* could leave her typecast. But, as she explains, the show's casting team managed to change her mind. "The casting director called my agent and said, 'Listen, I really think she should look at this, I think it's going to be pretty special.'" Ryan was intrigued enough to agree to read for the role, so Paramount sent over two scenes that Braga had written as audition pieces. Although Seven would make her debut as a full Borg drone, the scenes showed her later on in her

development, when she had started to regain her humanity. "One of them was my least favorite scene of all time," Ryan remembers, "which was this, 'Oh, you wish to copulate. Take off your clothes' scene with Harry Kim, which I hate because it was just so on the nose. But the second was one of the most beautifully written scenes that I've ever had for any audition. It was a scene with Seven having her first memory of laughter. It was so beautiful, and I could draw upon my experiences with my son, who would have been two-and-a-half at the time. With that scene I saw the potential of the character."

Ryan rapidly established herself as the front runner for the new role. "We read a lot of different actresses for it," Braga remembers the casting process. "We looked at different qualities, different ages. We didn't even have a particular look in mind. Jeri was able to do something that's almost magical to me. She could convey heartbreak and emotion while maintaining the steely veneer of Seven of Nine. That is almost a telepathic ability that I just marveled at."

Of course, Ryan was also stunningly beautiful, and this combination of factors led to her being cast. The studio was keen to push her beauty as a way of getting as many eyes on the show as possible. In the fall of 1997, images of Seven in a

form-fitting silver costume were on billboards all over Los Angeles. Some fans assumed that her sex appeal was the only reason she had been cast. "I was really angry about that," Braga remembers, "because Jeri Ryan created a character that we are still talking about. She's an amazing actress. The character was conceived with anything but exploitative intentions and I knew she was going to make the show better. It really bothered me that people were making assumptions before they had even seen her open her mouth. But that all went away very quickly once they saw Jeri in the role."

Frequent *VOYAGER* director David Livingston adds that Seven would never have been such a successful character, if all Ryan had brought to the table was sex appeal. "The fact that Jeri looked the way she did brought a whole other element to the show, but behind the sex appeal was quite a mind. Jeri is one of the smartest actors I've ever worked with. She's a voracious reader, always reading these really intellectual books on set that I didn't understand. She is really bright, and the way she combined the human side of the character with the Borg side was a brilliant piece of acting."

Meanwhile, Ryan was getting to grips with the character. The producers explained to her that although Seven was a former Borg drone, she was also something we had never seen before. "They showed me *STAR TREK: FIRST CONTACT* and said, 'Ignore that, because we're not doing that,'" she laughs. "They explained that what we were making was a completely new type of Borg."

But before they could get to the version of Seven that was on the billboards, the producers had to introduce her. When Seven first appears on screen in 'Scorpion, Part ll' she is very much a Borg drone. Even so, the producers asked Ryan to imbue the character with a little more life than the typical drone. "They said she's not as free as the Borg Queen, but she's not a complete automaton like the other drones," Ryan remembers. "That was my biggest struggle, figuring out who the Borg Seven was. Even then, she wasn't a full Borg, so finding that was the hardest part of the character for me.

"Rick Kolbe was directing my first episode, and he was the one who really helped me find who she was physically, how she moved, how she walked. A lot of that came from the costume too, because it was really, really restrictive, very stiff. It was made of very tight rubber and fiberglass, and who knows what else. But Rick gave me the image of a Prussian general, shoulders turned back, very stiff, erect. That's what

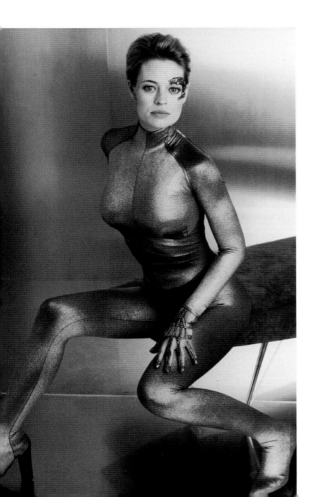

LEFT: *Images of Jeri Ryan in the silver catsuit were a major – and very successful – part of the marketing for VOYAGER's fourth season.*

her physical presence became, which worked great when I was in the Borg costume. It was a little more problematic once I was in that silver cat suit, and I'm locked into that particular physical stance, which," she shakes her head, "wouldn't have been my first choice with that particular costume and that particular fabric."

By the second episode of the season, Seven had shed most of the Borg costume and become a somewhat reluctant member of the crew. At this point, neither Ryan nor the writing staff knew much about Seven. Writer Ken Biller remembers that having her on board instantly suggested dozens of stories. "We all recognized right away that it injected a lot of new energy into the show. Once we had the idea that she was separated from her hive, we knew we had to explore that, because the Borg would be trying to get her back, she would want to return to the Borg, she would be struggling with trying to recover her humanity that was lost as a child. Then we could explore in flashback how she became a Borg in the first place. That opened up tons of possibilities."

The Seven who joined the crew was very much a blank slate. As Ryan says, this didn't trouble her. As an actress, she didn't need to know any more than Seven herself did. "There was no benefit to me coming up with some elaborate backstory about what her childhood was like, because she wouldn't have known that. Her backstory was: she was Borg. That's all she knew. She didn't know her childhood, she didn't remember any of that. She learned that as we learned it. So the only background that I needed to learn was what the Borg are – what drives them."

As Braga had intended, Seven and her Borg point of view created a new set of dynamics that challenged the other characters, who wanted her to be more human. He was influenced by the Francois Truffaut film *L'enfant sauvage,*

which deals with a man trying to save a boy who was raised by wolves. In his mind, however much Seven acknowledged her humanity, she had been a Borg so long that she could never entirely reject their way of viewing the world.

"To me," says Braga, "one of the keys to her is that you've got Jeri Ryan and everything she brings – this ability to convey this cool, icy character who is brilliant, probably smarter than the whole crew combined. She has been kidnapped, indoctrinated, stripped of her individuality and violated in every sense of the word by the Borg, but she doesn't see it that way. The key to a good villain is: how do they see themselves? The Borg see themselves as perfection and they have a very good rationale for it. She's torn. She knows that the Borg are bad, but part of her knows that they are also amazing and there are things she misses about being part of the Collective. She is complex in that way. She's tragic. She can never go back but she can never really be part of humanity."

One of the most important things about Seven was that she helped to further redefine Captain Janeway's character. "The scenes with Janeway were amazing," Ryan says of working with Kate Mulgrew. "They were some of the richest scenes I got to play. They were two really strong characters, Kate's a wonderful actress, and it was really fun for those characters to butt heads. It was a mother/daughter relationship; it was sort of a mother and unruly teenager really."

Braga had created Seven to make Janeway a better character, and he explains that the scenes between them forced Janeway to take a very clear stance on what it meant to be human and had an emotional intensity that was compelling. "That Seven would become a passion project for Janeway was an important dynamic. I really feel it paid off in an episode like 'Dark Frontier.' That was an episode that had a lot of sweep and action, but the best thing about it was the war of the two mothers – Janeway and the Borg Queen – over their daughter. Janeway has to think that Seven has betrayed her but then Janeway saves her from other mother. That's great stuff. You only care about that because you care about their relationship."

Not all of the writers saw the relationship between Janeway and Seven in terms of mothers and daughters. "What I saw," writer Bryan Fuller recalls, "was more like a police officer who was protecting someone rescued from a cult. She's trying to be sympathetic. She's looking at this woman who has been violated to the extreme. She's not seeing a child, but this woman who has experienced something horrific. I'm going to try to protect her and heal her because that's what people in our position should do."

Fuller picks up on Braga's point that Seven would still see what was attractive about the Borg, and that she would see

ABOVE: *We eventually learned that Seven was Annika Hansen, who was assimilated as child when her parents were studying the Borg.*

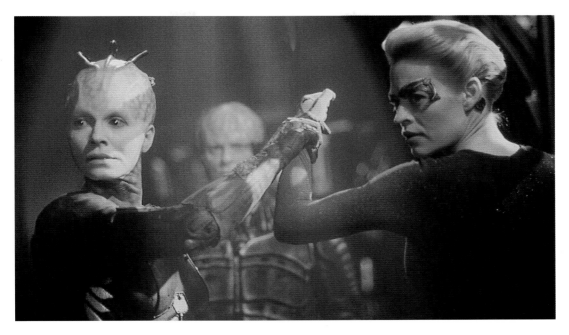

ABOVE: *Seven's relationship with the Borg Queen takes center stage in the double-length story 'Dark Frontier.' Brannon Braga saw Janeway and the Queen as competing mother figures, who offered Seven different routes to happiness.*

humanity's flaws. "In 'Hope and Fear,' there's a conflict between Janeway and Seven of Nine. Seven's saying, 'I'm kind of sick of humanity. I don't want to be human any more. I don't like you. I think you are inefficient. This is not who I am.' You see Janeway bristling and realizing that she's dealing with a traumatized person and she can't just bring the sledgehammer down. She has to listen and guide instead of order."

For her part, Ryan was delighted that the conflict was never painted in simplistic terms. "What I loved about the way Seven was written is that they weren't afraid to show the gray areas. Starfleet and Janeway are not always right and the Borg aren't always wrong. Seven was the perfect character to show that. In the early days there were scenes where she's pointing out to Janeway: 'You condemn the Borg for taking my choice away, but now you've done the exact same thing.' Forcibly separating her from the Collective against her will and keeping her from going back to the Collective. That was the same thing that the Borg had done to her, in her mind."

These beliefs would underpin Seven's approach to life, and give her a distinct identity. "She's such a specific character," Ryan says. "She had an efficiency. The Borg drive for perfection was a huge driving force for her, even long after she was separated from the Collective."

Biller points out that Seven's belief in the Borg way of life made her very different from the other members of the crew, who, in accordance with Gene Roddenberry's vision of the future, were highly evolved and respectful of other cultures. "When you introduce a character like Seven of Nine who thinks she's superior, of course there is a prejudice. She's prejudiced against the mere mortals who can't hold a candle to her. She had so much knowledge from being a Borg. A lot of the best *STAR TREK* characters think they know more than everybody else. That dynamic made the show a lot of fun."

Seven of Nine's utmost belief in her own superiority established a link between her and Spock, another iconic *STAR TREK* character who fundamentally believed in the superiority of his own people. "She's imperious," Braga says. "I'll share with you a little trick. I made very sure that Seven of Nine never once asked a question. There was never a line of dialogue with a question mark in it. Everything had to be declarative: 'State your demand. Explain.' Seven doesn't ask questions. She demands answers."

While the writers were determined that Seven was defined by having been a Borg, it was clear that as the series progressed, she would gradually recover her humanity. How fast this would happen was always a balancing act. "Early on, I think we

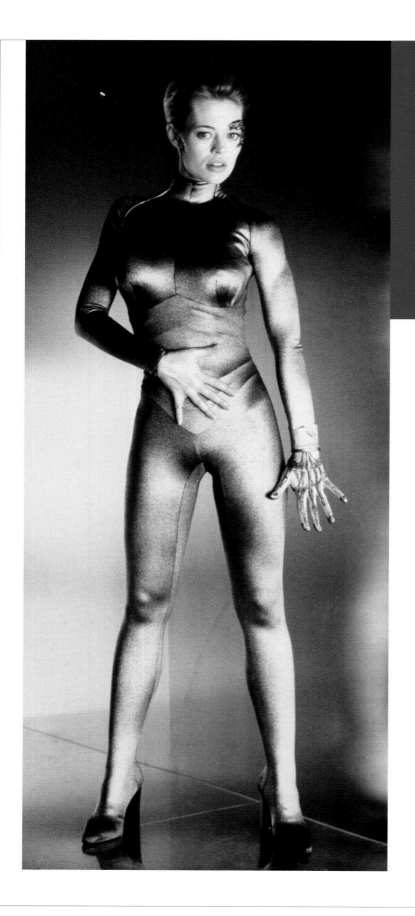

THE
SILVER
COSTUME

It's probably the most famous costume in the history of *STAR TREK*. It might even be the most famous costume in the history of television. It's one of those rare things that is instantly linked with a single character and it was at the heart of a marketing campaign that brought hundreds of thousands of new viewers to *STAR TREK: VOYAGER*. Now that costume seems inevitable, but at the time it was radical and unexpected.

"The gag," costume designer Robert Blackman says, "is that she is completely covered." Like everyone else, Blackman knew that the way Seven looked was designed to bring new viewers to the show, but he was determined that her costume wouldn't be crass and obvious. "They needed something so that guys could look at it and go, 'Oh wow!' But Seven doesn't think about her sexuality, she doesn't use her sexual form, it just happens to be there. It would be foolish not to take advantage of Jeri's figure, her body is too dramatic, but I chose to do it with something that contours her body. We didn't want it to look anything like *Baywatch*, so my agreement with Rick [Berman] and Brannon [Braga] was that we would never show her flesh."

Blackman produced a sketch showing Seven's body completely sheathed in silver,

which he handed to Rick Berman, who took it to the executives at UPN. Blackman remembers that the costume was so radical that the network didn't instantly understand what they were trying to do. "I was on vacation and I got a phone call from Rick. The studio had come back with a red neckline drawn on it that came down and exposed cleavage. He didn't want to do that, but he wanted to talk through the reasoning for what we were doing. The notion is not to give them what they want. As soon as we let them see it, it's over. It's better to tease them for years with it. We never showed her cleavage, eventually we showed that inch below her trachea, but that was so when she sits it doesn't strangle her."

That first silver costume achieved everything that Blackman and the producers hoped for. "Bob Blackman is a genius," says Jeri Ryan. "That costume was very striking, and it got all the attention that was wanted." But there was much more to the silver suit than anyone not working on the show realized. "That costume was a feat of engineering," Ryan explains. The suit itself was made of an incredible fabric that could be stretched in any direction without puckering or sagging when it was released. "That allows you to start molding it," Blackman explains. Blackman wanted the suit to follow the contours of Ryan's body like something you might see in modern dance, but he was at pains to make sure it had a structure, because he felt that a straightforward catsuit would look very dated. "I didn't want the suit to have heavy seams that could be seen. The magic of that suit is, you don't know how it takes its shape. What does it is the underpinning, which is essentially a through-the-crotch torso piece that has the ribs built on it."

This piece underneath the suit looked like a rigid swimming costume or corset. "It was not a stiff, fully-boned Victorian corset," Ryan laughs. "It was not like that at all. But it was a thing! The function of the corset was a) because they don't want to see contemporary bra lines and

things like that and, b) to make it look mechanical and sort of just strange, not totally human. You got the sense there was something strange and vaguely mechanical-looking going on underneath."

Blackman goes on to explain that the corset was so close-fitting that it could take 25 minutes to get in or out of it, before you even pulled the silver suit over the top. "It was really difficult because it had to fit so snug. Just getting the zipper up on the side and not catching Jeri was tricky and so slow going. She was so remarkably patient. Then over that comes the suit, which has about four seams in it, and that's it. Into that there are hooks and eyes to make it all look snug and fit well together."

Getting the suit on was only part of the story. "The highly reflective fabric on the silver catsuit was a nightmare," Ryan says, "because the fabric bruised. It was super thin, very reflective, and if you rubbed up against something or rubbed it too hard even with just your hands, the metallic silver would sort of smudge and bruise. It was a nightmare."

And, Ryan reveals, once she was in the suit, getting out of it was a problem. "I couldn't even undress myself. It was a whole thing. I had a full-time dresser, Jamie Thomas, bless her, who was a doll, who I just adored. Every time I had to go to the bathroom, the production shut down and everybody had to know about it. There's no privacy, so on the radio it'd be 'Jeri's 10-1. Take a break. Everybody go to craft service. Get some coffee.' I'm the new kid, it's already awkward, but I don't want to make more waves, so I wouldn't drink so I didn't have to go to the bathroom and shut down production! That's not a healthy thing, you can't do that."

That nightmare and the difficulty of getting in and out of the costume led to it being retired after only a handful of episodes, but before then it had become a part of STAR TREK history and been part of some of the most iconic scenes ever seen in the series.

BORG DRONE

When Seven of Nine made her debut in 'Scorpion, Part II,' she was a fully assimilated Borg drone and wasn't wearing the famous catsuit. Most of the drones in the story wore the upgraded costumes that had been created for STAR TREK: FIRST CONTACT, but the producers wanted Seven to look a little different. Makeup designer Michael Westmore and costume designer Robert Blackman created an entirely new makeup and outfit for her. "To make these things they take a plaster cast of your entire body," says Jeri Ryan. "You stand there, legs apart, hands holding onto poles in front of you. Then they wrap your body in plaster bandages, which at some point dry and harden, and that means you can't breathe. They have to cut you out of it."

Once Ryan had been freed from the bandages, they were used to make a cast of her body, which the makeup team could use as the basis for a perfectly fitting suit. "They build a suit of neoprene on top of that," Ryan explains. " The neoprene is great, it's what they use to make wetsuits. It's built to cover my entire body up to the neck. It stretches, but then they build the Borg suit on top of the neoprene, They put the rubber and fiberglass and all of those other elements on top of it, even electronics, there were lights in the headpiece."

Ryan wore this suit throughout her first episode, the process of getting into it and through makeup took about two-and-a-half hours. Because of her relative lack of experience with prosthetic makeup, she didn't realize that it was more uncomfortable than it had to be. "When they made the suit, we didn't take into consideration that I was also going to have a prosthetic bald cap, which wrapped around my whole neck and throat. It adds about an extra half inch, which hadn't been allowed for in the suit. So I was wearing a combination of things: the formerly stretchy neoprene is now covered in non-stretchy rubber. I have the prosthetic bald cap over and around my neck. If I turned my head to the side it pressed on the carotid artery and I would get faint. I never actually fainted, but I came close to blacking out. I was afraid to tell anybody, because I didn't want to make a big deal. That was my own fault. I didn't want to make waves so I didn't mention it. Once I finally explained that, okay, this is the issue, they brought oxygen to the set. I remember they were like 'My God, just tell us that!' Then they put a slit in the back and it was a non-issue."

The makeup for Seven's second appearance in 'The Gift' was even more intensive. This time the costume was shown coming to pieces. This meant that the joins in the bald cap had to be covered up, which added another half hour to the makeup process.

The full drone costume was saved for later episodes that flashed back to show Seven in the Collective, including 'Survival Instinct'.

started to make her too human too quickly," Ryan says. "The way I was playing her – which is how I auditioned as the character – was too free and too ready to embrace everything about humanity, I think early on I made her a little too loose. Once we had found who she was as a Borg drone, who she was physically, and who she was with an attitude, then I think we all realized that we were in danger of making her too human. So the writers, producers and I, together, kind of went, 'Ahh, let's pull this back a little bit, give us somewhere to go.'"

Ryan found that each new episode revealed a little more about Seven, allowing her to expand her performance. "There was a steady progression of development that I loved. With every new episode that came out, you learn something new about her or she's learning something new about humanity. I loved every discovery she made and that I got to go along with her. Especially in my first season, most of the episodes would add another color to the palette. Every piece of background or layer being peeled back gave you another little glimpse into what makes her tick. I think almost every episode there was something like that, that you could add to it that was helpful."

VOYAGER writer Michael Taylor says that they didn't have a specific goal in mind, but enjoyed exploring the character as ideas came up. "We didn't have to imagine where she'd end up. You were evolving with her. You knew she was never going to be fully one thing or the other because none of us are. We change but we don't change completely. If we're lucky we're a little more enlightened, a little less full of shit. We never

envisaged an end point for the character, we went on the journey with her."

The idea that Seven of Nine was on a journey to understand her innate humanity was essential to the character's core. Whenever the writers' room crafted a story for her, that sense of discovery was at the heart of what they were attempting to achieve. This underlying foundation is what made the character so attractive to Ryan. "With every new episode you learn something new about her," she says. "I keep saying it was a gift, but truly, that is such a unique, unusual experience as an actor, it really is a gift."

For Braga, the limits to how much Seven could change were essential to her character. "I always saw Seven as an immovable object. She would try things, but they never worked. When she tried to experiment with emotions and love, there's a piece of technology in her that will kill her if she falls in love. That's a great tragedy to me. That episode was called 'Human Error.' It was important because it was the moment we realized this was going to be a tragic character. Because if you can't love, what's the point of living?"

For Braga that tragedy was essential to the character. When it came to the series finale, he argued that Seven should have died. "I wanted her to sacrifice her life to get the crew home at the end. She was always a tragic character in my mind, which meant she could never change that much. I lost the argument. I still think it would have been a real emotional gut punch. But," he smiles, "I guess that would have sucked because she would never have been on *PICARD.*"

ABOVE: Seven could never forget that she had been a Borg. Her body was still full of Borg technology that affected the way she lived, even threatening to kill her if she fell in love.

> "I wanted her to sacrifice her life to get the crew home at the end. She was always a tragic character in my mind, which meant she could never change that much."

■ Brannon Braga on Seven's journey

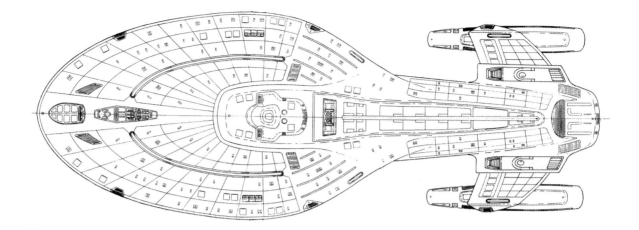

DESIGNING THE
SHIP
INSIDE AND OUT

AN INTREPID STARSHIP

"It is smaller, sleeker, and more advanced than the *Enterprise*. It holds a crew of some two hundred and does not have families on board. Details of the ship will be provided as it is designed."

This concise paragraph taken from the *STAR TREK: VOYAGER* series bible is among the earliest descriptions of the Starfleet vessel that gave the show its romantic, adventure-seeking title. The task for the art department, led by production designer Richard James, was simple: to create, as the prime location of a *STAR TREK* series, the first new hero starship not to be named Enterprise, and make it fresh and distinctive while retaining a familiar Starfleet aesthetic. In short, completely redesign the wheel, inside and out, but keep it the same.

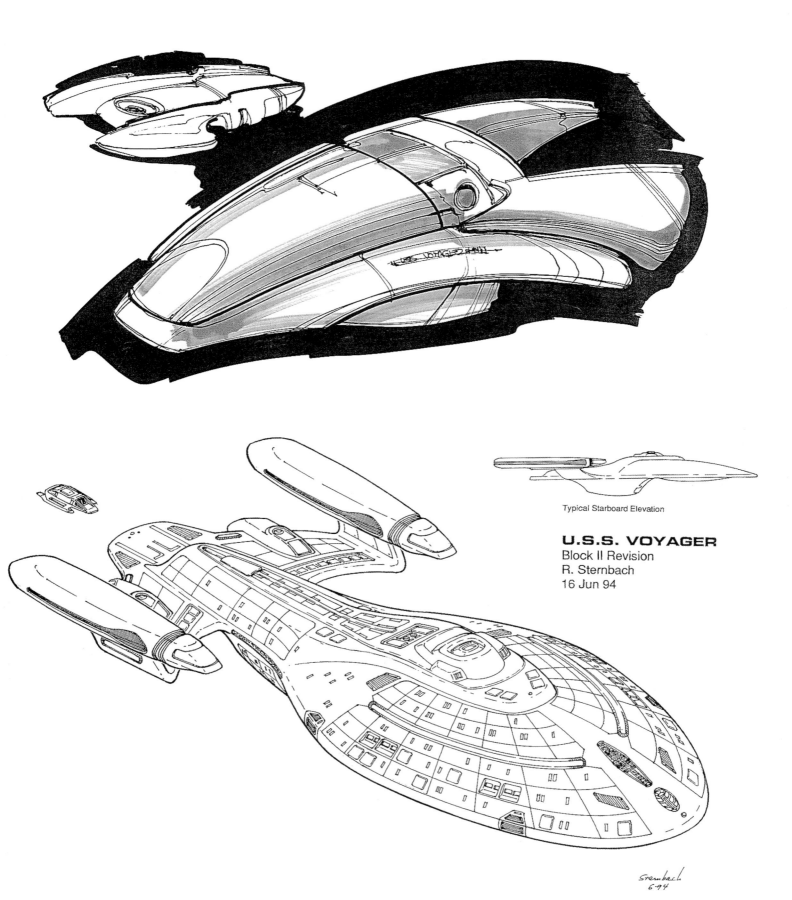

Typical Starboard Elevation

U.S.S. VOYAGER
Block II Revision
R. Sternbach
16 Jun 94

Sternbach
6-94

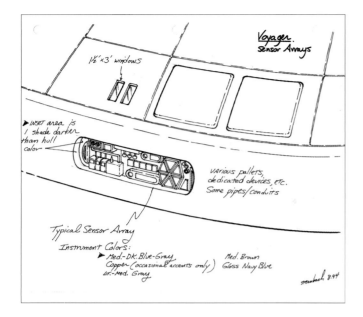

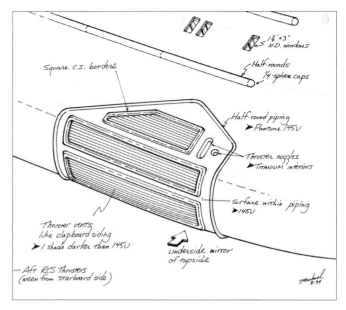

"Something that was different and also recognizable as *STAR TREK*..." says Richard James, who served as production designer on every episode of *VOYAGER* following a six-season run on *STAR TREK: THE NEXT GENERATION*. "I wanted to shake free of preconceived ideas, ideas that had been done before. We did concepts that were unique in many ways."

As production on *THE NEXT GENERATION* wound down in 1994, James and his art team, including production illustrator Rick Sternbach, turned their attentions to concepts for the new entry into the franchise. "I worked with Rick on developing concepts," remembers James. "Other concept artists submitted things too. We would take sketches over [to the producers] of the exterior and the bridge. Once we had a direction on those two items, it would guide the other sets."

"I got to play around with *Voyager* as a ship while we were finishing up on season seven of *NEXT GENERATION*," recalls Rick Sternbach. "I was doodling on script pages, I was doodling on big blank sheets of paper, just putting shapes together. As with lots of other ship and prop designs for the different shows, the stylistic cues could not be in some whacky direction. Starfleet was Starfleet. *Voyager*, like any other ship, Starfleet or alien, began with sketches and doodles."

As Sternbach's ideas for the exterior – described in draft scripts of 'Caretaker' as 'a sleek bullet of a ship' – were teased into being in the first half of 1994, James considered another iconic *STAR TREK* mainstay: the bridge. "We explored the possibility of no forward or aft designation in the bridge."

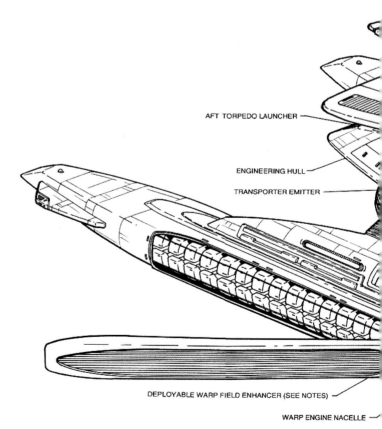

AFT TORPEDO LAUNCHER

ENGINEERING HULL

TRANSPORTER EMITTER

DEPLOYABLE WARP FIELD ENHANCER (SEE NOTES)

WARP ENGINE NACELLE

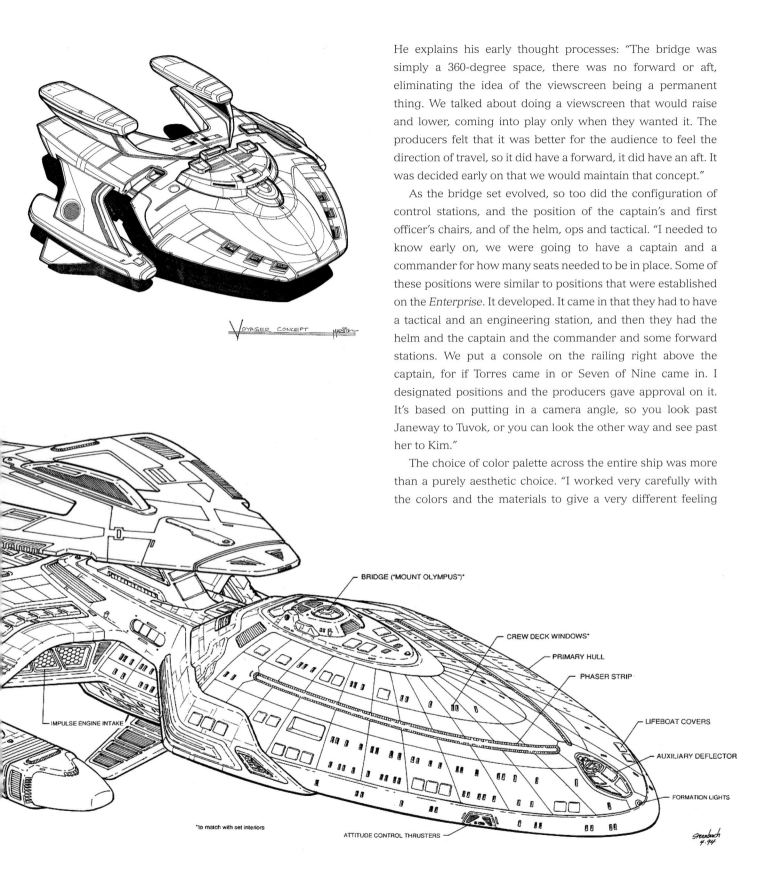

Voyager concept Martin

BRIDGE ("MOUNT OLYMPUS")*

CREW DECK WINDOWS*

PRIMARY HULL

PHASER STRIP

LIFEBOAT COVERS

AUXILIARY DEFLECTOR

FORMATION LIGHTS

IMPULSE ENGINE INTAKE

*to match with set interiors

ATTITUDE CONTROL THRUSTERS

Sternbach
4-94

He explains his early thought processes: "The bridge was simply a 360-degree space, there was no forward or aft, eliminating the idea of the viewscreen being a permanent thing. We talked about doing a viewscreen that would raise and lower, coming into play only when they wanted it. The producers felt that it was better for the audience to feel the direction of travel, so it did have a forward, it did have an aft. It was decided early on that we would maintain that concept."

As the bridge set evolved, so too did the configuration of control stations, and the position of the captain's and first officer's chairs, and of the helm, ops and tactical. "I needed to know early on, we were going to have a captain and a commander for how many seats needed to be in place. Some of these positions were similar to positions that were established on the *Enterprise*. It developed. It came in that they had to have a tactical and an engineering station, and then they had the helm and the captain and the commander and some forward stations. We put a console on the railing right above the captain, for if Torres came in or Seven of Nine came in. I designated positions and the producers gave approval on it. It's based on putting in a camera angle, so you look past Janeway to Tuvok, or you can look the other way and see past her to Kim."

The choice of color palette across the entire ship was more than a purely aesthetic choice. "I worked very carefully with the colors and the materials to give a very different feeling

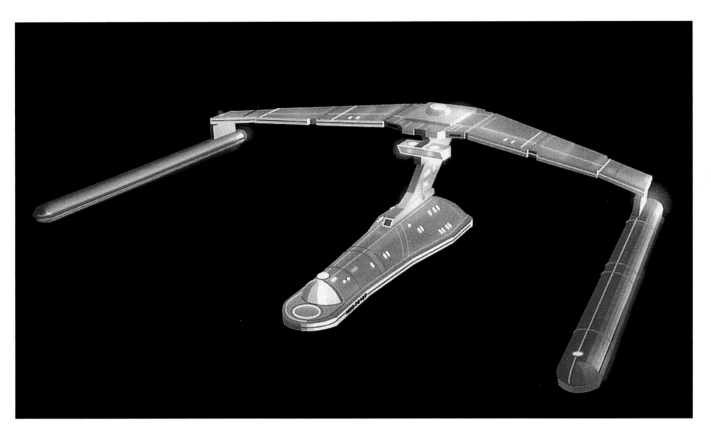

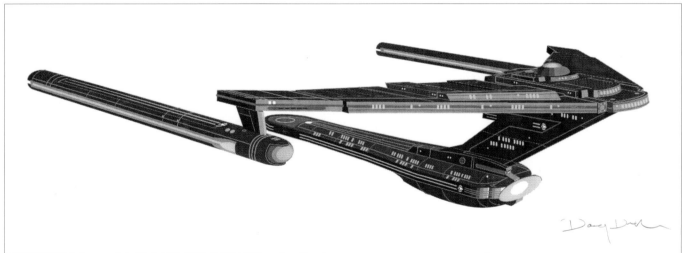

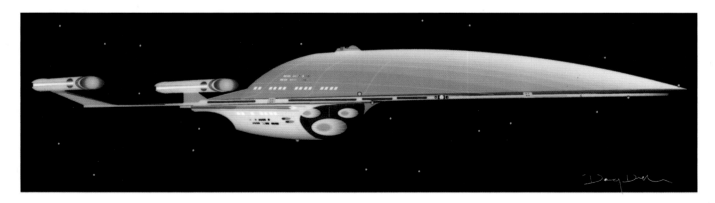

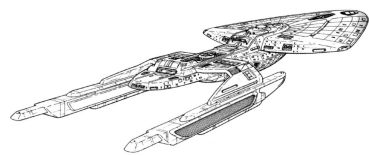

ABOVE: Rick Sternbach's original doodle sketches of Voyager, alongside a refined detailed design before the ship became 'curvier.'

to the ship. Executive producer Rick Berman wanted it so that if people were flipping channels, he wanted them to recognize that it was *STAR TREK*. So it still has a *STAR TREK* look."

To assist with the heavy workload of concepting the *STAR TREK* look of the *U.S.S. Voyager*, *DEEP SPACE NINE* production illustrator Jim Martin was loaned out to James's team during preproduction. "I went through a lot of bridge concepts," Martin remembers. "It was credit to Richard James that he let me have a chance to do some interiors. I decided I would push out and do some pretty unusual things. Some of them did not have a chance, including the odd bubble one. I was in that 'battleship' vein – what if it were a more compact bridge, where everyone was a little bit closer together and the action was really centered on the captain?"

Having designed the *U.S.S. Defiant* for *DEEP SPACE NINE*, Martin also worked up designs for *Voyager*'s exterior. "Rick was lead illustrator doing concept designs for the new ship, so again I took it upon myself to do some pretty far-out ideas. I knew that Rick had a firm hand on Federation design, and the way I can help is to push it out. We'll probably never do it, but maybe some ideas can grow from there. Part of design is just going for it. I did one that was kind of a flying wing, which wasn't going to make it either, but let's put it out there and see what happens. Rick was a gentleman, he guided the final design and delivered a great ship. When you're a young illustrator and only in the second year of your career, it's great to have a very experienced senior illustrator letting you have fun and explore. There was no ego at all. It was, 'Hey, let the kid have some fun, and I'm going to get this done.'"

Sternbach's exterior concepts became more focused throughout 1994, alongside the interior set concepts. "It was a smaller ship with a smaller crew," says Sternbach. "How small? I was doodling and I did a number of small-scale drawings that Rick Berman could take a look at. *Voyager* 1,000 foot long, *Voyager* 1,200 foot long. *Voyager* ended up being around 1,130 foot. Then we presented finished ink drawings to the producers just to see if it's the direction they want to go in. We got to the point that we had a three-foot mock-up based on approved blueprints. We got out the foam core and the bond-over automotive putty. They took a look at it and Jeri Taylor took me aside and said 'Can you make it a little curvier, kind of like a Lexus?' I said, 'Jeri, for you, anything!' That prototype was a perfectly valid starship. It had every element a good Starfleet ship needs. Every element was there, just in a different package."

"Rick had been spending weeks and weeks and did so many great designs," recalls Doug Drexler, who in 1994 was a scenic artist on *DEEP SPACE NINE*. "He sweated the details on them, worked out every little thing because that's the way he is. Then just before the train got there they changed the tracks."

ABOVE: U.S.S. Voyager *bridge concept design by Jim Martin. This adopted a classic Starfleet bridge configuration, with forward stations for the helm and ops, and two rear control stations to port and starboard that are close to the final design as seen on-screen.*

Building on Sternbach's concepts, Drexler took a pass at the ship exterior, incorporating the directive for a "curvier" look. "I remember from reading the script that it looked like a bullet," explains Drexler. "Which is what created that shape of the saucer, it is very bullet-like. It became less bullet like when Rick did the final revision of it that rounded everything off. If you look at it from the left profile, it's not just a bullet, it's almost exactly the profile of the nose and the air scoop of an F-14. Look at some pictures, it's *Voyager*!"

"The final blueprints got the more *Galaxy*-class hull curves, but with *Voyager*'s own take on it, with shorter nacelles," says Sternbach of the finalized design. The design would also take into account one last request from *VOYAGER*'s executive producers, something that had not been seen on any previous starship. "Since the producers wanted something on the ship to articulate, that's how we got the nacelle pylons to go up and down. We gave them maybe six different choices of things that could move. But the pylons seemed to be the parts that would

ABOVE: *Alternative bridge concept design by Jim Martin, featuring a large main viewscreen and unusually positioned control stations.*

ABOVE: *Jim Martin produced alternative bridge designs that adopted a more compact, 'battleship' feel, with the crew closer together.*

make the most visual impact. It would be noisy and exciting.

"From a technical standpoint, years later, I still don't totally understand why the nacelles had to move," laughs Sternbach. "You could say that at a certain velocity regime the warp field flow configurations are better when the nacelles are up, you can start throwing all kinds of words at it. I've learned over the years, you can make things technically accurate or technically rational, plausible, whatever words you want to apply, but for a popular media production, yes, it has to look cool!"

With the design concepts for *Voyager* and the bridge set established, Richard James and his team could extend the show's new visual language out into the corridors and other key areas of the ship. "We coordinated the interiors with the exterior," says James. "We'd give locations to the sets. We certainly showed the architecture of the ship in rooms like the ready room, the briefing room, and mess hall, because the windows took the shape of the ship, and we certainly have that in the design. You have to in *STAR TREK*! A lot of that's done for our own development, but it's also done by keeping in mind that we have to look like we're thinking it through. And we do; we give a lot of thought to it."

In establishing the makeup of interior sets, there is a fine line between true creative freedom and the practical needs of a weekly television drama. "My concern," says James, "was to design and build permanent sets that would accommodate the series, the shooting schedules. I called it 'shooting-friendly' because I created ports that opened and a lot of wild sections that come and go easily enough, that they come in and shoot through to see angles that they had never had the chance to see before. Even though the design might be good, you have to give consideration to whether or not it's easy to do it week after week for seven years."

IN THE DETAIL

Scenic art supervisor Michael Okuda remembers the race against time to put the finishing touches to *Voyager*'s studio miniature. "When it came time to put the markings on the ship, it was a very, very tight schedule," he says. "There wasn't really time. I was able to go down and measure *Voyager*, and I basically had to have everything ready and just go in and do it one night. "

"One thing about Mike Okuda, all he cares about is doing the best job possible in the time available," adds Doug Drexler. "When it came time to launch *Voyager*, Mike wanted me with him."

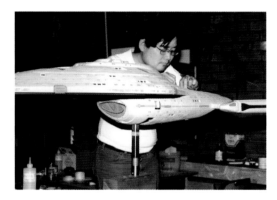

"There were a few things," says Okuda, "where I wanted people who were so steeped in *STAR TREK* and Starfleet tradition that I could say, 'Just do that.' And Doug Drexler was that person. At the same time, both *Deep Space 9* and *Voyager* were so heavy that we couldn't go during the day. "

"In the dead of night, Mike and I packed our gear and headed into the San Fernando Valley for Brazil Fabrications," continues Drexler. "To say that I was excited was an understatement. If I told you that I was not playing the *Enterprise* launch music from *THE MOTION PICTURE* in my head, I would be a big fat liar. So here it was, zero hour, and Mike and I are working gleefully to the finish. Mike and I had to lift the gorgeous model off of its stand in order to work on the bottom. One slip, and your career is over!"

"There wasn't time to finesse it," says Okuda. "I had to have enough variations of things in case something didn't fit or didn't look good. I make it out to be very stressful, which it was, but we were two kids getting to play with a starship!"

BRIEFING ROOM

Located off the main *Voyager* bridge set, the ship's conference room served as an area to accommodate all command crew, the windows following the curvature of *Voyager*'s exterior. This area would ultimately see many late nights of shooting as the series progressed. "We have the curved wall at the end," explains James, "and I wanted the conference table to reflect that. It's almost like a teardrop: instead of being symmetrical, it funnels right down to the captain. Nobody's hidden from her sight." James's design had practical as well as aesthetic considerations. "The table design breaks away and the camera can get in close, sections of the table will break away."

SICKBAY

James explains how the *Voyager* sickbay set evolved during the concept design process. "Sickbay was almost 50 percent larger than it is in the designs," he says. "The fact that [the Doctor] was a hologram didn't influence the designs. Whenever we saw him, he functioned just like a real person. He would just appear in sickbay, and on the holodeck. Then he got the mobile emitter and could travel anywhere with that."

The configuration of treatment areas in sickbay, the Doctor's office, and medlab shifted between the design stage and set construction, highlighting the ongoing and fluid design process throughout a lengthy preproduction period.

"In the original designs, we had a space as large as sickbay on the other side where the medlab is. It was medlab, but it was just a bigger space than it is now. We were running out of room and also money was an issue, time was an issue, so the lab became a smaller space.

"We put the office in the center so that the Doctor could view both sides," adds James. "I positioned the Doctor's office so he could see his patients, he could still survey his kingdom."

MAIN ENGINEERING

Among the largest of *Voyager*'s standing set requirements, main engineering was another element of *STAR TREK*'s familiar starship iconography dating back to the 1960s. James looked to the franchise's film history as a starting point, initially considering elements of forced perspective to create the set. "I would go back to *STAR TREK: THE MOTION PICTURE* to put a new spin on something, and also as part of keeping the *STAR TREK* element. The thing that happens with forced perspective is that you can't put people close to it, and I needed all the space that I could use. There was a lack of space because of the sets, and if you do a forced perspective you can't get close to it or you give away your scale. You can't have action scenes going into that particular area."

Moving away from forced perspective trickery allowed flexibility during shooting. "I felt it was worth sacrificing the space

with trying to make your lines create [the impression] that it goes on. We did a layered look so at least people can still play in the area. It's really three stories high. You want the warp core to be the focal point of the room. We spent a great deal of time coming up with the look: I didn't want neons going in a relay, that had been done before."

The warp core effect was achieved practically, with an ingenious blend of lighting effects, rotating foil, and rear-screen projection. "We could go faster, slower, and we had colored gels. It created the movement that really looks like gasses moving around inside. And it's on set rather than having to be done by visual effects."

CREW QUARTERS MARTIN

CREW QUARTERS

The crew quarters seen throughout the series once again emphasized James's practical approach to design, with just one single set serving as the various quarters for the crew.

"The space was permanent," James outlines, "but the interior walls had beams built into the set; we had channels and the walls could go in and out of those channels. It was modular, each segment we called a bay, and you could give it two bays, three bays, or one bay, depending on the importance of the character whose quarters it was to be. Of course, Captain Janeway

had four bays. We had crew quarters that were without windows, inside the structure of the ship, so you have walls that are just straight up and down."

Once brand-new sets had been designed and blueprints for an intrepid new generation of starship signed off, preproduction on STAR TREK: VOYAGER proceeded at a furious pace in the spring and summer of 1994. The feature film, STAR TREK GENERATIONS, wrapped on Stages 8 and 9 on the Paramount Pictures backlot in late May, bringing to a close one chapter of the STAR TREK story.

While the U.S.S. Voyager itself was realized as both physical and digital

starship models, set construction began in earnest for the new show, Voyager's bridge taking shape where the Enterprise-D's bridge set had stood for six years. The franchise had a home on Paramount Stage 8 dating back to 1978 and production on STAR TREK: THE MOTION PICTURE. A new crew was about to take up residency, and thanks to Richard James, Rick Sternbach, and the art department team, they had a fine ship that would see them through seven seasons, 172 episodes, and 70,000 light years to home. "I really wanted to explore the unexplored..." Richard James reflects on his personal STAR TREK journey.

THE LOST AEROSHUTTLE

Rick Sternbach had a hand in developing one more ship that ultimately remained unseen in *VOYAGER*'s run, but has nevertheless entered fan lore: a captain's yacht otherwise known as the *Aeroshuttle*. "I still like the *Aeroshuttle* as a concept," he says. "Something that would very naturally fit into *Voyager*. I will take credit for the bottom of the *Aeroshuttle*. The top of it was really developed over at Foundation Imaging, based on a few very early sketches I did called the *Manta*

Shuttle. I was very sad not to see it, but I was glad that Foundation Imaging did a test shot of it undocking and coming out from underneath the ship. We at least know that it could have been done. If you have to shoot more library shots of the ship with the *Aeroshuttle* missing, that comes down to economics."

Adam 'Mojo' Lebowitz and Rob Bonchune of Foundation Imaging animated a digital spec sequence of the *Aeroshuttle* leaving *Voyager*. "It was

a little bit more of my design, although not final," recalls Bonchune of his work on the sequence. "Even though it wasn't used, that was fun to do. Mojo and I did that on spec, so I built the *Aeroshuttle* and the little recess that it went into. Mojo animated it flying through the atmosphere, I did the lights and the way it drops out. Ultimately it was not used, so theoretically it's non-canonical. I had much more elaborate plans for what it should look like."

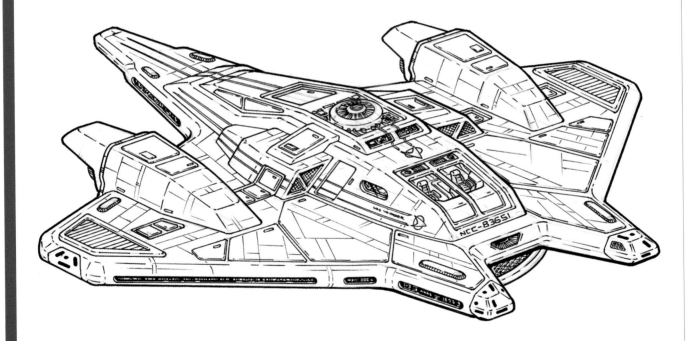

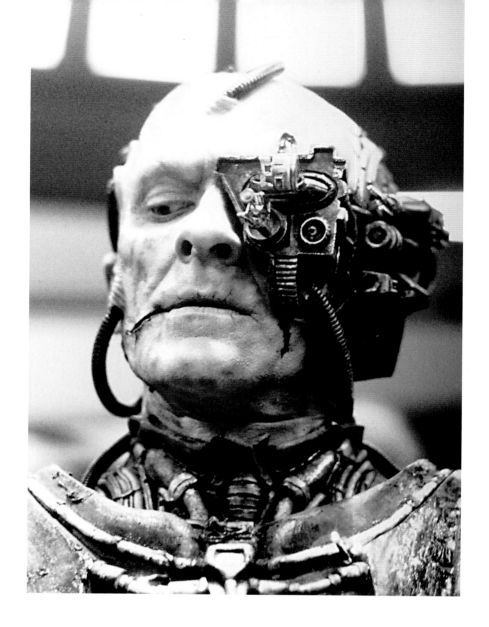

THE BORG

IN SEARCH OF PERFECTION

OYAGER's producers always knew that the Borg were waiting in the Delta Quadrant, but during the first two seasons, they were off limits. As writer Brannon Braga explains, they were a big part of the STAR TREK: THE NEXT GENERATION movie, FIRST CONTACT, released during VOYAGER's third season. "We didn't want to put the Borg on TV until FIRST CONTACT had its run."

Once the movie had been released, things changed, but it still wasn't a given that the Borg would play a major role on VOYAGER. Everyone knew they were some of STAR TREK's most compelling villains, but they presented the writers with problems. The Borg were so powerful that they couldn't be

used indiscriminately. If you kept defeating them, they stopped being so scary. The Borg were not interested in philosophical debate and had no obvious culture to explore. But FIRST CONTACT was a big hit and the Borg were massively popular. Almost as soon as the movie was out of theaters, the Borg made their debut on VOYAGER, in an episode called 'Unity.'

The script was written by Ken Biller. "I could be wrong," he says, "but I don't think we had the idea that the Borg were going to become the ongoing villains. 'Unity' was just a cool idea. We were in the post-Cold War era. The Soviet Union had come apart and Russia was this emerging democracy, but it was riddled with crime and corruption. The idea behind that

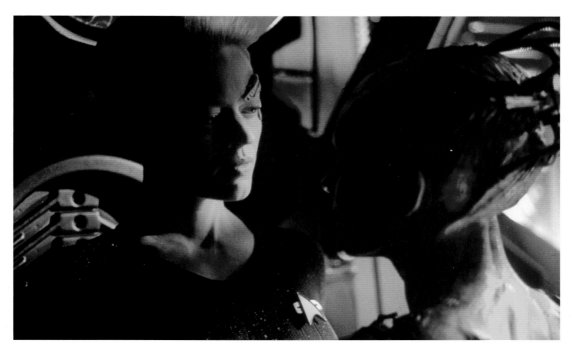

ABOVE: *Once Seven was on board* Voyager, *the writers had an easy way to explore how the Borg viewed the world. The longer she spent with the crew the more human she became, and she found herself in conflict with the Borg Queen, who believed that she had given up Borg perfection in favor of weakness.*

episode was that, like the Russians, these people who had been Borg were impoverished and miserable, fighting among themselves and disunified. They decided that they wanted to go back to the old Soviet days and have a dictator – to go back to the Borg Collective. We had one good concept for a single episode about people who want to go back to being Borg."

That approach to the Borg would turn out to be important, since it inspired Braga to suggest putting a former Borg drone on the crew and have her confront the same issues. Once Seven of Nine was in place, the writers had a different way to deal with the Borg without having to confront them every week. As Braga puts it, "Seven of Nine allows you to explore different aspects of the Borg so they're not just a faceless horde, which gets boring very quickly."

Seven was introduced in the two-part story 'Scorpion,' which also addressed the issue of how *Voyager* could survive an encounter with the Borg. The story opens with the crew discovering a cube that has been devastated by Species 8472, a race of aliens that even the Borg feared. "The origin of that show," Braga recalls, "was the idea that there's an alien out there that is even worse than the Borg, and Janeway ends up having to get in bed with the Borg to save everyone."

Kes's evolution at the end of 'The Gift' allowed *Voyager* to accelerate through most of Borg space, but they would still be

a recurring presence for the rest of the series. As Braga puts it, from this point on, they would become "*VOYAGER*'s Klingons" – the recurring villains that everyone remembers.

FIRST CONTACT had a profound effect on the way the Borg were presented. At a purely practical level, the movie's budget had provided for a massive upgrade to their costumes, which were now much more sophisticated. Equally important, the movie had given the Borg a point of view. In their early appearances, they were simply a monolithic race that assimilated every culture they came into contact with. But the movie had introduced the Borg Queen, giving them a voice, and revealing that they had a philosophy. "All sorts of themes came out of *FIRST CONTACT* that we would end up using," Braga explains. "The idea came out that they're after perfection, and that would resonate to *VOYAGER*."

Braga was keen to make sure that the Borg were never presented as mere villains in their VOYAGER appearances. "The Borg," he says, "believe that they are helping others by bringing them to perfection. That's a strangely philanthropic goal. They have their own point of view. It was about individuality versus the hive mind. It's kind of heinous, but you can't say it's wrong. It's just their thing, and they're right on some level. Maybe it is a state of perfection. The fact that they're imposing it on others is what's wrong."

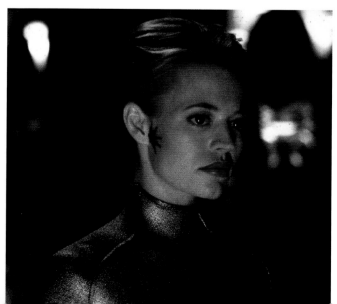

Seven would be a constant presence, who expresses the Borg point of view, which valued efficiency and collective consciousness over individuality. Episodes like 'Mortal Coil' established that the Borg aren't concerned with death because their consciousness is stored in the Collective, while 'The Omega Directive' explored their obsession with perfection.

> ## "Janeway's the surrogate mother and the Queen's the natural mother. You put Seven in the middle, and she's torn..."
>
> ■ Brannon Braga

If you take Seven out of the equation, the Borg make surprisingly few appearances on *VOYAGER*. As Braga says, it was important that they were "used sparingly because we don't want the audience to grow tired of them." The next major confrontation with the Borg would take place in 'Dark Frontier', a two-part story in the middle of *VOYAGER*'s fifth season. This story saw the Borg Queen make her TV debut. Alice Krige, who had created the role in *FIRST CONTACT* wasn't available, something that Braga remembers being profoundly disappointed about. "I was bummed," he nods. "I read a lot of actors as the new Borg Queen. Including some actors that I was a huge fan of. We cast Susanna Thompson, who was able to capture the Borg Queen's voice, but also bring a little of her own thing to it. My rationale was a) most people won't notice because of the heavy makeup, and b) the Borg Queen could constantly be a new person."

The Queen and Janeway would become surrogate parents for Seven, offering her competing points of view. "It was a triangle," Braga explains. "Janeway's the surrogate mother and the Queen's the natural mother. You put Seven in the middle, and she's torn about her loyalties. Ultimately, she chooses Janeway, but it becomes an archetypal emotional struggle done with the Borg on *STAR TREK*, and it's something the audience can relate to."

LEFT: 'Unity' (top) introduced the idea that former Borg might want to return to the Collective. This led to the creation of Seven of Nine (bottom), and the Borg children who joined the crew in the sixth season (center). All these characters could express what it was that appealed to them about having been Borg and how hard it was to lose that.

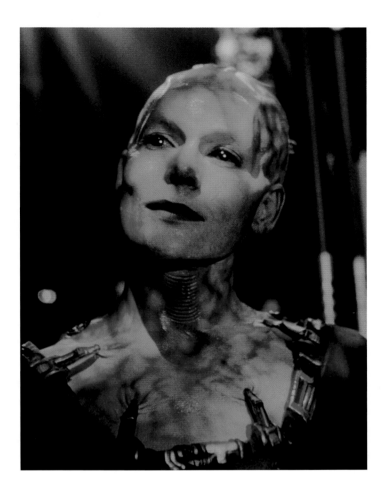

LEFT: Alice Krige, who had created the role of the Borg Queen in FIRST CONTACT, returned to the role in VOYAGER's finale. She wasn't available for the Queen's earlier TV appearances, when the role was played by Susanna Thompson.

In the sixth season the writers would return to the theme of what it meant to be a former drone when they brought a group of Borg children on to the ship. As writer Michael Taylor remembers, the story explored an unexpected element of what it meant to be a Borg. "A freelancer had a pitch about Borg children. I remember Brannon writing a scene with a Borg kid looking at an older kid who has grown a new implant and saying, 'When am I going to get one?' This covetous feeling that this young Borg has."

The children would open more story possibilities, but the emphasis was always on them as individuals, rather than the Collective itself. The next story to really focus on the Borg, 'Unimatrix Zero', revealed that they had problems of their own, and that some drones regained a sense of their individuality when they were regenerating and visited a form of virtual reality. The Borg Queen is clearly threatened by this and takes increasingly desperate measures to gain complete control of the drones, while Janeway works to restore their individuality when they are awake. "We didn't want to just wheel out the Borg Queen," Braga recalls. "We wanted to show new dimensions, so we thought it would be fun to see the Borg Queen unravel a bit. She's never been threatened before and suddenly there are drones all around her, but she can't hear their voices. She's losing her children and it's freaking her out."

It was inevitable that the Borg would feature in *VOYAGER*'s series finale. The Queen returned for a final appearance, this time played by Krige. Once again, Janeway is on the offensive. This time a future version of the captain – now an admiral – infects the Borg with a pathogen that disrupts their sense of order. In their final confrontation, the Borg Queen is literally torn apart, the Unicomplex is destroyed and *Voyager* blasts her way out of a Borg sphere to arrive at Earth.

Brannon Braga

WRITERS
IN THE ROOM

Creating a constant stream of inventive and intelligent
stories was one of *STAR TREK*'s greatest challenges.

Every year, *VOYAGER*'s writing staff would assemble and wonder how they were going to come up with ideas for 26 episodes. It didn't matter how talented the actors were or how brilliant the visual effects could be, if the script was no good, the series wouldn't be either. Ken Biller, who ran the writers' room in the final season, remembers that they were always under pressure. "The worst day was always the beginning of every season," he says. "The dread of, 'Oh my God, how are we going to do this, how can we come up with 26 fresh, original stories?!' That was the worst."

The way the writers came up with stories very much reflected the personality of the showrunner, who would give a story the go-ahead and shape the way it evolved. In the course of seven years, *VOYAGER* had four showrunners, which means that the show can effectively be divided into various eras. In the first two seasons, the writers' room (and it was literally a room, where the writers would meet to discuss stories) was run by Michael Piller and Jeri Taylor. Piller left at the end of the second season and Taylor took sole control. Brannon Braga was groomed to take over from her, which he did when she

retired at the end of the fourth season. Braga himself stepped away in the sixth season to create *STAR TREK: ENTERPRISE* and Ken Biller took his place. They all reported to Rick Berman, who was in charge of every aspect of production.

Piller (who died in 2005) was very much involved in setting *VOYAGER* up, but in 1995 he had also sold another series called *Legend*, so during the first year he was busy with that show and wasn't a constant presence. That changed in the second season, when he returned to run the writing staff full-time.

Piller had been responsible for reinventing *STAR TREK: THE NEXT GENERATION* in its third season and had played a major role in its success. He had a particular idea of what *STAR TREK* should be, which often revolved around the captain being confronted by a moral dilemma. He loved episodes like 'Tuvix' and 'Meld.' As Jeri Taylor remembers, "Michael was a brilliant writer. He had a certain kind of storytelling: dark, extremely intellectual – he loved an intellectual argument."

Piller's influence on modern television is profound and an extraordinary number of people who he recruited to work on *STAR TREK* went on to run their own shows. "He was a teacher,"

Taylor says, "but," she adds, "he could be a stern taskmaster." Piller's story notes could be brutal, and there cannot be a writer who worked for him who was not bruised by the experience. At the same time, Brannon Braga remembers, he could be incredibly supportive and he played to the strengths of his staff. "God bless Michael Piller," Braga says. "It was very rare I had to write something I didn't want to."

Another of *VOYAGER*'s cocreators, Jeri Taylor, was with the show for the first four years. While Piller was there, she shared showrunning duties with him, but once he had left, she was in sole charge. While Piller was normally focused on the ideas behind a story, she says that she was always concerned about how the story itself made you feel. "I have always believed that art needs to touch the emotions not the intellect. Engaging the mind is interesting, but I don't think it really gets to the heart of what it's all about. To me, it is that emotional aspect of a story that has the power to endure."

Taylor describes herself as being more of an Earth mother figure, who tried to empathize with her staff of (mostly) young men. Under her stewardship, the atmosphere among the writing staff became more relaxed. "I was the facilitator," she says. "I gave them more freedom and tried to make it easy for them to do what they did, and they rose to the occasion."

At this point, Brannon Braga started to step up to take on more and more responsibility. He had always been attracted to high-concept, experimental storytelling. "I wanted to try new things," he recalls. Unlike all the showrunners who had come before him, he'd started his career on *STAR TREK*.

Any writers' room depends on the chemistry of the people who are in it, with each writer contributing their unique point of view and taste in storytelling. Between the third and sixth seasons, Joe Menosky was one of the essential components of *VOYAGER*'s writing staff. Like Braga, he was a veteran of TNG and had written some of its best episodes. As Bryan Fuller, who joined the writing staff in the fourth season, explains, Menosky had no interest in running the show. "Joe doesn't want to be in charge. He doesn't operate that way. He just wants to do good work. He's a true artist in that sense. He would always find a fresh angle and he was a great inspiration to the writing staff."

Michael Taylor, who joined in the fifth season, remembers how invaluable Menosky's notes were to his own development. "The words he would cross out, or the few words he would write in, would just make a line perfect. The elegance of his writing and his ideas helped me become a better writer."

As Braga took on more and more responsibility, he had less time to concentrate on writing his own scripts, and as a consequence, he and Menosky started to work closely together. "Joe and Brannon became a unit," Fuller recalls.

PUTTING SCIENCE INTO FICTION

André Bormanis served as *VOYAGER*'s science consultant and as a scriptwriter, keeping the show's scientific accuracy on the right side of Warp 10 – mostly…

"*VOYAGER* was literally an opportunity to go where no one has gone before," says Bormanis. "My job was to read outlines and scripts, note any technical questions, terminology, science ideas, and weigh in on how I look at those things. Very often I would see in dialogue the word 'TECH.' The writer needed a technical term here to describe something. I filled in the blanks and gave them some options.

"Sometimes a writer would call me and ask about a story element, a comet, for example. They'd kind of know what a comet was – a snowball in space – but they wanted to know how big they were, what they're made of, and when the tail starts growing. We'd spend an hour or so on the phone talking about comets and they'd take that and incorporate it into the script."

"They wrote really well together and balanced each other out in a wonderful way."

Braga would often develop story ideas with Menosky before bringing them into the room. For example, when he had the idea of adding a Borg to the crew, he called Menosky before discussing it with anyone else. The conversations between the two men helped to form Braga's agenda, which was to make the show more ambitious and cinematic. That desire led Braga

ABOVE: *Every writer has their own way of generating stories. Brannon Braga would often start with an image, without knowing what it meant or how it fitted into anything. For 'The Killing Game,' he told the writing staff that he had an image of Hirogen hunters dressed as Nazis, and from there they developed the idea that they must be on the holodeck, which gave them the perfect opportunity to hunt.*

to develop more two-part stories, all of which were written by Braga and Menosky until the end of the sixth season.

Braga would often build stories from an image. Fuller remembers how "Brannon would often start with a visual or a sequence, and we would build a story around it in an exciting way. He would come in and say, 'We open with the crew being assimilated,' and we would say, 'Yes, and…' 'The Killing Game' was all about wanting to see the Hirogen in Nazi uniforms. We unpacked that and worked out how it could happen."

To give another example, 'Timeless' began with a vision of *Voyager* buried under ice. It was often during Braga's conversations with Menosky that the image became a fully fledged story. Rick Berman, though not actually in the writers' room, was still very involved in shaping the stories, since he had the ultimate power to say 'Yes' or 'No.' When Braga started work on 'Distant Origin,' the idea he had was of "dinosaurs with AK-47s." It was Berman who said that the story should be reworked as a science-fiction version of the trial of Galileo.

Berman was also very clear that he didn't want to change the format of the show. As Braga points out, TNG had been a huge success and there was a feeling that since the formula wasn't broken, they shouldn't stray too far from it. Nevertheless,

the writing staff often got enthusiastic about pushing the boundaries of what could be done in *STAR TREK*. As Fuller remembers, "Brannon loves horror, Brannon loves science fiction, and we would have all these forward-thinking ideas about how to tell those kind of stories in this format."

One of those ideas was that 'Year of Hell' could have lasted a whole season. In the story, *Voyager* has an increasingly difficult time after the Krenim attack the timeline. The ship is damaged and several members of the crew are injured. Berman, however, felt that stretching this out for a year was going too far, and insisted that the story be kept to two parts.

That tension resulted in some of *VOYAGER*'s most productive years, with Braga and the writing staff pushing to make the show more experimental, and Berman pulling them back to the elements that had made TNG so successful.

Time pressure also played an important role in how stories were written. The writing staff had to produce 26 episodes a year, with only two weeks off. Experimental ideas often required more work, which involved time that simply didn't exist. As Michael Taylor recalls, anyone who joined the staff had to be able to consistently deliver a very high quality of work on a tight schedule.

"It was a sink-or-swim environment. The question was 'Can you cut it?' My first episode was overly long. There was a lot of imagination in it, but there were a lot of issues. I remember being brought down to the office and I was given to understand that I had one week to rewrite this script or that would be it. Later that day I was at the ATM getting some money, and Joe, who would become my mentor, walked past and said, 'What's the matter, Taylor? Going to Mexico?' Fortunately, I turned the script around and everyone loved it. That gave me a lot of confidence."

Although the environment was tough, all the writers see *VOYAGER* as a place where they became better at their craft. Rob Doherty, who would go on to create *Elementary*, describes it as like going to film school. "On *VOYAGER* I learned how a story got built, more than just beginning-middle-end. It was how to be elegant. It was important to see a group of people craft a story together."

The job of being on the writing staff only got harder as the series progressed. When *VOYAGER* debuted, there had been just over 300 episodes of live-action *STAR TREK*; as it entered its final season, that number had grown to 579. The challenge the writers faced was how to keep coming up with new and interesting stories without radically changing the format. By this point, Jeri Taylor was a consultant who gave her thoughts on every script "There had been so

ABOVE: *The writing staff were all drawn to different characters but the Doctor was a firm favorite because he was a high-concept character that sparked off a lot of stories.*

many incarnations of *STAR TREK,* so many stories, so finding a fresh story becomes increasingly difficult as the years go by."

In this situation, the writers were very grateful for high-concept characters such as the Doctor and Seven of Nine, because their very natures instantly suggested stories, so it's not surprising that they came to dominate the later seasons. When Biller took over the show in the final year, he pushed for more serialization so that the staff could give the characters ongoing storylines. This was a departure for the show. In the 1990s, there were no streaming services that would allow people to catch up with the story, and research showed that a significant number of viewers only saw half the episodes. One of Berman's concerns was that too many people wouldn't know what was going on. But as this was the final season, Biller was allowed a little more latitude.

By the time the series reached its end, *VOYAGER* had come a long way. In seven years, both the show and the writing staff had evolved. The stories were told very much the way they had been on TNG, but the palette had been broadened and those high-concept characters, like Seven and the Doctor, had allowed new territory to be explored. Somehow, the writers hadn't just come up with 26 stories; they had come up with nearly 170, many of which are among the most innovative, entertaining, and ambitious stories ever told on *STAR TREK.*

DEBBIE HARRY IS LOVE PERSONIFIED

STAR TREK's voracious appetite for stories meant that the staff did something unusual: at Michael Piller's instigation, they took pitches from anyone who would sign a waiver. Typically, on a Friday they would sit in their offices and listen to countless story ideas. A handful of those ideas became stories, but there were many, many more that didn't make the grade.

"One of the most entertaining pitches," Bryan Fuller remembers, "was from a guy called Robbie Jacks who was

a friend of Garrett's. He was also friends with Debbie Harry, so all of his pitches revolved around Debbie Harry playing a mysterious alien species that would come to *Voyager* and spread love, because she was love personified. He would talk about her gowns, and he would well up as he told me how kind and beautiful Debbie Harry was. I tried really hard to push those stories through because I am a HUGE Debbie Harry fan, but," he laughs, "no one would go for it."

SEASON 5

EPISODE 6

AIR DATE: NOVEMBER 18, 1998

TIMELESS

Voyager hits a century and (almost) everybody dies, Harry Kim gets a major episode and a poor math grade, plus there's a message from a *NEXT GENERATION* alumnus.

Teleplay by	Brannon Braga & Joe Menosky
Story by	Rick Berman & Brannon Braga & Joe Menosky
Directed by	LeVar Burton
Synopsis	A failed attempt to return home results in *Voyager* crashing on an ice world and the crew dying. The only survivors, Chakotay and Harry Kim, 15 years later try to alter history and save the ship.

It was important to Brannon Braga that *VOYAGER*'s 100th episode was one of the best. In the end, the show would involve the crew getting home, a guest appearance from a TNG cast member, and allow Harry Kim to save the day. The trigger for 'Timeless' was an image that stuck in Braga's head: a shot of *Voyager* buried under ice. Story editor Bryan Fuller remembers being in the writers' room at the time. "It was very exciting. That episode really started with an image. We were talking with Joe Menosky and Brannon Braga, and the central image of that show was *Voyager* crashing in the ice and sinking, and finding the crew frozen decades later."

The job of creating that powerful image landed in the hands of VFX supremo Mitch

ABOVE: VOYAGER's 100th episode was a big deal and executives came to the set to celebrate.

Suskin at Image G. "The biggest problem with that was conceptual," he told *Cinefantastique*. "Even though Brannon Braga had imagined the ship being shown under 'tens of meters of ice,' nothing would actually be visible from the planet's surface if the vessel was under that depth." But Braga was insistent and the image was finally realized using a digital matte painting by Eric Chauvin.

Another major shot was *Voyager*'s crash-landing on the ice planet. A half-page of teleplay provided little guidance. "It's something we barely scripted," remarks supervising producer and cowriter Joe Menosky, "when

> **"I'm no time-travel expert, but can't we just call** Voyager **again? The past isn't going anywhere."**
>
> *The Doctor*

Voyager plunges out of space, down through the atmosphere of this ice planet, and then does a belly flop on this glacier and crashes into the screen."

Mitch Suskin said, "In the end we decided to do the combination of CG crash and actual filmed elements." VFX producer Dan Curry elaborates, "Mitch Suskin at Image G made a tableful of baking soda and shoved a rake through it, then composited the miniature ship into it. It looks so real because they were real particles."

Garrett Wang added gravitas to his portrayal of the older Kim: bitter, sarcastic, and blaming himself for the death of his crewmates. "What I brought to the older Kim was somebody who had been completely focused, or obsessed really, with saving the crew, changing the timeline," says Wang. Even the younger Kim seemed determined to see through the quantum-slipstream flight. Being forewarned that the launch was doomed, added tension to the scene of Kim and Chakotay guiding *Voyager* in the *Delta Flyer*.

A guest star who added prestige to the 100th episode was enrolled late in the day. *Next Generation* star LeVar Burton, already hired as director, remembers, "I got a call one

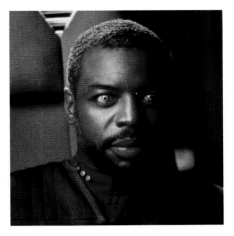

ABOVE: In this future, Geordi has risen to become a captain who is trying to protect the timeline.

Sunday afternoon from Brannon, who said, 'I'm just kicking around an idea, but before I start running with this, I want to know how you would feel about making a cameo appearance as Captain La Forge.' I laughed and said, 'I don't know. You write it, and we'll talk.'" About the script, Burton later enthused, "I thought the first draft was pretty good, and then with every set of revisions, it just got better."

It was the visuals that most inspired Joe Menosky. "What I think made 'Timeless' work was the imagery, the Doctor up in the *Delta Flyer* holding Seven's skull, and the mussed-up, tough, cynical Kim. Things like this are the things that I think carried that episode."

Despite the heavy production schedule, time was allotted to recognize the show hitting 100. Bryan Fuller recalls, "We had a huge cake. The entire cast was there, writers past and present, cast members that had come and gone. All came to tip their hat."

So, did the team deliver on the promise of the best episode of *Voyager*? "You could argue that it is one of the top three or four," says Wang. "The fact that it was all Kim made me feel like I did in the pilot – it's all about my character." Braga was enormously proud of the finished result. "It's filled with striking imagery and character moments. The image of a frozen ship is just perfect. If that had been a *Next Generation* episode, it would be a classic. It would be 'one of the good ones.'"

ABOVE: LeVar Burton directs Robert Picardo and Robert Beltran, whose characters have survived alongside Harry Kim and are prepared to do whatever it takes to reverse the mistakes of their past.

> **"Hello – Harry. I don't have much time, so listen to me. Fifteen years ago, I made a mistake and 150 people died. I've spent every day since then regretting that mistake. But if you're watching this right now, that means all of that has changed. You owe me one."**
>
> *Harry Kim*

ART
DEPARTMENT
FAMILIAR, STRANGE, AND TERRIFYING

The art department lifted ideas from the page and gave them visual life, establishing a consistent visual identity for *VOYAGER*.

As a weekly television drama series, *STAR TREK: VOYAGER* was a voracious consumer of ideas. The spark of those ideas would begin in a pitch meeting between writers and producers, or around the table of the writers' room. Those ideas then expanded, becoming narratively focused and structured into a 45-minute teleplay. But what happens then? "How do we, in the art department, get the stories from the writers?" asks *VOYAGER*'s senior illustrator Rick Sternbach. "How do we start thinking about the sets that are required, thinking about the props, the visual effects?"

Located one level above Stage 8 on the Paramount Pictures backlot, the *VOYAGER* art department was where words were lifted from the page and given visual life by a team of illustrators, set designers, concept artists, and graphic designers. Led by production designer Richard James, the art department provided the illustrative foundations of the environments *Voyager* and its crew traveled through, building dynamic and consistently believable alien worlds and civilizations. From LCARS displays to exteriors and interiors of vast alien city ships, a new medical prop, or a simple logo on a coffee cup, the art department gave

ABOVE: *Design sketch by set designer Tim Earls, dated 8 January 2001. This depicts the judges' bench that appears in the Voyager mess hall during Q's trial in 'Q2.' Earls' sketch includes information on the different elements involved in dressing the set, from upholstery to carpets, along with stock prop items.*

"SO PEACEFUL…"

TIM EARLS: "We did a lot of weekend work at the beginning and end of a season because there were such heavy episodes. I came in one weekend with Tony Bro to work on a Saturday, and I had the worst sinus headache. I took something and said, 'Tony, I'm just going to lie down on this couch for a few minutes.' The couch was just inside the art department door, next to the coordinator's desk, so I go over and put my head down. The next thing I know, I hear a door opening and it's Richard James stepping in. I jumped up so quickly I almost fell over, dizzy. Richard just started laughing. I checked my watch and I had been asleep for three hours. I said, 'Tony, why didn't you wake me up?' He said, 'You looked so peaceful.'"

VOYAGER an essential, cohesive visual language week after week. "Everybody in the art department, from Richard James to Mike Okuda and our set designers, will agree that we worked with all the other departments – the sign shop, carpentry mill, the painters – and it was this giant machine that turned out the elements for a new episode every 10 working days."

Having worked on all seven seasons of *STAR TREK: THE NEXT GENERATION* from day one, along with his close colleague and friend, scenic art supervisor Michael Okuda, Sternbach was an experienced senior illustrator on the franchise. He relished the opportunity to start work on a new chapter of the *STAR TREK* story. "When *VOYAGER* was announced to us internally near the end of *THE NEXT GENERATION* season 7, I was pretty excited," he remembers. "From the initial descriptions we got in the art department, *Voyager* was a smaller ship – faster, sleeker, new sorts of missions. That really felt like an exciting invitation to get to work on new designs, to think up new tech."

"When we started *VOYAGER*, it was different because we'd had experience in doing *THE NEXT GENERATION* and *DEEP SPACE NINE*," remembers Mike Okuda. "We knew how to make *STAR TREK*. It wasn't that we were making it up as we went along – you're always doing that – it was how do we make *VOYAGER* different, but keep it in the *STAR TREK* family?"

> "*Voyager... felt like an exciting invitation to get to work on new designs, to think up new tech.*"
>
> ■ Rick Sternbach

"The early part of any *STAR TREK* series is always that you want to respect what's gone before and you want to give it its identity," says Okuda, defining the art department's key role in establishing that cohesive visual look of *VOYAGER* during preproduction. "Where do you find that balance? It's always a tough question. You have an opinion when you start. As you execute, you find out you need to make things a little more different, a little less different, or make it a little more consistent. Sometimes you want to do something but the schedule or the budget doesn't let you."

"They had a really seasoned production design team with Richard James, Louise Dorton, and Andy Neskoromny," remembers Jim Martin, "so they knew what was really involved in getting this stuff down." In 1994, Martin was part of Herman Zimmerman's *DEEP SPACE NINE* art team based at The Mill on the Paramount backlot. "Richard James was a gentleman. He recommended me to Herman Zimmerman to be the production assistant for the first season of *DEEP SPACE NINE*. If Richard had not passed my name on to Herman, I would never have worked on *STAR TREK*. I owe them both a debt of gratitude."

During preproduction on *VOYAGER*, Martin was called on to repay that debt of gratitude when he was seconded to the new show's art department for the heavy development workload on the pilot episode. "Richard came over to talk to Hermann and me in the *DEEP SPACE NINE* art department about it. It was really exciting to watch another show get built from the ground up."

Martin worked in concert with Sternbach on wide-ranging concepts for the exterior of *Voyager*, while also providing

ABOVE: *An early Tim Earls design sketch, showing the interior of Irina's speedboat as seen in 'Drive.' This is very close to its on-screen appearance.*

ABOVE: *A STAR TREK designer's work can range from large sets to detailed props, such as Tim Earls' design for a new Starfleet monitor.*

ABOVE: *Tim Earls designed these concepts for gurney restraints to be added to an existing gurney prop, as seen in 'Critical Care.'*

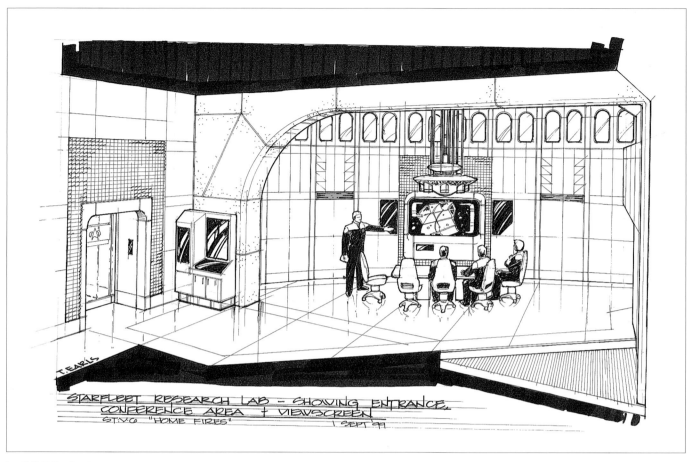

ABOVE: *Tim Earls' set design sketch dated 1 September 1999, showing the Starfleet reasearch lab as seen in 'Pathfinder.' At this early stage of preproduction – two months ahead of broadcast – the episode had the working title 'Home Fires.' The sketch shows a particular angle of a much larger set.*

> *"You want the unusual, you want the strange, the bizarre and terrifying, but not in Starfleet."*

■ **Mike Okuda**

concepts for elements such as the Caretaker array interiors and exterior. "I was doing my best at the time with being a pencil and paper concept artist," he recalls. "I look back on that stuff and it's of another time. If I were given that assignment now we'd be rolling through it all in 3D and really exploring the space. It's a completely different world. You start with some big, fun ideas and you bring in the more rational: what can we build and where do we spend the money? Let's get it done."

Alongside development of *Voyager*'s exterior, Mike Okuda's graphics team worked up the assets for the displays and signage. "The graphics on *Voyager* itself were very much consistent with what we'd done on the previous *STAR TREK*s," he explains. "I changed the color palette a little bit on the backlits and we added little brushed aluminum accents. I changed the color of the signage, but I kept the basic style very familiar. One of Gene Roddenberry's very first tenets of *STAR TREK* was that you want the unusual, you want the strange, the bizarre and terrifying, but not in Starfleet. We want Starfleet to be a believable organization, the familiar home base against which we view the wonders of the cosmos. The *Voyager* looks distinctly different from the *Enterprise*-D, yet it's in the same family."

"Stylistically, how do you keep everything consistent?" asks Sternbach, considering how the art department draws the line between the comforting familiarity of Starfleet and the strange, bizarre, and terrifying. "In terms of the alien elements we encountered in the Delta Quadrant, those were fun to

dream up. One specific example for me were the Hirogen. If you look at what the set designers were coming up with for the Hirogen hunter ship, I saw what they were building on stage. I looked at the set design, there were some giant, tall, pyramid-shaped spires. I thought, I'm going to grab these shapes and use them as the outer coverings for their warp engines. Watching the episodes, you may not make an instant connection, but subconsciously people may see this shape or that shape or these colors. Over all of these different shows and all the different episodes of *VOYAGER*, the producers trusted us to know our stuff. We were seeing what the costume designers and makeup were coming up with, seeing from a visual standpoint what these different crafts were contributing, and thinking to myself, how can I can make use of these things?"

That sense of team collaboration and passion defined the work of *VOYAGER*'s art department. "We had a great team of people that worked together," says *VOYAGER* and *DEEP SPACE NINE* video supervisor Denise Okuda. "We were *STAR TREK* fans, so we took a lot of pride to keep it within the *STAR TREK* vein. Michael's graphics department were all space geeks. [Scenic artist] Doug Drexler especially had all kinds of knickknacks and the walls were covered with genre-related things. It was very much a clubhouse."

"The best aspects of working with a lot of these folks was they understood their craft, and in a lot of cases were into science fiction," adds Sternbach. "Mike Okuda was a kindred soul. Any time there were people in the department who got it, it was the best. Some of the folks who were not into science fiction still understood things that had to be built and painted. Then guys like Dan Curry in visual effects, he knew this stuff forward and backward. When Tim Earls came in on *VOYAGER*, Tim was into this stuff. He understood science-fiction design."

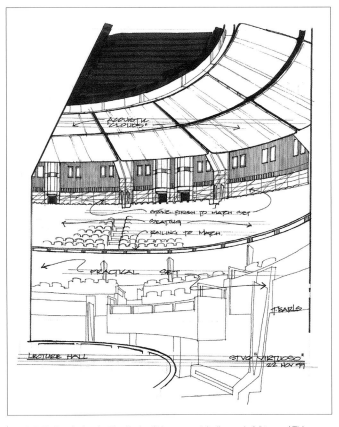

ABOVE: *Set design by Tim Earls of the concert hall seen in 'Virtuoso.' This set was realized as a blend of practical and visual effects elements.*

Set designer Tim Earls joined the *VOYAGER* art department during season 6. "I had such a blast on *VOYAGER*," he remembers. "Everyone took pride in what they were doing, what they were creating. I've been on a lot of films and television shows since, but no art department had the kind of

ON SET

Based above Stage 8 on the Paramount Pictures backlot, the *VOYAGER* art department staff were well placed to pay regular visits to the soundstages below. "The art department was my bubble, home base, but I would get down to the stage when I could," recalls Rick Sternbach. "You grab some coffee, go down to the stage, see things that were happening. Robbie McNeill was into the tech stuff, so we talked. Bob Picardo... we talked a lot because he was very much into the science and tech side of things. He's a major spokesperson for the Planetary Society. Tim Russ was

an amateur astronomer, we'd talk at the craft services table about that."

"We probably had one of the best craft services in the business on *VOYAGER*," says Tim Earls. "Although one of my worst memories is going down to set. There was a soda machine, I put some money in and right after the coin fell, they yelled 'Action!' My soda popped out with this rattling noise. I got screamed at for making noise on the set. I don't think they knew it was me, but there was a yell from somebody on the crew about making noise on set when the light was on!"

atmosphere that *VOYAGER* did. We all got along, we helped each other. It was great to go down to set and see the fantastic job that construction was doing. It was like a family. We were all in the same boat, paddling in the same direction."

Earls remembers the art department family during his time on the show. "There was Richard James, Louise Dorton the art director, Rick Sternbach. When I started, the graphic designer was Wendy Drapanas, then Geoff Mandel did graphics after Wendy left. The other set designer was Greg Hooper, then Tony Bro came in. The bottom of the art department stairs ended at Jeri Ryan's trailer – we'd always pass her or Roxann Dawson as you went up and down the stairs. Sometimes the cast would come up. Bob Picardo came up the most, he had a

huge interest in space sciences and he would have discussions with Rick about space exploration."

"It's the subject matter," says Sternbach on how the art department kept moving on the *VOYAGER* schedule. "These were things that I just loved for years and years. It was fun and exciting. Yes, there were crazy periods when the prop master needs a drawing in an hour because the prop has to be on stage for filming tomorrow morning. We did what we could with what we had. In film and television production, you know there are going to be crazy things, some things that happen on amazingly short deadlines. If you get to understand the system, it makes things easier. If we can't do a certain thing in a certain way that we really wanted to try, maybe we'll try Plan B."

"The early part of any STAR TREK series is always that you want to respect what's gone before and you want to give it its identity. Where do you find that balance?"

■ Mike Okuda

ABOVE: This alternative concept for the Caretaker's array by illustrator Jim Martin adopted a more organic look, and indicated Voyager's relative scale.

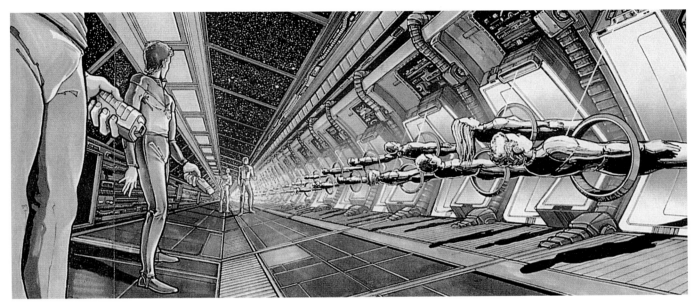

ABOVE: *Early production design sketch by Jim Martin of the interior of the Caretaker's array, seen in the pilot episode 'Caretaker.' Martin was seconded from* DEEP SPACE NINE *to the* VOYAGER *art team during preproduction, handling various assignments from interiors to exterior set concepts.*

"Working at Paramount was everything *STAR TREK* to me," Jim Martin says, looking back on his art department experience. "I can't set foot on that lot without a million memories flooding back. *VOYAGER* sits in that as another experience with my *STAR TREK* family, another chance to learn more from the seasoned professionals around me. That was such an important part for my growth as an artist, a golden time for me as an illustrator. I believe, after 25 years, I'm now a seasoned production illustrator myself!"

"It's the people," sums up Mike Okuda. "The biggest challenge of any weekly show is to keep up the challenge every week. Especially toward the end of *VOYAGER*, because we had done seven years of *THE NEXT GENERATION*, seven overlapping years of *DEEP SPACE NINE*. So to keep that up on a weekly basis and try to keep yourself and the work fresh – it becomes tough. But I'm thinking of the 12-year-old kid out there to whom *VOYAGER* means as much as the original *STAR TREK* meant to us. We owe it to them."

"I looked forward to coming to work, even during the hiatus times," says Rick Sternbach. "I consider myself astoundingly lucky to have been accepted into the *STAR TREK* franchise and to be able to invent out of thin air – with some stylistic rules – things that no one has ever seen before. It was a pretty astounding time."

GOOFY EQUATION

MIKE OKUDA: "One of my favorite episodes was 'Future's End.' One set, that was supposed to be at the Griffith Park Observatory, was the office of Rain Robinson, played by Sarah Silverman. If you look at that set, Jimmy Mees, the set decorator, let us put all kinds of stuff on there. Wendy Drapanas had a thing for Talosians, so she had a Talosian action figure she put on the desk. Denise put a picture of our dogs on the computer. When Gene Roddenberry first proposed the *STAR TREK* format, there had been some scientific papers that said there were alien civilizations. An astronomer, Frank Drake, developed the Drake Equation, a scientific expression of what questions you would have to answer to figure out how many civilizations there were in the universe. Gene Roddenberry had heard of it, and when he typed up the *STAR TREK* format, he made up this goofy-looking equation. In Rain's laboratory in 'Future's End,' I had the real Drake Equation and underneath it I put the Drake Equation according to Gene Roddenberry."

THE LOST
BARGE OF THE DEAD

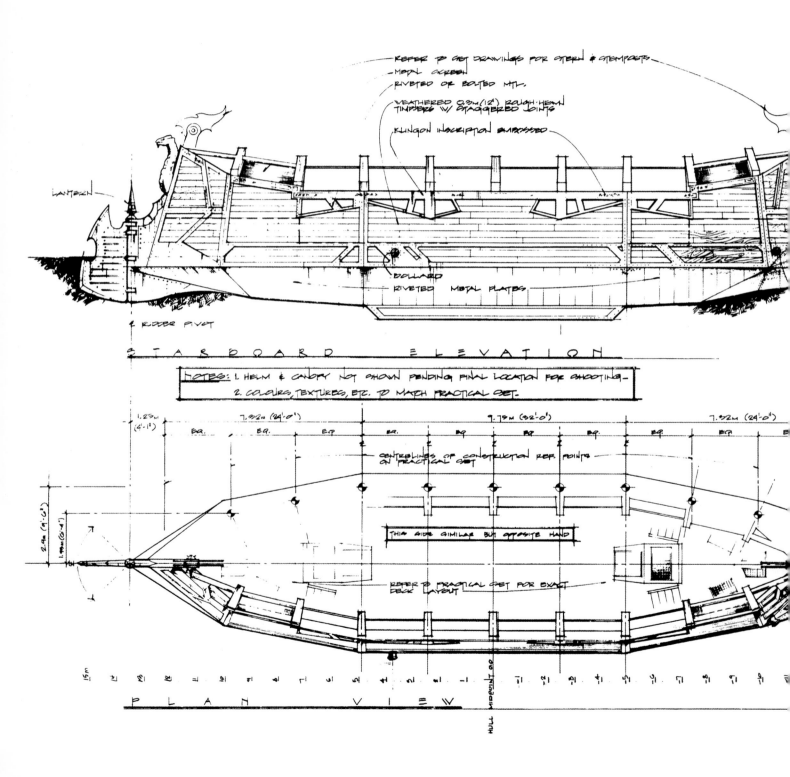

- REFER TO SET DRAWINGS FOR STERN & STEMPOSTS
- METAL SCREEN
- RIVETED OR BOLTED MTL.
- WEATHERED 0.3M (12") ROUGH-HEWN TIMBERS W/ STAGGERED JOINTS
- KLINGON INSCRIPTION EMBOSSED

LANTERN

BOLLARD

RIVETED METAL PLATES

& RUDDER PIVOT

STARBOARD ELEVATION

NOTES: 1. HELM & CANOPY NOT SHOWN PENDING FINAL LOCATION FOR SHOOTING.
2. COLOURS, TEXTURES, ETC. TO MATCH PRACTICAL SET.

1.25M (4'-1") | 7.32M (24'-0") | 9.75M (32'-0") | 7.32M (24'-0")

CENTRELINES OF CONSTRUCTION REF. POINTS ON PRACTICAL SET

THIS SIDE SIMILAR BUT OPPOSITE HAND

REFER TO PRACTICAL SET FOR EXACT DECK LAYOUT

PLAN VIEW

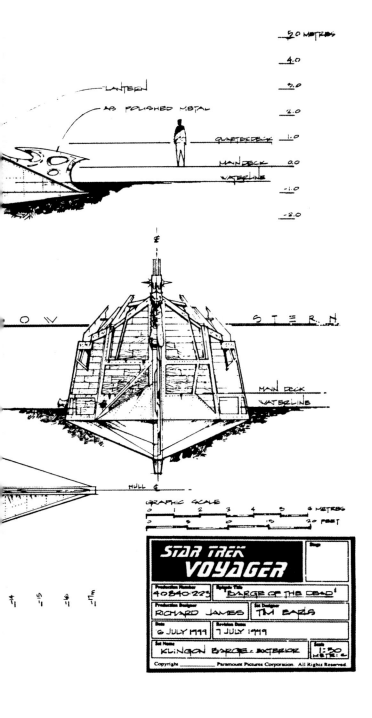

As originally envisioned, B'Elanna Torres' spiritual journey to the Klingon Barge of the Dead was a little more expansive. "[Production designer] Richard James gave me the assignment for the interior of the barge," says set designer and illustrator Tim Earls. "Then there was talk that there were going to be some exterior visual effects shots of the barge traveling through whatever dimension in which it existed. Unfortunately, they cut the exterior out, so it never got filmed. But I did these really elaborate blueprints of the barge.

"I did a bit of research because it's a Scandinavian mythical kind of thing, that's the way it was written. The big difference between the barge and Viking ships [was that] some of the Viking ships were very organic and curvilinear, whereas the Klingon aesthetic is very flat and angular. I enjoyed doing the barge – I think it was the really rustic design that was very non-*VOYAGER*."

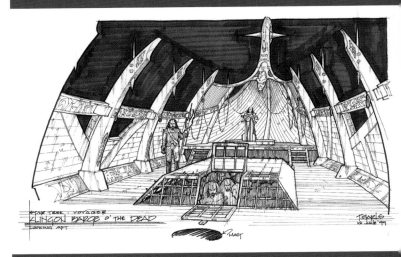

THE
DELTA FLYER
24TH-CENTURY HOT ROD

S everal seasons into *VOYAGER*'s run, Rick Sternbach developed a brand-new hero ship to add some dynamic action to the ship's roster of shuttlecraft.

"The actual design of the *Delta Flyer* was another interesting learning experience," Rick Sternbach recalls the development of this '24th-century, warp-powered, ultra-responsive hot rod' that debuted in season 5's 'Extreme Risk.' "Going through lots and lots of doodles, lots and lots of sketches. Dan Curry came up to the art department and was looking over my shoulder while I had a whole page of *Delta Flyer* doodles. He points at one and says, 'I think this one could work.' It was one of the drawings I put a little bit more thought into in terms of the tech that went into it.

"The set designers had the window and the cockpit well under way," continues Sternbach. "I used those shapes in the exterior design. The forward windows and some of the tech planted around the *Flyer* were supposed to be Borg inspired, so if you look at the cockpit window, it's not entirely Starfleet.

When designing a new ship several years into a series' run, Sternbach advises checking the size of the doors. "This goes back to the very beginning of *VOYAGER* where we were almost going to build the shuttlebay full size on the soundstage, which meant that it was only going to be a certain number of feet wide. I applied that to the miniature blueprints of *Voyager* in 1994. When it came to the *Delta Flyer*, the nacelles on the *Flyer* will not fit the door. You have to fudge these things. I think wingtip to wingtip, the *Delta Flyer* is maybe 75 feet. In my own head canon, somewhere along the seven seasons of *VOYAGER* they widened the doors!"

CGI supervisor Rob Bonchune of Foundation Imaging was delighted with the assignment to build the digital model of the *Delta Flyer*, putting him in a position to be part of *STAR TREK* starship lore. "I wanted to do it so I was able to say I built a hero ship for the show," he laughs. "We had dedicated model builders who usually would have done that, but I really wanted to do one ship, one of the important ships."

Bonchune enjoyed working from Rick Sternbach's detailed concept designs and blueprints. "We had Rick's sketches for the *Delta Flyer* – the three-quarter views, side views, blueprint views of what the flyer should look like – which made it much

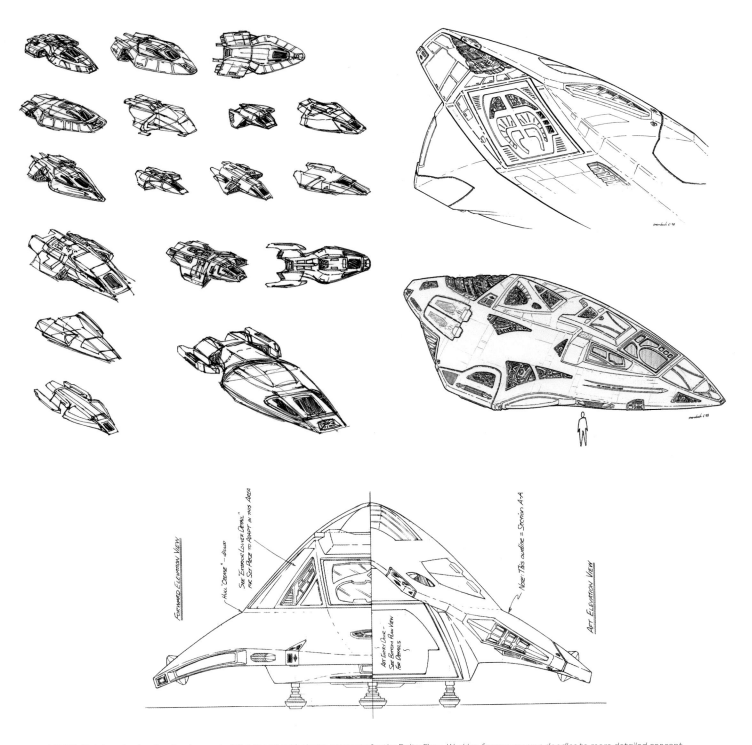

ABOVE: *Sketches showing the development of Rick Sternbach's design concepts for the Delta Flyer. Working from numerous doodles to more detailed concept designs, the final elevation blueprints allowed Rob Bonchune of Foundation Imaging to develop the digital model on the clear lines set out by Sternbach.*

easier to follow. I won't say it was easy to build, but at least I knew what every shape should be. Rick was great, he always had color references, so that part was easy. For me as a modeler, it was little bit challenging because it's not a blocky shape, it's all organic and curves. To get all that to look good, especially in

Lightwave, it took a while. It was a challenge, but I really enjoyed it. I think Rick liked what the *Delta Flyer* turned into. Not a lot of people know that I built it, but it didn't matter to me. I just felt good that I finally got to do a hero ship. I just wanted to be able to do one!"

I'M A DOCTOR, NOT A...

One of *VOYAGER*'s most iconic catchphrases picked up a joke that Dr. McCoy put down in 1968. As Robert Picardo recalls, the gag came about because of a throwaway line he had no idea he was stealing from *STAR TREK*'s history.

In his audition for the Doctor, Robert Picardo took a risk and ad-libbed a line, not even realizing that he was channeling a recurring joke from the original *STAR TREK*, when McCoy would insist he was a doctor, not something else, such as a bricklayer. "After my last scripted line," Picardo remembers, "the Doctor is left alone in sickbay. They forgot to shut him off, and he has nothing to do, so he looks around the empty room and says, 'I believe somebody has failed to terminate my program.' At the end of that line, I took a long, deadpan look at the 16 executives, all staring at me, and I said, 'I'm a Doctor, not a night light.' I didn't know I was making a Bones joke and was channeling DeForest Kelley. In retrospect, I'm delighted I didn't know because if I had, I would never have done it." The writers picked up on the joke, and over the next seven years the Doctor would repeatedly point out what he was not...

Writers worked the line into the script at key points, with variants making it into the show a dozen times.

"I'm a doctor, Mr. Neelix, not a decorator."
('Phage' Season 1, Episode 5)

"I'm a doctor, not a bartender."
('Twisted' Season 2, Episode 6)

"I'm a doctor, not a voyeur."
('Parturition' Season 2, Episode 7)

"I shouldn't have to remind you: I'm a doctor..." Torres interrupts: *"... not an engineer. Right..."*
('Prototype' Season 2, Episode 13)

"I'm a doctor, not a performer."
('Investigations' Season 2, Episode 20)

"I'm a doctor, not a counterinsurgent."
('Basics, Part II' Season 3, Episode 1)

"I'm a doctor, not a database." To which Henry Starling counters: *"I'd say you're a little bit of both."*
('Future's End, Part II' Season 2, Episode 9)

"I'm a doctor, not a peeping Tom. There's nothing I haven't seen before."
(when interrupting Torres in the sonic shower)
('Drone' Season 5, Episode 2)

"I'm a doctor, not a battery."
('Gravity' Season 5, Episode 13)

"I'm a doctor, not a dragonslayer."
('Bliss' Season 5, Episode 14)

"I'm a doctor, not a zookeeper."
('Life Line' Season 6, Episode 24)

"I'm a doctor, not an engineer."
('Flesh and Blood' Season 7, Episode 9)

SEASON 5

EPISODE 20

AIR DATE: MARCH 31, 1999

Teleplay by	Michael Taylor
Story by	Rick Berman & Brannon Braga
Directed by	Terrence O'Hara
Synopsis	A group of superintelligent aliens offers to help *Voyager* escape from the Hazari in exchange for Seven of Nine.

THINK TANK

The crew of *Voyager* have a puzzle or two to solve and, in Jason Alexander, one of their most high-profile guest stars. Kurros is not what the audience – or the writers – expected.

The idea for 'Think Tank' was in place before its famous guest star. Supervising producer Joe Menosky credits Brannon Braga with the concept. "That was an idea Brannon came up with [and] Michael Taylor did a really wonderful first draft." It was a challenge for the writer. "This is an intellectual puzzle, a game, which I hope we carry off well," he says.

The episode saw the crew outflanked by bounty hunters known as the Hazari and, coincidentally, offered a way out from a group of superintelligent aliens who provide their services for a hefty price. Taylor scripted the episode with no idea that *Seinfeld* star Jason Alexander was going to be cast as the think tank's negotiator, Kurros. "I had no clue it would be him," he says. "Of course, I was very

RIGHT: Jason Alexander, who played Kurros, was one of America's most high-profile comic actors.

excited and then terrified when I found out."

A *STAR TREK* fan since childhood, Alexander leaped on the role. "As soon as this came up and I was available, I took it," he says. "We discussed my take on the character. I was thinking of basing him on a kind of Gandhi figure or an Einstein figure, and all the designers came in and we talked about that, so it was very collaborative."

As Taylor recalls, one of Alexander's suggestions about Kurros caught the writers by surprise. "I remember he said, 'I don't think I'd like to have any hands or arms. I can do it all with the brain.' I remember saying, 'Well, occasionally, you might like to hold something...'"

While the writers insisted Kurros retain his limbs, Alexander was keen to find ways to make Kurros very different from his most famous role, the neurotic George Costanza. He enjoyed the contrast, "It was actually very subtle," he says. "There was nothing terribly comedic about it; it was a very subdued little performance for the most part. There're

> **"All we have to do now is...**
> **outthink the think tank."**
>
> *Janeway*

no histrionics. I took him as a kind of pure intelligence and a very gentle figure, so it's a very low key and very soft performance, not terribly emotionally charged. But there's a lot of balls to juggle when you're in that kind of show, getting through the technical stuff and knowing what's at stake at all times. I took embodying an alien fairly seriously – probably more seriously than they would have liked."

Taylor admits that Alexander played the character to the way the actor had originally imagined him. "It was a lesson for me as a writer, as I had this idea of this sharp, fast-talking, almost smart-alecky, crazy, eccentric Brainiac head and he was very slow, contemplative." But the results were impressive. "He had it inside out how he wanted to play the character and he did it brilliantly. So, let the actor do their work!" Taylor concludes.

The choice Alexander made in playing the part gently, rather than as a fast-talker, makes him all the more chilling, aided by a sinister

> **"There is nothing like a good**
> **problem to spark the synapses,**
> **is there?"**
>
> *Kurros*

Jay Chattaway theme that accompanies his arrival as an isomorphic projection on *Voyager*. Kurros is calm and ruthless, willing to let a planet starve rather than accept a

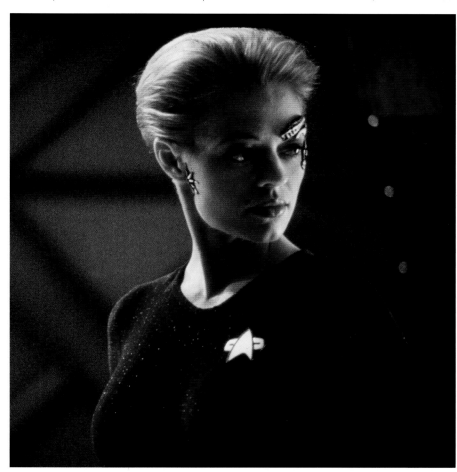

compromise on his agreed price.

The think tank itself contains a selection of aliens – large, small, floating, mechanical, and indecipherable. Menosky told *Cinefantastique* he found them "really interesting characters. This idea of a quirky group of extremely talented aliens who hire themselves out to

people for strange payments in order to solve their problems. If I was nine or ten years old, I would think, 'I wish I was on that ship.'"

The think tank's superiority is contrasted with the *Voyager* crew's failure to outwit an electronic game. When the price of accepting Kurros' help is Seven of Nine, Janeway must find a way to outsmart the quadrant's mega-brains. A briefing room sequence allows viewers the chance to join in on unraveling the paradox. "How will they get out of it this time?" It's a diverting conundrum with a satisfying conclusion. Of the final cut, Jason Alexander says, "I thought it was really smart and dramatic and they used my best moments. I was thrilled with it."

> **"Oh, I'm sure you'll find a solution.**
> **Just give it some... thought."**
>
> *Janeway*

ABOVE: The think tank are playing a complicated game and eventually it becomes clear that their real goal is to recruit Seven of Nine, whose unique abilities would make them even more powerful.

COSTUME
DEPARTMENT
WEIRD SURFACES AND BIG BOOTS

From Starfleet uniforms to Nazi Hirogen,
Robert Blackman and the costume team
dressed hundreds of characters over seven years.

Looking back at his time as costume designer on *STAR TREK: VOYAGER* in 2001, Robert Blackman said, somewhat philosophically, "I don't have anything where I can say, 'This is the best thing I've ever done,' because I don't think I've done my best thing yet! I think it's always coming."

There is something of the ethos of *STAR TREK* in Blackman's view of the *VOYAGER* costume team's work. Providing costumes for the ensemble cast and myriad guest stars may have been pressured and intense, but Blackman's approach was always to look ahead and meet each creative challenge head on.

Having joined *STAR TREK: THE NEXT GENERATION* for the start of season 3, Blackman was a veteran of two *STAR TREK* television series and one feature film by the time *VOYAGER* geared up for production. "I've seen it in all three of the *STAR TREK* series," he observed, with the voice of experience. "There's that first-season excitement and apprehension – 'Will it go, will they like me, can I do the job?' Then there's the second year, where you're still excited about what you're doing. Then you get to the third season and there's another energy. There is a feeling of, 'Well, if we get through the third season we may go to five, and wouldn't that be great?' It works differently for each discipline. When you get to the fifth season, everyone's fatigued and would like it to be over!"

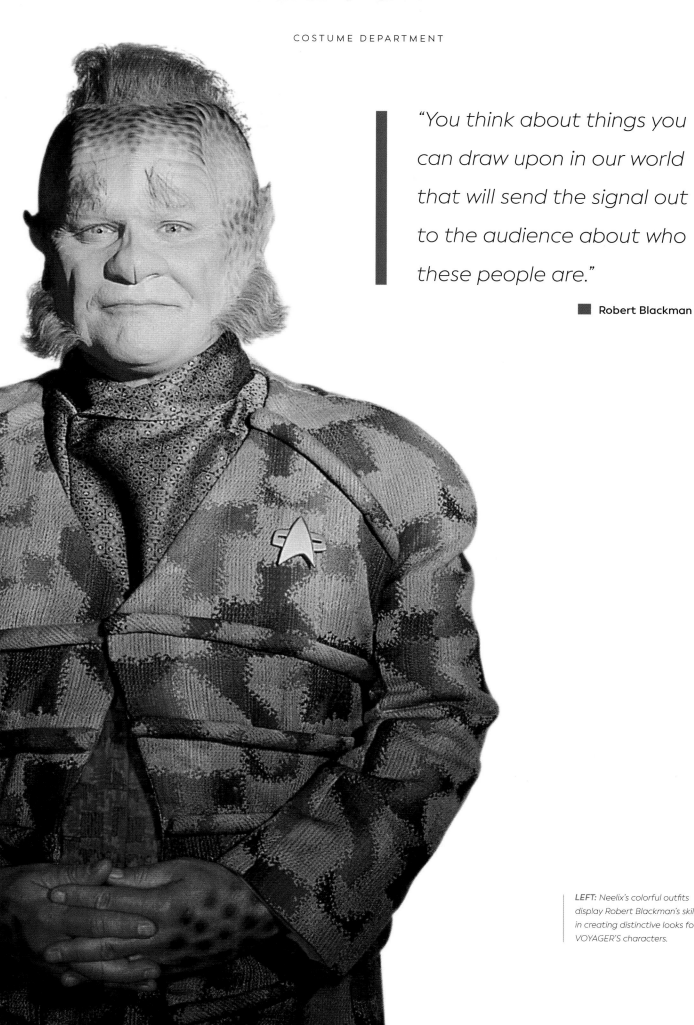

"*You think about things you can draw upon in our world that will send the signal out to the audience about who these people are.*"

Robert Blackman

LEFT: Neelix's colorful outfits display Robert Blackman's skill in creating distinctive looks for VOYAGER'S characters.

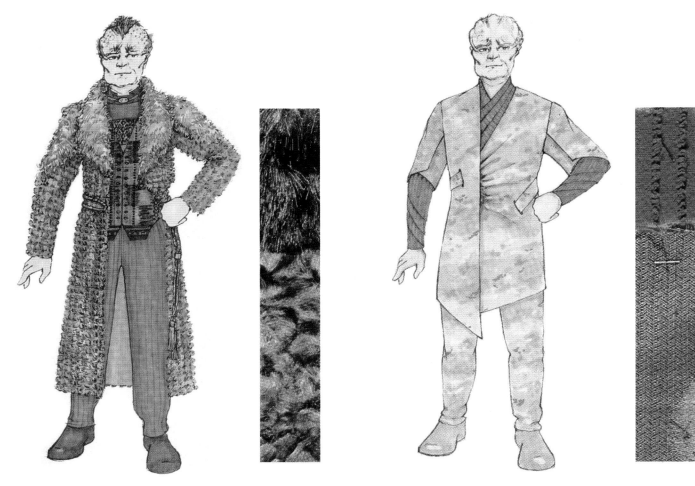

ABOVE: *Design sketches by Robert Blackman – alongside proposed fabric swatches – of various looks for Neelix as seen in 'Caretaker,' including the heavy fur coat that he wears in his first appearance.*

During production of *VOYAGER*, Blackman also oversaw costumes on *DEEP SPACE NINE*, which demanded the juggling of management skills with the creative side of costume design. "We have to present a budget for each script," he explained. "You may go over budget, but you have to rely on the fact that you've got a few behind you where you've gone under, so that you can balance it out.

"That's what Carol Kunz, my supervisor and right-hand person, did brilliantly," Blackman added. "I slowly realized that I did not need to be concerned with the money. I set the price of what things cost, then Carol worked it all out. Merri [Howard, supervising producer] would sometimes call me up and say, 'What do you mean, it's going to cost that?!', but in general I didn't have to think about it. When I first started this job, about 55 to 60 percent of my day was management, 30 to 35 percent was politics, and about 5 to 10 percent was actually creation. But it changed; it was about 50-50."

Carol Kunz's key role as costume supervisor highlights the work of Blackman's team, which included key costumers,

sewers, cutters, and fitters, many stationed on set for a full day of shooting. "The key costumers, Tom Siegel and Kim Thompson, worked in the wardrobe department, alternating episodes between them and doing all the organization and paperwork and breakdowns, so that the people on the set knew exactly how and what someone was wearing for each given scene. And because we didn't shoot in order, there was no continuity, so their job was to note down that someone walked through a doorway with something open and attach that to the fitting photos, so that two days later when you're shooting a corridor scene the costumers on the set made sure that it's open."

The start of a day saw the department get everybody into costume and on set, ready to work. Here the work of the costumers was essential in maintaining efficiency and consistency. "For *VOYAGER*, we had Matt Hoffman and Jamie Thomas," says Blackman. "They were my eyes. If something looked awry or there's something weird they were on the phone and I was over there. They'd put the costume on as directed and maintain it in all the takes as indicated on a breakdown

sheet. They'd say, 'Something looks a little bit odd about the collar here,' and I would go over. Or it might be that in the haste of being stitched, something was stitched an eighth of an inch or a sixteenth of an inch in the wrong direction – too tight or too loose – and we had ways of fixing that on the spot without holding anything up. I relied on them exclusively to do that. They were remarkable."

Of prime concern to Blackman's team was ensuring an actor was comfortable in the costumes they might be required to wear. "An actor in the theater is in costume for a maximum of four hours. Here, especially for a guest star, they can be in it for 15 hours a day for three days in a row, and so there had to be a certain amount of attained comfort. If you can take the jacket off, take the underthing off, get them down to just a pair of britches and a T-shirt, you've got a much happier actor and a happier situation. I would say 90 percent of the guest stars were delighted with their outfits, and happy to have anything that helped ground them! They often say the costume gives them a sense of person or place. Sometimes the guest actors do

> ## "I'm often asked asked if there is a favorite outfit, a favorite character, but there is not – I like them all."
>
> ■ Robert Blackman

not get their working script until the night before, so anything that you could do to give them something to work on is helpful. It's like, 'Oh, big boots; I'll stand with my legs apart.'"

Amid the challenges of readying costumes, Blackman was constantly in the planning stages. "I always do research," he explained. "I have an intuitive nature about what I look at and how to extrapolate from that what will be most useful. I try to find as much interesting surface texture, whether we create it or whether it's out there. I order things in advance just because I think it might be usable.

"I try to play with weird surfaces. Sometimes a director was nervous about how they would light them. There are times when I've talked them into things and then they go, 'Oh, too weird!'" Blackman highlights the costumes worn by Species 6339 in 'Infinite Regress' as a prime example. "We had amazing clear vinyl suits over other suits. They had this

light wire in them that looked like outer circuitries, and then on the underneath suits there was a different kind of circuitry. They looked really good – and they made noise, so they had to go and loop it all! I think it was worth it, and the producers thought it was worth it, because it was something they had never seen before.

"There are things that are fun when you are doing them," said Blackman of the sheer enjoyment of creativity. "'Muse' had a theatrical troupe, and because I come from a theater background it was fun to do that. We had these two characters

UNIFORMITY

The *VOYAGER* cast's Starfleet uniforms required careful management from Robert Blackman...

"They're in them for 10 minutes and they're cleaned. Over the season we made five for them. What's interesting is that all the garments are made by the same people and one would suppose that they are all identical, but in the actor's mind they are not! I encouraged the set people to put them in the first costume one day, and the second costume the next day, and so on, but the actors could tell, and they ended up for the most part wearing one uniform all year. They always offered amazingly, infinitely minute challenges. As you go along, you start refining them and refining them and eventually you have that Coco Chanel little black dress: the little thing that seems perfect because it's got no trim, no anything. It's all about fit and construction."

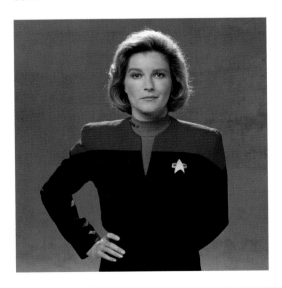

HARLEM AND HIROGEN

VOYAGER's 'The Killing Game' and *DEEP SPACE NINE*'s 'Far Beyond the Stars' shot at the same time...

ROBERT BLACKMAN: "'Far Beyond the Stars' had about 200 extras from 1953 Harlem, and that's a big challenge for us in one week. But we met it smartly and wisely, and it looked really good, I'm really proud of it. And at the exact same time that we were prepping that, *VOYAGER* was doing 'The Killing Game,' which was a massive two-parter, and they were shot concurrently. It was one of those really ugly luck-of-the-draw moments where we were doing 180 to 200 costumes on one and another 120 or so on the other. On 'The Killing Game' we were trying to get Hirogens to fit into Nazi uniforms, as well as doing clothes for our principal players: a '30s chanteuse dress for Jeri Ryan, a kind of Marlene Dietrich white

tail suit for Kate Mulgrew. And we want our principal players to look perfect, so that's a lot of extra work. That was a real challenge of the spirit, but it's one of those amazing things that, because of the artistic treadmill that you have to be on, you just do it."

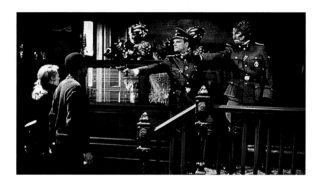

who were in total leather garments that were encrusted with copper plating. You make certain decisions in order to send a signal to the audience. All of these garments needed to look primitive; some of that is about unfinished edges, a kind of bunching thing, usually color stripped out and then repainted. There's a whole bunch of artistically devised technical processes that have to be done. You have to think about things

you can draw upon in our own world that will send the signal out to the audience about who these people are." Blackman and wardrobe supervisor Carol Kunz were nominated for an Emmy in 2000 for their work on 'Muse.'

In total, Robert Blackman spent 16 years with the *STAR TREK* franchise, including all seven seasons of *VOYAGER*, providing a creative and dynamic look for the fashions of the

LEFT: Robert Blackman's early design sketches for the Hirogen (left) and the Kazon (right).

RIGHT AND BELOW: Blackman's design for Flotter in 'Once Upon a Time,' and a close-up detail of a color swatch.

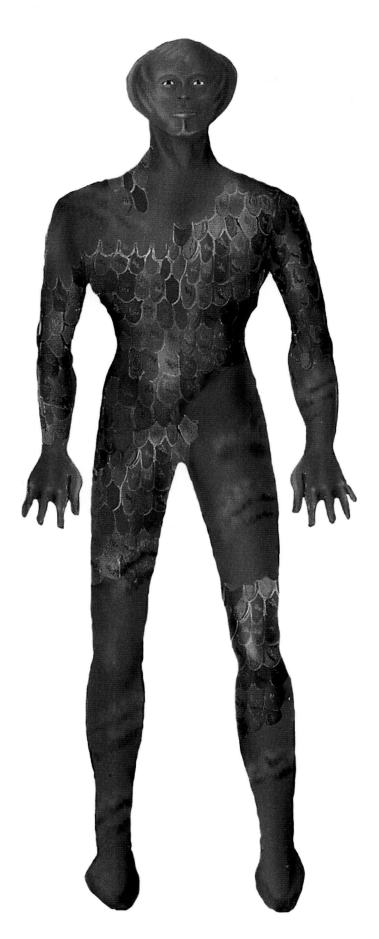

Delta Quadrant. "If I was an actor," he summed up at the time, "one week I could be Henry V and next week I could be Willy Loman. Here, I could take on the characters that I had to design for, even though there were tight parameters; I could do things I had never done before, and that's what's kept me on. I'm often asked if there is a favorite outfit, a favorite character, but there actually is not – I like them all!"

EXECUTIVE INPUT

Robert Blackman recalls how executive producer Rick Berman was essential to the success of *VOYAGER*'s costumes...

"Rick's intuitive skills were enormous, and he had an excellent eye. He could look at the roughest line drawing, just a silhouette, little scribbles, not even a thumbnail – they're a hangnail, they're so primitive! Sometimes I'd present a sketch without fabric swatches and he'd say I can start making mockups. Sometimes I've started on something and he'd look at it and walk around and say, 'What would happen if this was just there,' and he'd move something a quarter of an inch. At first it was sort of embarrassing for me, because he was right – it looked better. Then I'd do whatever I could in the amount of time that we had, and sometimes it was important enough that we rescheduled the shooting day so that I could have a couple of hours to do what I needed to do. The bottom line was we just wanted the episode to look good!"

SEASON 5

EPISODE 18

AIR DATE: MARCH 3, 1999

Teleplay by Bryan Fuller & Nick Sagan

Story by Bryan Fuller

Directed by Anson Williams

Synopsis Paris and Torres get married, but their honeymoon is interrupted by a phenomenon that degrades both *Voyager* and her crew.

COURSE : OBLIVION

A high-concept episode and unexpected sequel, 'Course: Oblivion' gave the *VOYAGER* writing team the opportunity to steer the starship crew down a calamitous path that ends with everyone dying.

'Course: Oblivion' starts out with a moment of joy aboard the *U.S.S. Voyager*, as Tom Paris and B'Elanna Torres tie the knot. Their relationship had been building ever since season 3's 'Blood Fever.' But all is not what it seems. This is not the real *Voyager* crew but a series of biomimetic replicas who have no idea they aren't the real thing and only find out when they start dying.

How long did it take for viewers to get a clue? Was it the wedding teaser when Janeway refers to Lieutenant Tom Paris rather than his demoted rank of ensign? Was it Torres' tragic death in sickbay? Or Chakotay and Tuvix in Astrometrics, counting back to their encounter with the biomimetic life-forms created in the Vaskan sector? (Chakotay helpfully summarizes

RIGHT: The story ends in tragedy as the crew discover their true natures and literally fall apart.

the episode for those that missed it.) The revelation of the true nature of the ensemble cast came early in Act Two but, while viewers knew they were not watching the real crew, it didn't make *Voyager*'s fate any less piteous.

The plot for 'Course: Oblivion' came from writer Bryan Fuller, inspired by the unheralded *VOYAGER* episode 'Demon' and a classic *Twilight Zone* episode. Cowriter Nick Sagan remembers, "The point of comparison for 'Course: Oblivion' was the episode of *The Twilight Zone* ['The After Hours'] where there's a person in a department store. They think that the mannequins are talking to them, and that they may be losing their mind. You learn by the end of it that this is a mannequin who's allowed to be human and has forgotten that they were a mannequin. So, you combine that reinvention with 'Demon' and the idea of whatever happened to that mimetic crew."

For Sagan, the story was a chance to explore something that the show's episodic

> **"How's my old lady?"**
> **"Well enough... to break your nose if you call me that again."**
>
> *Tom Paris, B'Elanna Torres*

nature generally prevented the writers from doing with the crew. "These people are cut off from everything they know. The ship should be taking increasingly greater damage," he says. "What is the psychological and physical cull from that? Does it bring out the best in you, or the worst?" 'Course: Oblivion' was a case of have your cake and eat it: show consequences and keep the reset button. Sagan continues, "There's an expression in terms of writing scripts where you get to the low point, sometimes called the glimpse of hell – here's how things could really go badly for these characters."

The original plan was for a two-parter where the mimetic aliens from the Demon Planet had reached Earth. Ken Biller recalls Brannon Braga's take on the plot, "Brannon wanted to do a tragedy about a crew trying to understand who they were and behaving

ABOVE: *The idea gave the writers the chance to give the audience things they wanted, such as Tom and B'Elanna's wedding, only to take them back when viewers discovered they were watching copies of the crew.*

the way the real crew would have done." In the end, the scripting duties were given to Fuller and Sagan who had previously shared teleplay credits on the episode 'Gravity.'

There are many poignant moments in the episode: Paris trying in vain to resuscitate Torres; Janeway switching from her insistence on continuing toward Earth after Chakotay's passing, and later touching Neelix's hand as they face their inexorable fate. Michael Westmore's makeup crew had their work cut out applying a melting texture to the regular cast's features as the decay gradually blurs their faces. Their voices and manner become weary as their bodies tire and wither, succumbing to acute cellular degradation.

The biomimetic crew had little chance of saving themselves. They have a stay of execution for eight minutes but not enough to get home. Even their time capsule fails to launch and is destroyed. Their history becomes just a footnote in the true *Voyager*'s log: a distress call answered, no ship left, no survivors. "There was some discussion about whether it was too bleak," Biller remembers. "I did suggest a version where they actually get that time capsule out in time and the real *Voyager* finds it." But Nick Sagan was resolute in defending his conclusion: "I was adamant about the importance of the near miss."

On airing, there were quibbles from some fans that the episode barely involved the real crew. Sagan could sympathize: "I totally get fans were like, 'That's not our crew, and so why did I watch that?' I accept that, but for the people who felt something from it, I'm so proud that came together." Braga describes the episode as "a little gem."

The biomimetic crew act exactly the way that the people they are based on would, and their feelings are equally genuine. 'Course: Oblivion' is a pure, high-concept, science-fiction show that gave the creators, cast, and viewers an opportunity to explore a darker path for *Voyager* and imagine how the crew would deal with losing those they have grown close to. "I don't think anyone thinks 'Demon' is an

> **"We received a distress call at 0900 hours. Arrived at the vessel's last known coordinates at 2120. The ship was destroyed. Cause unknown. No survivors."**
>
> *Janeway, for the ship's log*

amazing episode," said Sagan. "But to take a continuity from that, to create a new episode and one that came together as beautifully as 'Course: Oblivion' is an unexpected magic trick."

VOYAGER'S JOURNEY

The *U.S.S. Voyager* was stranded in the Delta Quadrant for seven years. The crew made the 70,000 light year journey back to Earth in record time, thanks to wormholes, alien technology, and a little luck. This is how they did it...

n 2371, *U.S.S. Voyager* was stranded 70,000 light years from Earth. The ship returned to Earth seven years later. Working out how far *Voyager* traveled at any given time in the show is a challenging exercise – but by studying the episodes and doing a little math, we can try...

In 'Caretaker' we were told that the journey home would take 75 years, but a careful examination of the figures shows that this was a rather optimistic estimate. *Voyager* may have been capable of reaching warp 9.975, but according to Rick Sternbach (*VOYAGER*'s senior illustrator and technical advisor) it could only maintain this speed for periods of up to 12 hours. More realistically, the ship would have cruised at warp 6 – something backed up by the season 6 episode

'Pathfinder', where Hawkins estimated an average warp speed of 6.2. Even then, the ship would have needed to make regular stops to refuel, cool the engines, and refit worn out components, to say nothing of exploring strange new worlds. Using these figures, it would have taken *Voyager* approximately 200 years to reach Earth.

The powers that be realized that this kind of timespan was rather excessive, so they re-examined their thinking and decided that *Voyager* could cover something like 1,000 light years in a year. This was somewhat challenged by Torres's comment in 'Friendship One' that visiting a planet 132 light years away would take a "two months' round trip" at maximum warp – equating to 792 light years in a year. Then again, in the

earlier season 5 episode, 'Scorpion, Part II', we were told that 40 light years was a "five-day journey" at maximum warp – adding up to 2,920 light years over a year.

The crew were obviously slowed down by various detours and practical problems. In 'Dark Frontier', Captain Janeway said that avoiding Borg cubes added two years to the journey. We also know that going around B'omar space added another three months. On the other hand, the advanced systems in astrometrics helped the crew plot a more direct course that reduced the length of the journey by five years.

If you're being pessimistic you could argue that, although *Voyager* had traveled 6,000 light years at this point, the other factors meant that if it wasn't for the shortcuts, they would be no closer to home than when they started. Fortunately, those shortcuts had a dramatic impact. In 'The Gift,' Kes transported the ship 9,500 light years closer to home. Then in 'Hope and Fear,' they gained 300 light years as a result of their brief journey in the quantum slipstream.

The following year the crew found a wormhole that shaved 2,500 light years off the journey. Then, in 'Timeless,' they spent enough time in the quantum slipstream to take "nearly 10 years" off, which we can work out as roughly 10,000 light years. The stolen transwarp coil in 'Dark Frontier' brought the crew another 20,000 light years nearer home. In 'The Voyager Conspiracy,' Janeway said that the subspace catapult threw the ship over 30 sectors, which translates as 600 light years.

All of this added up to approximately 42,900 light years by the end of season 5. If we then add this to the 6,000 or so light years the crew traveled by conventional methods, we can see that at this point they had covered 48,900 light years. However, if they'd really gone this far they would have been in the Beta Quadrant, and nobody ever mentions this, and you would have thought they would have. But of course, we haven't taken into account the additional delays and detours the ship would have faced, which would have pushed *Voyager* further from home and added extra time to its journey.

Seasons 6 and 7 saw the *Voyager* crew benefit from additional shortcuts – 200 light years was shaved off thanks to a Vaadwaur subspace corridor in 'Dragon's Teeth,' while Q's information saved the ship an additional "few years" in 'Q2.' Finally, in 'Endgame', the future version of Janeway told her past self that *Voyager* would have taken another 16 years to return home without the aid of the Borg transwarp hub, which would have made a total journey time of 23 years.

While the crew of *Voyager* went through their fair share of trials and tribulations over the course of their adventures, they could be thankful that their final seven-year journey time beat Janeway's original 75-year estimate by some way.

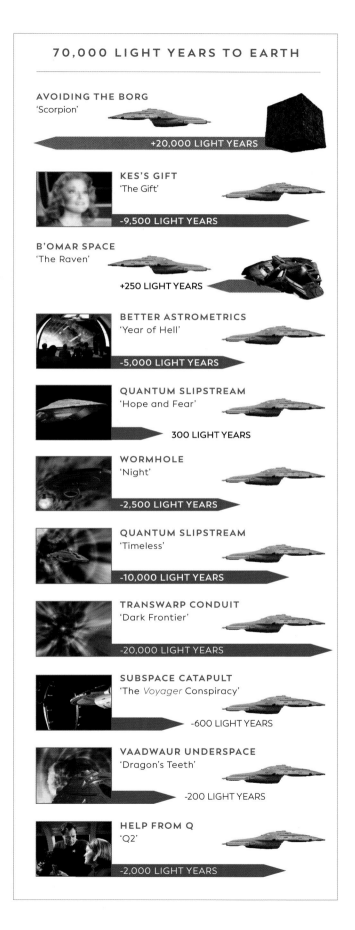

70,000 LIGHT YEARS TO EARTH

AVOIDING THE BORG
'Scorpion'
+20,000 LIGHT YEARS

KES'S GIFT
'The Gift'
-9,500 LIGHT YEARS

B'OMAR SPACE
'The Raven'
+250 LIGHT YEARS

BETTER ASTROMETRICS
'Year of Hell'
-5,000 LIGHT YEARS

QUANTUM SLIPSTREAM
'Hope and Fear'
300 LIGHT YEARS

WORMHOLE
'Night'
-2,500 LIGHT YEARS

QUANTUM SLIPSTREAM
'Timeless'
-10,000 LIGHT YEARS

TRANSWARP CONDUIT
'Dark Frontier'
-20,000 LIGHT YEARS

SUBSPACE CATAPULT
'The *Voyager* Conspiracy'
-600 LIGHT YEARS

VAADWAUR UNDERSPACE
'Dragon's Teeth'
-200 LIGHT YEARS

HELP FROM Q
'Q2'
-2,000 LIGHT YEARS

VFX
DEPARTMENT
NEW CHALLENGES, NEW OPPORTUNITIES

Visual effects underwent a digital revolution during *VOYAGER*'s lifetime, but there was still room for tried-and-tested methods.

Visual effects is an arcane school of screen arts, blending multiple techniques, state-of-the-art technology, and old-school experience into extraordinary feats of sorcery. *STAR TREK* constantly redrew the line between the possible and the impossible, creating dazzling magical visions in a matter of days. *VOYAGER* entered production at a time when the tools of visual effects were changing almost in real time, with the series an evolving hybrid of the physical and the digital. Whether the tool was a detailed starship miniature, high-end digital animation package, or a tray of baking soda, the *VOYAGER* VFX crew had one guiding principle. As Dan Curry says, "We knew in the back of our minds that we were working on something greater than the sum of its parts. We all knew we worked for the audience."

Curry served as visual effects producer across both *THE NEXT GENERATION* and *DEEP SPACE NINE*, a key role he would continue on *VOYAGER* in 1994. Curry maintained a practical, hands-on approach to running the VFX department. "Every day was different," says Curry, "which is what keeps that kind of work interesting. Some days you have a production meeting, some days you're budgeting, some days you're on the motion-control stage,

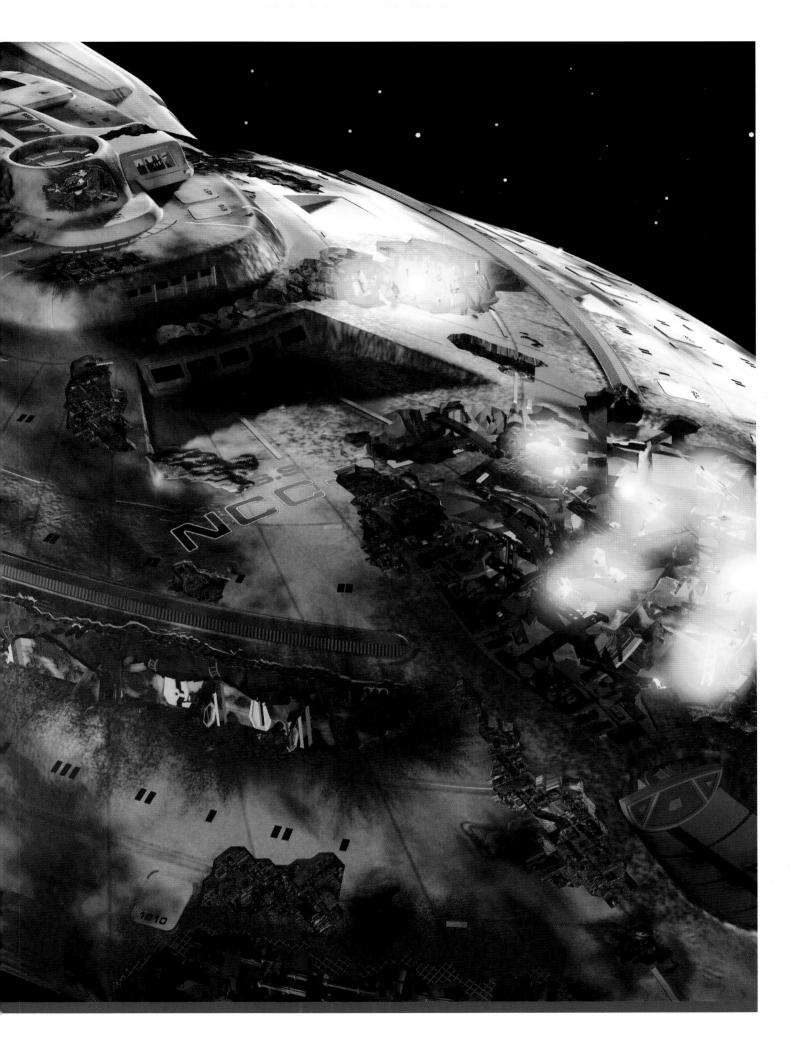

> "You'd read a script and it says: 'Ensign Kim is going to walk up and kiss the girl and she's going to turn into a cow.' Well, that doesn't happen in every episode!"

■ Ronald B. Moore

some days you're running to do 2D compositing, some days you're working with the animators, others you're working with the special effects team because we're doing explosions, other days I'd be directing second unit. Each day presented a new opportunity and a new challenge."

VOYAGER's pilot proved to be an endurance test for the VFX department. "'Caretaker' was a challenge," remembers David Stipes, who joined the series as visual effects supervisor after several years on *THE NEXT GENERATION*. "We were working so hard, everybody was doing a lot of preproduction work. Once we started on the motion control, we were working so many hours. The motion control was a huge number of shots. It was brutal, I got very sick, I could hardly talk. It was crazy, but we got it done. Everybody sacrificed a lot of family time."

"The pilot was a super-challenge," agrees Curry. "I submitted different ideas for the Caretaker array, and I was thinking something much more organic, like a floating coral reef. But the producers wanted to go with something a little more familiar. So they chose a design that we lovingly called the 'Casablanca ceiling fan.'"

RIGHT: Dan Curry plans a shot of Voyager on the motion-control stage at Image-G.

ABOVE: 'The Haunting of Deck Twelve': this close-up detailing demonstrates how the digital model of Voyager became more sophisticated over the years.

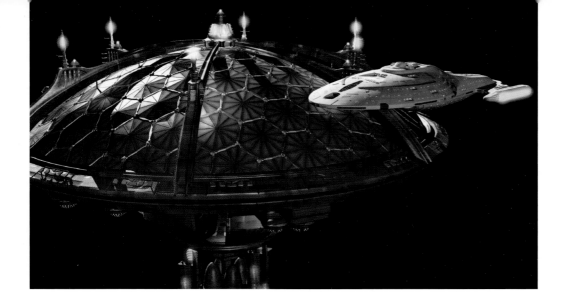

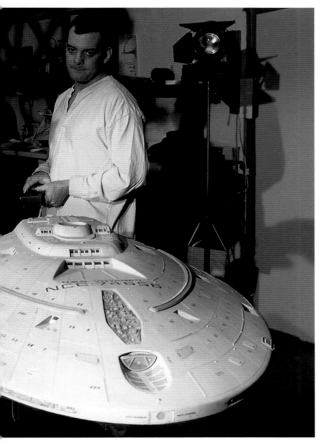

During the production of 'Caretaker,' 24-year-old Robert Bonchune arrived at the premises of Image G, then regular suppliers of motion-control photography to the *STAR TREK* franchise. "The first job I got in effects was at WonderWorks Inc.," recalls Bonchune. "WonderWorks got the contract to do the models of the Kazon ships. I brought them across to Image G. Dan Curry was there, the first time I ever met him. He said, 'These models aren't dirty enough, we need to dirty them down. You're going to help.' So Dan's on one side of the ship, I'm on the other, looking at what Dan was doing and copying him. I was just a kid from Montreal, how does this happen? And it foreshadowed the future..."

For decades, *STAR TREK*'s quota of starship-based VFX shots were achieved with physical models. This tradition endured into the 1990s, alongside sporadic use of developing digital technology. A five-foot hero model of *Voyager* was built, but the hints of a shift in the dynamic between physical and digital were seen in the creation of the ship's jump to warp.

"We knew that we were going to be doing jumps to warp," explains Stipes. "I said, 'Well, if we're going to stretch *Voyager* you can't do it with the physical model, I'm going to need a digital model.' I talked the producers into taking the five-foot model of *Voyager*, having it scanned and sent over to Amblin Imaging to be processed and turned into a digital model. So now we could do a jump to warp digitally instead of having to do slit-scan, which was a tremendously difficult photographic process. I was able to get a digital model and that became the beginnings of the move toward CG."

The challenge of completing 'Caretaker' soon gave way to the challenge of achieving each new episode's VFX demands on schedule and on budget. "You've got time, you've got money, and they fight each other all the time," says Ron B. Moore, who joined the *VOYAGER* VFX department as a supervisor from

'The Cloud' onwards. "After the end of *THE NEXT GENERATION* I was asked to go and work on *STAR TREK GENERATIONS.* That was a great experience, but I figured it probably meant the end of my days with *STAR TREK*. Michael Backauskas and Phil Barberio took over from me. When *VOYAGER* started I was still doing the movie, I figured I'd go out on that and move on. When it was over, I got a call asking me to come back."

Working under Dan Curry as their visual effects producer, Moore and Stipes drove much of the on-the-ground work as *VOYAGER*'s principal visual effects supervisors during the first two seasons. "You usually had three episodes going at the same time," outlines Stipes. "We were in postproduction on one, production on another, and in pre-production on a third episode. Some weeks I would spend more time planning and in pre-production meetings. Other weeks I'd be on set, or my coordinator Joe Bauer would be on set. Thank God I had a coordinator like Joe, he and I had a rapport that I knew I

> ## "We all knew that we were working on something that was greater than the sum of its parts..."
>
> ■ Dan Curry

could send him off to the compositing lab and he would nail the shots. Joe was my right-hand man." Today, Bauer is an Emmy-winning visual effects supervisor in his own right for acclaimed work, including *Game of Thrones*.

"In preproduction, you're budgeting, you're going over a script," adds Moore. "You're trying to iron it out, work out what the saves are. Then there's production, where you try to make sure on the set that they're doing what they need to do so you can do your job properly. In postproduction, you get all the pieces together and deliver it. I've gone up to directors and started talking to them about shots that weren't even in their show. 'You remember when that planet blows up?' and the guy's looking at me with a blank look on his face. You have to have a sense of humor. Everybody has a shot at a bad day."

In addition to a sense of humor on long working days on the *VOYAGER* set a visual effects producer just needs a

RIGHT: A close-up detail of a starship being worked on at the Utopia Planitia Fleet Yards in 'Relativity.'

RIGHT: The Delta Flyer breaks through digital ocean waves for an underwater mission in the Emmy-nominated 'Thirty Days.'

BELOW: A highly detailed exterior shot of a landed Voyager undergoing repairs in 'Nightingale,' created by Digital Muse.

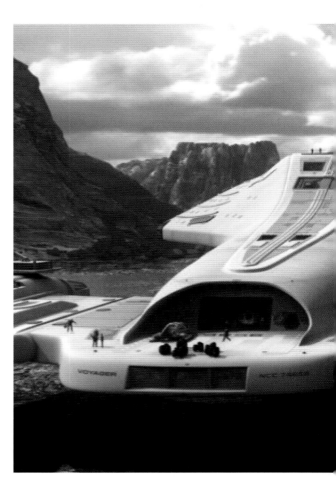

BELOW *How to blow up a corridor: elements showing the build up of a digital ship corridor created by David Lombardi for 'Fury.'*

nap. "Sometimes there'd be long gaps between VFX shots," says Curry. "They were doing an all-nighter, shooting on the bridge. I went into Janeway's ready room, which had a very comfortable curved couch and I lay down on it. The next thing I knew, Kate Mulgrew was shaking me. 'Dan, we can't shoot right now.' I realized my propensity for snoring at a high decibel level was interfering with the sound recording. When I walked out onto the bridge, 30 people all snored at me.'"

From the first episode, *VOYAGER*'s outlook was toward feature-film sized plots, placing the VFX under pressure to match that with feature-film sized effects. To continue to achieve the

impossible, the tools would have to evolve. David Stipes was a strong advocate of computer-generated imagery. "The writers were asking for stuff I couldn't produce," he explains. "When you're working on physical models in a physical space, we had 32 feet of motion-control track and so you can make the model only a certain scaled-down size. You can make it really big, but you can only get so far away. We had some shots that had to be redesigned because I couldn't do them in the manner that was needed.

"There was quite a bit of resistance, and I understand it," adds Stipes. "There had been seven years with Tony Meininger

and Greg Jein, all the people at Image G. There were a lot of friendships and a lot of concern that we were going to hurt our friends who we wanted to take care of. But there were still things that needed to be photographed that we just couldn't get very easily with the physical models."

"We could never have done *STAR TREK* without the crew at Image G," adds Curry in tribute. "They were the fastest, most efficient motion-control crew on the planet. But like all technological advances, CG was a two-edged sword. The invention of the internal combustion engine was bad news for people operating stables. It was exciting because we could do stuff we couldn't do before, but it also meant some of that medieval alchemy of creating visual effects with practical elements was going away. We didn't get to handle the coolest toys, we weren't blowing stuff up ourselves as much."

While the scales tipped gradually from physical to digital during during *VOYAGER*'s first two seasons, David Stipes cites the ninth episode of Season One, 'Emanations,' as a prime example of what could be achieved digitally on the budget available. *Voyager*'s movements in the vicinity of a planetary ring system could be rendered in more dynamic fashion. "Doing all of that in digital really made a difference, because we were able to show the planet's rings, all the layers of the asteroids, *Voyager* cruising between and around them. They were going to have *Voyager* approach the planet and then jump to the bridge and look at everything on monitors. We can't just sit here and talk about it, we've got to be able to see this.

The guys at Amblin Imaging stood up and donated time, which seems extreme, but that's how people were on the show. People were willing to step up when they needed to and help out."

As the VFX techniques and tools changed along with the scope of VOYAGER, Curry reflects on how it changed the work at the top of the VFX department. "It changed my job and the supervisors' jobs," he says. "We stopped spending 60 hours a week shooting motion control; it turned my life into being like an orchestra conductor rather than playing the instruments."

The end of VOYAGER's second season brought changes to the orchestra line-up. David Stipes moved to DEEP SPACE NINE, with Mitch Suskin taking up the vacant visual effects supervisor's role. Suskin's experience with digital VFX further bridged the shift to CG work. Moore and Suskin led two alternating VFX teams through to the VOYAGER finale in 2001.

For seasons one and two, Amblin Imaging provided the share of digital effects on VOYAGER. When the company closed down in 1995, many staff followed Amblin's senior figures, John Gross and John Parmenteau, who were setting up the CGI company, Digital Muse. Foundation Imaging meanwhile stepped up to supply VOYAGER with digital effects, and Robert Bonchune came into STAR TREK's orbit once again as a digital animator.

"Foundation was taking on more CG for STAR TREK, so I came full circle," he remembers. "I became the anomaly guy. It always seemed to be, 'We need an anomaly, Rob'll do it'! A lot of things we'd never encountered before... 'Hey Rob, do something! You're the physics guy.'"

With the morphing of Amblin Imaging into Digital Muse complete, the new company was also tasked with an increasing number of digital assignments for VOYAGER. "I started at Digital Muse in 1996," remembers CG supervisor David

ABOVE: 'Dragon's Teeth' featured an underground hangar packed with Vaadwaur fighters, an environment created with CGI elements.

LEFT: Voyager makes a dramatic escape from the Vaadwaur homeworld, pursued by Vaadwaur fighters.

Lombardi, "but for the first year I worked on *Sliders*. While that was going on, I saw they were working on *VOYAGER* and *DEEP SPACE NINE*. I was then mostly on *DEEP SPACE NINE* as a CG supervisor up until the finale, and then I moved full-time on to *VOYAGER* in 1999, with 'The Killing Game.' It was a young company, we had space on Santa Monica Promenade. You had this great feeling when you left for lunch with everybody, you were on the Promenade! It was a neat location."

Lombardi relished the chance to work with the *VOYAGER* team, seeing it as a learning experience. "Working for Dan Curry, Ron Moore, and David Stipes, those guys did the effects, they were artists. You got a lot of good feedback. Not only were they clients, they were mentors and people you respected."

Over at Foundation, Bonchune continued to earn a reputation as the "anomaly guy," being challenged to create the Borg's idea of perfection for 'The Omega Directive.' "The

Omega molecule was fun," he recalls. "Mitch Suskin came into the office and said 'Rob, I got something for you! In this story there's this molecule and we need something that the Borg think is god. Good luck!' And he walks out. That was it, no sketches – nothing. You're on your own, just come up with what the Borg think god looks like."

By this stage, Bonchune was sharing an office with Foundation's CG supervisor, Adam 'Mojo' Lebowitz. That quirk of seating arrangement had a direct effect on Bonchune's future with *VOYAGER*. "Mojo had his own office because he liked to play techno music really loud," laughs Bonchune. "Nobody wanted to go in there because of the music, but he came over to me one day and said, 'Hey Rob, you want to come in my office, it'll be really cool and you'll be right in there on all the *STAR TREK* meetings.' It was the smartest thing I ever did. Because Mojo was a supervisor, Mitch Suskin was always in

NICE CORRIDOR

On the sixth season episode 'Fury,' a computer-generated exploding corridor was a proud moment...

DAVID LOMBARDI: "They didn't do a lot of digital FX on interiors, it was almost always all exterior shots. We did go on set and photograph the proper reference of the environments. We used an early version of photomapping, and so the first thing we did was go and snap the corridor set and see if we were on to something. That was our first step, to see if we could photo-model this or are we just going to build it and hope we can make it look as good as the real thing. Could we get the lighting to look real, could we get the environment to look real? But it was fully CG, all the way back, a long corridor that you never saw in the show, because everything was a set and you never had a shot in the show where you had a 50-yard corridor. And here it was on screen. Dan Curry looked at it, and said, 'Nice corridor.' Dan Curry gave me a little nod which, honestly, was my biggest triumph on that entire show. One of my favorites."

RIGHT: *'Relativity' gave the visual effects team the opportunity to show the origins of U.S.S. Voyager, seen here in drydock at Utopia Planitia.*

FAR RIGHT: *Further detail of the Utopia Planitia Fleet Yards created for 'Relativity,' featuring Excelsior- and Galaxy-class starships.*

there, Dan Curry came to visit, so I was in on all the meetings. It made it easier to eventually make me CG supervisor because they got to know me. It snowballed across a couple of seasons."

Bonchune's first episode as CG supervisor for Foundation was 'Timeless,' the 100th episode that serves as an emblem for *VOYAGER*'s developing digital sophistication, while making use of practical techniques.

"Those were the two most stressful weeks of my time on *STAR TREK*. But I had the help of everybody there, [digital effects supervisor] John Allardice, [Foundation co-founder and visual effects producer] Ron Thornton. The software we had could not replicate snow, so we were going to have to come up with another way. Ron was an old-time, practical models guy and said, 'We're going to take baking soda, we're going to put shapes through it that'll look like *Voyager*.' We built this whole set up to do snow explosions in baking soda, while [visual effects designer] John Teska created all the mountains and glaciers. Everything was down to the wire, because it took so long to render. We were given a date that everything had to be done by, and I remember being there all night. I thought I'd let everybody down... oh great, my first time supervising and I can't make it look the way I want it. But it worked out!" The VFX on 'Timeless' were subsequently nominated for an Emmy award in 1999.

"You didn't," Lombardi laughs, when considering how to survive *VOYAGER*'s schedule. "That's why Nerf-gun fights happen when you're waiting for renders at 2am on a Friday. Somebody had a laser pointer and the Promenade was right below us. You would shine the pointer down into somebody's drink, and as soon as it hit the liquid it would glow."

"That's dedication," says David Stipes. "*STAR TREK* was way beyond just a job for hire. People cared about their work, their contribution, and the quality of the work."

Over the course of *VOYAGER*'s run, the tools of visual effects changed, but the work of the VFX department was still to achieve the impossible. "When I first started on *STAR TREK*, I was thinking, 'What is it?'" says Ron Moore. "Once you've flown a couple of spaceships and you've beamed somebody in and flipped a phaser at somebody, what could go wrong? And yet every single time you got a script, you'd think, 'Oh my God'. Look at 'Spirit Folk.' You read the script and it says: 'Ensign Kim is going to walk up and kiss the girl, and she's going to turn into a cow.' Well, that doesn't happen in every episode!"

"There were two things about *STAR TREK*," says Lombardi. "It had a longer lead time [than was usual], and it was high

"We had to be careful that even as we were using digital, it stayed true to the STAR TREK style and look."

■ **David Stipes**

standard. You did a ship flying left to right, but man, you learned a lot about how to light that ship. It was a simple flyby, but it could not be sloppy. You had the almost military precision of getting those shots really good, and then you got to do unique episodes, like floating holographic babies, or the Doctor rezzing in a new way."

Sometimes, the art of visual effects was achieving the mundane. "There were a lot of invisible effects," says Stipes, "even homogenizing smoke in a battle scene. Trying to keep the set full of smoke was difficult because the front half of the bridge set would be missing, so the smoke is dissipating out. We'd add haze, smooth it out so that nobody would notice the difference."

Despite the leaps in digital technology, Stipes emphasizes that the impossible had to have boundaries. "Once I got the *Voyager* digital model, I could do things I couldn't do with the motion-control model. I could really fly that thing around. I had a scene with *Voyager* in the distance – it banks over and goes whizzing past, showing its nose and tail as it goes whooshing off into the distance. I was getting a little carried away whipping these giant starships around like they were fighters. We had to be careful that even as we were using digital, it stayed true to the *STAR TREK* style and look.

"The job gave me a chance to work with people I knew and cared about," concludes Stipes. "I'd like to put in special mention for Dan Curry. He championed my cause to get me on *STAR TREK*, so it was truly wonderful to work with him on a daily basis. I met and worked with a lot of really wonderful people. I'm so grateful to so many people on *VOYAGER* and *STAR TREK*."

"You get in the edit bay, you shoot this stuff and you do the best you can," says Moore of his time on *VOYAGER*. "Sometimes, the most fun part was when you get in the bay, you put the shot together and it didn't work. I look at *VOYAGER* and there are shots in there that are mine. Not that you ever did them alone.

I had Paul Hill in the edit bay, Adam Howard, and these guys working with us were genius. They always made me look good, because frankly, I needed all the help I could get! It was the people. I was with them for more than 18 years and I'm still with a lot of the cast and crew today. We were a family and I miss them to this day."

"We were silly enough to not know what we couldn't do," says Dan Curry, with an honesty born of decades of experience in a constantly evolving visual discipline. "So we just took on anything. The challenge was getting done on time, the air dates were relentless and could not be missed. That was the biggest challenge. The joy of *VOYAGER* was getting the work done, earning the respect of our colleagues on the show, earning the respect of the cast, working with such a wonderful group of talented people. That was the joy of going to work every day. My biggest joy was at the end of a season, looking back and thinking, yeah, we did that work, and it was cool."

ABOVE: 'Dark Frontier' featured the Borg Unicomplex, one of the most intricate effects sequences created by Foundation Imaging.

BELOW: Voyager docking at the Markonian outpost in 'Survival Instinct' – digital assets for the outpost would be modified to feature in further episodes.

THE STRAWBERRY MONSTER

The virus in 'Macrocosm' was created with visual and digital effects that pointed to the future...

ROB BONCHUNE: "The first thing I did for *VOYAGER* was the little virus in 'Macrocosm.' There was me flying it around. I called it the 'Hershey Kiss,' with the little ribbons hanging off it. I didn't build the model, but I animated it for the different shots. The thing I'm most proud of is the microscope shot. I thought I mimicked it well, what it might look like under a microscope. It took a little ingenuity to figure out what that look should be. Nobody was going to tell me, I had to figure it out. It was a nothing little moment in the show, but I was proud of that."

RON B. MOORE: "There was a lot of experimentation. We called it the 'Strawberry Monster.' Dopey-looking monsters are as much a part of *STAR TREK* as starships. This was a really fun episode because we got to explode it. It chases Janeway around the ship and it blows up. We had experience at blowing stuff up, but we'd leave a mess behind, so when they knew I was going to blow up the Strawberry Monster after I'd built it up with slime, they refused to let me shoot it on set. We had this old bluescreen and put it up outside on the backlot and hung up the monster, filled it up with slime, and blew it up several times. We really made a mess. Even though we exploded a physical model, a big part was CG. Jeri Taylor was really happy with the way it turned out, and was going to write something for a bigger CG monster as we could handle it better. That's where Species 8472 came from.

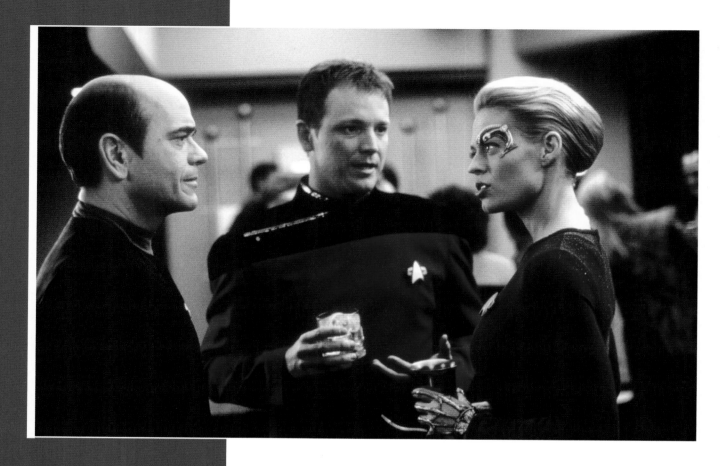

SEASON 5

EPISODE 22

AIR DATE: APRIL 28, 1999

SOMEONE TO WATCH OVER ME

One of the most popular episodes of *VOYAGER* is a bottle show, with the captain barely seen and no serious peril, unless failed diplomacy and a broken holographic heart count.

Teleplay by Michael Taylor

Story by Brannon Braga

Directed by Robert Duncan McNeill

Synopsis The Doctor teaches Seven about dating, then realizes he may have feelings for her himself.

That Robert Picardo's EMH was going to be a standout character was obvious from his first scene in *VOYAGER*'s pilot episode. Three seasons later, Jeri Ryan's Seven of Nine revitalized the show with her debut. Pairing them proved to be a magic formula.

The Doctor established himself as a mentor for Seven, helping her come to terms with her humanity, a complement to Captain Janeway's maternal approach. The on-screen rapport between the two was self-evident. Ryan agrees: "I loved any of my scenes with

Bob Picardo's character, the Doctor. I love their dynamic. He's a delightful human being to work with and be around anyway. So that was always fun."

RIGHT: In the B-story, Neelix has to look after a monk who has never experienced bodily pleasures before.

In season 5's 'Someone to Watch Over Me,' when Seven reveals a curiosity about human mating behaviour, the Doctor eagerly prepares a lesson plan for her first steps into romantic

> "You're teaching Seven how to date? Ha... talk about the blind leading the blind."
>
> Tom Paris to the Doctor

relationships. His class is initially played for laughs, with the Doctor performing a farcical interpretive dance in front of the image of an ovum. When Tom Paris adds his own input, he turns the tuition into a wager, which the Doctor happily agrees to. However, when Seven discovers that she is the subject of a bet she is genuinely hurt, leaving the Doctor to realize how insensitive he has been.

If the plot seems familiar, it is. "It's *My Fair Lady* with Seven," cowriter Brannon Braga smiles. "'Someone to Watch Over Me' is one of my favorites. I thoroughly enjoyed writing that episode." Cowriter Michael Taylor summed up the setup. "Putting those two characters together in that episode, it's not the blind leading the blind, but it's the partially sighted learning from each other, and also standing apart from the rest of humanity."

A key early scene has the Doctor select a tune for Seven to sing, which she does with aplomb. Taylor said, "I remember walking around with all these ideas I had for what the song should be, and Brannon just picked this much simpler song, which was all that was needed to really focus on their interaction." The Doctor and Seven perform a duet of the much-covered 1939 ditty, 'You Are My Sunshine,' which elicits a look of pride, or first hint of love on the Doctor's face. The story was becoming more than an amusing look

at Seven's clumsy dating efforts, though her dinner with Lieutenant Chapman at Chez Sandríne was a comedy highlight.

This episode marked cast member Robbie McNeill's third stint in the director's chair. "That was one of my favorite episodes to direct," he says. "It had more comedy than we'd typically have, it had rom-com silliness. I reached out to some actors who were very good friends of mine to play some of the supporting roles that Seven went on dates with: Brian McNamara (Chapman) – and David Burke (who played the hologram Steven Price) was one of my best friends and a wonderful actor."

The parallel story involving Neelix's ordeal with a visiting Kadi ambassador was also farcical. "That was the episode where we had the comic actor from *The Kids in the Hall* [Scott Thompson]," McNeill continues. "He was the alien that came on board, the Drunk Monk. We cast an actor who had a lot of comedy chops. It was one of the better light-hearted, but also really meaningful and heartfelt episodes."

The story shows just how versatile *VOYAGER* could be. It's a romantic comedy involving an artificial intelligence teaching a former Borg drone how to be human. There are no action sequences or alien threats and yet it is one of the series' best stories.

"There is nothing wrong with that episode," Braga says. He was particularly pleased with one shot. "The Doctor realizes he's in love with Seven of Nine and that she isn't in love him, when she's singing. Robbie McNeill does this nice little push in to the Doctor as she's singing 'You Are My Sunshine' – a great moment. That wasn't planned and you know it kind of ended there for most part, unrequited."

The ending for the episode was yet to be written when shooting began, leaving the director and crew having to wing it. McNeill

remembers, "It definitely kept us on our toes, kept us aware of how much we were telling, in what order we were telling the story, and not to have the Doctor fall in love with Seven in Act One, to really find the whole journey, and fill it out fully."

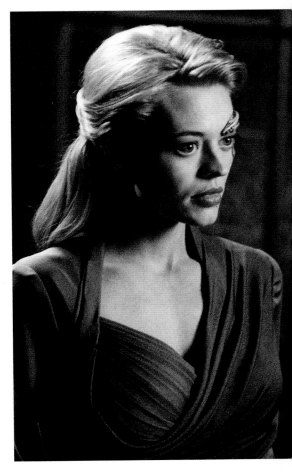

ABOVE: At first, Seven's attempts at dating are less than successful. She has no grasp of small talk or social niceties, but she is a good student and reveals a very human vulnerability.

On the last scene between the Doctor and Seven, Jeri Ryan reflects, "I thought that was so lovely and so touching. [The end] just broke my heart." The conclusion is deliberately subdued as the writers were not planning to develop a romance between the Doctor and Seven of Nine. And so, the Doctor returns to holo program Paris 3, Chez Sandríne, for what would be a final visit, to perform the title tune for the episode – "Won't you tell her please to put on some speed, follow my lead, oh, how I need someone to watch over me."

> "Seven, has anyone ever told you, you have a beautiful voice? It's a true gift."
> "The gift is from the Collective. A vocal subprocessor designed to facilitate the sonic interface with Borg transponders."
>
> The Doctor, Seven of Nine

David Livingston

D I R E C T O R S

PUSHING THE ENVELOPE

VOYAGER's roster of experienced directors brought their episodes together in a matter of days.

E pisodic television directing is a strange animal," says David Livingston (pictured above). "You try to push the envelope as much as possible, but you can't go too far because they won't have you back!" It's a statement born of experience. From 1987, Livingston served as a supervising producer on *STAR TREK: THE NEXT GENERATION*, *DEEP SPACE NINE* and the early days of *VOYAGER*, taking on directing assignments alongside his producing commitments. Turning to the life of a full-time freelance director in 1995 during production of season 2 of *VOYAGER*, Livingston stands as the most prolific director in the history of *STAR TREK*, directing 28 episodes of *VOYAGER* out of 61 directing credits on the franchise. "You wear two hats on the set," he laughs. "As a producer I wore a hat with the bill forward, when you direct you turn the hat around so you can see better. They didn't like it when I had the hat forward as a producer!"

Livingston cheerfully describes himself as a "contrarian" whose approach to the pressures of directing perhaps didn't make him many friends on set. "The episodes were structured so you had seven days of prep," he outlines the fast turnaround of directing episodic television, "and either seven or eight days of shooting depending on the complexity of the episode. A lot of times the scripts came in late, sometimes you wouldn't get a script until day four of prep. You'd get a story, and [production designer] Richard James would have an outline and knew what sets to build – the 'swing' sets – so they could start. I would get the designs for those and would comment. I'd ask for changes on the sets knowing what I wanted to do with the camera.

"I liked to ask questions about the script," he continues. "I insisted on tone meetings and the writers would cringe because they knew that I came in with pages of notes! I know I did not make a lot of friends by asking so many questions.

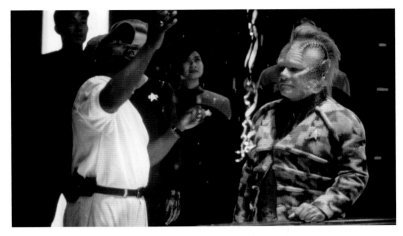

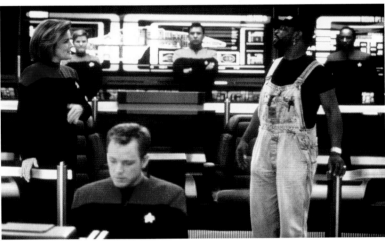

ABOVE: *LeVar Burton on set directing the* VOYAGER *cast. The* NEXT GENERATION *star directed eight episodes of* VOYAGER, *including 'Timeless,' in which he also guest-starred.*

I wanted to know what the intention of everything was. Without understanding the intention of a script or the scene, you aren't going to be able to deliver it dramatically. Even in episodic television where directors are lower than pond scum," he adds, once more with that knowing smile, "they still have to shoot it in a way that accentuates, mirrors and interprets what's on the page. It's the job of the director to make the script come alive visually and dramatically."

While Livingston was an experienced hand on *STAR TREK*, John Bruno's work on 'Tinker, Tenor, Doctor, Spy' and 'Fury' in season 6 were his first television directing assignments. An experienced Oscar-winning visual effects supervisor and feature-film director known for his work on *Ghostbusters* and collaborations with James Cameron, Bruno was introduced to the production team by his close friend and *VOYAGER* director, the late Terry Windell. "I'd just directed the film *Virus* in 1999,

and Terry said Brannon Braga was looking for feature-film directors. I'd never done television but I went in. Brannon was trying to change things up and they had some shows planned that were effects heavy. I was interested, but I'd heard you had to do eight pages a day on the shoot. I'd only done films where we were lucky if we did a page-and-a-half a day. Brannon said, 'You might have to do 10 pages a day'!

"For 30 days I followed a production," Bruno recalls the intensive period of preparation he went through ahead of work on 'Tinker, Tenor, Doctor, Spy.' "I sat in on production meetings, learned how the art department worked, who planned what. Ron B. Moore was the visual effects supervisor and we'd worked together on *Ghostbusters*. I was a little nervous – could I just jump in when everybody knows their routine? They sent me a stack of the shows on VHS. I was calling everybody I knew, asking what you do for television?" Bruno called on the

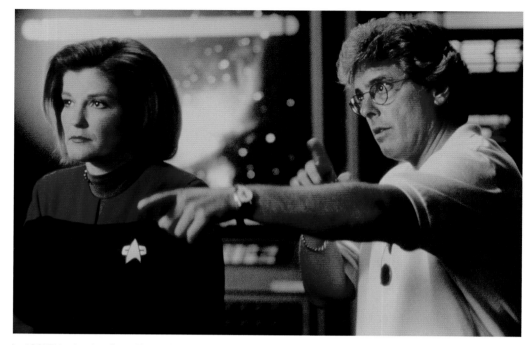

ABOVE: *Les Landau directs Kate Mulgrew on set. Out of 46 directing credits on* STAR TREK, *Landau directed nine episodes of* VOYAGER, *and shared his wisdom of directing on the show with fellow director John Bruno ahead of his first episode.*

wisdom of fellow *VOYAGER* director Les Landau. "Les said, 'Study the page, try to get three set ups per page, look for 'oners,' something you can do in one take.' I thought I'm just going to go in and ask people, 'Help me out here.'"

In his early days as a *STAR TREK* director, David Livingston also looked to voices of experience to guide his approach. "You get time on the permanent sets," he says. "You want to go in and do your homework. It's something I learned from [*THE NEXT GENERATION* director] Corey Allen. I'd worked with him at Universal on pilots, I always respected his work ethic. You'd have to give him a stage pass on the weekends. It was called 'noodling time,' where he would plan out everything to the Nth degree and come in with all these diagrams of what he wanted to do. He would always finish on schedule, and that's the lead I followed."

By the time he was directing episodes of *VOYAGER*, Livingston's style had evolved with experience. "I always wanted to find out where a scene should start and where it should end. Let the actors stage the scene for you, rather than me forcing them into it. My initial style of directing was to say 'You need to move there, and you need to move here.' It's not organic and you're taking advantage of actors who know the characters better than you do. Let them take the scene. An intelligent actor should know what the scene is. As long as you give them a starting point and say where you want them to end up, they'll take you there. That's a great lesson I learned about directing: at some point, sit back and watch."

"Marvin Rush, the Director of Photography, gave me some advice," recalls Bruno. "The actors know what to do. When you come in and set up a shot, see what the actors do, and then jump in. It was all different to movies where you plotted out the shots and designed the set for everybody to work on. On *VOYAGER*, here are sets that were permanent and everybody knew where everything was. I had to go in on weekends and study the sets."

Directing on *VOYAGER* was a learning curve for Bruno, but he brought his wealth of experience working on major feature films to the craft of directing television. "I did something that nobody does: I storyboarded everything. Shot for shot. Roxann Dawson came up to me and said: 'I've never see anybody do that.' But I didn't know any other way. Every scene had them, I had my boards with me and when we finally got going I shot it exactly. I don't think you can be overly prepared but I wanted to go in there ready."

On starting prep work, Bruno was surprised to be reading the script of 'Tinker, Tenor, Doctor, Spy' and not the visual effects, battle-heavy episode he was originally hired for. "I read the opening line and the Doctor sings this little opera thing. That threw me because I thought, 'This is funny.' Comedy is much harder to do than regular drama, or some battle or shootout. I went over to Bob Picardo's trailer. I'd talked to some of the other actors and said hi, but Bob and I started going through the script. We hit it off. I would just go and sit in Bob's trailer. That's something I've always done. Sit with actors and talk about stuff. I didn't know if that was good or bad, that's all I did. This was a good show for Bob, it was a good show for me and I think we hit this rhythm." Bruno remains close friends with Picardo today, and their initial collaboration on 'Tinker, Tenor, Doctor, Spy' led to the actor and director working up the story that became the acclaimed sixth season episode 'Life Line.'

Ultimately the job of a director on *VOYAGER* was to keep the episode moving, shooting on time and on budget. "I'd shoot for a seven-day schedule and go for eight days," says Livingston. "I was a long-term production manager and then a line producer, I knew the game better than anybody. My problem was, my ego was bigger than my talent! For an episodic director, that's not a good trait. I tried my best to be as subversive as possible because if you're not fighting and tilting against windmills, why are you there? The script has a point of view, but the director has to bring a point of view to the table as well."

"You had to plan as a *VOYAGER* director," adds Bruno. "Tim Burton can make it up, I can't! You got one day of Steadicam, one Technocrane day, and one two-camera day. Marvin Rush would help out by doing hand-held shots if you were falling behind,

he'd just pick the camera up and we'd go and he'd catch you up." As a director, Bruno found he was always in thrall to the unrelenting schedule. "Three days in, [supervising producer] Merri Howard came in and told me I was 45 minutes behind. I said, 'that's great, right?'. 'No, you have to make the time up.' If I was 45 minutes behind on a movie, I'd be saying 'are you kidding?!' I went to the first AD [assistant director], Jerry Fleck, who told me not to worry. 'We've got a corridor scene, a walk and talk next, that usually goes pretty quickly.' We did that, and then I was an hour ahead. It was a really interesting experience for me. I was nervous. Jerry told me to relax and worry about it on day five!'"

Helming more episodes of *VOYAGER* than any other director, Livingston worked to bring the familiar standing sets to life. "My view when we were on the bridge set was to tie them together and do something a little bit different with the

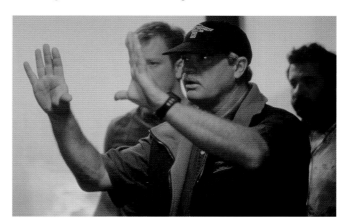

ABOVE: Marvin Rush was VOYAGER's director of photography, but found time in his schedule to direct two episodes, 'The Thaw' and 'Favorite Son.'

CLIFF BOLE

Among many acclaimed *STAR TREK* directing credits, Cliff Bole directed ten episodes of *VOYAGER* over a period of four years, including 'Meld,' 'Tuvix,' and 'Dark Frontier.' Bole passed away in 2014, but previously shared his wisdom of directing on *STAR TREK* and *VOYAGER*.

"*STAR TREK*'s so stylized in itself. I've seen many a good actor challenged by that. It's not a street show, it's a stylized format and you start putting makeup on some of these people's faces, they come in at four o'clock in the morning,

and by the time they get on the set they're just intimidated. I've seen a lot of very good actors challenged and falter.

"You just try to pour everything you can into it. You try to bring something to the table that is as different as you possibly can come up with. You try to do that on every show, you don't try to shortcut something if it's not one of the biggest ones, you try to give it everything you can. A director should try to come to the table and pour in everything they possibly can until they cut you off at the knees."

camera to just give the audience a break from the relentlessness of seeing that set. I always wanted to do a scene where you started in the conference room, move on to the bridge and then into Janeway's ready room. And I finally got an episode when Kate's talking to everybody in the conference room, they go on to the bridge, and she ends up in her ready room. That was all one shot. It wasn't just because it was glitzy as a shot, it was the connective tissue which showed that the bridge was all one piece. It ties things together and gives a sense of the wholeness. It makes it seem like a real place.

"You need visual excitement in the background," believes Livingston. "*STAR TREK* is an incredibly static show and anything you can do to keep the audience visually engaged, you've got to give them little things. You need to create energy. It became a cliché, but instead of yelling action, I would say, 'Energy up! Action!' Every scene should be life or death in some way, shape or form. If it isn't, the scene should not be there."

Much of a *VOYAGER* director's life was spent enclosed within Stages 8 and 9 on the Paramount backlot, meaning location work became something to be savored. "When I quit the show as a producer, Rick Berman said, 'Oh, you just want to go out and direct and wreck stuff!'" laughs Livingston. "That's exactly right. I was always fan of the non-shipboard episodes, so 'The Killing Game' was my favorite. We got to go back and do World War II, Nazis and all the heroics involved in that. Jeri Ryan became a torch singer. It had so many different elements, we shot on the backlot at Universal in the period village. It was terrific fun to do."

"I liked the rapidness of *VOYAGER*," says John Bruno, summing up his work on 'Tinker, Tenor, Doctor, Spy' and 'Fury.' "I got to do the one thing I think every director of *STAR TREK* wants to do: the ship getting hit, sparks fly, the lights flash, the camera tilts and everybody moves together in unison. I thought, 'Wow! We just did that!' I learned a lot doing the two shows that I did, and took it with me."

"Actors are amazing," David Livingston says of the *VOYAGER* ensemble he worked with across 28 episodes. "You don't realize the broad range of abilities and experiences they have, and you're so shocked to have them revealed to you. It's quite a delight, they're special people. The *VOYAGER* cast, everybody was grateful to be on something that they knew was going to give them annuity for the rest of their lives.

"For all the cast and crew on *VOYAGER*, life couldn't have been better. We didn't have studio interference, we didn't have network interference, the producers gave us leeway, and they wrote wonderful stories that respected Gene Roddenberry's vision of the future. It was a rarefied period in television and I was incredibly grateful to be part of it."

TERRY WINDELL

Terry Windell passed away in 2018. His extensive resume included directing episodes of *VOYAGER*, including the second half of the epic 'Dark Frontier,' on which he shared his experiences of directing.

"There's a ton of opticals. It made it interesting to shoot because when you're filming you have to do a lot of your pacing for that aspect. I have a strong visual effects background, I used to be a visual effects supervisor for features. So I have a very strong concept in my mind of what I'd like to see, although I don't supervise once I'm done with filming. The visual effects supervisors are on the set, and we discuss the scene pretty intimately as we go along so it gives you a good idea of what its going to be.

"I don't want to get too involved with the technical aspect, it's more about me discussing what that effect is doing for the story, what I need from it, where are they looking and so on. The thing you want to avoid is where you have one world inside the ship and you cut to outside the ship and your world can get disjointed. Some of the extra effects were having things outside the windows to tie the characters to the actual world that we're talking about.

"You have to be careful about what you see and what you don't see. My personal take is that if you're in a world that you want to be bizarre and disorientating is that sometimes it should be dark. I'm a big proponent of using sketchy light, there's some good examples of the Borg Queen in the early part where her lair is smoke and the light is backlighting her, so there's less visual clarity. There's more of an ominous figure back there and her contacts glow a little, and then as the scene unfolds she walks forward and becomes very clear and there's a bit of mystery there."

DIRECTING SCHOOL

GRACE UNDER PRESSURE

S TAR TREK has long held a tradition of affording its stars the opportunity to sit in the director's chair, from Leonard Nimoy and William Shatner, through Jonathan Frakes, Patrick Stewart, Avery Brooks and René Auberjonois. The cast of *VOYAGER* was no exception. One member of the ensemble announced their directing ambitions at a very early stage.

"The very first day of the pilot, when Geneviève Bujold was still our captain, Rick Berman was there for the wrap," remembers Robert Duncan McNeill. "We were walking out and I said, 'Hey Rick, I just want you to know that I've been shadowing directors on some other shows, and I really want to direct. I know you have a track record of letting actors direct and I'd love to do it'. He said, 'Oh yeah, sure, maybe, let's get a few seasons under our belt and then we'll talk about it.' We sort of let it go, but it was the very first day I put it out there."

"In the first year I talked with [executive producer] Jeri Taylor about directing," Roxann Dawson recalls her own route to the director's chair. "I had directed in the theater and I just liked bossing people around! I wanted to give it a try but I honestly didn't know if I'd like it. I told Jeri I'd love to learn, if they'd give me the opportunity. Then she and Rick Berman opened up Director in Training."

Over the course of seven seasons, McNeill and Dawson, along with fellow *VOYAGER* cast members Tim Russ and Robert Picardo all helmed at least one episode of the show as directors. The process of swapping Starfleet uniform for megaphone involved going back to school. "We had DiT school," explains prolific *VOYAGER* director David Livingston. "'Director in Training,' where Rick Berman would allow actors and crew to go through a training program, observing as much of production and postproduction as their schedules would allow, showing a commitment to study. Even though I went to film school, I had never directed on a large scale until I got to *STAR TREK*. Rick offered me that opportunity."

"I had shadowed a little bit, but it was very informal," says McNeill. "Somewhere around season 1 or 2, I went to a career coach, believe it or not. She specialized in career coaching for creative people. She was really helpful for me in putting together a plan. She had me sit down and make a commitment to myself to figure out where the most value was in spending time shadowing, and not just floating around randomly. These are little things that add up to building relationships so people can trust you, and that's what I did in the second season a lot."

"I became a Director in Training and I could go into everything," adds Dawson. "I observed other shows that were

ABOVE: *Roxann Dawson on set directing Ethan Philips as Neelix in 'Riddles.' Despite the challenges of directing television for the first time with "grace under pressure," Dawson has since become a highly sought-after director.*

shooting at Paramount. I did so much observing, I would be on an all-nighter downtown in Los Angeles on *Buffy the Vampire Slayer*, then come into work on *VOYAGER* at 4am so I could take a nap. I learned a lot and I put myself out there."

"Roxann would come and sit with me in the editing room," remembers Livingston. "She was very observant, asked a lot of questions and it was clear that she knew exactly what was going on. Roxann recognized that she needed to go through the process to be grounded, not only in the aesthetics of how to do this, but the technical aspects of it. I respected and admired her for that."

While directing his first episode of *VOYAGER* during season 6, John Bruno remembers Dawson's observant approach to DiT school: "I had one day on set in the conference room when I was shooting with two overlapping cameras. Roxann was standing behind me, looking over my shoulder at my storyboards. I explained what I was doing, and then I realized she was going to direct a show. She was following me, and I didn't really know what I was doing!"

After shadowing and working through the Director in Training program, McNeill's eventual call to direct an episode of *VOYAGER* came with just a few day's notice during early production of season 3. "Jonathan Frakes was supposed to direct 'Sacred Ground,'" he recalls. "I was at a convention somewhere in Florida and got a call from Rick Berman. He said, 'Jonathan was supposed to start prepping Monday, but

he's going to be directing 'First Contact,' so he can't do the episode. Are you ready?'"

"The reason I started directing later is because I was pregnant and we waited until after I gave birth in order for me to start," says Dawson, whose first directing assignment was the early season 6 episode 'Riddles.' "How prepared can you be for something you've never done before? You can prepare and prepare and prepare, but if it's an experience you've never had before, for somebody who really likes to be prepared, it's torture. There are a million scenarios that you'll be facing, things that you couldn't possibly have prepared for because you had no idea and no experience. It's learning how to deal with all that with grace under pressure."

"I was incredibly nervous, I didn't sleep for two weeks," laughs McNeill. "I'd just be panicking about it. Do I know how I'm going to stage this? How many shots? Television directing is a really tough job, a very challenging puzzle of skills. That's why I was panicked with 'Sacred Ground,' I knew that I needed to be the one to know how I was going to shoot everything, that I could do it in time, that it was going to tell the story the right way, that the actors agreed to my staging.

"I know that Kate really loved 'Sacred Ground,' that spiritual exploration of faith, the mysteries of life and Janeway's inner journey through it. There's one simple moment where people in the caves are bathing Janeway, preparing her to go on her vision quest. It was a story moment to show the captain in a

very vulnerable position. Even though it was my first episode as a director, I thought it was an important image. I first talked to Kate and asked if she'd be willing to let me have the uniform come off and let them bathe her in this ceremonial way. She said, 'Wow, I wouldn't do it for anybody but you, but yes, it sounds great, I'll do it.' I always tried to find ways of finding moments or images or shots that will be memorable and add to the story."

"You're with people that you love and want you to succeed," Dawson says of the support she received from her fellow *VOYAGER* ensemble. "It made me a better actor. I began to understand that I'm not just dealing with this part of the pie, but the entire pie. All of a sudden there were so many moving parts of which I was this much a part of. Often, actors need to be myopic, they need to concentrate on what they're doing and I respect that. But as a director, I've come to respect and understand those insecurities, understand that actors need to do that in order to show up and do the job. But at the same time, I've had payback. I've been on the other side, I've paid my dues in terms of actors doing things that have cost me time and money and face. On every level! I've had payback because in the beginning I was one of those actors who judged every director that came in."

McNeill agrees that directing altered his view of the entire *VOYAGER* experience. "The atmosphere on our set was very light-hearted, there was a lot of laughing and joking. In hindsight, I don't know that the crew and everyone else was as loose and informal as some of us were! I had wanted to direct for a long time, but once I started, my experience as an actor on *VOYAGER* changed dramatically, for me. I felt a sense of living in a world that was completely filled out. Before I was focused on my one little story thread, but then I had to look at the priorities of the whole show in a different way. It took my actor ego down to where I could pay attention to what the Doctor's doing in a scene, because I'm directing the scene, I want to make sure that character is hitting the right notes."

"After the first time I directed, I was in so much physical pain, there was so much pressure I didn't know if I wanted to continue with it," Dawson honestly recalls the aftermath of directing 'Riddles.' "That was a learning experience. I would call my husband after the first few episodes I did and let him know if it was a two Advil day or a six Advil day. I literally was in physical pain!"

"I was so exhausted from it that I was very split," adds McNeill of his own debut stint as a *STAR TREK* director. "Was this something that I really wanted to do? If this was how hard it was all the time, I can't do this. It's too stressful and too difficult. But I also loved it and when it was all put together I was very

happy, so I wanted to direct more." Following 'Sacred Ground,' McNeill directed three further episodes of *VOYAGER* – 'Unity,' 'Someone to Watch Over Me,' and 'Body and Soul.' In the years since *VOYAGER*, he has become a successful television director and producer. "*STAR TREK* was my film school," he sums up, "all that shadowing and directing. It wasn't until I started directing outside or made my own projects that I started learning some of the different ways of doing things. I still learn different ways of doing things. Everyone was very supportive when actors on the show directed: Roxann, Bob Picardo did a couple, Tim Russ. People were just very supportive. When people inside the family were directing, it felt like the right thing to do."

"After I did my first episode," remembers Dawson, "Rick Berman came up to me at the wrap party for that season and said he liked 'Riddles.' 'So I'm going to give you another opportunity to fail.' It was the oddest wording, I will never, ever forget that!" Dawson subsequently directed 'Workforce, Part II' during season 7, and has since become a highly sought-after director on some of modern television's biggest shows.

"I just fell in love with it," Dawson say, looking back. "It was trial by fire, especially moving out of this *STAR TREK* world into the rest of the world that didn't care whether you succeeded or not. Now it's a complete and utter joy. I love directing and I have loved it for a long time. I'm so glad and so grateful to Rick Berman and Jeri Taylor, who gave me this opportunity and literally changed my life."

ABOVE: *Robert Picardo directed two episodes of* VOYAGER, *joining fellow castmembers Roxann Dawson, Robert Duncan McNeill, and Tim Russ.*

SEASON 6

EPISODE 24

AIR DATE: MAY 10, 2000

Teleplay by Robert Doherty & Raf Green
and Brannon Braga

Story by John Bruno and Robert Picardo

Directed by Terry Windell

Synopsis The Doctor is sent to the Alpha
Quadrant to cure the dying
creator of his program.

LIFE LINE

The only live-action *STAR TREK* show based on a pitch from a cast member, 'Life Line' saw Robert Picardo on a double shift as differing doctors, a challenge for the star and the film crew.

Having made his name and won an Academy Award® as a visual effects supervisor working with James Cameron, John Bruno had recently directed the movie *Virus* before taking on two episodes of *STAR TREK: VOYAGER*. His first episode, season 6's 'Tinker, Tenor, Doctor, Spy' was a comedic highlight starring the ship's Doctor. Bruno and Robert Picardo became firm friends on the shoot. "We just hit it off," says Picardo. "John is such a great explainer and he's one of those people who visualizes everything in his head, so I realized that

I had to learn from him. And I also was going to direct myself that season, so we were helping each other."

As Bruno had a few weeks free between

RIGHT: Marina Sirtis guest stars as Counselor Troi, who is trying to help the egotistical Zimmerman.

directing gigs, he turned his hand to scriptwriting, and who better to write about...

"Everybody had an origin story," says Bruno. "Janeway had a sequence back on Earth with her family, Chakotay had an origin story, so I said to Bob, you were created by this guy Zimmerman, right? He goes, 'Well, I did play Zimmerman on *Deep Space Nine* ['Doctor Bashir, I Presume'].' So, I said, why don't we come up with your origin story? Like, why are you such an a-hole? Why do you have this attitude? Where did that come from?"

"I thought it would be cool to do a father-son drama," says Picardo, "with all of those issues of being a parent or a child from the parent's and the child's point of view."

Bruno's original backstory for Dr. Zimmerman was bleak. "I had a darker take on it," he says. "I think his wife dies or something. That was what made him bitter." Bruno and Picardo were invited to pitch the story to the show's

> "He used his own physical parameters as a model for my matrix. Can't say I blame him. A doctor needs to inspire confidence in his patients. Compassionate eyes and a strong chin can go a long way."
>
> **The Doctor**

producers. "The idea opened on a machine in a lab," Bruno recalls. "There's a big bright light and some shimmering sparkly visuals and an egg appears. It had just been transmitted from Earth. Then everybody realized, 'We made contact! We can transport and transmit data!' Everybody thought that was cool, but they didn't like the rest of the story, it being so dark. So when I left there, I thought I'd blown it. When I got to my car, my phone rang. It was Joe Menosky. He said, 'It's too dark. It has to be funny and I'm going to do a pass at it.' And then he made it what it is."

Menosky, with Robert Doherty, Raf Green, and Brannon Braga, took Bruno and Picardo's plot, keeping the father-son dynamic but

ABOVE: Dwight Schultz returns as Reg Barclay, who summons the Doctor to help Zimmerman, a man who is surrounded by holograms he designed himself – including his assistant Haley.

adding humor to the conflict. The teleplay also provided an opportunity to invite back two *Next Generation* alumni from season 6's 'Pathfinder,' with Dwight Schultz as Reg Barclay, and Marina Sirtis needing all of her skills as Counselor Troi to help the Doctors communicate.

"It was called 'I, Zimmerman' – like 'I, Robot,'" says Bruno. "I thought I was going to direct but I got a call from my friend Terry Windell. He goes, 'Hey man, I just got this script in the mail with your name on it. It's called 'I, Zimmerman.'" In retrospect, Bruno was happy to have his script passed on to a different *Voyager* helmer: "I thought, he's probably a better director than I am."

The script was certainly a challenge to work with. "There were eight pages of script that had repeat motion control on dollies," says Bruno. With Picardo playing both *Voyager*'s EMH and his older creator, Dr. Zimmerman, scenes had to be filmed several times, with cameras following the exact same movement.

VFX supervisor Ron B. Moore remembers the process. "One shot could take us half a day, maybe four or five hours. I worked with motion-control camera operator Les Bernstein, and we worked out these scenes on a track so we could set up and do three shots at once. Bob Picardo is unbelievable. He knew what it would take and he was willing to do it. This was probably one of the biggest motion-control shows that I did for *VOYAGER* and I'm very proud of the way that one came out."

In an interview for *STAR TREK: Voyager Companion*, Picardo made fun of his role. "I achieved a lifelong ambition of working with an actor who I've admired. Of course, the hardest thing about acting with myself was coming up to my own level. I was very demanding."

'Life Line' was a showcase for Picardo and *Voyager* as a whole, an episode with family issues, heart, and humor. The episode was a technical triumph, too. Bruno was impressed with how it all came together. "It was an eight-day shoot and they hit the schedule." But, as for the multiple repeat motion-control shots, Bruno laughs, "They just said they would never do that again."

> "I came here thinking that you were opposite sides of the same coin, identical, but different. Now I see you're both exactly the same. You're both jerks!"
>
> **Counselor Troi**

Michael Westmore

MAKEUP
DEPARTMENT
FIRST IN, LAST OUT

Michael Westmore ran *VOYAGER*'s makeup department, populating the Delta Quadrant with countless aliens for seven seasons.

4 am: the Paramount Pictures backlot is dark and deserted. By the time the sun comes up, the maze of soundstages will buzz with activity as crews prep, actors assemble, and a director shouts 'Action!' for the first time that day. But not at 4am – apart from the *STAR TREK: VOYAGER* makeup department near Stage 8, which is already open for business. "Every day was an adventure," says Michael Westmore, *VOYAGER*'s makeup supervisor and designer for the entirety of its run. "That's what I loved about the job. No two days were ever alike, they were always changing with what was going on."

An Oscar-winning makeup artist with decades of experience in film and television, Michael Westmore was a *STAR TREK* veteran by 1995, his tenure dating back to the pilot episode of *THE NEXT GENERATION*. Frequently overseeing two separate *STAR TREK* series in tandem, Westmore was responsible for designing

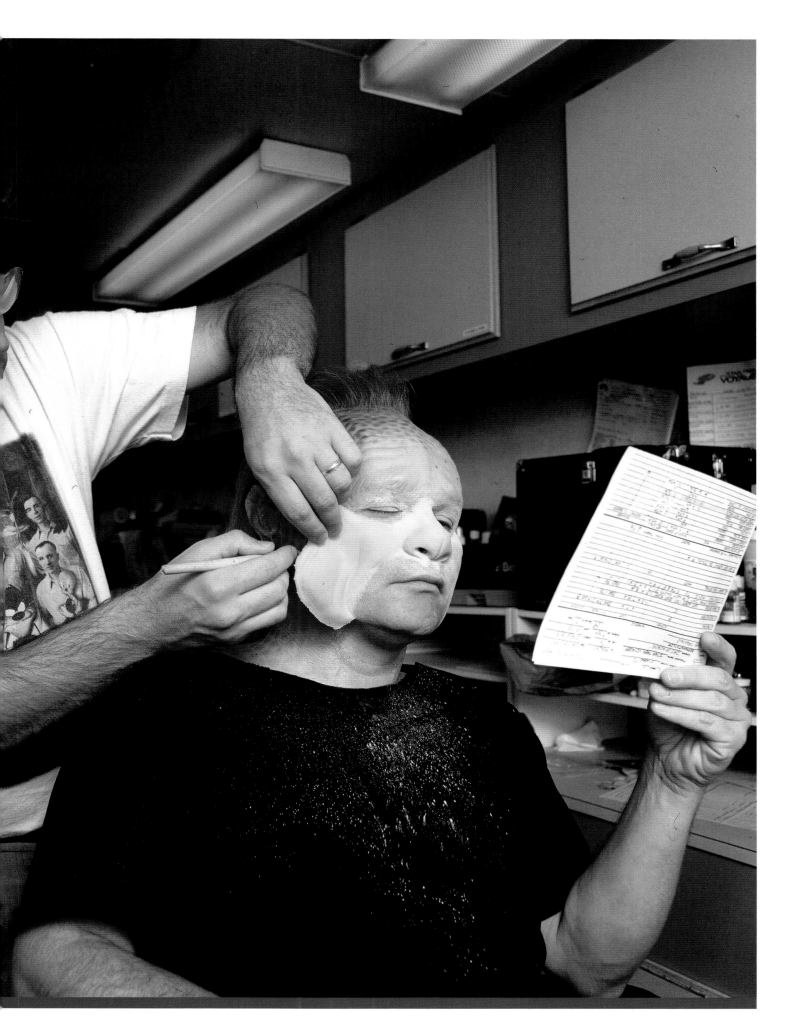

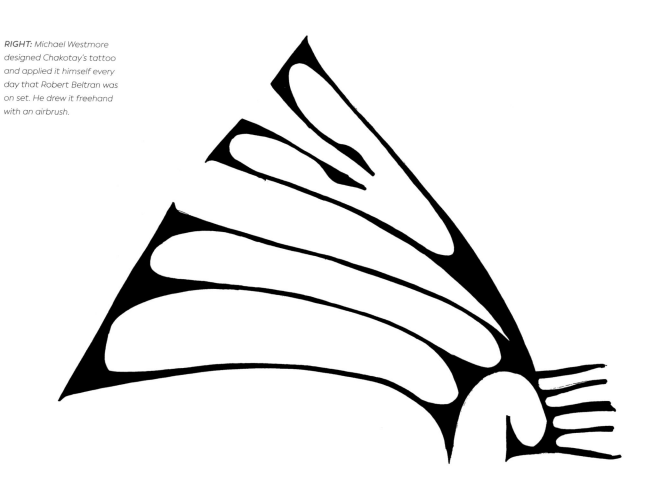

RIGHT: Michael Westmore designed Chakotay's tattoo and applied it himself every day that Robert Beltran was on set. He drew it freehand with an airbrush.

Klingons, Ferengi, Cardassians, Bajorans, and numerous other aliens, teasing and sculpting them into being, in an uninterrupted run of nearly 18 years. By the dawn of *VOYAGER*, Westmore's makeup department was a finely honed operation, where actors stepped through the door human and walked out an unrecognizable alien in efficient order.

Westmore's *VOYAGER* adventure began with the makeup requirements of a new ensemble, ranging from familiar Vulcan and Klingon prosthetics through the Talaxians and the Ocampa to a Native American first officer's tattoo. "No writers ever gave me any direction," says Westmore of the creative freedom he was afforded. "I got the script and it would just say 'alien.' Once I designed something, they may give a suggestion. Not a total change in a character – maybe too much or too little, add or subtract something. It was up to me to come up with the designs and, in reading the characters, whether it was going to be a full makeup or a humanoid or something simple. It was left

up to me to start the ball rolling on each one of the characters, Neelix being the biggest one."

In direct contrast to Ethan Phillips' elaborate and time-consuming Talaxian full-head prosthetic, Westmore's approach to Jennifer Lien's Ocampan makeup as Kes was tempered by practical production considerations. "There were some scenes in the pilot where we had maybe 30 Ocampa, which meant I needed a makeup crew of 10 to 15 people to be able to put that many together and have them ready by 7am. So with Jennifer, I wasn't going to be able to go crazy; it had to be a type of makeup that could be applied in a reasonable amount of time. The easiest way was to do something with the ear, and so we had those ears with the little holes around the jaw line. There were so many of them that had to be done, I had them all different sizes, between large, medium – and we had a couple of children at one time. That became the standard look for the Ocampa.

"Anything that was going to be more elaborate, we tried to keep them to just three aliens," Westmore continues. "When we first did the Borg, between them getting dressed and twice in the makeup chair, it took five hours. I had to run two makeup teams, one to put them in and one to take them out, because it took so long. With Neelix's makeup, we got it down to three hours, there was so much to glue in and blend off and paint. It wasn't just a wig, it was the whole giant mohawk. Then he had to go to hairdressing and get dressed, and then the mutton chops had to be re-curled. It was easier to do everything at night, to dress everything so it would save time in the morning."

One final major makeup element tackled by Westmore was the design and application of Commander Chakotay's tattoo. "I looked at tattooing from native cultures all over the world: Africa, the Philippines, Hawaii, New Zealand," he recalls. "We did sketches and tested them over a couple of days. The first

THE KAZON

MICHAEL WESTMORE: "With the Kazon, I was thinking of a Thanksgiving turkey. That's why they have all the little pieces hanging off the front of the face. There was a nose tip and a wattle down the front of the throat. Then we painted them orangey-red. I did that with all the characters. Instead of trying to be so creative and come up with something that you weren't familiar with or didn't know, it was easier researching through books and finding something that people are familiar with."

ABOVE: Michael Westmore tried to limit the number of alien prosthetics to three on any one day, as with the Hierarchy in 'Tinker, Tenor, Doctor, Spy.'

time I did it was by hand and I kept thinking maybe with a stencil it would be better. I found I could do it by hand faster than working with a stencil. Working with a stencil, if you made a mistake you'd have to take it off and start over. It was applied over Robert Beltran's regular makeup, so it would have been a mess. I held on to a picture in my left hand while I applied it. It didn't take very long before I didn't need the picture, I knew exactly where to go. I could put that on by hand in around 15 minutes. I think I applied it every single time Robert worked. I did it 750 times, and underneath the collar of his uniform I would put my initials and the number in Roman numerals."

As with other departments, following the initial flurry of creative decisions made in preproduction for the pilot, Westmore's makeup team soon fell into the weekly step of production, as *Voyager* set course for the Alpha Quadrant. Westmore outlines a typical day. "We couldn't start before 4am, which meant I'd have to get up at 3. Whenever we had a large crowd, I would be in when the actors piled in at 4am, to make sure everybody had everything they needed. The makeup crew would be there – we had a big room upstairs with tables where each person had their own little spot. I did Kate Mulgrew's makeup and that would take 40 minutes. We

ABOVE: *Although much of the makeup department's work was based on prosthetics, the makeup requirements on VOYAGER were highly varied from day to day, including makeup for Captain Janeway/Queen Arachnia and Dr. Chaotica in 'Bride of Chaotica!'*

usually had everybody ready by 7am. If it was simple makeup, an artist would come in at 5:30am, but the earliest were 4 in the morning. We'd have them on set by 7am, ready to film after rehearsal by 7:30am. They'd shoot until 1 o'clock, break for lunch until 2. Touch-ups until 2.30, and they'd be filming anywhere up to 8, 9 or 10 o'clock at night – whenever they finished. That determined what time they started the next day."

As important as applying makeup at the top of the day was having the makeup department on hand at the end of the day to safely remove prosthetics. "First in and last out," laughs Westmore. "They're long days. Tim Russ, Roxann Dawson, and Jennifer Lien were about 30 minutes each to pull everything

off. The liquids we used, we had a cocktail made up – it would break down the adhesive. Neelix was the longest to take out, and we had to be careful with the head. We tried to use the same one for an episode rather than a new one each day. Ethan wasn't usually in all seven days, so one head would last and we could have another head painted up. You're always thinking time and money, and ways of being prepared ahead of time."

Even on long production days, part of being prepared involved research and design. "Between 4 and 5 it would get quiet. A typical day would involve drawing, sculpting, or making moulds, making face casts of new actors. As soon as I read a script, I would start on the aliens. I'd sculpt in a green

"*Every day was an adventure. That's what I loved about the job. No two days were ever alike, they were always changing with what was going on.*"

■ Michael Westmore

THE VIDIIANS

MICHAEL WESTMORE: "All the aliens were fun to do, but my favorite were the Vidiians. I loved doing them. It was so much fun to figure it all out and then paint them; it was like putting a puzzle together. They were all different. Even if I had a big section and didn't have time to go back and resculpt things, I would just make up some pads with different texture on and just glue a single pad over another pad. You painted it differently and you wound up with a totally new character. It was like a horror makeup, and in the beginning I even had to make teeth for them so it looked like they were rotting out or they had got teeth from another alien race."

modeling clay. Most of the time, we tried to sculpt right on the actors. I had Sonny Burman in the lab. Like me, Sonny could do it all, but he was getting ready to retire so I hired him for several years. The two of us could pop out a cast in 50 minutes, or even less with the two of us working together. He'd take one half, I'd take the other and we'd have an actor in and out of the door. With Neelix, we had Ethan out in an hour and a half."

The greater part of Westmore's days were spent on the Paramount backlot between the makeup department, his office and the lab, but some days involved heading out on location. "The hardest days were if we got overburdened with any one alien race. If it's a big day, with a lot of Kazon or Vidiians, you're under pressure to get everything out on time and on set. Being on location is much harder, because you're having to pack up, move everything, open up boxes, and pull everything out. Once it's all done, you've got to clean it up, pack it away again, and ship it back to the studio. Next morning you've got to unpack all this stuff because it might be needed for a shot at the studio."

The demands of *VOYAGER* were met by the dedication of Westmore and his team of experienced professionals, along with leaps made in the tools used. "Between the glue and the paint that we used, *VOYAGER* couldn't have been done like this back into the '80s," he says. "You couldn't do as much as we did without the products and the technology that came around. It was difficult when we first started on *NEXT GENERATION*. We were still using rubber greasepaint in the very beginning."

Westmore sums up a highly creative and happy period in a long and distinguished career. "The whole time I was on *VOYAGER* and *STAR TREK*, I was into it every day. By the time we got to *VOYAGER*, it all worked like clockwork, it was like a science. I never woke up and said, 'Oh my God, I've got to go to work.' I didn't care if it was 3 in the morning. The creative challenges that it gave me were never-ending, and I've been told I had the best job of any makeup artist ever!"

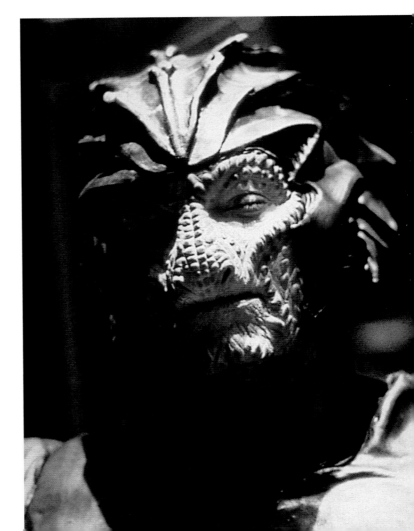

RIGHT: Westmore's design for the Hirogen was inspired by the look of a gila monster: "I had research on everything – birds, lizards, snakes, microbes..."

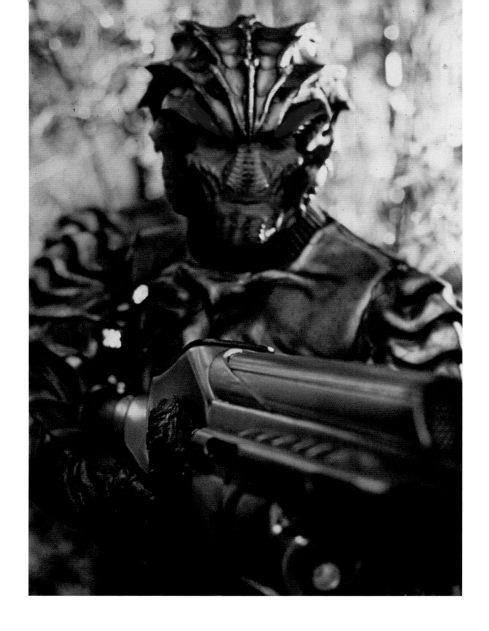

THE HIROGEN

LIVING FOR THE HUNT

A s with many ideas on *STAR TREK*, the creation of the Hirogen for *VOYAGER* was a convergence of different thinking over a period of time. This race of reptilian nomadic trophy hunters appeared in a run of episodes mid-way through season 4, forming something of a mini arc.

The initial spark behind the Hirogen's creation was the NFL, specifically the size of the football players. Watching a football game one evening with writer Bryan Fuller, executive producer Brannon Braga was inspired to develop a new race of aliens whose sheer size would set them apart from the general human height of featured aliens.

When breakdowns for various Hirogen roles on *VOYAGER* were circulated around the casting agents of Hollywood, the requirements called for actors in excess of 6'6" or taller, which posed a challenge for the show's casting directors, not to mention the costume and makeup departments.

"The Hirogen were an enormous challenge," says costume designer Robert Blackman. "That would be the most complete 'head to toe' thing that we've done. They were conceived to be constructed in a certain way, but halfway through the process Brannon Braga and I looked at it and thought, 'You know, this is not going to work.' We didn't have enough time to rethink it, so we had to quickly come up with a viable alternative. They

ABOVE: *Seven of Nine faces a Hirogen in 'Hunters'. This race of trophy hunters were inspired by the hulking size of football players in the NFL, calling for actors over 6'6" to be cast. Designing flexible armour for actors of such height proved a particular challenge for costume supervisor Robert Blackman*

were originally going to be vacuformed, which would have made them rigid and armor-like, but that didn't allow them enough maneuverability for the things that they were planning. "The stuff we ended up using is essentially silicone, which weighs a lot. So the four or five suits we made were huge. It would take two or three people to just lift the jacket or the leg units on to the actor."

Makeup supervisor Michael Westmore took particular inspiration in a distinctive look for the Hirogen. ""The Hirogen were inspired by a Gila monster," he says. "I picked out the Gila monster because they had the bumpy little skin and were basically down to a brownish, blackish orange coloring on them. In the beginning the Hirogen had a breathing mask, but we got rid of it because the producers wanted to see their whole face. I had research on everything – birds, lizards, snakes, microbes and everything you can think of."

The Hirogen first appeared at the end of 'Message in a Bottle,' with actor and former basketball player Tiny Ron – a mere 7ft 1in – playing Alpha-Hirogen Idrin. 6ft 4in Tony Todd featured in 'Prey.' No stranger to prosthetics and elaborate costumes as Klingon Kurn in THE NEXT GENERATION, Todd called it the most uncomfortable role he'd ever played.

The creation of the Hirogen allowed a story idea that had been in development for some time to finally enter production.

While living in Europe for three years, writer/producer Joe Menosky had conceived the idea of the VOYAGER crew entering a World War II environment, battling aliens in Nazi uniforms. The Hirogen provided the perfect opportunity.

"I had wild ambitions, and I introduced the Hirogen to get to that two parter," recalls Brannon Braga on the making of 'The Killing Game,' one of VOYAGER's most popular episodes. "The Hirogen were introduced with that hunter/prey combo, but in the back of my mind I had this crazy idea of the Hirogen using the holodeck as a hunting ground. I had the thought of somehow getting to the point where we had Hirogen, humans, Nazis, Klingons, all battling at the same time. And I thought, that's never going to happen, how are we going to get to that point?! And we did."

Broadcast as a feature-length event episode, 'The Killing Game' was a natural development of the Hirogen concept, featuring a great deal of action. It remains a favorite episode for cast, crew and fans. "We filmed on the backlot at Universal," continues Braga, "which had a great European town. El Niño was happening so we had pouring rain for free. I remember thinking that we just had to go with this.

"It was crazy to do, those were the kind of things we were into at the time. What can we do that's going to be nuts and fun and put the characters in these weird situations."

STARSHIP
GALLERY

In the course of its seven years, *STAR TREK: VOYAGER* featured nearly 200 different designs of ship. Because Janeway's crew were stranded in the Delta Quadrant, the VFX team rarely had the opportunity to reuse existing models from the previous series, so most of the designs were created from scratch. Many of the ships were re-purposed and used for different species, but the advent of CG made creating new ones relatively affordable. Ship-designing duties normally fell to senior illustrator Rick Sternbach, but many people had the chance to contribute, including VFX producer Dan Curry, art director Tim Earls, freelance artist Steve Burg, and the modelers at CG effects houses, Foundation Imaging and Digital Muse.

THE BORG
QUEEN'S SHIP
ARTISTS: Dan Curry and Brandon MacDougall

VFX producer Dan Curry worked with CG modeler Brandon MacDougall to come up with a unique geometric shape that could be used for the Borg Queen's ship. They settled on a diamond.

THE 'FLEA' SHIP
ARTIST: David Lombardi

Digital Muse's David Lombardi originally designed this ship for 'Vis à Vis,' but the design was considered too strange for that episode's story. It resurfaced in 'The Fight.' Lombardi wanted it to look truly radical, so abandoned the idea of making it aerodynamic and giving it windows.

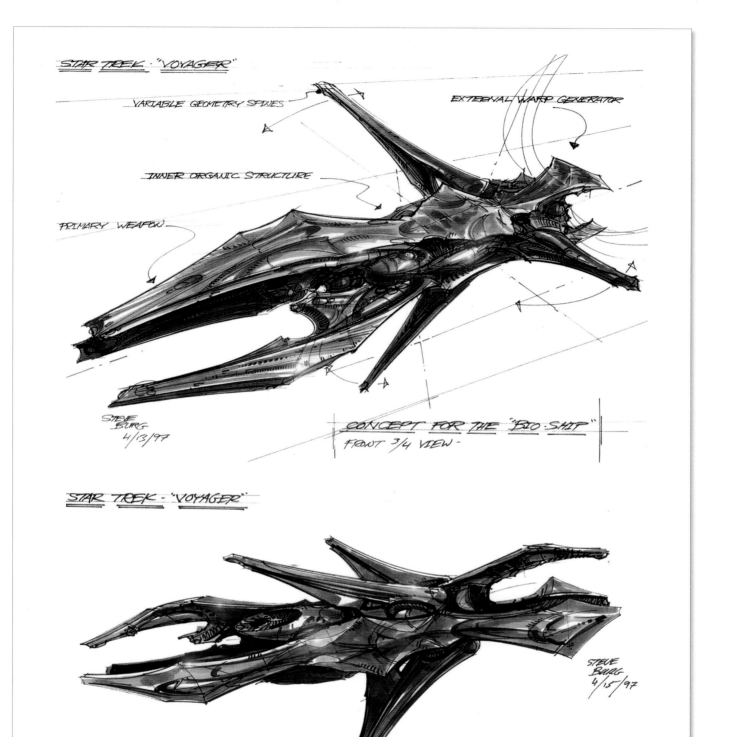

STAR TREK · "VOYAGER"

VARIABLE GEOMETRY SPINES

EXTERNAL WARP GENERATOR

INNER ORGANIC STRUCTURE

PRIMARY WEAPON

STEVE
BURG
4/13/97

CONCEPT FOR THE "BIO·SHIP"
FRONT 3/4 VIEW -

STAR TREK · "VOYAGER"

STEVE
BURG
4/15/97

SIDE VIEW

CONCEPT FOR BIO·SHIP

SPECIES 8472 BIOSHIP

ARTIST: STEVE BURG

The extradimensional Species 8472 and their ships were meant to look strange and alien. They operated in fluidic space, so Steve Burg drew inspiration from sea creatures. It was important that the design could latch onto a Borg cube, and that the ships looked good flying in formation.

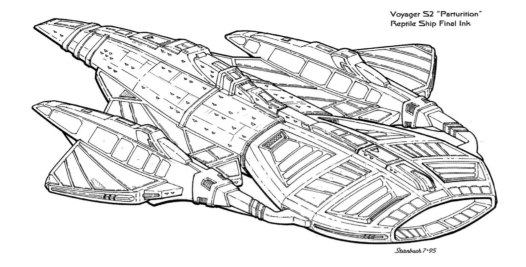

Voyager S2 "Parturition"
Reptile Ship Final Ink

Sternbach 7·95

REPTOHUMANOID SHIP

ARTIST: Rick Sternbach

The reptohumanoid ship, which makes its debut in 'Parturition', was one of VOYAGER's first CG models. Its design would be adapted to several different ships in the show, starting with the Vidiian ship in 'Deadlock.'

THE DAUNTLESS

ARTIST: Rick Sternbach

The U.S.S. Dauntless had to look as if it was capable of incredibly high speeds, and as if it could be an evolution of Starfleet design. Rick Sternbach gave it a more aerodynamic shape than any Starfleet ship seen before, but kept familiar Starfleet markings so it could pass for a Starfleet ship.

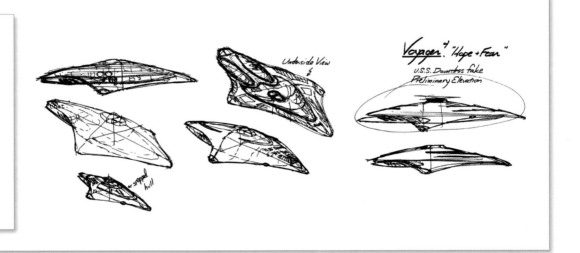

Underside View

Voyager⁴ "Hope + Fear"
U.S.S. Dauntless fake
Preliminary Elevation

stepped hull

THE RAVEN

ARTIST: Rick Sternbach

The ship that Seven's parents used to track the Borg was designed to be a larger version of the Starfleet runabouts that were used on DEEP SPACE NINE. Sternbach saw it as a civilian, rather than a Starfleet, ship so suggested it should be tan rather than blue. The first time we see the Raven it is a wreck and the design was modified when it reappeared in 'Dark Frontier.'

Impulse Vents
darker shade of
hull color

Sensors:
Med Blue-gray

Shuttlebay door
darker shade of
hull color

► Hull Color should be Gray, Warm Gray,
or TAN. No Starfleet Blue.

Borg spidery "plant-ons"

Dark blue glass;
system is off,
no light

Yellow ochre
coils

Dark red glass;
system is off, no light

see Mike Okuda for
stripes + typeface +
"arrowhead"

sternbach 8·97

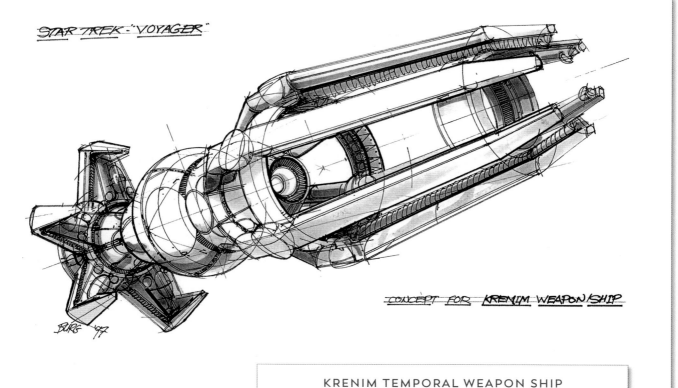

STAR TREK · "VOYAGER"

BURG '97

CONCEPT FOR KRENIM WEAPON SHIP

KRENIM TEMPORAL WEAPON SHIP
ARTIST: Steve Burg

The idea behind Annorax's ship was that it was a massive gun that would fire a beam of temporal energy that altered history. Designer Steve Burg saw the aft as a massive energy core and the fore as kind of focusing ring. He describes the final ship as being like a rail gun.

VAADWAUR FIGHTER

ARTIST: Tim Earls

Art director Tim Earls suggested this design for the Vaadwaur fighters in 'Dragon's Teeth,' but in the end, the ships were designed and built in CG by Foundation Imaging.

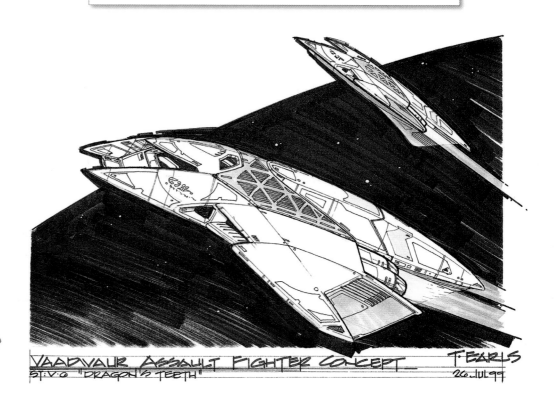

VAADWAUR ASSAULT FIGHTER CONCEPT
ST:V·G "DRAGON'S TEETH"
T. EARLS
26 JUL 97

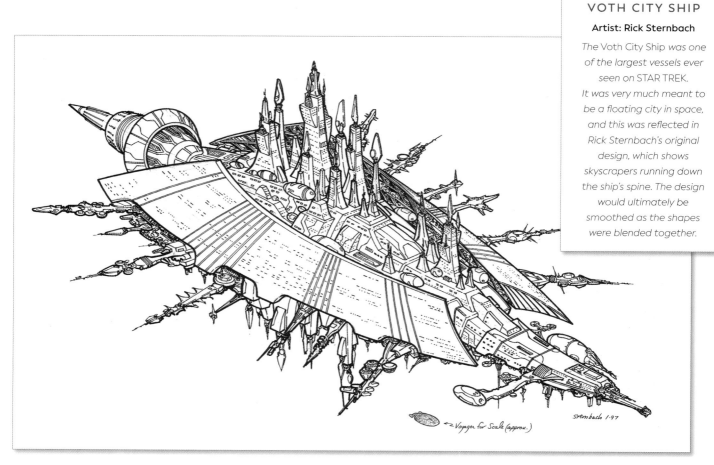

VOTH CITY SHIP

Artist: Rick Sternbach

The Voth City Ship was one of the largest vessels ever seen on STAR TREK. It was very much meant to be a floating city in space, and this was reflected in Rick Sternbach's original design, which shows skyscrapers running down the ship's spine. The design would ultimately be smoothed as the shapes were blended together.

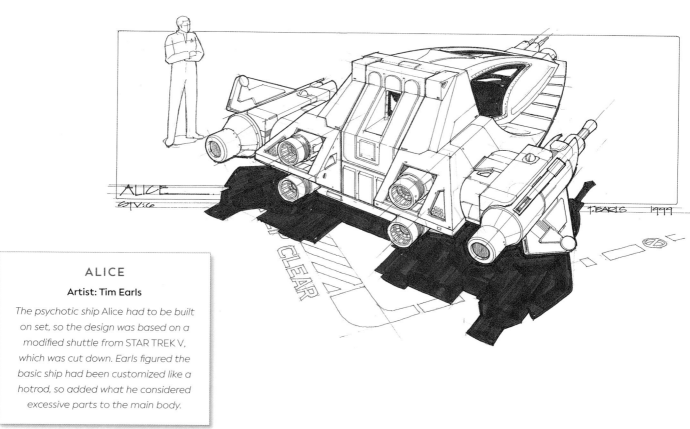

ALICE

Artist: Tim Earls

The psychotic ship Alice had to be built on set, so the design was based on a modified shuttle from STAR TREK V, which was cut down. Earls figured the basic ship had been customized like a hotrod, so added what he considered excessive parts to the main body.

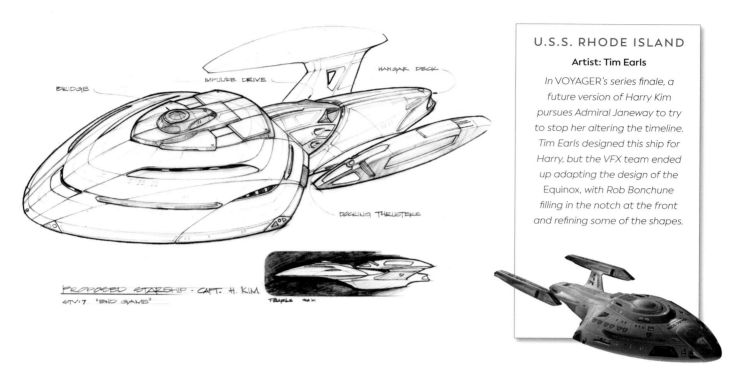

BRIDGE
IMPULSE DRIVE
HANGAR DECK
DOCKING THRUSTERS

PROPOSED STARSHIP - CAPT. H. KIM
STV:7 "END GAME"

U.S.S. RHODE ISLAND
Artist: Tim Earls

In VOYAGER's series finale, a future version of Harry Kim pursues Admiral Janeway to try to stop her altering the timeline. Tim Earls designed this ship for Harry, but the VFX team ended up adapting the design of the Equinox, with Rob Bonchune filling in the notch at the front and refining some of the shapes.

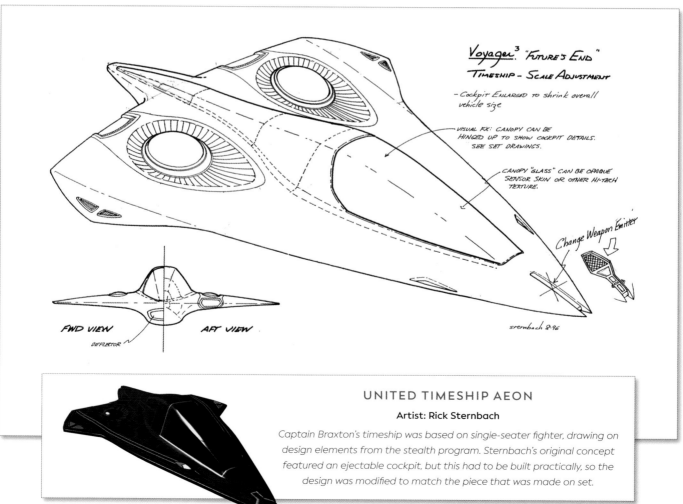

Voyager³ "Future's End"
TIMESHIP - SCALE ADJUSTMENT

- Cockpit ENLARGED to shrink overall vehicle size

VISUAL FX: CANOPY CAN BE HINGED UP TO SHOW COCKPIT DETAILS. SEE SET DRAWINGS.

CANOPY "GLASS" CAN BE OPAQUE SENSOR SKIN OR OTHER HI-TECH TEXTURE.

Change Weapon Emitter

FWD VIEW AFT VIEW
DEFLECTOR

sternbach 8-96

UNITED TIMESHIP AEON
Artist: Rick Sternbach

Captain Braxton's timeship was based on single-seater fighter, drawing on design elements from the stealth program. Sternbach's original concept featured an ejectable cockpit, but this had to be built practically, so the design was modified to match the piece that was made on set.

MALON GARBAGE SCOW

Artist: Rick Sternbach

The Malon were a race of interstellar polluters. Sternbach wanted to make their tanker look as large as possible, so he contructed the design around massive spherical tanks. The script called for the ship to leak noxious substances, so he added some obvious vents that could spew waste.

BORG TACTICAL CUBE

Artist: Doug Drexler

In 'Unimatrix Zero,' Janeway takes on a heavily-armed Borg tactical cube. The job of designing the cube fell to STAR TREK veteran Doug Drexler, who had recently joined VFX house Foundation Imagining. He remembers being amused at the idea of a "different kind of cube," and produced several sketches. The producers chose an approach he describes as "a cube in a flak jacket."

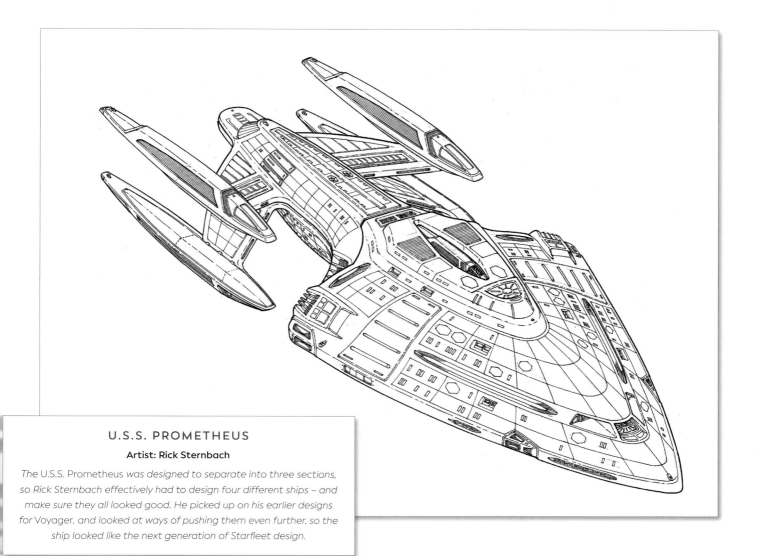

U.S.S. PROMETHEUS

Artist: Rick Sternbach

The U.S.S. Prometheus was designed to separate into three sections, so Rick Sternbach effectively had to design four different ships – and make sure they all looked good. He picked up on his earlier designs for Voyager, and looked at ways of pushing them even further, so the ship looked like the next generation of Starfleet design.

MOVES IN THIS DIRECTION

MIRROR IMAGE ALONG THIS AXIS

'NIGHT' SHIP

Artist: Dan Curry

VFX producer Dan Curry contributed the design for the mysterious ship that Voyager encounters in the void, an area of space with no stars. The ship was intended to operate in complete darkness, so Curry based it on bioluminescent creatures that live in the ocean depths. He wanted the ship to look organic – as if it had been grown, rather than built. The CG model was constructed by Brandon MacDougall.

KAZON RAIDER

ARTIST: Dan Curry

The Kazon ships were based on the work of architect Lebbeus Woods, which Curry felt had an unusual "steampunk aesthetic." Curry remembers that Rick Berman had him shorten the nose at the front, which was designed to echo the rudder on contemporary planes.

HIROGEN WARSHIP

ARTIST: Rick Sternbach

The Hirogen Hunter was built around a mace-like shape, with nacelles on either side, and a nose section that was inspired by the design of the Hirogen's helmets and elements of their control room set.

VIDIIAN SHIP

ARTIST: Dan Curry

The goal with the Vidiian ship was to create something that looked as if it could have been developed on the far side of the Galaxy, but still used the same kind of technology. So Curry gave it glowing engines that resembled warp nacelles.

VIDIAN FIGHTER

Dan Curry
3/96

PLATES AND OTHER
DETAILS TO FOLLOW

BACK WING
ANGLES DOWN AT FOLD

U.S.S. EQUINOX

ARTIST: Rick Sternbach

The design of Captain Ransom's ship was borrowed from a concept Rick Sternbach created for STAR TREK: DEEP SPACE NINE Technical Manual, *which was meant to show an early version of the U.S.S. Defiant.*

HIERARCHY SHIP

ARTIST: Dan Curry

The design of the Hierarchy ship was inspired by Mexican lamps. Curry's idea was the ship had a framework that would be filled up with a hollow material, as if glass had been blown into it.

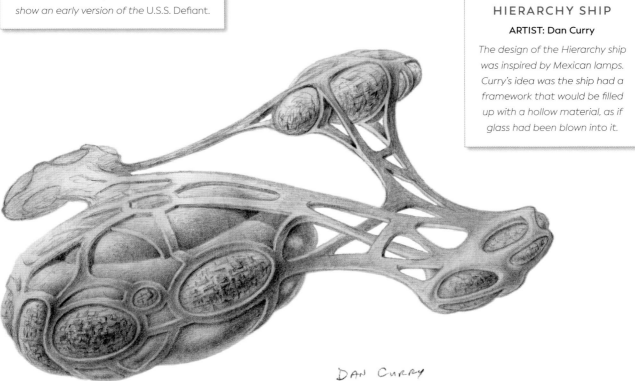

DAN CURRY

CAPTAIN PROTON

20TH-CENTURY HOLODECK HERO

Initially conceived as an extended holodeck gag, *The Adventures of Captain Proton* was a homage to the classic *Flash Gordon* serials of the 1930s and '40s. Keying in to Tom Paris's love of 20th-century pop culture, what started out as background color developed to drive an entire episode and allow the cast to indulge in the most fun they had making *VOYAGER*.

'Spaceman First Class, Protector of Earth, scourge of intergalactic evil,' *Captain Proton* was a favorite holonovel of Paris. Starring plucky sidekick Buster Kincaid (a role taken by Harry Kim) and secretary Constance Goodheart, *The Adventures of Captain Proton* opened Season 5 premiere,

'Night.' Battling the evil Doctor Chaotica (Martin Rayner) and his minions, Robert Duncan McNeill felt the concept of Captain Proton was a more satisfying embodiment of his character's affinity with the 20th century. "When it was just a decoration it felt a little gimmicky," says McNeill. "Sure, we That's one reason I thought [Captain Proton] was a little more emotionally character connected to Tom's love of the 20th-century than just a car."

The first performance of Captain Proton felt fully formed, with cast and crew enjoying the chance to indulge in a contrasting style of acting and design. "Oh, I think everybody did," recalls production designer Richard James. "I think they

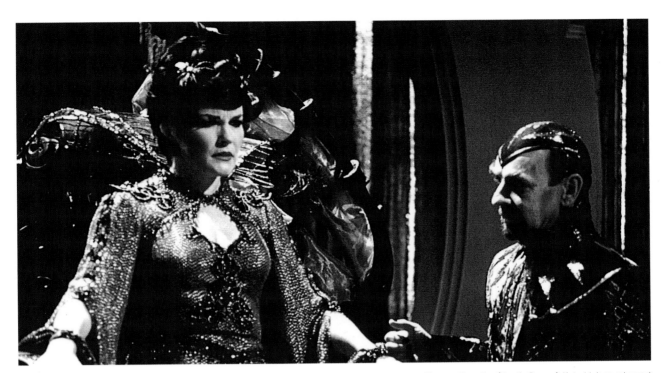

ABOVE: *Captain Janeway is... THE BRIDE OF CHAOTICA! Masquerading as a potential paramour of Doctor Chaotica (Martin Rayner), Kate Mulgrew showed a different side to Captain Janeway in 'Bride of Chaotica,' demonstrating a vulnerability and the capacity to play at comedy and make-believe.*

almost felt we were having too much fun, everybody got such a kick out of that. It was kind of relaxing because there was a certain rigidness to the show because it's Starfleet and kind of military, but with Captain Proton we got broad and silly and fun. We all loved it and certainly the art department had a lot of fun with the sets."

Striking a chord with the *VOYAGER* cast and crew, Captain Proton would return. Shot mostly in monochrome, 'Bride of Chaotica' added a dramatic dimension to Proton's world as photonic aliens infiltrate *Voyager*, mistaking the simulation for reality. "That episode was so much fun," says co-writer Michael Taylor. "I remember sitting in [executive producer] Bryan Fuller's office trying to figure it out. Then the idea came to us about how Janeway would be involved. Just saying, 'She will be THE BRIDE OF CHAOTICA!' And that's the title!"

With Kate Mulgrew entering the holodeck as Queen Arachnia, Taylor felt the episode allowed Mulgrew to portray another aspect of Janeway's character. "She gets to let her hair down in this very theatrical role. They're in a situation with serious stakes, they're also enjoying the capacity to play... That moment when you see not so much the captain's vulnerability, but the captain's enjoyment, showing a side that's always contained."

For Proton's next appearance, in '30 Days,' McNeill was in the firing line, as visual effects supervisor Ron B. Moore recalls. "At the beginning of that we did a Captain Proton part where Robbie was flying around with his jet pack. We shot that on bluescreen, put this jet pack thing on his back, essentially they were like rocket motors that they could light on fire. It doesn't take long to realize why the jet pack hasn't taken off! You got these two jets and they were essentially pointing right at the guy's behind. And the idiots lit it on fire. It was okay for a few seconds, but Robbie starts pointing to his back because they're setting him on fire! In situations like that, it's maybe a place for CG. We always like real, real looks better, but not at the expense of burning Robbie's behind off!"

The world of Captain Proton made one further appearance in 'Shattered,' but the 1930s throwback remains a highlight for cast and crew, including Captain Proton himself. "I thought there should have been much more," says McNeill. "The whole cast could have found a way to become involved. There's a show-within-a-show, a self-awareness of what we're doing that the fans love, that I love. I don't think we're ever going to make a *VOYAGER* movie, but I have some vision of doing a web series or mini series of just Captain Proton serial stories with our cast. I'd love to do that because I feel there's a lot more to explore creatively in that holodeck world."

LIFE ON SET

Filming *VOYAGER* was hard work, but the cast were determined to make it enjoyable. They were famously happy to joke about, indulging in everything from word play to secret jokes that left people in tears of laughter.

The cast of *STAR TREK: VOYAGER* liked to have fun – so much so that most of them feel they should apologize to the crew. "We were bad children," Roxann Dawson smiles. "There was a lot of joking around. There were times we'd be laughing so hard I thought they'd have to get me another uniform because I was going to pee in my pants. Basically, anybody who could come up with the best joke of the day was the one who was winning. We were awful, but we had fun, a lot of fun."

Kate Mulgrew, who was famously well-prepared, professional and not a practical joker, adds that they should apologize to her too. "I should be canonized!" she exclaims, "not given any award for acting, canonized as a saint for what those people did to me.

Tim Russ would be naked behind his console. Naked! Shocking. I had to really deal with this. It was unbearably hard to keep a straight face. I am to be commended!"

That humor was the way the cast dealt with an incredibly demanding work environment. They filmed 26 episodes a year. That's nearly double what most shows shoot today. Each episode took seven days to film and, as Robert Duncan McNeill remembers, those days could be long. "Very regularly we would have 14, 15, 16 hour shooting days," he says. "We'd come in at eight or nine and shoot until midnight, or 1am. And for the people that had prosthetic makeup, it's an even longer day."

The way television works, the same scene is filmed repeatedly as the camera focuses on a different person. Plus, there are

ABOVE: The cast and crew of VOYAGER spent so long filming on the sets that they learned the best way to handle almost any piece of action and they worked together for so long that everyone felt it was like an extended family.

rehearsals for lighting and a lot of standing around waiting while the crew get ready. So the cast's response was to take every opportunity they could to lighten the mood.

"There were," Tim Russ remembers, "a lot of things we would do on a regular basis just to amuse ourselves. Ethan Phillips, myself and Bob Picardo, and Beltran would play these word games all the time. It wasn't anything super sophisticated, they were just goofy stupid games, but they were hysterical."

Asked exactly what was involved, Russ fails to mention the scenes where he appeared naked, or the times he had the sound engineer record his farts. Instead, he remembers running gags. "We had a thing where you would start to say something that somebody might interpret in one way, but then you'd correct them and say, 'What I meant was....'"

Or there were certain catchphrases, lines of dialogue from dimly remembered episodes, such as "warp bubbles!" that the cast would shout at certain moments. Often the jokes were shared by one or two cast members and, as Robert Beltran explains, even their colleagues didn't understand them. "There was this one thing where Tim and Ethan would hit each other in the arm if something happened. I didn't always understand what that was. I just thought, 'What are they doing?' I think they had to make an okay sign, if one of them looked at it they violated the rule and they would get hit in the arm. Then when they showed me what the game was, I would make the okay sign and just hit somebody. 'So that's the game, yeah?' They said, 'That's not how it's played!'

It won't come as much of a surprise to learn that comedians Robert Picardo and Ethan Phillips were always performing. Picardo would drop devastating one liners or end his scenes with a deadpan remark. Phillips has literally memorized thousands of jokes and could always produce one in any situation. "My great uncle was a stand-up comic," he says, "as a kid I always loved hearing the punchline, so I just started collecting jokes from a very young age. To this day, I have two or three thousand jokes in my head."

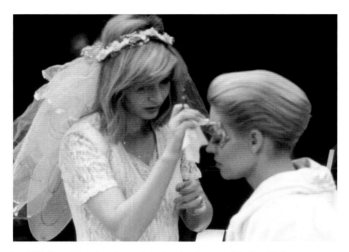

ABOVE: *Jeri Ryan has her makeup touched up on set before filming a scene.*

But Phillips admits he would also resort to outright silliness. "I remember Tim was at his station on the bridge and was reciting something. 'Captain, we've got a corned beef sandwich on deck 11,' whatever the hell he's saying. I remember sneaking under his console and whispering to him, 'Tim, it's just a TV show. You're not a Vulcan,' as he was shooting the scene. That probably was wrong of me."

Laughing, Jeri Ryan admits that she found Phillips so funny that it was actually difficult for her to work with him. "Seven is as unlike me as you can get," she explains. "I'm very emotional. I'm quick to laugh, and quick to cry. The hardest part for me was keeping all of that in check and keeping a straight face when I was working with, say, Ethan Phillips or Bob Picardo. Ethan loved me because he's constantly, constantly, constantly making jokes. It's like a nonstop, stand-up comedy show. He is the funniest man, and I'm the best audience because I will laugh and laugh and laugh the hundredth time I hear a joke, as if it's the first time I've ever heard it. If you get the giggles, you get the giggles and you just have to wait it out and try and get through it.

"It got to a point in my later seasons if I had a scene with Neelix, I couldn't even look at him. He wasn't even trying to make me laugh. He didn't have to do anything. On my close-ups I would have to look past him because if I looked at him I would burst out laughing. The poor guy wasn't even trying to do anything, he was just trying to do his job, and I couldn't even look at him."

Garrett Wang was another serial offender, constantly slipping into impressions during lighting rehearsals and even occasionally breaking into a dance. Everyone is keen to make it clear that every single member of the cast was up for the joke. Phillips happily admits that he has always been a clown, but he clearly remembers the first time he realized the *VOYAGER* set was a place he could have some fun. "I was on the bridge.

ABOVE: *The VOYAGER cast were known for their willingness to joke around. In retrospect, many of them worry that they slowed things down a little too much, but they were well prepared and could (almost always) slip straight into character and deliver their lines without missing a beat.*

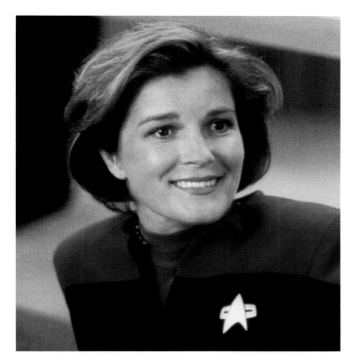

ABOVE: Kate Mulgrew insists that she should be commended for keeping a straight face amid all the madness going on around her.

Robbie had a line to me. He said, 'Neelix, can you pass me the PADD.' In the script the name is written PADD with two Ds. We're shooting, and he says to me 'Neelix, can you pass me the padd-D-D.' I just sort of smiled and I realized he's just messing with me. That's when I knew, 'Oh, we can have some fun here.' That was the beginning of the end."

McNeill confesses that he was not the most serious person during the working day. "We'd always be doing something inappropriate with props," he says, "or not wanting to wear a uniform off camera, wearing bathrobes and that kind of silliness. All the boys would be a little rowdy now and then. We'd have a lot of jokes between takes."

Some of the funniest moments would take place in the briefing room scenes, because this was the only time that almost the entire cast would be assembled in the same place. "That was party time," Dawson says, "because we'd all be together for the first time in a while. The director wanted to work and we just wanted to catch up."

Russ is keen to point out that the humor never seriously interfered with the work, and that the actors could instantly snap into character and deliver their lines as soon as the cameras were ready to roll. He adds, a lot of the joking actually took place off set. "A lot of times it was the crew that were the

funniest. The security guys that guarded the soundstage were a riot. Other times we were in the makeup trailer with other cast members and we were all cutting up and goofing off. Those were some of the best times."

McNeill does worry that they probably made the crew's life a bit harder and the days a bit longer than they could have been, but he adds that the humor had a real value. "The actors had a lot of time between lighting set ups and we could just be silly and entertain ourselves. I think we *were* funny and we made each other laugh. There was no tension. Everyone really got along well and really enjoyed each other's company. We liked watching each other do well and succeed. It was a very supportive, relaxed environment."

You get the definite impression that although Mulgrew and Dawson could be as funny as anyone, they were often innocent victims in the middle of things. "When the boys took over," Dawson admits, "I was an audience member, so all I did was enjoy watching them."

Wang admits that in the midst of all the insanity, Mulgrew might have just been a little long suffering. "On the bridge, she would always give a sideways glance, roll her eyes every now and then, or she'd say, 'Come on guys, let's get it together.'"

As Mulgrew puts it, she didn't have much choice. "You know when I start laughing and I lose it, I'm a goner. And these guys knew it!"

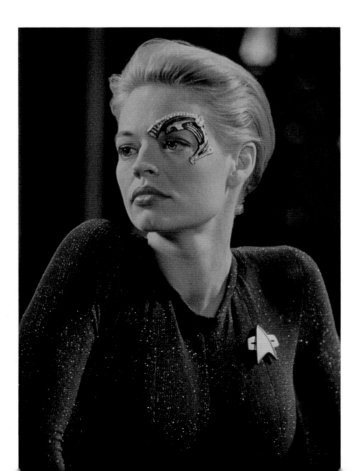

RIGHT: Jeri Ryan is much more relaxed than Seven of Nine, and admits that she found it all too easy to laugh.

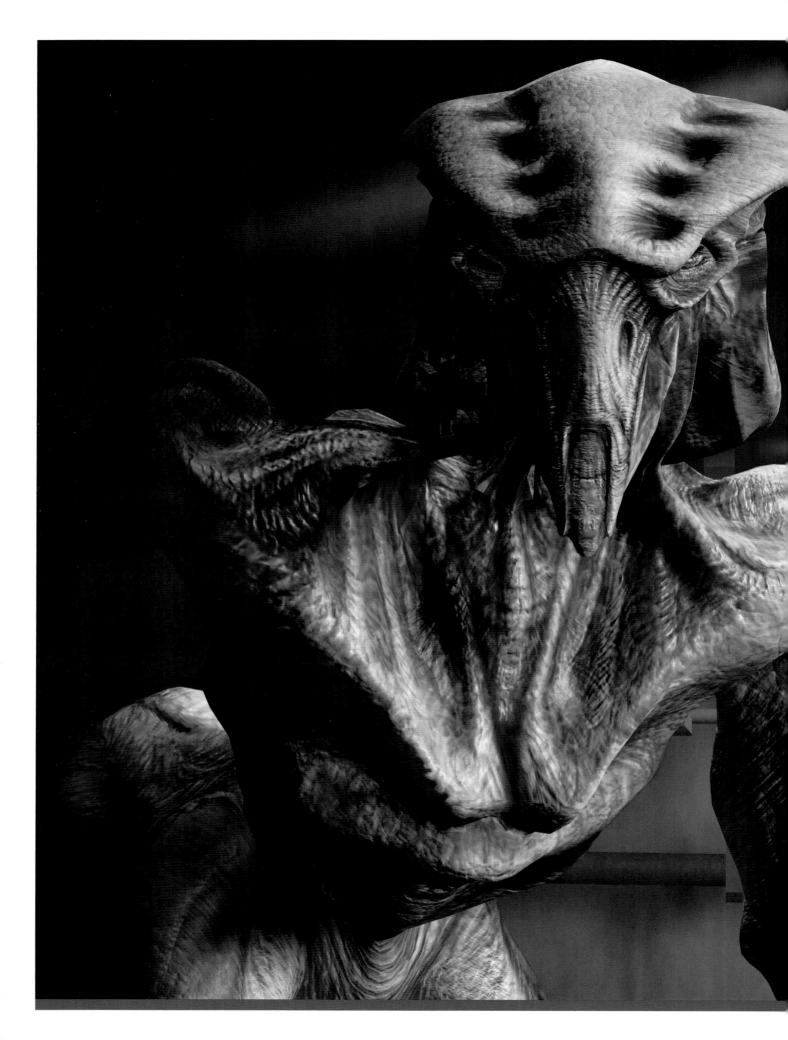

SPECIES
8472

TRULY ALIEN

The creation of Species 8472 was a significant turning point in the history of the *STAR TREK* franchise, a convergence of creative thinking from different departments. This savage and brutal alien race marked a new, darker direction in *VOYAGER*'s storytelling and an increasingly sophisticated use of computer-generated imagery from the visual effects team.

The success of the feature film *STAR TREK: FIRST CONTACT* in 1996 influenced the decision to have *Voyager*'s crew face the Borg in the Delta Quadrant. Executive producer Brannon Braga had earlier conceived the idea of a 'Borg graveyard,' an image he returned to when developing Season 3's epic finale, 'Scorpion Part 1.' It begged the question: exactly what creature could decimate *STAR TREK*'s ultimate villain… Meanwhile, the visual effects team were turning to CGI to create ambitious effects sequences.

"I remember sitting on the set one night," says visual effects producer Dan Curry. "Jeri Taylor was there and she had just seen 'Macrocosm' with the 'flying strawberry.' She really liked the way that had gone and it gave her confidence that we could probably

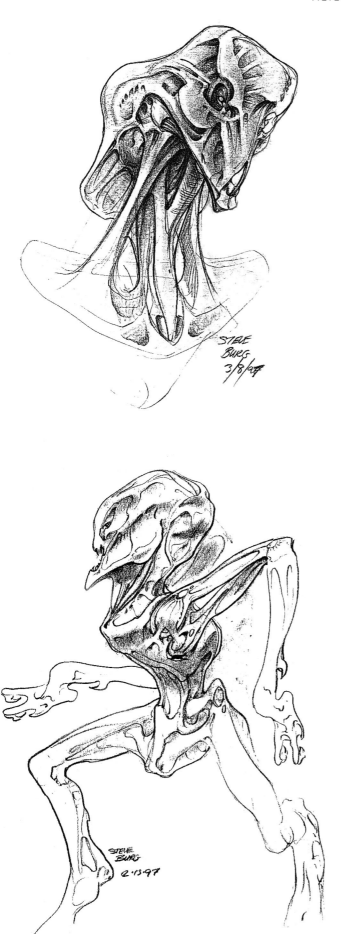

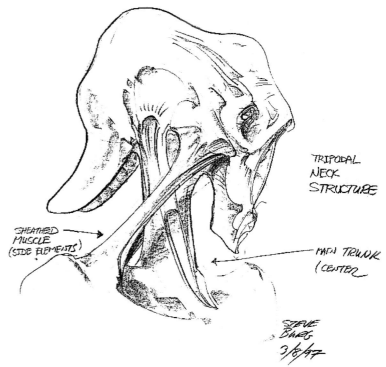

TRIPODAL
NECK
STRUCTURE

SHEATHED
MUSCLE
(SIDE ELEMENTS)

MAIN TRUNK
(CENTER)

make a more fully developed character. When the concept of Species 8472 came up there was some initial talk about doing it as a human actor in a suit. But I had always been intrigued by the idea of a tripod creature. When I was in graduate school, one of my thesis plays was a live-action theater piece set in an alien prison, where one of the characters was a tripod creature."

Curry recalled previous work by digital effects house Foundation Imaging that meshed with his own thinking. "I knew that on *Hypernauts*, Foundation had done a tripod creature, a kind of pet antelope called a 'gloose.' [Foundation founder and producer] Ron Thornton had shown me a tape of the character, so I said, 'Well, let's do something that can't be a man in a suit, so it's really alien; let's do a tripod creature. I sent some sketches to Foundation and they said, 'How about if we can redesign it so that it's something we can really do here,' and that's when [illustrator] Steve Burg came into the picture."

"It was a very unusual thing," recalls Burg, "not at all traditional for *STAR TREK*. It just said, 'a great beast of some sort.' [The creature] was 14-feet tall at one point and it just said it blasts through the wall, kills two of the Borg and hits Harry, knocking him out. That was about it. I think it deliberately

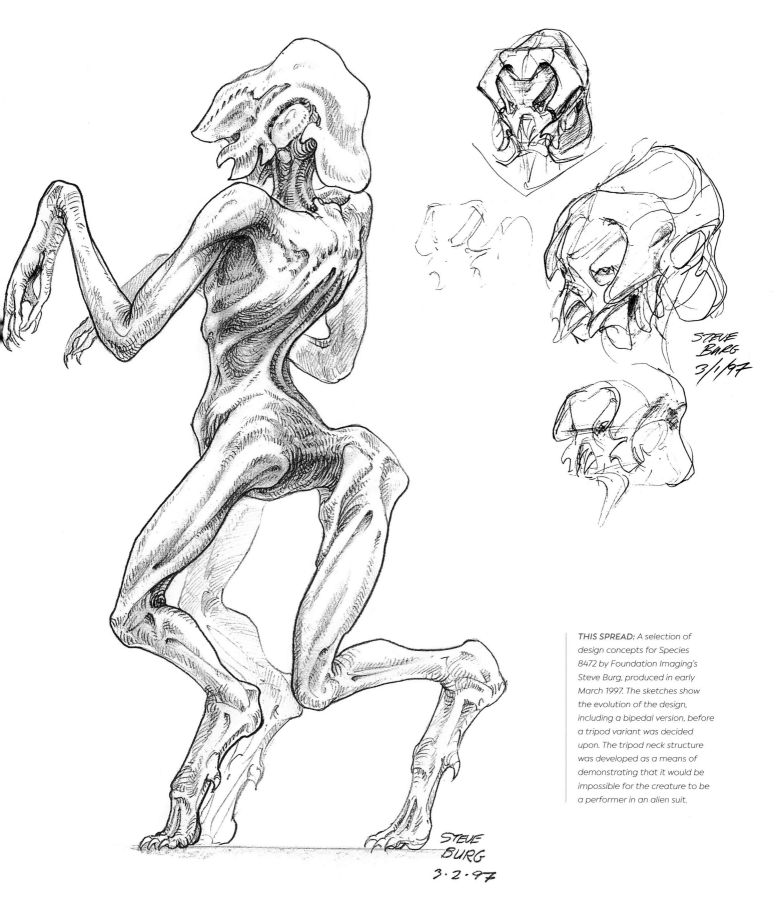

STEVE
BURG
3/1/97

STEVE
BURG
3.2.97

THIS SPREAD: *A selection of design concepts for Species 8472 by Foundation Imaging's Steve Burg, produced in early March 1997. The sketches show the evolution of the design, including a bipedal version, before a tripod variant was decided upon. The tripod neck structure was developed as a means of demonstrating that it would be impossible for the creature to be a performer in an alien suit.*

didn't have a detailed description because they wanted to see what we could come up with."

"The way I like to work with the CG houses is to be nebulous," adds Curry. "I don't like to be real specific because it ties their hands in. That allows their creative flow, so I can see it. A lot of times, it'll be, 'No, I'm sorry, let's do it this way instead.' But at least I get to see another version. I would never presume to jump on that three-legged thing unless it was a script point. I'll just say, 'Show me some alien creatures.'"

"I did a first pass," continues Burg. "They thought that it was too humanlike, too similar to the alien from *Alien*. I think they kind of wanted something like the alien, but not to look like it. They didn't want a rip-off but they did want something that was that distinct, something very nasty and powerful. It also had to be intelligent. One thing that Ron Thornton mentioned was that the thing was to have practically no mouth. One way of making it look smart is to not give it big teeth, like a tyrannosaurus. If something looks very nasty and it doesn't have obvious claws or teeth, you figure it works on a whole other level."

"A lot of sketches were swapped back and forth," says Curry. "We arrived at a kind of Steve Burg and [animator] John Teska final version of it. We brought the sketches to Rick Berman and Peter Lauritson. They would make comments and I would have my comments, and then Steve kept making adjustments in sketch form until they were satisfied."

"It's not like it's any one moment the design suddenly appears," explains Burg. "It's more of a process that evolves. There are various people who affect it. Your job is to try to capture the quality that people are looking for in a visual, lock it down as a shape. There's the initial stage when you're just trying to find a basic direction. In the refinement, it becomes

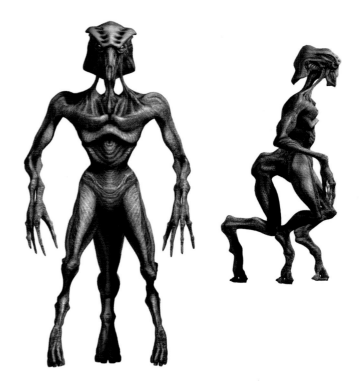

more connecting the lines. There are just basic silhouettes; some have three legs, some have two legs. Some of them have a split, tripodal base, with below the knee bifurcated. I guess they felt it was just too typical. When you first start in on something, you tend to put slug in placeholders and those tend to be derived from other things you've done, but then it starts to take on its own identity. There was one out of that bunch that they liked. It was sort of a side view. It was good to have something at least moving in the right direction.

"The focus then turned to designing the head. I remember I just sat down and churned out a whole bunch of weird alien heads. Somewhere in the middle of doing that, I started gravitating toward the tripod neck structure. That seemed like a good way of making it something obviously that a person could not be wearing, even if you are in a close-up. Out of all of them, they picked two or three that were similar to each other; variations on a theme. They decided that was the direction they wanted to go. From there, there was a set of more revised drawings that were much more specific – a front and side view of the whole creature. At that point the whole concept began to move into 3D which is where John Teska came in."

"John Teska's a wonderful animator," says Curry of Foundation Imaging's CGI artist. "He was the best guy to do that animation."

"You have to think about how it will move," says Burg. "When you're designing things that have to be built, you've got to think about how it will be achieved. With CG, even if

ABOVE: Space walk: hunted by the Hirogen, a lone member of Species 8472 attempts to board Voyager, clinging to a warp nacelle in open space in 'Prey.'

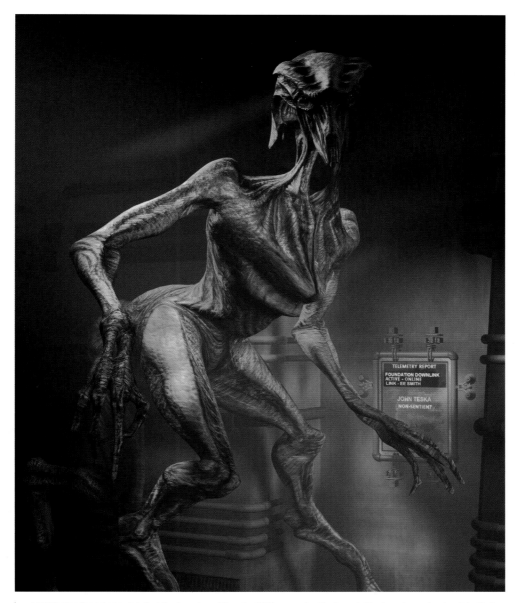

ABOVE: *The final stage: detailed final renders of Species 8472 as created by Foundation Imaging animator John Teska. The process of building the digital model from Steve Burg's concept designs took around a week from start to finish.*

things don't have to support their own weight, you still have to think about how they will move in a general sense. John Teska is an interesting guy because he has a background in creature effects, but he's great at doing these things on the computer. I'm sure that John went through his own thing, but it ended up very close to the drawing. Sometimes, something will wind up being changed quite a bit when you leave it; other times it just goes through and doesn't really change that fundamentally. The next time I saw it, it was the rendered creature. It looked tremendous. It was incredible because it was like a week later. It was really fast!"

Species 8472 added a compelling and brutal new villain to the *STAR TREK* canon, one that would change the perception of the Borg and develop in surprising ways throughout the next two seasons . It also displayed the rapidly developing sophistication of digital visual effects achievable on a television budget.

"I think it's really interesting that there's no motion capture on that thing – it's all hand animated," says Steve Burg, summing up the final look of Species 8472. "The 3D work is beautiful. I was very happy and amazed. It's always surprising to see something come to fruition. It was a lot of fun. I wish opportunities like that came up more often."

MUSIC
DEPARTMENT

'THERE'S SOMETHING WRONG IN SPACE'

M usic has been at the emotional heart of *STAR TREK* from its earliest days, distilling a romantic spirit of adventure and exploration at the edge of the final frontier into bold orchestral tones. "Music's the last thing that goes in, and it can either make or break an episode," believes *VOYAGER* composer Jay Chattaway.

Between 1990 and 2005, Chattaway scored 183 episodes of *STAR TREK*, including 54 episodes of *VOYAGER*, alternating duties with Dennis McCarthy, David Bell, and Paul Baillargeon. In 1994, Chattaway was selected to provide the score for *VOYAGER*'s feature-length pilot, 'Caretaker.' The approach came with a request the composer didn't take entirely seriously: "They called and said, 'Okay Jay, you got the job, you're going to do the pilot. But you'll have to write ten minutes of banjo music. I thought, they're just teasing with me. Then Rick Berman called and said, 'No, seriously, one of the characters in this new show is going to play the banjo.' I thought being asked to do banjo music for a new *TREK* series was pretty outrageous!"

Jay Chattaway

Writing the score for 'Caretaker' gave Chattaway the opportunity to establish a musical identity for the new series. "The fact they had a female captain was interesting and I thought the music should represent that a little differently. Jerry Goldsmith did the main theme. It's gentler, not as militaristic, a little softer in its approach. We would reprise the theme quite a bit. On 'Caretaker' there were instances where Jerry's theme would color the scoring, especially when Janeway was on screen."

With *VOYAGER* running alongside franchise stablemate *DEEP SPACE NINE*, Chattaway was keen to differentiate the two shows, while retaining the house style. "*VOYAGER* was more action-oriented," believes Chattaway, "so it was going to be brassy, with more percussion. It was a little more adventurous. I started using a lot more electronics and digital sampling, just to add a contemporary element, but never to replace live orchestral instruments. It was to add a different timbre."

As a weekly television drama, *VOYAGER*'s brutally fast turnaround kept the music department under pressure, with Chattaway and his fellow composers working across multiple episodes and shows at once. "You get a script messengered over," he explains. "I'd sort of score the episode based on the script, but I didn't write anything down, I just put it into my mental hard drive. We'd get a rough cut of the episode ten days before writing the score, then have a spotting session with the producers and the music editor. We'd take precise notes of when the music would start and stop. I'd transform that into musical language and start writing. I had between eight and ten days of composing and orchestrating maybe 25 minutes of music. You have to write around three minutes of music a day; if it's an action piece, that can be 150 pages of musical score."

Alongside the creative considerations there were practical issues, such as ensuring the score meshed with other departments – and the *U.S.S. Voyager* itself. "In an action scene, you'd go to the film mix session and there were seven sound

effects guys there and one music guy," Chattaway laughs. "So you're going to get drowned out; the only time the music is going to sound terrific is on the scoring stage. It's a challenge to figure out how to get the music to come through. If you listen carefully, *Voyager* is always making noise, and the frequency of that noise is right in the mid-range. So you try to avoid writing instruments that are in the same range as the ship's air conditioning!"

Often Chattaway had some surprises on the day of the scoring session which took place on various stages in Los Angeles, including Stage M on the Paramount lot. "At the same time as I'm writing, the visual effects people are doing their CGI or motion control, and it's usually not finished until that morning. You go in to score with a full symphony orchestra, 40 or 50 people. You pass out the music and look at the show and think, 'Oh, so that's what *that* looks like.' You make hurried adjustments to the music to fulfil the visuals."

By the end of *VOYAGER*'s run, the show was being scored by three regular composers, and Chattaway valued those relationships. "Dennis McCarthy and I were real pals. At first it was required that we'd go to the dub session and that's where the producers told us what they liked – and mostly what they didn't like! Dennis and I would keep all the cues that they didn't really like. We'd go out in our car and play the cues for each other and commiserate together. I was responsible for getting David Bell involved. I heard a piece he'd done for an amusement park ride that was really good, so we got him on board. He did some great work. With two series running – and *VOYAGER* was much more musically intense – we had to have other people working with us. We'd have been completely burned out if we had to do 40 minutes of music a week!

"I would say 90 percent of the time when the music starts, there's something wrong in space. Somebody shakes the camera, the music comes in. You have to learn how to spell danger, and I treated each episode as a separate movie. It's very hard over 14 years of writing 'There's Something Wrong in Space,' you've got to figure out a different way to do it."

Despite Chattaway seeing his job as underpinning moments of drama and danger, there was opportunity along the way to add different textures. "The fun episodes were the ones on the holodeck or with something like 'Spirit Folk.' We had an Irish band in the studio with the orchestra, which was great, except the Irish band didn't read music all that well, so I had to poke the bagpipe player and tell him when to play. Every episode was unique. I liked a lot of the stuff with Chakotay because we were able to play up on the Native American vibe with percussion and native chants. Any episodes we could get off the ship and do something that wasn't just 'There's Something Wrong in Space' were interesting. And 'Scorpion' was a big deal, that was action-oriented, very scary."

Chattaway feels that the *STAR TREK* franchise has always celebrated and embraced orchestral music in the DNA of its shows, and like its namesake starship, *VOYAGER* took that into uncharted territory. "*VOYAGER* stands out for me as having the most adventurous music I've written. The biggest joy was having my music created in such a frenzy, yet feeling so complete when I heard it played back while I was conducting. It was the ultimate experience, you're up there conducting an orchestra, using aerobic techniques that make your heart pump, and then having these professional musicians, who've never seen the music before, play. There's nothing like it."

I'D LIKE TO THANK…

After four previous nominations for his work on *STAR TREK*, Jay Chattaway won the 2001 Television Academy Emmy Award for Outstanding Music Composition for a Series, for his scoring of *VOYAGER*'s finale, 'Endgame.'

"I didn't go," laughs Chattaway. "I didn't think there was a prayer of winning. I'd been there four times and I had the same speech in the pocket of my tuxedo every time I went, and I lost. The last year, both Dennis McCarthy and I were nominated, and there was no way either of us were going to win so I decided not to go. I was at home writing an episode of *ENTERPRISE*." Chattaway's then-future wife, *DEEP SPACE NINE*'s associate producer Terri Potts, called to tell him he had won.

"They wrap up the Emmy, put it in a plastic bag, and take it to the Academy," Chattaway remembers. "I went to pick it up from the Academy one evening, and there's the elderly night watchman there. He tells me a story. He says, 'I wish I could have won an Emmy. I'm from the south and I'm an artist but because I'm black, I couldn't go to college.'

I said, 'Let's go out to the parking lot'. There's this giant Emmy statue out there. 'Why don't you tell me about your history and I'll present you with this Emmy, and then you can give it back to me.' He told me all about his life, I went out and I presented him with the Emmy. He smiled, it was so beautiful. Then he said a few nice things to me and then gave me my Emmy in a plastic bag."

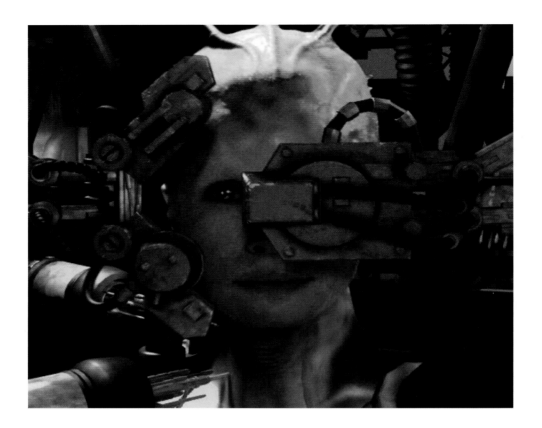

ENTER THE
BORG QUEEN

A true *VOYAGER* classic, 'Dark Frontier' was an epic confrontation between Captain Janeway's crew and the Borg. Underpinning the feature-length adventure's ambitious scale was a more personal story, placing Seven of Nine between two dominant personalities: Captain Janeway and the Borg Queen, who made a shocking reappearance. The Queen's entrance in 'Dark Frontier' was a tour de force of the visual effects craft, a sign of how technologically sophisticated *VOYAGER* had become since its debut.

This was a different Borg Queen from that encountered by the crew of the *Enterprise*-E in *STAR TREK: FIRST CONTACT*, with actress Susanna Thompson in the role first played by Alice Krige. In *FIRST CONTACT*, Industrial Light & Magic created the effect of the Queen's head and shoulders fusing with her body, but *VOYAGER*'s VFX department were keen to go even further in devising a new transformation sequence.

"The first time we did it, [executive producer] Brannon Braga said he wanted to see 'something new and cool,'" recalls visual effects producer Dan Curry. "In *FIRST CONTACT*, the body is just waiting for her head to drop into it. When I looked at the set, I had the idea that it would be cool if we made this floor panel open, and then the parts of her body were assembled robotically from below." Curry provided detailed storyboards of the sequence ahead of production. "We filmed Susanna Thompson against a blue screen and cut her head and shoulders out, so they could be combined with a CG body."

"We shot a plate of the actress, a close-up that they tracked in," visual effects supervisor Mitch Suskin explained to *Cinefantastique*. "She's just standing on the stage in front of a blue screen, but we actually had the camera tilting, and coming down, so we'd have a little bit of a perspective change. It was tracked in and composited at Foundation Imaging."

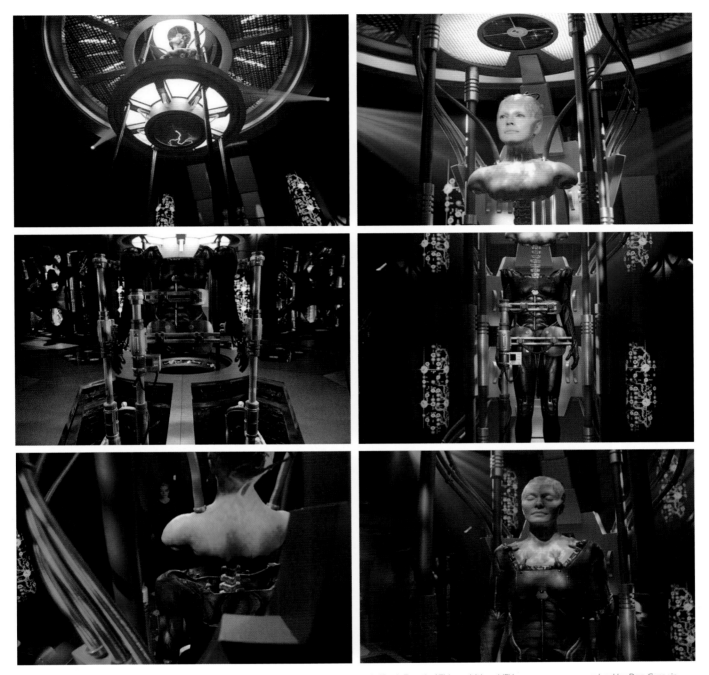

ABOVE: *The Borg Queen (Susanna Thompson) makes her shocking initial appearance in 'Dark Frontier.' This ambitious VFX sequence was conceived by Dan Curry in response to Brannon Braga's desire to see something 'new and cool.' The digital elements were animated by John Teska of Foundation Imaging.*

John Teska of Foundation Imaging animated the extensive digital elements of the sequence, marrying the live action components with his animation. "At first, I was concerned that the constantly changing light on the set would make it difficult," adds Curry, "but the brilliance of John Teska made it work. The only CG is bits of Susanna, and the floor. The rest is real."

For Susanna Thompson, the Borg Queen was a challenging role, involving extensive time in makeup and an uncomfortable costume. At the time of making 'Dark Frontier,' she recalled, "I found the costume, probably because it fit Alice Krige better than me, slightly constricting, particularly around the shoulders, so I just sort of went with that. The makeup can't not have an affect on your performance. You can embrace it and be 'at one with it,' then it works in your favor. The only time it starts to really disassociate from the character is at the end of a really long day. It was not an easy experience, physically."

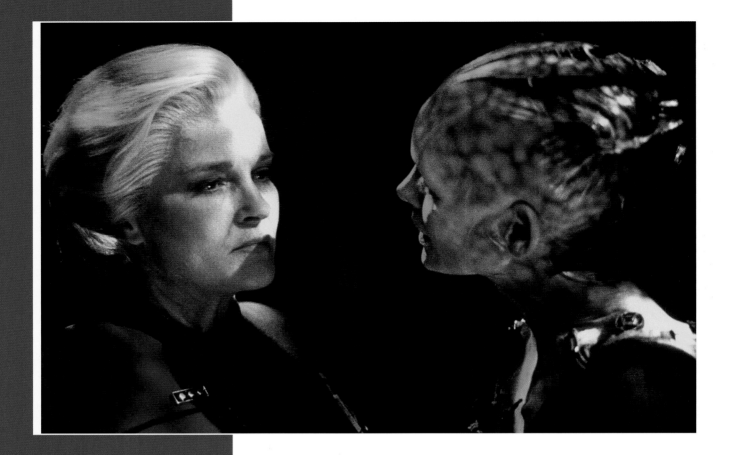

SEASON 7
EPISODES 25/26
AIR DATE: MAY 23, 2001

ENDGAME

Teleplay by Kenneth Biller & Robert Doherty

Story by Rick Berman & Kenneth Biller & Brannon Braga

Directed by Allan Kroeker

Synopsis Years after *Voyager*'s return to the Alpha Quadrant, Admiral Janeway determines to change the past to help her crew get home sooner.

After seven years, Janeway's crew finally make it home, but the writers were determined to avoid expectations for 'Endgame' – by jumping forward in time, then back again, for a moving finale.

The trick with the finale was going to be about giving people a surprise. After seven years, the audience could be pretty certain that *Voyager* would get home. "We were really struggling with it," writer Ken Biller remembers. "Is the end of the show just they get home? That's a bit of an anticlimax. Did we want some people to die? Did we want some people to stay behind? Did we want them to decide to stay out there? We even talked about getting home a few episodes before the end and then seeing what happened to them, but that felt like an anticlimax."

RIGHT: The story centers on a future Admiral Janeway intent on altering the past to get the crew home.

As Brannon Braga recalls, the task of working out how to end fell to him, Biller and their boss Rick Berman. "I always knew that *Voyager* would get home and they would arrive with

fireworks. I knew that the Borg Queen should be involved somehow." All of this provided them with elements but, Biller remembers, the three men were still struggling to find a story. "We couldn't come up with a story that was

> **"Nobody can guarantee what's going to happen tomorrow, not even an admiral from the future."**
>
> *Chakotay*

emotional enough and big enough. We started looking at all of the big two-part finales. They all really involved time travel. My recollection is that I said, 'What if they do get home but people die? It isn't the way Janeway envisioned it, so she's on a quest to undo what happened and make it right.'"

Suddenly a story started to fall into place. "*Voyager* got home and we missed it!" Biller explains. "They got home but people died or get injured, and Janeway is on a years-long quest to undo what happened, even if it's through some unethical manipulation of time. Once we came up with that idea, that was like, 'Oh, that's cool, 'cause now you can start with a very old Janeway.'"

The story also allowed them to explore what would happen to the characters without having to hang around after the party was over. Biller is particularly proud that in the end, *VOYAGER* was saved by a septuagenarian woman. "How often do you get to see a woman of a certain age as a hero? It was great that we had a female captain but we extrapolated that to say she's a septuagenarian and she's still kicking ass! You could never sell that to a network. Imagine going in and saying, 'The hero of my show, who's going to break all the rules and steal shuttles and change the course of human events, is a woman in her seventies!'"

Braga wanted to add another element to the story but was ultimately overruled by Berman. "My big thing," he says, "and I lost the argument to Rick, is that Seven of Nine should die. I still feel that it would have given that finale an emotional mega punch, and would have just brought people to tears."

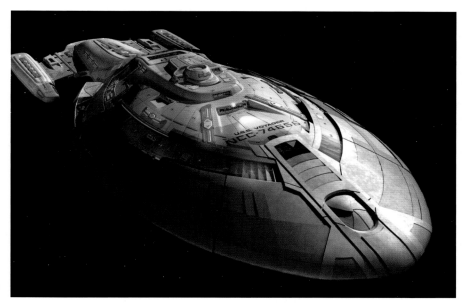

ABOVE: The future version of Janeway brought advanced technology with her that could be used to defeat the Borg, in complete defiance of every rule Starfleet had about time travel.

One star who favored going out in a blaze of glory was Kate Mulgrew, who told the creative team, "I think Janeway has to go down with the ship, but not at the full cost of her being." She got her way, albeit as her future self.

Biller was swamped with all his other duties, so he brought Rob Doherty in to help him finish breaking the story and to write the teleplay.

Alice Krige, who had created the role in *STAR TREK: FIRST CONTACT*, returned to play the Borg Queen. and shared many of her scenes with Kate Mulgrew and Jeri Ryan, something which she felt created an intriguingly different dynamic than the one she had enjoyed with Picard and Data.

In the future, Dwight Schultz's Barclay helps Janeway and LeVar Burton returned as Geordi

RIGHT: One of the key events in the finale is the birth of Tom and B'Elanna's baby.

La Forge, trying to stop Janeway just as he had tried to stop Chakotay and Kim in 'Timeless.' Because the writers knew that there were no plans for more episodes in the 24th century, they felt free to destroy the Borg, apparently forever.

> **"I think it's safe to say no one on this crew has been more... obsessed with getting home than I have. But when I think about everything we've been through together, maybe it's not the destination that matters. Maybe it's the journey, and if that journey takes a little longer, so we can do something we all believe in, I can't think of any place I'd rather be, or any people I'd rather be with."**
>
> *Harry Kim*

Mulgrew watched the episode with her family as it aired. "I was very moved, and I understood that night that I was having a cathartic moment," she remembers. "I had tears because I realized that I was saying goodbye for the first time in a genuine and emotional way."

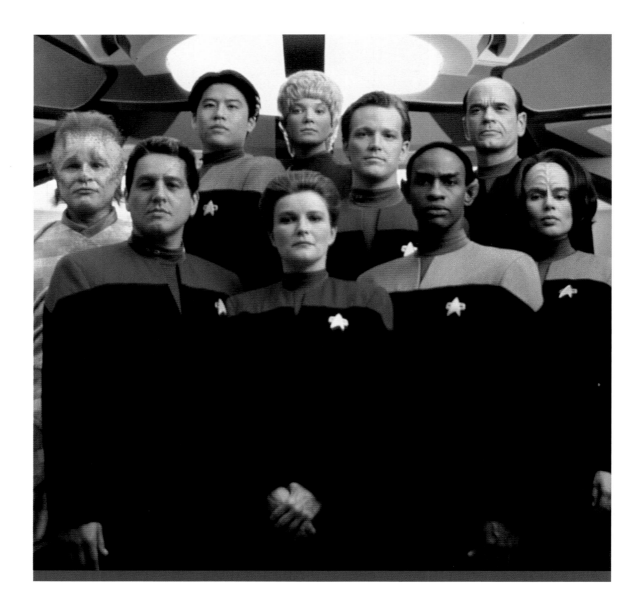

S E A S O N 1

STAR TREK: VOYAGER made its debut in the January of 1995, six months after the last episode of THE NEXT GENERATION. Rather then being sold into syndication like its immediate predecessors, it was used to launch a new network called UPN (United Paramount Network). The feature-length pilot, 'Caretaker,' achieved massive ratings, but the new network had less reach than its rivals and the ratings soon settled at a lower level. The first season ran alongside the third season of DEEP SPACE NINE.

'Caretaker' left the crew stranded 70,000 light years from home in a part of the Galaxy that STAR TREK had never visited before. The writing staff created new recurring aliens, with three candidates in the first year: Kazon, Vidiians, and the pleasure-loving Sikarians. The latter made just a single appearance.

The original plan was for the first season to consist of 20 episodes – 'The 37's' was originally planned as the season finale – but the network decided to hold four episodes back to the next season.

1.1 & 1.2 CARETAKER
In pursuit of a Maquis ship in the turbulent badlands, the *U.S.S. Voyager* is transported to the distant Delta Quadrant. Once there, Captain Kathryn Janeway must choose between defeating the ruthless Kazon or returning her crew home.

1.3 PARALLAX
As tensions between the Starfleet and Maquis crews escalate, *Voyager* detects a stranded ship in a quantum singularity. After attempting to rescue the vessel, it becomes clear that it is in fact a future projection of *Voyager*.

1.4 TIME AND AGAIN
When *Voyager* discovers a world where the population have been wiped out by a polaric detonation, Janeway and Paris are transported back in time to a point just before the explosion.

1.5 PHAGE
While searching for dilithium deposits on a planetoid, Neelix's lungs are stolen from his body by Vidiian organ harvesters. While Neelix is kept alive in *Voyager*'s sickbay, Janeway goes in pursuit of the thieves.

1.6 THE CLOUD
In search of omicron particles, *Voyager* penetrates a nebula only to discover that it is actually a life-form and they have injured it. They endeavor to heal the wound they have inflicted while also escaping unscathed.

1.7 EYE OF THE NEEDLE
Hopes of returning home are high when *Voyager* discovers a micro-wormhole that leads back to the Alpha Quadrant. Contact is made with a Romulan scientist on the other side of the anomaly who is willing to help Janeway and her crew.

1.8 EX POST FACTO
On an alien world, Tom Paris is convicted of murder, but insists that he is innocent. However, evidence extracted from the mind of his victim would appear to confirm his guilt.

1.9 EMANATIONS
While investigating an asteroid, an away team from *Voyager* discovers that it is the final resting place for the dead of the Vhnori race. Ensign Kim is accidentally transported to the Vhnori homeworld, while on *Voyager* one of the Vhnori corpses is revived.

1.10 PRIME FACTORS
The crew of *Voyager* are delighted when the encounter the Sikarians, who possess technology capable of cutting *Voyager*'s long journey home in half. However, to share that vital technology would breach the Sikarian prime directive.

1.11 STATE OF FLUX
Janeway and her senior officers are disturbed to discover that one of *Voyager*'s crew is acting as a spy for the Kazon-Nistrim and is sending them intelligence about the ship.

1.12 HEROES AND DEMONS
When Harry Kim disappears, Tuvok and Chakotay track his last known location to the holodeck. When Tuvok and Chakotay also disappear – transformed into photonic energy like Kim before them, *Voyager*'s holographic Doctor is sent to rescue them.

1.13 CATHEXIS
When Chakotay and Tuvok's shuttle is attacked, Chakotay is left brain-dead, and an apparently malicious alien entity infiltrates *Voyager*.

1.14 FACES
While on an away mission to the Avery system, B'Elanna Torres is captured by the Vidiians and imprisoned in a hidden complex. Operated on by a Vidiian surgeon, B'Elanna's human and Klingon sides are split in two, forcing her to confront her innermost feelings.

1.15 JETREL
Neelix is disturbed when the Haakonian scientist Jetrel comes aboard *Voyager*. Jetrel was the architect of a weapon of mass destruction that killed thousands of Neelix's people, but now brings a warning that Neelix may be fatally ill.

1.16 LEARNING CURVE
Tuvok is tasked with training some unruly former Maquis members to enable them to integrate better with *Voyager*'s crew. An alien cheese might be the solution to *Voyager*'s failing bio-neural systems.

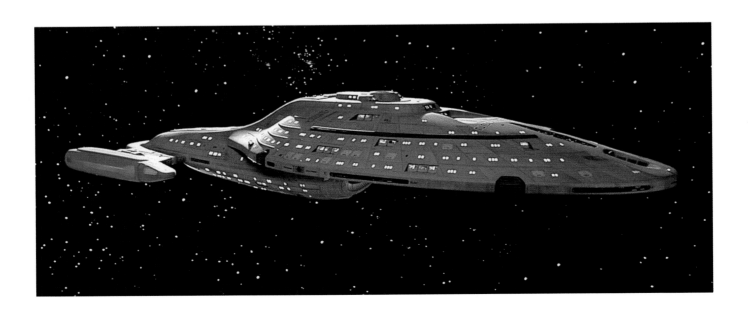

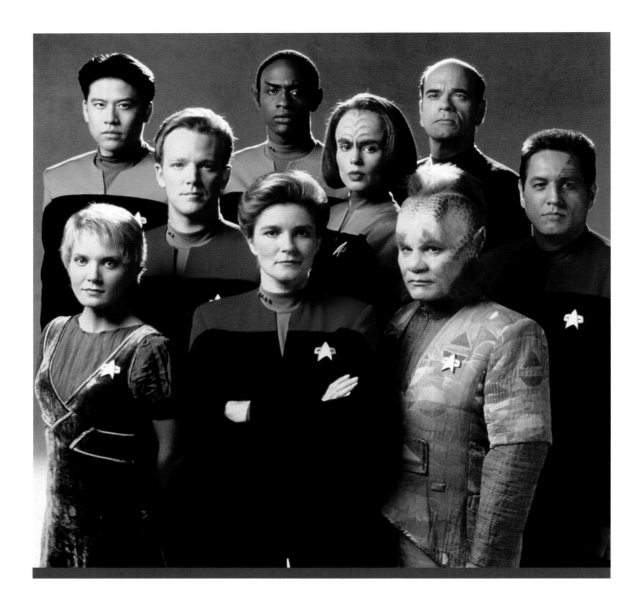

S E A S O N 2

The second season involved a recurring storyline in which former crewmember and Cardassian spy Seska aligns herself with the Kazon. *VOYAGER*'s cocreator Michael Piller was a strong advocate of the Kazon, but few people felt that they were particularly successful. The storyline also addressed Tom Paris's 'bad behavior,' as he pretends to be unhappy with the constraints of life in Starfleet, but this was considered difficult because not all the viewers would see the conclusion.

The phage-ravaged Vidiians returned in three episodes, but would make their final appearance in 'Resolutions.' Janeway's crew found the Caretaker's mate in 'Cold Fire,' but didn't get any closer to home as a result. This second season also saw the first of several guest appearances from John de Lancie as Q, kicking off a storyline that would carry on until the final season. He was joined by Jonathan Frakes, who had a cameo in 'Death Wish,' when Q summons Riker as part of Quinn's hearing.

2.1 THE 37'S
Following an ancient SOS signal to a planet, Janeway and her crew are amazed to discover eight humans from 1930s Earth in cryogenic suspension. Among the frozen group is the lost aeronautical pioneer, Amelia Earhart.

2.2 INITIATIONS
Seeking solitude to honor the anniversary of his father's death, Chakotay becomes the target of Kar, a young Kazon-Ogla who is on a mission to make a killing to earn his name.

2.3 PROJECTIONS
Following an accident, the Doctor believes that he is Lewis Zimmerman, the creator of the emergency medical hologram program, and that his experiences aboard Voyager have been a holodeck fantasy.

2.4 ELOGIUM
An encounter with spaceborne aliens initiates Kes's Ocampan fertile state, forcing Neelix to confront the possibility of becoming a parent.

2.5 NON SEQUITUR
Harry Kim awakes to discover he is in 24th-century San Francisco. There is no evidence that he was ever part of Voyager's crew.

2.6 TWISTED
When Voyager runs into a spatial anomaly, it begins to distort the structure of the ship which will ultimately cause it to implode.

2.7 PARTURITION
When Tom Paris gives Kes lessons on how to pilot a shuttle, Neelix is jealous of their intimacy. He and Paris must reconcile their differences when their shuttle crashes.

2.8 PERSISTENCE OF VISION
When Voyager enters Botha space, the crew fall victim to a series of disturbing hallucinations induced by a psionic field. Only the Doctor remains immune.

2.9 TATTOO
On an away mission to an uninhabited moon, Chakotay is surprised to discover tribal symbols that he recognizes from his youth.

2.10 COLD FIRE
Voyager encounters Suspiria, the female counterpart of the Caretaker who first brought Voyager to the Delta Quadrant. The leader of a colony Ocampa offers to help Kes develop her telepathic abilities.

2.11 MANEUVERS
With the help of the traitor Seska, the Kazon-Nistrim send a raiding party to Voyager where they steal vital transporter technology. Chakotay goes in pursuit, determined to retrieve the equipment.

2.12 RESISTANCE
While on an away mission to purchase urgently needed tellerium for Voyager, Tuvok and B'Elanna are taken prisoner. To rescue them, Janeway has no choice but to trust a mentally disturbed resistance fighter.

2.13 PROTOTYPE
Voyager discovers and reactivates a sentient robotic humanoid known as automated unit 3947. B'Elanna is abducted by 3947 who orders her to construct new robots. If she refuses, Voyager will be destroyed.

2.14 ALLIANCES
As Voyager continues its journey through Kazon territory, it comes under repeated attack by the various sects of the Kazon collective. Janeway is persuaded that it would be in their best interests to form an alliance with the Kazon.

2.15 THRESHOLD
Piloting an experimental shuttlecraft, Tom Paris successfully reaches Warp 10, breaking the transwarp barrier. However, the experience triggers a dramatic physiological transformation in Paris.

2.16 MELD
When former Maquis crewman Lon Suder commits an apparently motiveless murder, Tuvok initiates a mind-meld to discover the truth. The procedure stimulates Tuvok's own violent impulses, through contact with Suder's murderous tendencies.

2.17 DREADNOUGHT
Voyager encounters Dreadnought, a deadly Cardassian missile from the Alpha Quadrant controlled by a sophisticated artificial intelligence. Torres must reprogram Dreadnought before it detonates on an inhabited world.

2.18 DEATH WISH
When a member of the Q continuum seeks asylum aboard Voyager so that he may end his own life, Janeway is forced to mediate between the fugitive and Q, who is determined to stop him.

2.19 LIFESIGNS
Answering a distress call, Voyager takes on board a Vidiian female named Pel, who is very ill. The Doctor attempts to cure her, and during the treatments he finds that he is falling in love with her. Tom Paris becomes increasingly insubordinate.

2.20 INVESTIGATIONS
Neelix launches a daily news program for Voyager, while a disgruntled Tom Paris departs the ship for a new life. Looking for news stories, Neelix discovers that there is a traitor aboard Voyager who is in league with the Kazon.

2.21 DEADLOCK
While navigating around Vidiian space, Voyager passes through a spatial scission that causes a duplicate ship to be created.

2.22 INNOCENCE
When Tuvok's shuttle crash-lands on a moon, he encounters a group of seemingly abandoned Drayan children. When the children begin to disappear one by one, Tuvok learns that they are in fact aging in reverse.

2.23 THE THAW
When Voyager arrives at an abandoned world, they discover that three colonists are being held hostage in a virtual environment by a sinister clown – a personification of fear. Harry Kim is also taken hostage and Janeway must devise a plan to defeat the clown.

2.24 TUVIX
A transporter accident causes Tuvok and Neelix to be combined into a single person – Tuvix. A means to separate them is eventually discovered, but Janeway questions if she has the right to deny Tuvix his life.

2.25 RESOLUTIONS
After contracting a deadly disease, Captain Janeway and Chakotay are forced to leave Voyager and live together on an alien world. While they adapt to their new relationship, Voyager's new commander – Tuvok – comes under pressure from the crew to find a cure for the illness.

2.26 BASICS, PART I
A desperate message from Seska, claiming that she has given birth to Chakotay's son, leads Voyager into a deadly trap. The Kazon-Nistrim finally take control of Voyager, abandoning Captain Janeway and her crew on a hostile world.

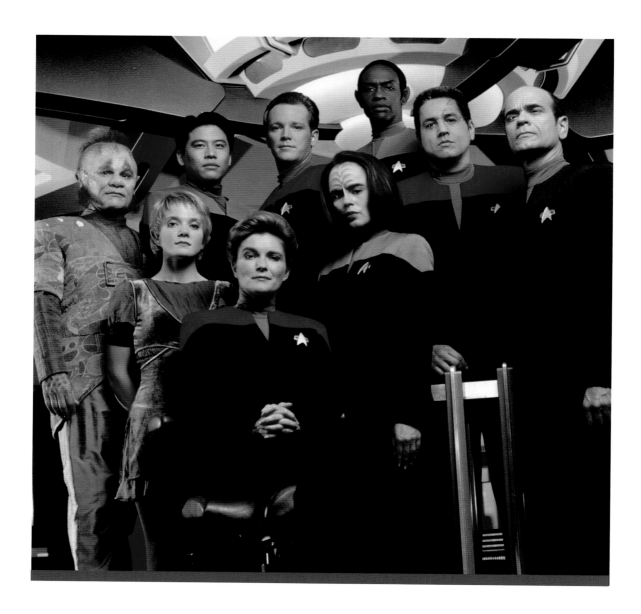

S E A S O N 3

The season opened with the Kazon's last appearance in 'Basics, Part II,' before September 1996 saw *STAR TREK* celebrating its 30th anniversary, which was marked by guest appearances from George Takei and Grace Lee Whitney in 'Flashback.' Brannon Braga identified the two-part story 'Future's End,' in which the crew visit 1990s Los Angeles, as a turning point. From then on, *VOYAGER* regularly featured double-length stories during the season, which Braga felt gave them the chance to be more ambitious and cinematic. 'Future's End' also saw the Doctor gain his mobile emitter, meaning that he could leave sickbay. The seeds were laid for Tom and B'Elanna's romance in a series of episodes, most notably 'Blood Fever.'

Behind the scenes, the VFX team expanded their use of CG effects, which until now had been relatively light. This ultimately led to the creation of Species 8472, who appear in the season finale when *Voyager* enters Borg space.

3.1 BASICS, PART II
Janeway and her crew are marooned on a volcanic planet by the Kazon. As they struggle to survive, the Doctor and Suder work with Paris to retake *Voyager* from the treacherous Seska and her Kazon allies.

3.2 FLASHBACK
When Tuvok suffers from disturbing hallucinations, Captain Janeway volunteers to mind-meld with him. The experience takes them 80 years into the past, aboard Captain Hikaru Sulu's *U.S.S. Excelsior*.

3.3 THE CHUTE
While on shore leave, Paris and Kim are wrongly convicted of a terrorist act and thrown in an Akritirian prison. They must survive while Captain Janeway finds a way to rescue them.

3.4 THE SWARM
The Doctor's memory circuits have started to degrade and he faces being shut down. At the same time, Captain Janeway determines to cross a zone of dangerous alien space, which is filled with a swarm of hostile alien ships.

3.5 FALSE PROFITS
The *U.S.S. Voyager* finds a wormhole that may lead back to Federation space, but sensors reveal that technology from the Alpha Quadrant has recently been used on a nearby planet. The culprits are two Ferengi, who are exploiting the world's primitive inhabitants. Enter the Grand Nagus!

3.6 REMEMBER
When the *U.S.S. Voyager* takes some telepathic Enarans on board, B'Elanna Torres finds herself reliving someone else's life. The Enarans appear gentle, and have astonishing gifts and talents, but they are also hiding a terrible secret.

3.7 SACRED GROUND
When Kes is struck down by a mysterious biogenic energy field, she is left in a coma. Captain Janeway volunteers to go through a ritual that forces her to question her own scientific beliefs, in an attempt to seek the help of the Nechisti spirits.

3.8 FUTURE'S END, PART I
The *U.S.S. Voyager* encounters a temporal rift and is suddenly attacked by a Federation time ship named the *Aeon*. The captain of the *Aeon* tells them he has to destroy *Voyager* before it causes a massive temporal explosion that will devastate Earth in the 29th century.

3.9 FUTURE'S END, PART II
In 1996, Starling intends to use the *Aeon* time ship to travel to the future to acquire more technology. His plan could destroy Earth unless Captain Janeway and her crew can stop him.

3.10 WARLORD
Voyager rescues three Ilarian survivors from a damaged starship, but one of them seemingly dies. However, it transpires that Kes has been taken over by the Ilarian, who is in fact a paranoid tyrant who seeks to rule Ilari again.

3.11 THE Q AND THE GREY
Q pays a visit to *Voyager* and demands that Janeway have a child with him to stop a civil war in the Q Continuum. When she refuses, Q abducts her and takes her to the Continuum.

3.12 MACROCOSM
Janeway and Neelix return from a trade mission to find the crew have been infected by macroviruses. The Doctor and Janeway are soon the only ones able fight off the viruses.

3.13 FAIR TRADE
Voyager stops at a trading station before entering the Nekrit Expanse. Neelix runs into Wixiban, an old Talaxian friend who persuades him to get involved in trading stolen items.

3.14 ALTER EGO
A troubled Harry Kim seeks advice from Tuvok after he falls in love with a holodeck character named Marayna. Tuvok agrees to help but after meeting Marayna, she becomes obsessed with him and takes control of the ship.

3.15 CODA
Janeway and Chakotay are caught in a time loop where their shuttle repeatedly crashes, ending in their apparent death each time. Janeway's father appears to her to explain that she has died...

3.16 BLOOD FEVER
Preparing for an away mission, the Vulcan Ensign Vorik suddenly declares his desire to mate with Torres. When she firmly rejects him, he attacks her and initiates a telepathic link, passing on the Vulcan *Pon farr*.

3.17 UNITY
Commander Chakotay and Ensign Kaplan investigate a nearby planet. They are attacked and Kaplan is killed. Chakotay is rescued by former Borg drones who treat his wounds and claim they have regained their individuality.

3.18 DARKLING
Inspired by a desire to improve his personality, the Doctor studies some of the great figures from literature and history. Unfortunately, he unintentionally includes some of their strongly suppressed dark sides, which take him over.

3.19 RISE
During an asteroid bombardment on an alien world, Tuvok and Neelix become stranded. Their only means of survival is to break through the ionosphere in an orbital lift.

3.20 FAVORITE SON
Harry Kim takes control of *Voyager*'s weapons and fires on a seemingly friendly ship. Kim cannot explain his actions, but his DNA is found to be changing and he believes he isn't human.

3.21 BEFORE AND AFTER
Kes finds herself living life backward, due to a temporal anomaly. Episodes of her life are revealed as she learns that she has married Tom Paris and had a child, while Captain Janeway and B'Elanna Torres have died.

3.22 REAL LIFE
The Doctor creates his own holo family in an effort to experience a more 'normal' life. With a wife, two children, and a typically suburban house, the Doctor enjoys his creation until Torres and Kes point out that it is unrealistic.

3.23 DISTANT ORIGIN
A reptilian scientist follows *Voyager* in an effort to prove that his species descended from warm-blooded bipeds on Earth. To prove his theory, he kidnaps Chakotay.

3.24 DISPLACED
Members of the *Voyager* crew disappear, to be replaced by aliens that are taking control of *Voyager*, while the vanishing crew are being held in an Earth-like habitat.

3.25 WORST CASE SCENARIO
Torres finds a holonovel set early in *Voyager*'s mission, in which a Maquis mutiny led by Chakotay takes over the ship. It proves so entertaining and popular that Tuvok wants to finish it, with dangerous consequences.

3.26 SCORPION, PART I
Voyager has reached the point in its journey where it must enter Borg space. The crew discover a narrow corridor free of Borg ships, but when they enter it, they find an adversary even deadlier than the Borg.

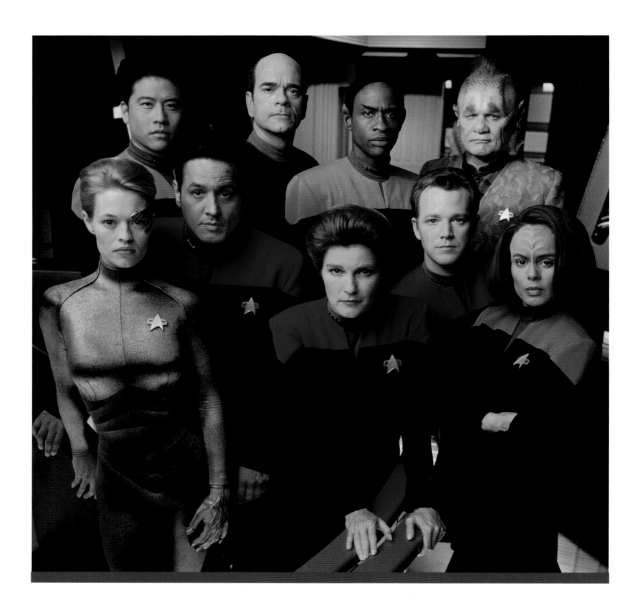

S E A S O N 4

The fourth season was a major turning point for *VOYAGER*, since it saw the introduction of Seven of Nine and the departure of Kes. Seven's arrival galvanized the series. The resulting publicity surrounding her debut made a signficant impact, and her presence onboard gave the writers a new way into stories dealing with the Borg, who would become *VOYAGER*'s principal villains. During the season, the crew are finally able to make regular contact with the Alpha Quadrant in 'Message in a Bottle,' a story that establishes that the Doctor can be transmitted back home.

The season included two two-part stories: 'Year of Hell' and 'The Killing Game.' The latter was broadcast on one night, effectively becoming a TV movie. At the end of the season, after seven years with *STAR TREK*, one of *VOYAGER*'s cocreators, Jeri Taylor, stepped away from the day-to-day running of the show, leaving Brannon Braga in charge of the writers' room.

4.1 SCORPION, PART II

Captain Janeway forges an uneasy alliance with the Borg against the immensely powerful Species 8472. On a Borg cube, Janeway and Tuvok meet a drone named Seven of Nine.

4.2 THE GIFT

Kes's telepathic powers increase exponentially to the point that they threaten to tear *Voyager* apart, while Seven of Nine has been freed from the Borg collective.

4.3 DAY OF HONOR

Torres is having a terrible day on a Klingon holiday, known as the Day of Honor. After ejecting *Voyager*'s warp core, she and Paris take a shuttle to retrieve it but are attacked by an alien race, and left adrift in space.

4.4 NEMESIS

Chakotay is surveying a world when his shuttle is shot down. In defiance of the Prime Directive, he becomes personally involved in a bitter war between two alien species. .

4.5 REVULSION

Answering a distress call, Torres and the Doctor are sent to help a vessel, but encounter a psychotic hologram who has killed his crew – and now comes after the away team .

4.6 THE RAVEN

Voyager attempts to negotiate a route through Bomar space while Seven of Nine is compelled to steal a shuttle. She finds the wreckage of the *Raven* – her parents' ship.

4.7 SCIENTIFIC METHOD

When the crew experience various debilitating medical conditions, no explanation can be found until the Doctor and Seven of Nine discover hidden aliens are carrying out grisly experiments on them.

4.8 YEAR OF HELL, PART I

Annorax, a Krenim scientist in command of a temporal weapon ship, alters timelines to restore his species' worlds. *Voyager* gets caught in the temporal war and has no defences in a running battle with the Krenim.

4.9 YEAR OF HELL, PART II

With *Voyager* abandoned and Chakotay and Tom Paris captured by Annorax, Captain Janeway faces certain death unless she can find allies, launch a last desperate attack on the temporal weapon ship, and restore the original timeline.

4.10 RANDOM THOUGHTS

On a planet of telepaths, Torres finds herself arrested after a violent thought from her mind causes another man to commit a crime. Tuvok investigates the case and has to delve into the darkest aspects of his personality.

4.11 CONCERNING FLIGHT

When *Voyager*'s main computer processor is stolen, Janeway and Tuvok masquerade as traders. They meet a holographic Leonardo da Vinci from *Voyager*'s holodeck who helps them retrieve their stolen technology.

4.12 MORTAL COIL

When Neelix is killed during a shuttle accident, Seven of Nine uses her Borg nanoprobes to revive him. Realizing there is no promised Talaxian afterlife, Neelix begins to question his own deeply held beliefs.

4.13 WAKING MOMENTS

The crew all experience the same vivid nightmares, which feature a mysterious alien. Only two people are unaffected: the Doctor and Chakotay, who is undergoing medical treatment in sickbay.

4.14 MESSAGE IN A BOTTLE

Seven of Nine finds a Hirogen relay station that allows the Doctor to be sent to an experimental Starfleet vessel in the Alpha Quadrant. Arriving on the ship, the Doctor finds the crew dead and Romulans aboard.

4.15 HUNTERS

Voyager downloads a transmission from Starfleet Command sent through a Hirogen relay station, which turns out to be letters from home. Later, Seven of Nine and Tuvok are on the relay station when they are captured by Hirogen, a species of hunters.

4.16 PREY

An injured Hirogen hunter pursues a highly prized prey onto *Voyager*, which turns out to be a member of Species 8472. Captain Janeway wants to show compassion to both the Hirogen and Species 8472, but Seven of Nine has different ideas.

4.17 RETROSPECT

Seven of Nine recalls a repressed memory of being assaulted by a trader offering to sell weapons to *Voyager*. However, Tuvok discovers evidence that refutes the allegation that the trader was trying to steal Borg nanoprobes from Seven of Nine.

4.18 & 4.19 THE KILLING GAME, PARTS I & II

The Hirogen take over *Voyager* and force the crew to participate in dangerous games of violence on the holodeck. With the holodeck safety routines disabled, armed holograms of Nazi soldiers overrun *Voyager*, joining forces with the Hirogen to eliminate the crew. Janeway breaks free from the simulation and tries to stop the Hirogen and retake *Voyager*.

4.20 VIS À VIS

When *Voyager* encounters a damaged ship, Paris is assigned to help the alien pilot with repairs. The alien turns out to be a genome thief, who switches bodies with Paris.

4.21 THE OMEGA DIRECTIVE

Voyager detects Omega, the most powerful substance known to exist, which is highly unstable. A secret Starfleet protocol means that Captain Janeway must destroy the substance at all costs.

4.22 UNFORGETTABLE

Chakotay meets an alien who claims that they fell in love weeks earlier, but he has no memory of their relationship. She belongs to a species who emit a pheromone that erases memories and repels technological scans.

4.23 LIVING WITNESS

The Doctor's backup module is reactivated by a historian centuries in the future on an alien world. The Doctor is shocked to learn that the people of the planet remembers the crew of *Voyager* as sadistic warriors who started a war.

4.24 DEMON

Desperate for deuterium fuel, Kim and Tom Paris seek supplies on a Demon-class planet. The pair go missing and Janeway's only option is to land on the planet and search for them.

4.25 ONE

With *Voyager*'s entire crew placed in stasis for a month, Seven of Nine and the Doctor are left alone in charge of the ship. Irritated by each other's company, the two seek solitude. However, once alone, Seven finds herself vulnerable and afraid.

4.26 HOPE AND FEAR

When an alien linguistics expert helps to unravel a garbled message from Starfleet, the crew of *Voyager* are thrilled to hear they will soon by speeding home aboard a prototype vessel capable of delivering them to Earth in just three months.

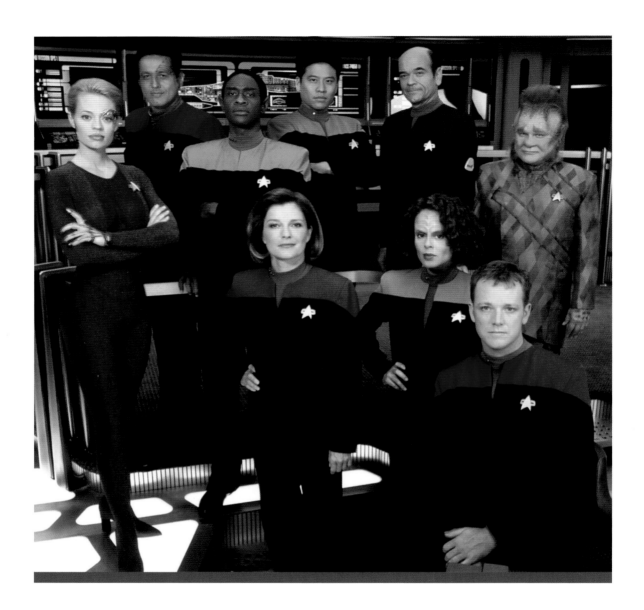

S E A S O N 5

By the fifth season, *VOYAGER* was firing on all cylinders. This year saw the series' 100th episode, 'Timeless,' which is widely regarded as one of its best. It would be joined by other fan-favorites, including 'Someone to Watch Over Me' and 'Course: Oblivion.' The Borg Queen returned in the double-length story 'Dark Frontier.' Species 8472 made their final appearance in 'In the Flesh,' while the polluting Malon made their debut in 'Night.' The season opener also saw the introduction of the holodeck character Captain Proton, who would make three appearances during the season.

The *Delta Flyer* made its debut in 'Extreme Risk,' while 'Relativity' wrapped up the fate of the 29th-century time policeman, Captain Braxton, who had made his debut in Season 3's 'Future's End,' and showed us *Voyager* before it left Earth in 'Caretaker.' The cliffhanger at the end of the season saw the crew encounter another Starfleet ship that had been stranded in the Delta Quadrant.

5.1 NIGHT

Crossing a vast, dark region of space with no stars or planets, monotony hits the *Voyager* crew's morale before strange night creatures attack, wrongly believing they are in league with a polluting Malon garbage freighter.

5.2 DRONE

A transporter accident fuses Seven of Nine's nanoprobes with the Doctor's mobile emitter to create a highly advanced Borg drone, who attracts the attention of a Borg sphere.

5.3 EXTREME RISK

The crew races to build the *Delta Flyer* in an effort to retrieve a multi-spatial probe trapped in the hostile atmosphere of a gas giant before the Malon steal it.

5.4 IN THE FLESH

Voyager stumbles across a space station containing a perfect recreation of Starfleet Academy, but it is a training ground for Species 8472, who are planning an invasion of Earth.

5.5 ONCE UPON A TIME

Neelix takes care of young Naomi Wildman by distracting her with a whimsical hologram after her mother is missing and seriously injured when the *Delta Flyer* crashes.

5.6 TIMELESS

A failed attempt to use slipstream propulsion technology results in *Voyager* crashing on an ice planet and the deaths of most of the crew. In the future, Chakotay and Harry Kim devise a plan to prevent the disaster.

5.7 INFINITE REGRESS

Voyager encounters the wreckage of a Borg vessel, but a compromised vinculum causes Seven of Nine to be possessed by the personalities from her assimilated victims.

5.8 NOTHING HUMAN

When an alien parasite attaches itself to Torres, the Doctor creates a hologram of a Cardassian exobiologist to help him, but the Cardassian is revealed to be a war criminal.

5.9 THIRTY DAYS

Tom Paris disobeys orders when he helps an ocean world by protecting it from its own inhabitants. As a consequence, he is demoted to ensign and thrown in the brig for 30 days to contemplate recent events.

5.10 COUNTERPOINT

Voyager hides telepathic refugees when it smuggles them through a sector controlled by the telepath-hating Devore. A Devore commander claims to be a defector, but Captain Janeway is unsure of his motives.

5.11 LATENT IMAGE

While using his holo-imager, the Doctor discovers unsettling evidence that some of his memory files have been removed. He is distraught to discover he was responsible for the death of a crewmember.

5.12 BRIDE OF CHAOTICA!

Photonic life-forms from another dimension become involved in a war with the characters in Tom Paris's *Captain Proton* holonovel, after mistaking it for reality.

5.13 GRAVITY

Trapped on a planet where time passes faster than in normal space, Tuvok and Paris spend months struggling to survive before meeting an alien woman who falls in love with Tuvok.

5.14 BLISS

The *Voyager* crew are excited when they discover a wormhole that apparently leads to the Alpha Quadrant. Seven of Nine is extremely skeptical and enlists the help of an alien pilot to prove her fears correct.

5.15 & 5.16 DARK FRONTIER, PARTS I & II

The crew plan a daring heist to steal transwarp technology from a damaged Borg sphere. The Borg Queen learns of the raid and contacts Seven of Nine with an ultimatum: rejoin the Collective or *Voyager* will be assimilated.

5.17 THE DISEASE

While helping to repair a generational ship belonging to a xenophobic species, Harry Kim ignores Starfleet regulations when he falls in love with an alien woman. Their relationship becomes biochemically interdependent, so putting everyone's lives in jeopardy.

5.18 COURSE: OBLIVION

A mysterious phenomenon leads to the gradual disintegration of *Voyager* and threatens the lives of everyone on board. The deteriorating crew make the shocking discovery that they are a bio-mimetic duplicate starship crew created on the Demon-class planet previously visited by *Voyager*.

5.19 THE FIGHT

Voyager becomes trapped in an area known as "chaotic space," an environment not even the Borg can escape. The crew's survival depends on Commander Chakotay, who tries to contact aliens existing there through an intense hallucination in which he is a boxer.

5.20 THINK TANK

An alien collective of brilliant thinkers offers to help the *Voyager* crew escape from a race of ruthless bounty hunters, but the price of salvation is high. In return, they want Seven of Nine to join their group.

5.21 JUGGERNAUT

A damaged Malon freighter is about to explode, spreading deadly radiation over three light years. B'Elanna Torres leads an away team to save the doomed ship, but they are hindered by a legendary Malon beast.

5.22 SOMEONE TO WATCH OVER ME

While teaching Seven of Nine about socializing, dancing, dating, and romantic relationships, the Doctor unexpectedly finds that he is becoming increasingly attracted to her.

5.23 11.59

Captain Janeway learns more about one of her favorite ancestors, Shannon O'Donnel. Newly discovered historical records reveal that Shannon was very different from what the family had led Janeway to believe.

5.24 RELATIVITY

Seven of Nine is recruited by Captain Braxton of a 29th-century timeship to prevent a saboteur from destroying *Voyager* on its launch in 2371, but the mission turns out to be far more complex.

5.25 WARHEAD

With Harry Kim given the chance to command, *Voyager* rescues a sentient missile, but it takes over the Doctor's program to complete its mission to destroy an entire civilization.

5.26 EQUINOX, PART I

Voyager encounters the *U.S.S. Equinox*, another Starfleet vessel lost in the Delta Quadrant. Under Captain Ransome, the *Equinox*'s crew have been slaughtering nucleogenic life-forms to use their unique physiology to enhance their vessel's warp engines, placing them in direct conflict with *Voyager*'s crew.

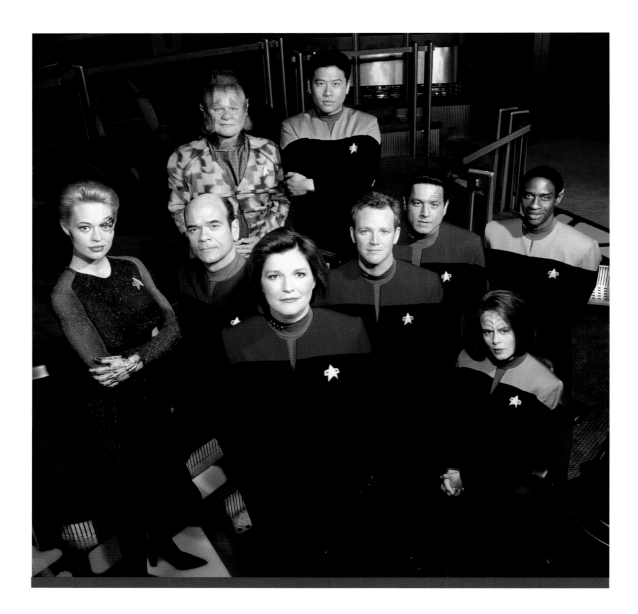

S E A S O N 6

The sixth season marked the first time in four years that the series had no midseason two-parter. *VOYAGER* did have one of its most signficant guest stars, when the Rock made his acting debut in the episode 'Tsunkatse.' Bob Picardo became the first cast member to have a writing credit when he and director John Bruno came up with the idea of 'Life Line.' The crew finally established regular contact with the Alpha Quadrant in 'Pathfinder,' a story that would lead to TNG's Reg Barclay and Deanna Troi becoming recurring characters. A vengeful and confused Kes returned to make her final appearance in 'Fury,' and a group of Borg children joined the crew in 'Collective.'

At the end of the year, executive producer Brannon Braga stepped back, so he could work with Rick Berman to create the next *STAR TREK* series, which would become *ENTERPRISE*. Ken Biller, who had been with the series since the beginning, stepped up to take charge of the writers' room.

6.1 EQUINOX, PART II

Outraged by the actions of the *Equinox* crew, Captain Janeway goes to extreme lengths, almost killing an *Equinox* crewmember under interrogation, to bring them to justice.

6.2 SURVIVAL INSTINCT

Seven of Nine encounters three ex-Borg drones from her unimatrix. They ask for Seven's help to fully regain their individuality.

6.3 BARGE OF THE DEAD

On the brink of death in a shuttle accident, B'Elanna Torres experiences a series of hallucinations in which she travels to a representation of Klingon hell in the Barge of the Dead where she meets her mother.

6.4 TINKER, TENOR, DOCTOR, SPY

Planning a raid on *Voyager*, aliens known as the Hierarchy tap into the Doctor's 'daydream' program and believe his fantasies are real – including that *Voyager* is armed with photonic cannons that can destroy Borg vessels.

6.5 ALICE

Paris acquires a shuttle that he restores and calls *Alice*. When he activates its neurogenic interface, it appears as a clever, beautiful woman. Paris cannot resist her requests.

6.6 RIDDLES

When Tuvok is attacked by a Ba'Neth energy weapon, he suffers severe neurological damage and loses emotional self-control. Neelix tries to nurse him, but the Ba'Neth need to be found to provide an effective cure.

6.7 DRAGON'S TEETH

Fleeing from hostile aliens, *Voyager* takes refuge on a planet where the crew discover rival aliens in stasis. They find themselves caught in the middle of an ancient battle between these alien civilizations.

6.8 ONE SMALL STEP

When *Voyager* encounters a graviton ellipse, Chakotay takes an away team to investigate. Inside the phenomenon, they become trapped after finding the ancient command module of Earth's first manned mission to Mars.

6.9 THE VOYAGER CONSPIRACY

Seven of Nine downloads the *Voyager* database, which leads her to believe she has uncovered huge conspiracies. She spreads paranoia among the crew about why Janeway chose to strand the ship in the Delta Quadrant.

6.10 PATHFINDER

On Earth, Reg Barclay becomes obsessed with a holodeck recreation of *Voyager* as he searches for a way to communicate with them. His actions draw criticism from his superiors.

6.11 FAIR HAVEN

While passing through a stellar wavefront, the *Voyager* crew take refuge in Paris's holodeck recreation of the Irish town, Fair Haven. One character catches the eye of Captain Janeway.

6.12 BLINK OF AN EYE

Voyager becomes trapped in the orbit of a planet where time passes more quickly. Civilizations rise and fall before the technology develops fast enough to enable a mission to visit the mysterious "sky ship."

6.13 VIRTUOSO

While treating advanced aliens, the Doctor introduces them to music for the first time. He is invited to their homeworld, where his singing performances lead him to be treated as a superstar, and the acclaim goes to his head.

6.14 MEMORIAL

Returning from a mission, an away team begin having nightmares about a military massacre. All of the crew begin to remember being involved in the terrible atrocity.

6.15 TSUNKATSE

On shore leave, some of the crew attend a violent fight contest known as Tsunkatse. They are shocked to discover that one of the brutal tournament's contenders is Seven of Nine.

6.16 COLLECTIVE

Several *Voyager* crewmembers are taken hostage by a Borg cube, but it is operated by partially assimilated children who have been separated from the Collective.

6.17 SPIRIT FOLK

The holocharacters from Fair Haven show signs of sentience after they accuse the *Voyager* crew of witchcraft. Paris and Kim try to fix the holoprogram, but they are captured by the townsfolk and with safety protocols offline, their lives are in danger.

6.18 ASHES TO ASHES

A crewmember returns to *Voyager* after she died on an away mission three years earlier. She was brought back to life by the Kobali, a species who procreate by resurrecting the dead – and they want her back.

6.19 CHILD'S PLAY

Voyager locates the parents of Icheb, one of the young Borg now living on the ship. Seven does not trust Icheb's parents, and her fears are proved right when they try to send their child back to the Borg.

6.20 GOOD SHEPHERD

Captain Janeway takes three misfit crewmembers under her wing and they accompany her on a routine mission. Events take an unexpected turn, and their survival depends on their performance as a team.

6.21 LIVE FAST AND PROSPER

Voyager attempts to track down a trio of con artists who have been impersonating Captain Janeway, Chakotay, and Tuvok, committing a series of frauds over several worlds.

6.22 MUSE

After crashing on a primitive planet, B'Elanna Torres becomes friends with an alien playwright. He believes that Torres is a deity and she becomes the inspiration for his plays. In return, he brings her parts for repairing her communication device.

6.23 FURY

An older, angry, powerful Kes returns to *Voyager* seeking revenge. She blames Captain Janeway for abandoning her when she became too troublesome, and attempts to use her immense telekinetic powers to take them back in time and deliver the *Voyager* crew to the Vidiians.

6.24 LIFE LINE

The Doctor has his program sent to the Alpha Quadrant when he learns that his creator, Lewis Zimmerman, is dying with no hope of a cure. But the Doctor is dismayed when Zimmerman wants nothing to do with him.

6.25 THE HAUNTING OF DECK TWELVE

Voyager powers down to enter a nebula to harvest fuel materials. Neelix attempts to keep the Borg children amused by telling ghost stories, but the creature in his tale may be real.

6.26 UNIMATRIX ZERO, PART I

Seven of Nine rediscovers a virtual reality that certain Borg drones inhabit when regenerating, where they experience their individuality before assimilation. The Borg Queen tries to find and dismantle these drones, but Captain Janeway sees an opportunity to fatally weaken the Collective.

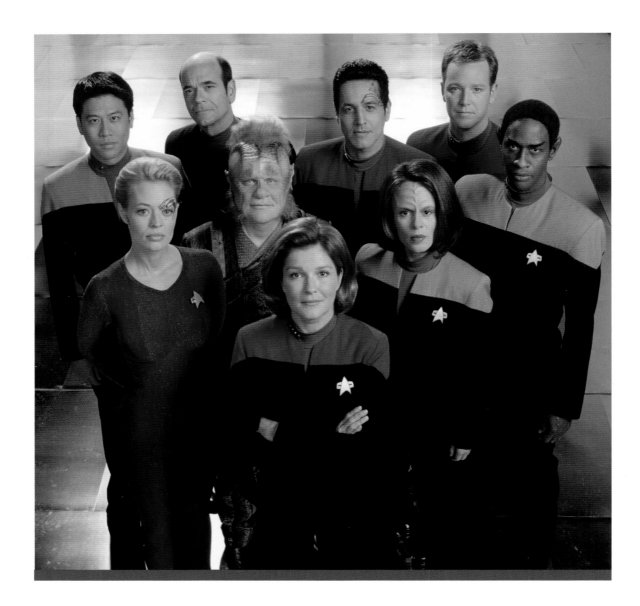

S E A S O N 7

The final year of *VOYAGER* saw the writers wrap up some story threads: in 'Homestead,' Neelix left the ship before they reached Earth, and the series finale featured the birth of Tom and B'Elanna's baby. Q returned, along with his son, to close out the storyline that had begun with Quinn's death in the second season.

The producers revived the idea of two-part stories. The first, 'Flesh and Blood,' saw the Hirogen return, and showed them dealing with a holographic rebellion that addressed many of *STAR TREK*'s core themes. In the second two-parter, 'Workforce,' the crew forgot who they were and became enslaved by an alien race.

The biggest question of all was how – and if – the crew would get home. They did so, with the aid of a version of Captain Janeway from the future and a network of Borg transwarp corridors. The story saw Janeway defeat the Borg Queen, who returned for one final confrontation.

7.1 UNIMATRIX ZERO, PART II

Captain Janeway, Tuvok, and B'Elanna Torres deliberately allow themselves to become assimilated so they can spread an 'individuality' virus throughout a Borg cube. Tuvok soon becomes fully assimilated and under Borg influence, while the Borg Queen captures Janeway. She demands a cure for the virus or she will kill the recently freed Borg drones.

7.2 IMPERFECTION

Seven of Nine faces death when her vital Borg cortical node implant begins to fail. With no way to replicate the device, any replacement must be taken from a live Borg drone. The crew consider the enormous ethical dilemma when Icheb volunteers to donate his own.

7.3 DRIVE

Tom Paris enters the *Delta Flyer* in an interstellar race to promote peace against once-warring species. Feeling their relationship is reaching its end, B'Elanna volunteers to accompany him in the race, but the *Delta Flyer* has been rigged as a bomb.

7.4 REPRESSION

Tuvok investigates a series of attacks on *Voyager* crewmembers who were part of the Maquis, and after receiving a subliminal message in a letter, he makes the shocking discovery that he is the perpetrator, .

7.5 CRITICAL CARE

The Doctor is stolen and sold to a hospital ship where he finds that more valuable patients receive better medical treatment. He finds this unacceptable and takes matters into his own hands to change the unfair system.

7.6 INSIDE MAN

A hologram of a superconfident Reg Barclay is sent to *Voyager*, who tells the crew that he has found a way to bring them home within a few days. It turns out this is too good to be true, as the hologram is part of a Ferengi plot to steal Seven of Nine's nanoprobes.

7.7 BODY AND SOUL

When the *Delta Flyer* is boarded by a species who hates holograms, Seven of Nine downloads the Doctor's program into her cybernetic implants to keep him safe. Now controlling Seven of Nine's body, the Doctor attempts to negotiate their release, while indulging in some romance – and cheesecake.

7.8 NIGHTINGALE

When Harry Kim helps a medical ship, the crew are so grateful that they offer the young Starfleet officer the command of their ship. Kim finds that being a captain is much harder than he thought, especially when the aliens are not telling him the whole truth.

7.9 & 7.10 FLESH AND BLOOD, PARTS I & II

Voyager answers a distress call to find mutilated Hirogen hunters killed by sentient holograms that were created by Starfleet technology. Having originally provided the holo technology to the Hirogen, Captain Janeway feels obligated to clean up their mess. Meanwhile, the leader of the holograms embarks on a crusade against all organics, enlisting the Doctor's help.

7.11 SHATTERED

After encountering a temporal anomaly, *Voyager* is shattered into multiple timelines, and key moments in the past and future play out in different areas of the ship.

7.12 LINEAGE

B'Elanna Torres discovers that she is pregnant. Due to her childhood experiences, she wants to remove the baby's Klingon cranial ridges with genetic modification, but Tom Paris is horrified by the idea.

7.13 REPENTANCE

Voyager rescues a damaged ship transporting prisoners to their execution, but the crew face a moral dilemma when most of the prisoners are from a minority race who don't feel guilt.

7.14 PROPHECY

Voyager encounters a generational Klingon ship that left the Alpha Quadrant 100 years earlier, and its captain believes that B'Elanna's unborn child is their messiah.

7.15 THE VOID

After passing through an anomaly, *Voyager* becomes trapped in a void where there are no resources, and other ships stuck there have to fight each other for supplies or face starvation.

7.16 & 7.17 WORKFORCE, PARTS I & II

Returning from an away mission, Chakotay, Harry Kim, and Neelix find that the crew have been kidnapped and brainwashed to work on a nearby planet desperate for laborers – and Captain Janeway has fallen in love.

7.18 HUMAN ERROR

Seven of Nine spends so much time on the holodeck having a relationship with a holographic version of Chakotay, that she is not helping *Voyager* when its engines fail while passing through a weapons testing area.

7.19 Q2

Q brings his son, threatened with banishment from the Q Continuum, to Captain Janeway, in the hope that she can improve his behavior and teach him humility. He continues to get in trouble and endanger the lives of others.

7.20 AUTHOR, AUTHOR

The Doctor has a holonovel published in the Alpha Quadrant in which the characters are closely based on his shipmates, but the crew are upset about how they are portrayed.

7.21 FRIENDSHIP ONE

Starfleet gives *Voyager* a mission to retrieve a 21st-century Earth probe lost in the Delta Quadrant. It turns out to have contaminated a world with radiation and deformed the inhabitants, who all want to be relocated to a new planet.

7.22 NATURAL LAW

On the way to a conference, Chakotay and Seven of Nine's shuttle crashes due to an energy barrier, and they are left stranded among primitive people. They find a way to contact *Voyager* and be rescued, but their actions will violate the Prime Directive.

7.23 HOMESTEAD

Discovering a colony of Talaxians living inside an asteroid, the *Voyager* crew help them avoid being evicted by ruthless asteroid miners. Neelix decides to remain with his own species.

7.24 RENAISSANCE MAN

When Captain Janeway is abducted by aliens, the Doctor has to impersonate various members of the *Voyager* crew in order to steal the ship's warp core and exchange it for the captain's life.

7.25 & 7.26 ENDGAME, PARTS I & II

Ten years after *Voyager* returns to the Alpha Quadrant, Admiral Janeway sets out to change history and bring *Voyager* back much earlier in the hope of saving many of the crew's lives. Her plan will involve taking on dozens of Borg ships – and the Borg Queen.